Drawing

Drawing

Space, Form, and Expression

Third Edition

Wayne Enstice
School of Art, University of Cincinnati

Melody Peters
Sculptor and Designer

PEARSON
Prentice
Hall

Upper Saddle River, New Jersey 07458

Library of Congress Cataloging-in-Publication Data

Enstice, Wayne
 Drawing: space, form, & expression/Wayne Enstice, Melody
Peters.—3rd ed.
 p. cm.
 Includes bibliographical references and index.
 ISBN 0-13-098113-3
 1. Drawing—Technique. I. Peters, Melody, 1949- II. Title.

 NC730 .E65 2003
 741.2—dc21
2002038102

Executive Editor: Sarah Touborg
Publisher: Bud Therien
Assistant Editor: Kimberly Chastain
Production Editor: Jan H. Schwartz
Editorial Assistant: Sasha Anderson
Cover Design: Bruce Kenselaar
Cover Art: *Inside a Passage Structure*, 1986
 Robert Stackhouse
 Arkansas Arts Center Foundation: Purchased with a gift from
 Virginia Bailey, 1987
 87.024.002
Buyer: Sherry Lewis
Director, Image Resource Center: Melinda Reo
Manager, Rights and Permissions: Zina Arabia
Interior Image Specialist: Beth Boyd-Brenzel
Cover Image Specialist: Karen Sanatar
Image Permission Coordinator: Charles Morris

This book was set in 10/12 Palatino by Interactive Composition
Corporation and was printed by Courier Companies, Inc. The
cover was printed by Phoenix Color Corporation.

© 2003 Pearson Education
Upper Saddle River, New Jersey 07458

Printed in the United States of America

10 9 8 7 6

ISBN 0-13-098113-3

Pearson Education LTD., London
Pearson Education Australia PTY, Limited, Sydney
Pearson Education Singapore, Pte. Ltd
Pearson Education North Asia Ltd, Hong Kong
Pearson Education Canada, Ltd., Toronto
Pearson Educación de Mexico, S.A. de C.V.
Pearson Education—Japan, Tokyo
Pearson Education Malaysia, Pte. Ltd

**In memory of Dr. Robert W. McMillan
For his encouragement
and professional insights.**

Contents

Preface

Our challenge in writing the third edition was to maintain the virtues of previous editions, with their emphasis on the absolute beginner, while increasing the usefulness of *Drawing: Space, Form, and Expression* for students who have progressed beyond the fundamentals of drawing. With reference to adapting our book for more advanced study, the major change in this revised edition is the addition of a chapter on drawing the human figure. In developing this new chapter, our goal was to condense material appropriate to an introductory figure class into a manageably sized text for life drawing students. Organized around the principle of drawing the human form "from the inside out," this chapter starts with analyses of the bony and musculature systems, and a discussion of gestural response to the figure as a means to summarize bodily form and to test layout. It concludes with a detailed examination of the narrative potential in figurative art.

The third edition also features extensive revisions of three chapters that appeared in earlier editions. "Visualizations: Drawing from Your Imagination," a chapter tailored for students who wish to expand their source material beyond observed reality, benefits from enhanced practical guidelines to conceiving envisioned drawings and also from a memorable collection of invented images, over half of which are new. Inspirational works of peers are once again concentrated in the chapter "Portfolio of Student Drawings." This chapter showcases 24 sustained drawings, selected from 16 schools and departments of art nationwide. By devoting a chapter solely to student works, accompanied by a text that examines the form and content of each image, we attempt to furnish realistic benchmarks of quality and ambition for the student reader. The wholly revised chapter, "Portfolio of Contemporary Drawings," anchors the art and craft of the drawing tradition in the twenty-first century. By exploring today's trends through images drawn by leading contemporary artists, advanced students may begin in earnest to associate the drawings they make with the streams of theory and aesthetic practice that define art now.

Left intact in this new edition is our commitment to showcasing a vital mix of old and new masterworks. The richness of these images selected from across the arc of history not only serves as an essential complement to the written word, but each image stands on its own as an exemplary visual model, able to teach volumes

through the silent power of significant form. Looking to strengthen and diversify the graphic definition of our book, we have for this new edition replaced nearly half of the artworks (not counting technical illustrations), including over 40 new student works dispersed throughout the text.

As in the first two editions, the organizational principle of our book is to proceed from the most basic information to the gradual introduction of more sophisticated concepts. Arranged into 14 chapters, this revised and expanded edition may be divided into two interrelated halves that more clearly echo the learning curve experienced by undergraduate art students. Chapters 1 through 7 lay the foundation for "the facts of seeing." In the first five chapters the dual nature of the picture plane is given special emphasis, first as an imaginary window onto space, and second as the literal flat surface upon which one draws. This approach is aimed at fostering an awareness of the natural union of drawing and design, while demystifying the systems of proportion and perspective. Chapters 6 and 7 retain their focus on the depiction of three-dimensional form by urging students toward an understanding of the structural properties of form through diagrammatic analysis, and the observation of surface phenomena as revealed by light. Chapters 8 through 14 are geared for students who have completed basic instruction and are ready to more deeply investigate matters of expression. Covered in these later chapters are the expressive values of formal and subject-matter narratives, the applied and aesthetic dimensions of color in drawing, the use of imaginative source material, empathic responses to the human figure, and critical questions embedded in the modern/postmodern debate.

The scope of our revisions may exceed expectations for a new edition, but entering into this project we felt the need to renew our purpose. The extensive modifications were not purchased without toil, in stretches unremitting. But we were buoyed by our goal: to have the third edition be received as a complete guide to drawing, one that will serve art students from the onset of their foundation classes through their final drawing projects as seniors. In the largest sense, then, it is our hope that *Drawing: Space, Form, and Expression* will take its place among the essential texts as a prized resource companion for serious students of drawing.

Acknowledgments

Organizing a book that contains over five hundred illustrations and much technical information could not have been accomplished without the assistance of many people. We do not have space to list all the gallery and museum personnel, both here and abroad, who have gone out of their way to help us in obtaining reproduction rights and photographs for the fine works of art you see on these pages. In regard to the new figure chapter, we gratefully acknowledge Dr. Rebecca German, Department of Biological Sciences, University of Cincinnati, and Dr. D.J. Lowrie, Jr., University of Cincinnati College of Medicine, who answered our questions about human anatomy with the most up-to-date information. We are, of course, most profoundly indebted to our respective families for their forbearance. We also owe thanks to the University of Cincinnati for Wayne Enstice's Special Duty Leave to work on the third edition; to Posners Art Store for help in assembling the Glossary of Media; to Nanda Araujo, Librarian, University of Cincinnati, for her research assistance; to Bud Therien, our acquisitions editor; to our assistant editor, Kimberly Chastain, who with good humor helped us through the numerous stages of development; and to our production editor, Jan Schwartz, who worked unflaggingly through the very complex process of seeing this book through to completion.

In striving to invest this edition with new and exciting student works we solicited slides from instructors around the country. We are grateful to all who

participated and extend special thanks to the instructors and former graduate teaching assistants from whom we have selected student examples to use as illustrations, including: Luis Alonso, Pratt Institute and Rhode Island School of Design; Anthony Batchelor, Art Academy of Cincinnati; Nancy Hall Brooks, University of Arizona; Gary Buhler; Jane Burgunder, Middle Tennessee State University; Linda Caputo, University of Arizona; Ying Kit Chan, University of Louisville; Lynn Charron, University of Arizona; Maureen Ciacco, University of Arizona; Allyson Comstock, Auburn University; Robert Evans, Indiana State University; Stephen Fleming, Kansas City Art Institute; Sean Gallagher, Central Connecticut State University; John P. Gee, Ball State University; Ben Gibson, Edinboro University of Pennsylvania; William Greider, University of Arizona; Charlie Hacskalo, University of Arizona; Christi Harris, Iowa State University; David James, University of Montana; Mary Frisbee Johnson, University of Northern Iowa; Al Kogel, Cochise College; Billy Lee, University of North Carolina, Greensboro; Perry Mahler, Kendall College of Art and Design; Susan Messer, University of Wisconsin at Whitewater; Catherine Nash, University of Arizona; Sheila Pitt, University of Arizona; Janice Pittsley, Arizona State University; Jan Reeves, University of Oregon; Chuck Richards, Iowa State University; Carol Saarinen, University of Arizona; Joseph Santore, New York Studio School of Drawing, Painting and Sculpture; William B. Sayler, Pratt Institute; Ophrah Shemesh, New York Studio School of Drawing, Painting and Sculpture; Robert Stolzer, University of Wisconsin, Stevens Point; and D.P. Warner, Edinboro University of Pennsylvania.

Finally we would like to acknowledge the following colleagues for their helpful reviews of our manuscript: Therese Bauer, Anne Beidler, Adrienne Lavallee, Evan Lindquist, George Mauersberger, Elen Feinberg, Steve Bleicher, Gary Thomas, Anita Giddings, Michael Cook, David James, and Karen Kittelson.

Wayne Enstice
Melody Peters

Introduction

So you have the urge to draw! This urge is something you share with millions of people, from prehistoric times (Fig. 0–1) to our own day. Young children, whose primary activity is making sense of the world, seem naturally inclined to draw. As they reach preteen years, however, many, if not most, stop drawing, due perhaps to self-consciousness, frustration, or simply a decreasing need. Adolescents and adults who resume the habit of drawing frequently become aware of their role as artists, and those of us who spend a large part of our waking hours in the pursuit

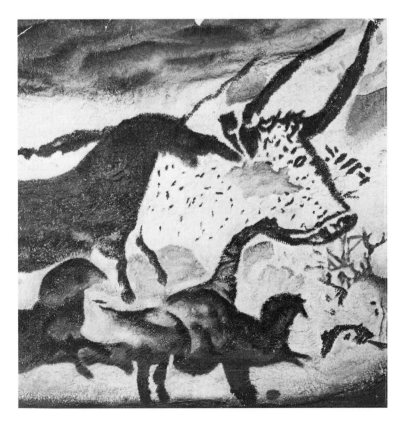

FIGURE 0–1
Prehistoric art
Cave painting of great black bull and red horse at Lascaux, France
Courtesy, Art Resource

of art feel that our compulsion to do so sets us apart somewhat from the rest of society. Yet, we also know that making art puts us in touch not only with ourselves but also in a very special way with visible and even invisible realities. You will repeatedly experience this sense of communion while making art of any kind, but most frequently this will come as a result of drawing, the most intimate and spontaneous of all visual-art practices.

The professional artist and serious student alike use drawing for a multitude of purposes. We sometimes produce drawings for their own sake, but frequently we draw to record, explore, or consolidate visual ideas. In this respect, drawing is the visual counterpart of writing and like writing can be used to utilitarian or expressive ends.

In this chapter we introduce you to the drawing tradition and its practice. We begin by tracing the impact that Renaissance attitudes have had in shaping drawing's role within the visual arts. Included is a review of developments in drawing today, which will help you relate your daily pursuits in the medium to the larger historical mainstream of drawing activity.

The remainder of this chapter centers on advice we customarily give our beginners to smooth their entry into the world of drawing, which, for all its excitement, may at times seem a bit overwhelming. The benefits of much of this advice will become more apparent as you progress; in the meantime, the counsel you receive here will help you get an early start on developing good drawing habits.

The Legacy of Drawing

We think of drawing as the primary field of study for the aspiring artist since its practice is the most expedient way of training the eye to observe accurately. This is of enormous benefit to anyone who wants to be involved with representing perceived reality. Practice at drawing and close observation will also prepare you to visualize things that exist only in your imagination.

Our interest in making accurate representations of visual reality has its foundation in Renaissance art. Before that time, artists were more concerned with the symbolic import of their subject matter. And in most cases, conventions for representing common subjects eliminated the necessity for the artist to engage in firsthand observation of natural appearances.

In the Renaissance period, scholars began to redefine the relationship between the secular and spiritual worlds. For the first time, artists began to feel justified in taking more interest in the material world around them. As a result, Renaissance artists disciplined themselves to look at and think about what they saw in a manner that would have been foreign to previous generations of artists. And for the first time, Western artists devoted a great deal of rational thought to the problems of form and space. They also had to work hard to sharpen their perceptual skills. This reliance on personal observation backed up by rational thought informed a new spirit of drawing, as seen in the Leonardo da Vinci (Fig. 0–2).

The increased availability of paper in Europe during the fifteenth century did much to encourage the practice of drawing. Before this time, the cost of drawing materials, such as parchment or prepared wooden panels, limited the practice of experimental drawing. With paper, however, the artist could afford to draw in an exploratory way, making many studies of one subject before settling on a final image (Fig. 0–3). Because of its new investigative role, drawing in the Renaissance gained the prestige of a science. This spirit of investigation has been with the study of drawing ever since and accounts for the existence of art programs in colleges and universities today.

In the two centuries following the time of Leonardo, the radical scrutiny of human anatomy as practiced by Renaissance artists became conventionalized. As an example, let us look at a life drawing (or *academie*, as it was called) by the

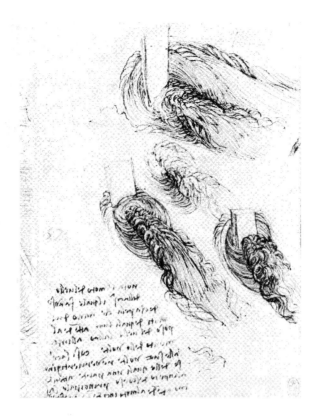

FIGURE 0–2
LEONARDO DA VINCI
Four studies of swirling water
Pen and ink
*The Royal Collection © 2003 Her Majesty
Queen Elizabeth II*

FIGURE 0–3
CLAUDE LORRAIN
Landscape Studies, 1630–1635
pen and brown ink, 184 × 272 mm
(verso of *Wooded View*)
Teylers Museum, Haarlem, The Netherlands

eighteenth-century sculptor and academician, Bouchardon (Fig. 0–4). Note that in this drawing there is a very systematic way for representing the figure in its environment. The artist employs only three categories of marks. A pattern of lines is used to indicate the background; short, scarcely visible strokes are used for the surface of the body. The most varied stroke is reserved for the outside edges of the figure. This conventional use of line was common practice in life drawing of

FIGURE 0–4
EDME BOUCHARDON
Standing Male Nude with Staff
Red crayon on paper, 22⅞ × 11⅞"
Courtesy, Santa Barbara Museum of Art.
Museum Purchase

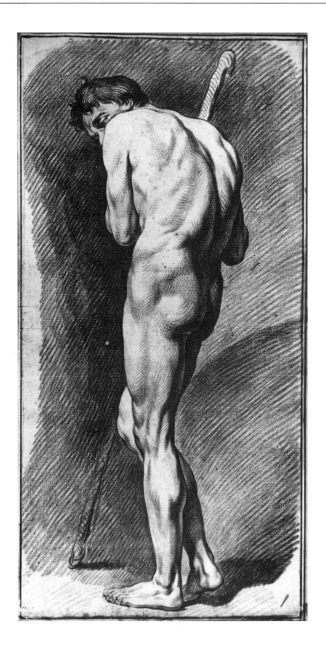

the period. To enhance the presence of the figure, artificial light was used, which had the effect of throwing the anatomy into sharp relief while letting the background drop away.

It is instructive to compare the Bouchardon with a work made a generation later (Fig. 0–5). In this drawing, Ingres *does not* dramatically set the figure apart from the background. The same natural light that illuminates the lively features of the sitter also brightens the haze below and is a harbinger of the increased role that nature would play in French art during the rest of the nineteenth century.

How very different is the attitude toward light, form, and space in the self-portrait by Courbet (Fig. 0–6). Here light is not that flattering, all-pervasive entity that it is in the drawing of Ingres. Instead, it is harsh and reveals the forms of the artist's face roughly and imperfectly. The parts of the face obscured by shadow merge with the gloom that envelops the figure. As a realist, Courbet demonstrated that the natural tendency of strong light is not to separate the figure from the background but rather to break up form so that parts of it become indistinguishable from the space around it. By observing the impartiality of natural light,

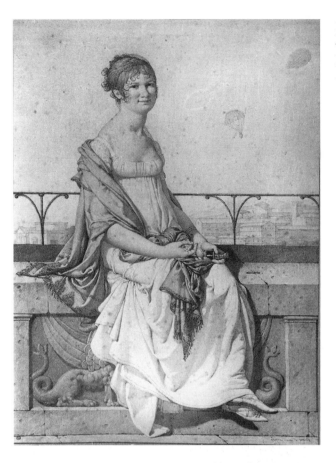

FIGURE 0–5
J.A.D. INGRES
Portrait of Barbara Bansi
Copyright © Réunion des Musées
Nationaux/Art Resource, New York

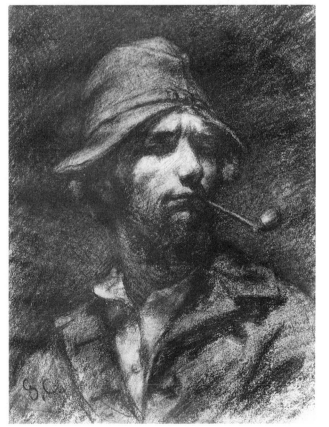

FIGURE 0–6
GUSTAVE COURBET
Self-Portrait (The Man with the Pipe),
c. 1849
Charcoal, 11½ × 8¾"
Wadsworth Atheneum, Hartford. Purchased
through the gift of James Junius Goodwin

FIGURE 0–7
CLAUDE MONET
Two Men Fishing, ca. 1880–1882
Black crayon and scratchwork on
paper coated with gesso and
incised with fine lines for
reproduction by "guillotage,"
256 × 344 m
*Courtesy of The Fogg Art Museum, Harvard
University Art Museums. Bequest of Meta
and Paul J. Sachs*

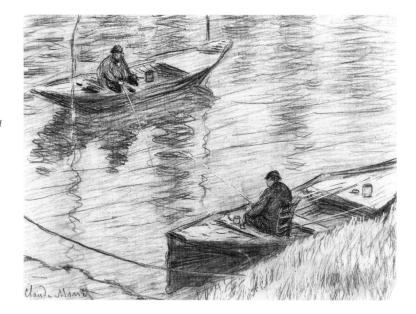

the artist effects a brutish realism. Once again, the investigative potential of art is fully present, and objective observation is seen as an end in itself.

Later in the century, the Impressionists achieved a directness in their use of media that was unprecedented. In paintings and drawings, they asserted the actuality of their media to recreate the ephemeral aspects of constantly changing moments in the natural world. Look at the drawing by Monet (Fig. 0–7) and compare its inventive use of marks to the more convention-bound approach of Bouchardon (Fig. 0–4). Note how in the Monet, many of the marks achieve a physical presence that recalls our experience of actual objects. One kind of mark stands for the fishermen's rods, another for the twisted cable, and yet another for the wavering reflections of the cable. Also note the absence of outlines in the Monet. The Impressionists often did away with them, reasoning that no such lines may be observed in nature.

Impressionist artists were dedicated to expressing with immediacy their experiences of the natural world. But in contradistinction to earlier artistic traditions, the Impressionists, and many of the modern artists that followed, let the actual stuff of their media stand as a metaphor for the physical reality they described on paper and canvas. In works of this kind, every mark exerts a material presence of its own rather than imitating the surface appearance of natural things. This insistence on the physical nature of the artist's media is just one of the Impressionist traits that began to undermine the long-lived Renaissance tradition of illusionistic realism.

Looking again at the Monet, note that particular attention is paid to the design, or composition, of the drawing. The two boats in effect mirror each other along a diagonal, making us aware of the small space between them. Running counter to these large diagonal shapes is the series of vertical reflections on the water, which function to stabilize the image. These compositional devices make us aware of the play of two-dimensional forces within the rectangle of the picture. The emphasis on two-dimensional organization over the more traditional illusion of deep space marks the general trend toward a flattening of the picture image in the late nineteenth and early twentieth centuries. (Note, too, that a sense of depth is restricted by the elimination of the horizon line.)

The modern artist's emancipation from the illusionistic tradition can be seen as emblematic of a wider-ranging movement toward greater artistic freedom. In the early years of the twentieth century, artists offered increasingly

daring interpretations of the visible world, sometimes refashioning appearances beyond easy recognition. Drawing in the later half of the twentieth century, as we shall see, has been characterized by a multitude of forms and styles of drawing, some traditional and some radically new, that have resulted from artists' attempts to extend or redefine the nature of the drawing medium.

Extending the Definition of Drawing

Drawing today is firmly established as a medium in its own right. Drawings now have an aesthetic and commercial value that gives them a stature equivalent to that of painting and sculpture. But this has not always been the case.

Renaissance concepts about the role of drawing within the visual arts were deeply influential for a long time. During the Renaissance, skill at drawing was highly valued and was in fact considered the most precious tool at the artist's command. Nevertheless, drawings themselves were not accorded the status of a legitimate art form, but were regarded merely as preparatory studies for painting and sculpture.

For centuries after the Renaissance, drawing had two functions. First, it was the customary means of training young artists. Second, it became a way for more established artists to try out ideas before embarking on their more ambitious work, as we may see by comparing the study and final painting by Tintoretto in Figures 0–8 and 0–9.

Today, drawing continues to fulfill both these functions. It remains the accepted foundation for aspiring artists, and the use of drawing to work out ideas persists unabated. In fact, the preparatory studies, or *working drawings*, that artists make are frequently held in high esteem by the art-viewing public. Let us examine why.

Among all visual-art forms, preparatory drawings put the viewer most in touch with what an artist thinks and feels. This opportunity for an intimate look

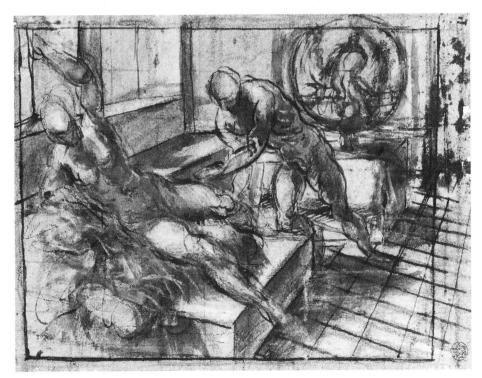

FIGURE 0–8
TINTORETTO
Venus and Vulcan, c. 1550
Pen and brush, black ink and wash, heightened with white on blue paper
Staatliche Museen zu Berlin-Preussischer Kulterbesitz, Kupferstichkabinett
Photographer: Joerg P. Anders

FIGURE 0–9
JACOBO ROBUSTI (TINTORETTO)
Venus, Volcano and Mars
from the copper pass cabinet
Berlin inclusive. Versand. Oil on
canvas
Gemalde- & Antiquitatenphotographie

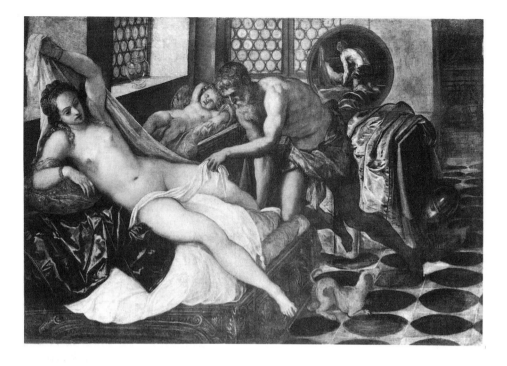

FIGURE 0–10
BARRY LE VA
*Drawing Interruptions: Blocked
Structures #4*
Mixed media, 48 × 72"
Courtesy, Sonnabend Gallery

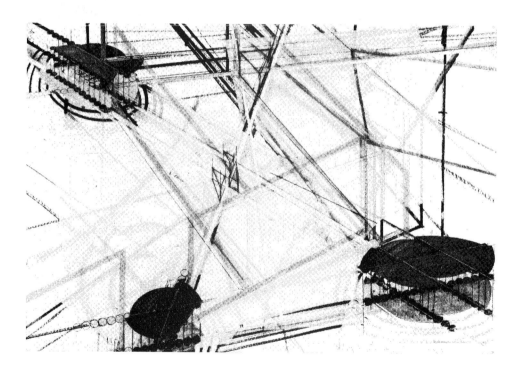

at the origins of a work has a special attraction for viewers and has given rise to numerous exhibitions of artists' working drawings. Compare, for example, the drawing by Barry Le Va (Fig. 0–10) with one of his works as it appeared installed in a gallery (Fig. 0–11). The representation of space in the graphic work is surprisingly different from the effect of the installation. The drawing has a sense of interior, psychological space and as such lends an unexpected romantic slant to what otherwise appears to be a matter-of-fact assembly of objects on a floor.

In addition to the popularity of working drawings, a finished drawing by an artist is today regarded as a complete and independent art form. Accompanying

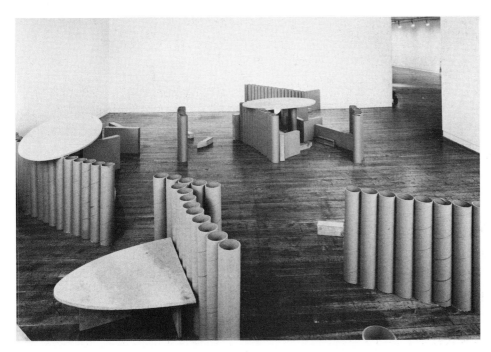

FIGURE 0–11
BARRY LE VA
Twisted Chain (of Events): Sketching a Possibility
Particle board, homosote, wood, cardboard tubing. Dimensions variable. Installation at Sonnabend Gallery, New York City, 1981
Courtesy, Sonnabend Gallery

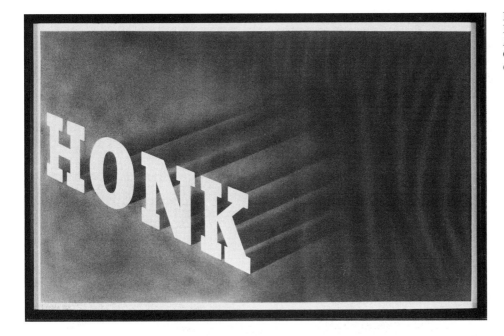

FIGURE 0–12
ED RUSCHA
Honk, 1964
Gunpowder on paper, 14½ × 23"
© Ed Ruscha. Photo: Dorothy Zeidman

this loosening of the Renaissance concept of drawing has been a profusion of interpretations as to what defines drawing in the twentieth century. Particularly today, in an age marked by aesthetic "pluralism," the diversity of drawing styles seems unlimited (Figs. 0–12 and 0–13).*

In the midst of this unprecedented wealth of drawing styles, two tendencies prevail in contemporary drawing. On the one hand, the Renaissance concerns for representing forms in space continue to thrive (Fig. 0–14). Simultaneously, a more

*For further examples and a discussion of contemporary drawing styles, see Chapter 14, "Portfolio of Contemporary Drawings."

FIGURE 0–13
ROBERT BECK
*The Funnel (The Modern Man's
Guide to Life by Denise Boyles, Alan
Rose, Alan Wellikoff), 2000*
Charcoal on paper
120 × 108" (304.8 × 274.3 cm)
*Whitney Museum of American Art, New
York; purchase, with funds from the Drawing
Committee*
2000.252

FIGURE 0–14
ROBERT ALAN BECHTLE
(American, born 1932)
Nancy Ironing, 1977
Graphite, 12⅞ × 15"
(32.7 × 38.1 cm)
*Museum purchase. Courtesy San Diego
Museum of Art*

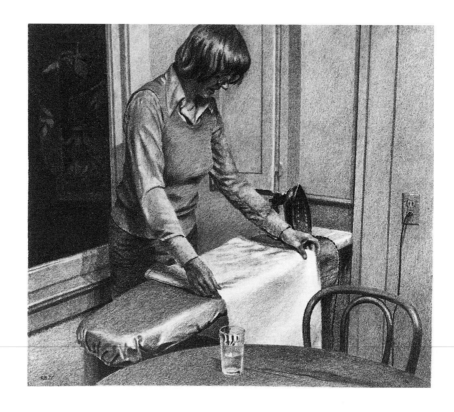

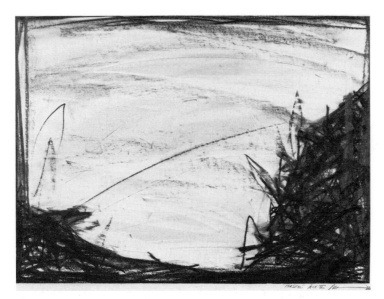

FIGURE 0–15
ROBERT WILSON
Parsifal, Act II, 1985
Graphite on paper, 22¼ × 30"
Courtesy, Paula Cooper Gallery, New York.
Photo: James Dee (RW458)

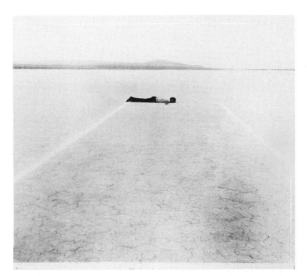

FIGURE 0–16
WALTER DE MARIA
Mile Long Drawing, 1968
Mojave Desert, California. Two
parallel chalk lines on desert dry
lake. One mile long, lines 12 feet
apart and 3 inches wide, artist
lying on the desert floor
Copyright © 1969 Walter De Maria

modern bias toward the actuality of media has emerged as a viable alternative (Fig. 0–15). Less predictable is the genre of works that challenge conventional beliefs about drawing, such as Walter De Maria's *Mile Long Drawing* (Fig. 0–16), which consists of two parallel mile-long lines of chalk drawn twelve feet apart in the Mohave Desert.

The Student and Master Drawings

Presumably, we all look at master drawings for enjoyment. That enjoyment might include anything from the simple wonder that an artist could achieve so realistic a likeness of a particular thing to the more sophisticated appreciation of an inventive use of composition and imagery.

To increase your skills as an artist, you will also be studying master drawings to find out what gives them so much expressive power. While seeking this information, you will become more familiar with the basic principles of drawing and gain a sense of how and why those principles have been manipulated to meet specific ends. Moreover, spending time with drawings from various phases of art history will help you to see the relationship between past and present drawings. You also will find countless instances when new forms of expression coexisted with older drawing practices. Indeed, even the most startlingly reshaped concepts have never invalidated drawing in traditional terms.

The Issue of Talent

When you look at works by esteemed masters, you may find yourself in awe of their virtuosity. Your admiration for these works may lead you to wonder if you have sufficient talent to undertake a serious study of drawing. This question is frequently expressed by beginners and usually results from a misunderstanding about what it takes to learn to draw.

Learning to draw is an acquired skill. The fundamentals of drawing form a body of knowledge well within the reach of the college student. This body of knowledge is imparted through concepts that are often easy to grasp but require repeated application to fully comprehend. Through consistent application, you will obtain a set of measurable skills that you will use as if by second nature.

Learning to draw is also based on desire. Talent, viewed in this way, is more a matter of inclination than anything else. Someone with the ambition to draw well can learn to excel. But the person possessing sound basic skills and a personal need to express ideas visually will be equipped to do work of a more serious and personal nature.

The Public Side of Drawing

The bulk of your learning will take place while you are drawing. In this respect, learning to draw is like learning to ride a bicycle. The theory of what to do can only be imperfectly explained. Actual understanding must be gained from the experience of getting onto the bike or applying marks to paper.

At first, many students are uncomfortable when drawing in the presence of others. After all, drawing is an intimate activity, and what you make is always to some extent autobiographical. Ironically then, the most common setting for learning to draw is the *public arena* of the classroom.

If you are self-conscious about revealing your lack of skill to your classmates, remember a couple of things. First, with the exception of one or two students who may have had more experience, you and your classmates are pretty much in the same boat; you are all beginners. Second, learning to draw is a process of accumulating knowledge and experience. Focusing on the concept presented in a particular exercise or assignment will relieve you of the obligation to make a drawing that looks "really real."

Fortunately, your participation in the drawing process will ease all such anxieties. You will find that the challenge of drawing requires such concentration that you will become oblivious to the presence of other people in the classroom. And attaining this level of concentration will make it easier for you to draw, unhampered by the insecurities of working in a relatively public setting. Later, when you notice the very rapid development of your drawing skills, you will probably appreciate the energy and support of the classroom situation.

Seeing Versus Naming

Achieving feelings of privacy while drawing in a crowded classroom is the result in large part of switching your thinking from the usual verbal mode to a nonverbal mode. Whenever you concentrate on a nonverbal task, such as drawing, you will be inclined to block out verbal distraction, such as a conversation taking place in the same room. This nonverbal state of mind has another, and even more important, role to play in your drawing practice, however, since it encourages you to focus on the *visual* character of your subjects rather than relating to your subjects only on the basis of their *names* and *uses* in the everyday world.

Since our main form of daily communication is verbal, or symbolic, we tend to deal with the world on the basis of objects we can name: telephone, car, dog biscuits. In drawing, this situation is almost reversed, since we attribute meaning to our subjects more fully on a visual basis. Correspondingly, their worldly associations are de-emphasized—or at least, they should be.*

But beginners often feel more secure if a subject is loaded with meaning, in the verbal sense, or has an abundance of nameable parts. The more nameable parts, they feel, the more likely the drawing will succeed as a recognizable image. For example, let us say a beginner were asked to draw a still life containing an old boot and some draped cloth. Attracted to the boot because of its more specific cultural identity, the beginner will record individual details much as an itemized grocery list is compiled: two broken laces, twelve hooks and eyelets, one stiffened tongue, and so on. Less scrutiny will be given to the general form and structure of the boot, and far less information given about the draped fabric. This tendency to draw each unit of the subject separately arises from the habit of naming and usually results in a drawing that looks fragmented and superficial in its treatment of the subject matter.

On the other hand, beginners who emphasize a subject's visual character are able to see its wholeness and the way each part is integral to that whole. In a visually oriented state of mind, the beginner might, for instance, decide to exaggerate the robust volume of the boot as opposed to the linear twisting of the piece of cloth (Fig. 0–17).

So, seeing means to stress a *visual* interpretation of the subject to be drawn. Your ability to overcome the tendency to name what you see (three pencils on a tabletop) and depend instead on visual insight (three diagonals on a flat surface) may take some practice to develop. But a visual approach yields far more satisfactory drawings than one that accentuates a subject's everyday identity and symbolic connotations.

Drawing as a Process

Making a drawing is like participating firsthand in the development of an organism. This development is a natural process, from the drawing's genesis to its completion.

In this regard, consider that making a drawing is a process of *forming* something; it is a way for the artist to materialize responses to things that are real or imagined. Although process is integral to the realization of any artwork, its visual traces are usually obliterated by the time a work is completed. However, we are afforded insights into the developmental process of a work of art when different states are preserved. In Figures 0–18 and 0–19, two successive impressions of the

*This is not to deny the cultural content in subject matter. At this stage, however, the *visual* content of what we draw cannot be overemphasized. For further discussion of content that is culturally based, see Chapters 8, "Subject Matter: Sources and Meanings," and 14.

FIGURE 0–17
MIKAL KOROSTYSHEVSKY, Pratt
Institute
Student drawing: still life with
visual character of subject
emphasized, 4 × 5′
Courtesy, the artist

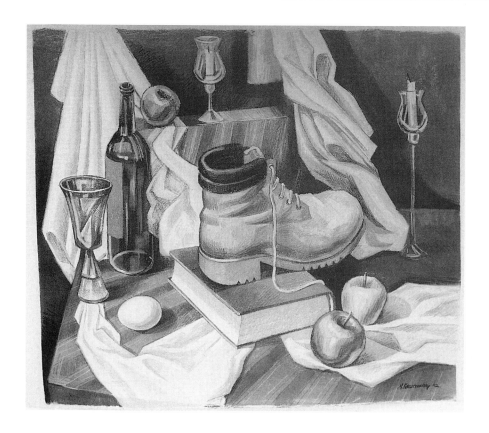

FIGURE 0–18
HERMENSZ VAN RIJN REMBRANDT
Christ Presented to the People, State II
Etching
*The Metropolitan Museum of Art, Gift of
Felix M. Warburg and his family, 1941
(41.1.34)*

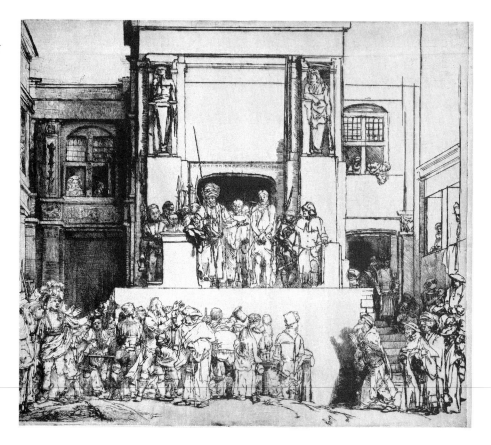

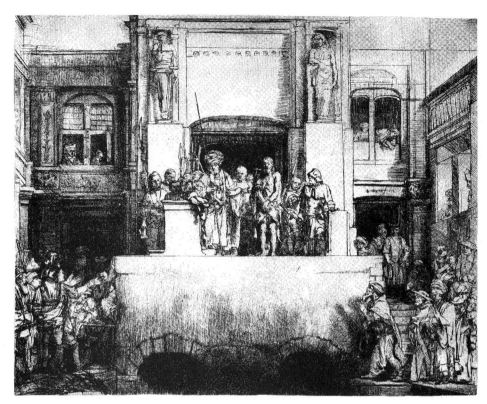

FIGURE 0–19
HARMENSZ VAN RYN REMBRANDT
*Christ Presented to the People,
State VIII*
Etching
*The Metropolitan Museum of Art, Gift of
Felix M. Warburg and his family, 1941
(41.1.36)*

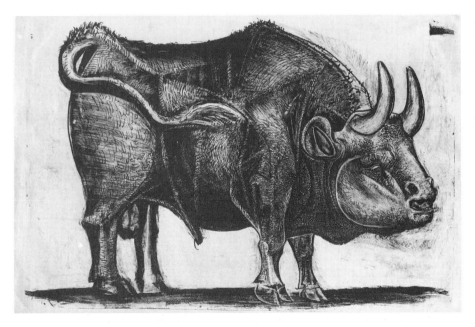

FIGURE 0–20
PABLO PICASSO
Bull, State III. (December 18, 1945).
Lithograph, printed in black,
composition: 12⅜ × 18¹⁵⁄₁₆"
*Collection, The Museum of Modern Art, New
York. Mrs. Gilbert W. Chapman Fund. Digital
Image © The Museum of Modern
Art/Licensed by SCALA/Art Resource NY.
© 2003 Estate of Pablo Picasso/Artists Rights
Society (ARS), New York*

Rembrandt print *Christ Presented to the People* show, among other changes, the crowd in front of the podium replaced by two rusticated arches. Serial images may also provide evidence of an artist's process, as in Figures 0–20, 0–21, and 0–22, which showcase Picasso's mastery of form improvisation.

So, like any organic thing, a drawing must be permitted to grow and change. And the process of making a drawing is most successful when the artist is alert and responsive to this potential for change as the drawing is being formed.

FIGURE 0–21
PABLO PICASSO
Bull, State VI. (December 26, 1945).
Lithograph, printed in black,
composition: 12 × 17 7⁄16"

Collection, The Museum of Modern Art, New York. Mrs. Gilbert W. Chapman Fund. Art Resource, NY. Digital Image © The Museum of Modern Art/Licensed by SCALA/Art Resource NY. © 2003 Estate of Pablo Picasso/Artists Rights Society (ARS), New York

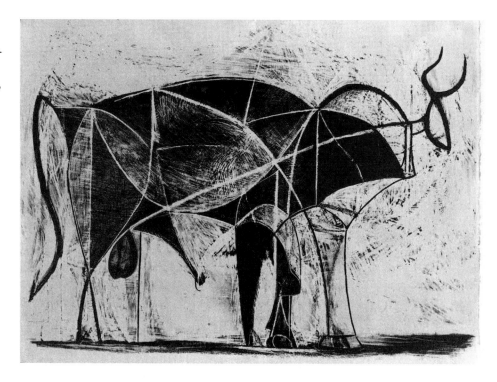

FIGURE 0–22
PABLO PICASSO
Bull, State XI. (January 17, 1946).
Lithograph, printed in black,
composition: 11 3⁄8 × 16 1⁄8"

Collection, The Museum of Modern Art, New York. Acquired through the Lillie P. Bliss Bequest. Digital Image © The Museum of Modern Art/Licensed by SCALA/Art Resource NY. © 2003 Estate of Pablo Picasso/Artists Rights Society (ARS), New York

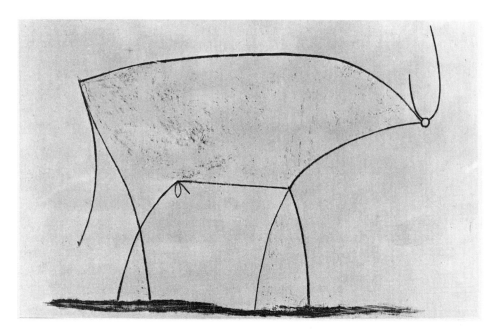

In practical terms, this means that your drawing method should not be limited to only up-close, detailed work. Working up close does have its benefits, since you can concentrate on detail and enjoy the sensuality of applying drawing media to paper. But working at arm's length or less may make it difficult to see how all the parts of a drawing fit together.

To fully gather in the whole effect of a drawing, it is necessary to "shift your perception" away from the representation of subject matter detail. One means for doing this is to physically move back—several paces from your drawing—to gain an overview of its progress. Another way is to turn the drawing upside down or view it in a mirror to reverse the image. These simple strategies will help you

diagnose problems that might otherwise escape your notice. They also place you in a better position to see, and take advantage of, new possibilities emerging in a drawing.

Regularly taking stock of your work has the added value of helping you appreciate a drawing's identity as an independent, created object. You will become more accustomed to the fact that all drawings, even those filled with convincing descriptions of things, have their own logic quite apart from those properties of illusion or imitation of the natural world.*

The Merits of a Sketchbook

A sketchbook is a handy means for accelerating your progress in drawing. Bound sketchbooks may be purchased at any art supply store, although some artists prefer to bind their own so that they can insert papers of different weights, surfaces, and colors. Media of all kinds are suitable for a sketchbook; indeed, part of the pleasure of keeping a sketchbook is experimenting with media not commonly used in the classroom, such as ballpoint pen, felt-tip markers, or collages made with available materials like leaves and matchbooks.

For many artists, the act of filling a book has almost magical significance, as we sense when looking at the UR sketchbook page (Fig. 0–23), which is clearly obsessive in character. For others, keeping a sketchbook is simply a practical alternative to recording ideas on random scraps of paper, which tend to get lost or discarded.

Often considered an artist's personal diary, the sketchbook is an excellent context for recording a whole range of ideas, verbal as well as visual. There are times when you are flooded with ideas, some of them related to a particular endeavor and others coming seemingly from out of the blue and distracting you from your major purpose. In your sketchbook you are free to jot down all these ideas without the pressure of making them relate to each other (Fig. 0–24); at least you will know where to find this information at a later date should you need it.

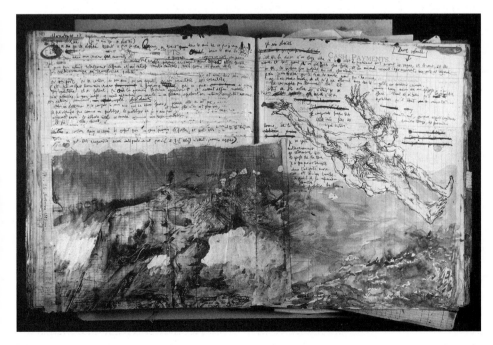

FIGURE 0–23
UR
Stinking King, Book # 3, Oct 9th,
2 pages, 1994.
Pencil, watercolor, ink, and oil on
paper. Each page 18 × 16"
Courtesy, the artist

*For more on the drawing process, see "Troubleshooting Your Drawings" in Chapter 9, "The Form of Expression."

FIGURE 0–24
JAMES ENSOR
Head in Profile and Other Studies,
n.d.
Black crayon
*© 2003 Artists Rights Society (ARS), New
York/SABAM, Brussels*

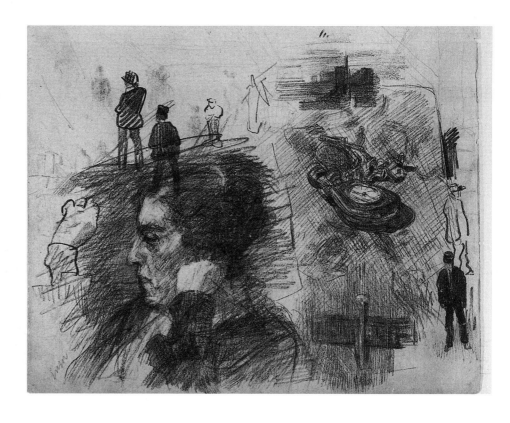

FIGURE 0–25
ALBRECHT DÜRER
Alpine Landscape
210 × 312 mm
Ashmolean Museum, Oxford

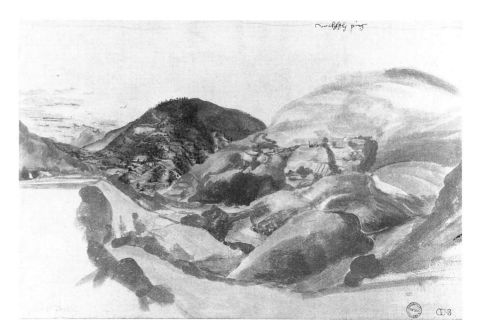

There will be times when you will use your sketchbook in a more directed fashion. You might use your sketchbook as a vehicle for sharpening your perceptual skills, filling it with literally hundreds of drawings of things encountered in daily life. In addition to the benefits bestowed by such constant application to drawing, leafing through an entire book of sketches will assure you of your growing skill.

The itinerant artist of the past used the sketchbook to record natural phenomena in distant lands (Fig. 0–25), a practice that is continued today by the

contemporary artist who uses the sketchbook to extend the processes of search and discovery beyond the confines of the studio (Fig. 0–26).

Make a habit of carrying a sketchbook with you on your daily rounds, and pull it out when anything in the visual world about you catches your interest. Sketching is less instantaneous than photography, but it is a much better way to record the visual ideas that form your unique vision of the world. In the Cézanne sketch, Figure 0–27, the artist's visual idea consists of the contrast between the complicated shapes bound by gnarled tree branches and the quiet horizontals and verticals elsewhere in the landscape. Can you imagine how difficult it would have been to record this visual fact in a photograph without also recording a great deal of extraneous information?

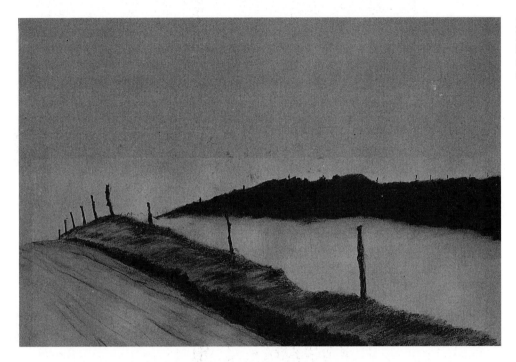

FIGURE 0–26
KEN O'CONNELL
Sketchbook page: *Eastern Oregon* Charcoal, 24 × 30"
Courtesy, the artist

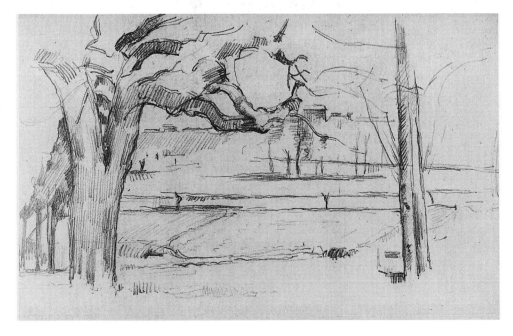

FIGURE 0–27
PAUL CÉZANNE
Sketchbook: *Landscape with Trees*, ca. 1885–1887
Chappuis 915, pencil, 12.4 × 21.7 cm
Arthur Heun Fund. Photograph © 1994, The Art Institute of Chicago (1951.1, page 31 verso). All Rights Reserved

The sketchbook also has its uses in a studio context. It is an appropriate place to try out ideas for more prolonged works (Fig. 0–28). You might also find the sketchbook a handy format in which to make analyses of masterworks (Fig. 0–29), where the information you glean from proven masters may be seen in the context of your own emerging artistic identity.

FIGURE 0–28
EDWARD HOPPER
Artist's Ledger—Book III, page 13.
Rooms for Tourists, 1924–1967
Ink, graphite, and colored pencil on paper.
12³⁄₁₆ × 7⅝ × ½" (30.96 × 19.37 × 1.27 cm)
Whitney Museum of American Art, New York; Gift of Lloyd Goodrich
(96.210bb)

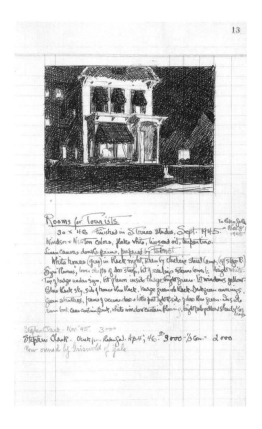

FIGURE 0–29
DENNIS CHENG-YEN TAN, Indiana State University
Student sketchbook drawing: analysis of masterwork
Courtesy, the artist

1

The Three-Dimensional
Space of a Drawing

When was the last time you dragged your finger across the condensation on a car window? Or had the urge to make your mark on the surface of a building, an underpass, or a freshly leveled sidewalk?

As kids, most of us loved to make marks on available surfaces. As adults, some of us still do, using art as an outlet for these energies. This chapter invites *you* to explore mark making anew and with a refreshed purpose. You will observe how the marks you make suggest space in a drawing; and you will learn the organizational principles behind this phenomenon, principles that will be fundamental to your growth in descriptive drawing.

Making Your Mark

The word *mark* as we have been using it has three major ramifications in regard to artistic expression:

1. Its primary meaning is a trace or blemish left on a surface. As such, it may be a scratch, dent, hole, stain, or deposit. In shape it may range from that of the meaningless smudge, spot, tick, or line to the more meaning-laden forms of punctuation marks, letters of the alphabet, or corporation logos.

2. A mark also records the presence of the agent that made the mark. The graffiti artist who sprays a cryptic sign or tag on a subway train is in effect indicating a territorial claim to a piece of corporate property. Likewise, a manufacturer stamps a trademark on a product not only to indicate its origin but also to stake a claim on the public's consciousness.

3. Finally, a mark is often used as an indicator of spatial quantities: Spatial distance may be indicated by road markers; area by boundary markers; and volume by calibrations such as those found on a measuring cup.

A mark in a drawing may take into account all three meanings. First of all, artists are generally concerned about the quality and range of marks they make on the surface of their paper. Second, a mark is a record of the action taken by the

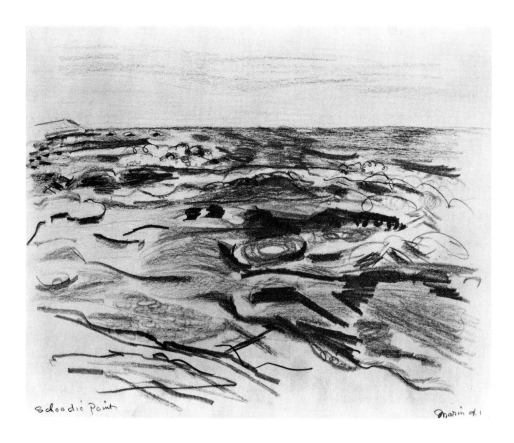

artist who made it. Third, the artist, as one who is interested also in making visual representations of nature, uses marks to measure relative spatial quantities in the world (Fig. 1–1).

The Mark Versus the Line

The conception that most people have of a drawing is that of a picture made with line. The use of flowing line is particularly suited to the portrayal of subjects of great complexity, but a line is only one kind of mark, and for many artists, a much larger repertoire of marks is in order. Many other kinds of marks are the result of short, direct gestures. They are, therefore, relatively abrupt in appearance. Such marks are seldom used for full-blown representation; instead, they most often function as spatial indicators in a drawing, as in their verbal counterpart, "mark that spot" (Fig. 1–2). A variation on this concept, applied to a more shallow space, is found in Figure 1–3 where the profusion of marks appear to move back and forth between the surface of the drawing and the sketchy image of the flag.

Figure–Ground

As soon as you put a mark on a surface, you set up a figure–ground relationship. To clarify this, place a blank sheet of drawing paper in front of you. Consider it carefully. It has a particular tone (in most cases white or off-white), a particular shape (usually rectangular), and a particular size and texture. This clean, flat surface is the *ground* of your drawing.

Make a single mark on this ground, and you have created a thing of visual interest, or what we call a *figure*. A figure in a drawing may represent a recognizable object or it may be a nonrepresentational shape, but in either case, it is something

FIGURE 1–2
ARTHUR DESHAIES
Cycle of Love: Then What? 1959.
Conté crayon, and dry pigment.
27¾ × 33⅞" (70.49 × 86.04 cm).
Whitney Museum of American Art, New York; purchased, with funds from the Friends of the Whitney Museum of American Art 60.64

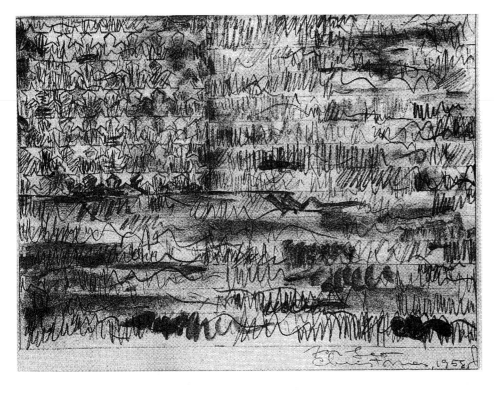

FIGURE 1–3
JASPER JOHNS
Flag, 1958
Pencil and graphite wash on
paper, 7½ × 10⅜"
© Jasper Johns/Licensed by VAGA, New York, NY

that may be readily distinguished from its visual context. The term *figure*, as used here, is not limited to the human body. A figure may be, for instance, the representation of a tree, an invented symbol, or a letter of the alphabet (Fig. 1–4).

 This first mark (or figure) you make heightens your awareness of the area of your ground by making the vertical and horizontal dimension of the drawing

FIGURE 1–4
Daniel Bergman
Graphos
Graphite on paper, 22 × 34"
Courtesy, the artist

paper more apparent (Fig. 1–5). It is as if a magnetic attraction exists between the mark and the edges of your paper.

Let us return to our example of a blank sheet of paper. Looking at this paper with a different intent, you can probably conceive within its emptiness the existence of an amorphous and relatively infinite space. Imagining this space will take an act of will on your part. Experiencing it will be somewhat akin to staring at a patch of clear blue sky—there is no beginning, middle, or end.

One mark dramatically alters this perception of space (Fig. 1–6). It is now as if a solitary bird has appeared in that blue sky, giving you a single point of spatial reference. This first mark on a page changes the formless character of the space into a more defined and tangible volume. In a sense, the mark creates the space in which it exists.

A second mark of a lighter or darker tone than the first increases the illusion of a specific spatial volume (Fig. 1–7). Appearing to be at a measured distance from the first, it provides a second point of reference in the space of the drawing. Each mark thereafter adds another station to the space, thereby increasing its structural definition.

So, the first two marks on your paper may be seen as figures against a ground, in which case they make the physical presence of the ground easier to grasp. They may also be seen as two spatial points in your drawing, thus opening up the ground illusionistically.

Artists frequently play one mark against another to create spatial tension. In this regard, let us look at the Dana Velan drawing pictured in Figure 1–8. You will note that, in general, the marks are different in some way from one another. It is that difference, what we might call the distinguishing character of a mark, that influences how we read a mark's position in space. And by extension, it is the range of differences in the accumulated marks that expresses the kind of space in total that is portrayed.

FIGURE 1–5

FIGURE 1–6

FIGURE 1–7

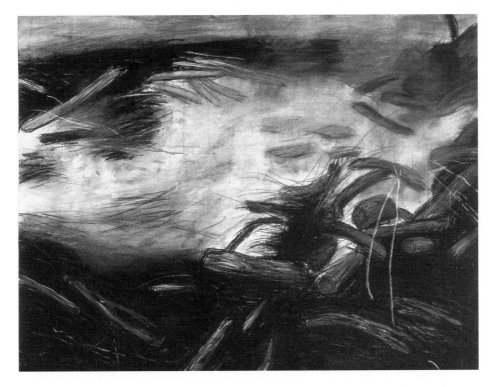

FIGURE 1–8
DANA VELAN
Hearths, 1997
38 × 50"
Courtesy, the artist

The Picture Plane

The space represented in a drawing is a semi-enclosed volume. Except for the potential of unlimited depth, the illusion of three-dimensional space in your drawing is bounded on all four sides by the edges of your paper and in front by the transparent "wall" we call the *picture plane*.

Common usage has given the term *picture plane* two meanings. First, it refers to the actual flat surface, or opaque plane, on which you draw. Second, it is often

FIGURE 1–9

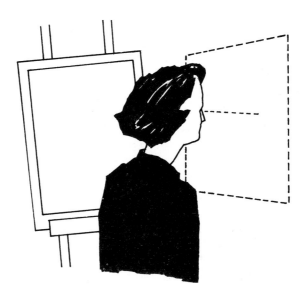

regarded as an imaginary, transparent "window on nature" that represents the format of your drawing mentally superimposed over the subject you wish to draw (Fig. 1–9).

The act of drawing links the two meanings of the term *picture plane*. When drawing, you look through the imaginary picture plane to gather information about the space and form of your subject, and you transfer this information to the actual picture plane of your drawing surface. As a result of this process, your drawing paper is virtually equivalent to the window on nature that you have imagined.

Of course, the imaginary picture plane does not actually exist except as an abstract concept to assist the artist in depicting things as they appear. Looking through this artificial plane can be compared to sizing up a subject through the viewfinder of a camera: you are framing, or selecting, that portion of the subject you wish to draw from the visual field before you. In so doing, you have taken the first step in organizing the three-dimensional space of your drawing.

This concept was developed (actually rediscovered) in the early Renaissance, at which time artists were becoming increasingly involved in duplicating natural appearances. Not only did they develop the idea of the picture plane as a mental device, but they also experimented with mechanical means for transferring points located on actual objects in space onto the flat surface of the picture plane (Fig. 1–10).

The Picture Plane Begins Your Space

To reinforce your understanding of the concept of the picture plane, we offer the following scenario. Imagine that you are looking through a picture window at a gorgeous meadow backed by rolling hills. All of a sudden, a large and colorful insect lands with a smack on the pane of glass. Made aware of the window's presence, you would no longer be looking through the glass, but *at* it. And the thought may even have struck you that this window is the beginning of the space opening up before you.

The picture plane in a drawing may be thought of in the same way. In fact, if we interpret the atmosphere of natural space as a series of receding planes, we are

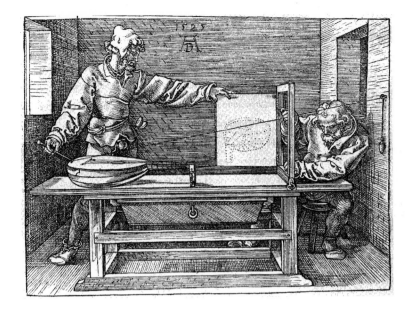

FIGURE 1–10
ALBRECHT DÜRER
*The Artists' Treatise on
Geometry*, 1525
Woodcut
*The Metropolitan Museum of Art,
Harris Brisbane Dick Fund, 1941 (41.48.3)*

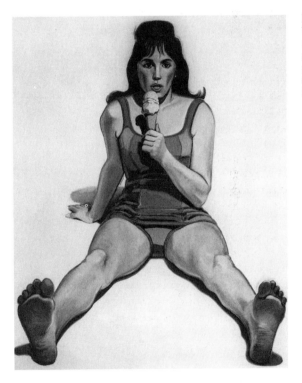

FIGURE 1–11
WAYNE THIEBAUD
Girl with Ice Cream Cone, 1963.
Oil on canvas, 48 × 36"
*Collection of Mrs. Edwin A. Bergman.
©Wayne Thiebaud/Licensed by VAGA,
New York, NY*

ready to regard our "transparent" picture surface as the first plane in the series. With this in mind, let us look at two illustrations.

The female figure in Wayne Thiebaud's painting (Fig. 1–11) sits securely in a shallow space. Yet we cannot help but notice the illusion that her big toes are pressed against the back of the picture plane. In Figure 1–12, the inner rectangle has a slablike appearance. This effect gives the picture plane a more immediate physical presence (it seems more real than the actual paper margins) and makes it clearly the initial contact point through which an atmospheric vista unfolds.

FIGURE 1–12
JOHN LEES
Study for a Landscape, 1985
Pencil, ink, gouache on paper,
12 × 15"
Courtesy, Hirschl & Adler Modern, New York

In each case, then, the primary position of the picture plane in the spatial illusion has been declared, whether by pressure against its surface or by heightening its physical palpability.

Exercise 1A *These exercises will enable you to transform your sheet of paper into an imaginary space of unlimited depth. You will need the following drawing media: vine and compressed charcoal, conté crayon, graphite stick, kneaded and artgum erasers.*

__Drawing 1.__ To create your spatial illusion, use a variety of marks. These marks should not be descriptive of objects. Instead, each mark should simply indicate a distinct physical point in the illusion of space you are making. Do your best to vary your marks in terms of size, tone (lightness and darkness), and clarity to create the illusion that they are set at different depths in a spatial field (Fig. 1–13).

Experiment freely with your media. Use your fingers, chamois, or side of your hand to blur some of the marks. Maneuver about so marks are distributed at various places across and up and

FIGURE 1–13
A. VAN CAMPENHOUT
Zonder titel, 1998
No. 4, Charcoal on paper,
150 × 117 cm
Courtesy, the artist

down your paper. Apply some marks with heavy pressure using the motion of your entire arm; arrive at others by merely flicking your wrist. Make some fast, some slow. And do not forget to explore the mark-making possibilities of your erasers. By erasing into dark areas you can make white lines and marks that seem to glow from a brilliant inner light. Also, try smearing heavy deposits of media with your erasers or scumbling over them (this means to rub lightly or "feather" an area). Both of these techniques will soften dark marks, making them appear more hazy, or atmospheric (Fig. 1–14).

Drawing 2. *Your objective here is to make a more finished-looking drawing. Begin by once again using marks to represent a space. But as your drawing develops, consolidate your marks until more definite areas of light and dark appear. The Barnes drawing (Fig. 1–15) is a fine example of how*

FIGURE 1–14
ALISON NORLEN
Pinball II, 1996
Mixed media, 8 × 12'
Courtesy, the artist

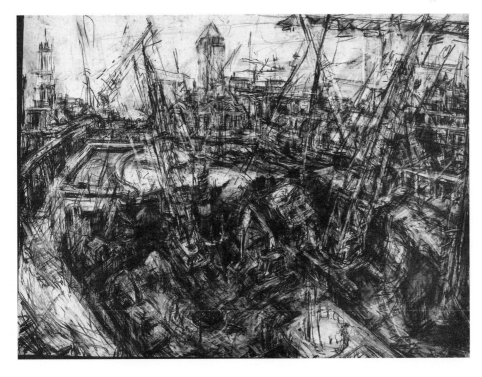

FIGURE 1–15
JEANETTE BARNES
Limehouse Excavation Docklands, 2000
Conté crayon, 150 × 211 cm
Courtesy, the artist

FIGURE 1–16
SUSAN MESSER workshop,
Indiana State University
Collaborative student
drawing
Mixed media on paper
and acetate
Courtesy, Susan Messer

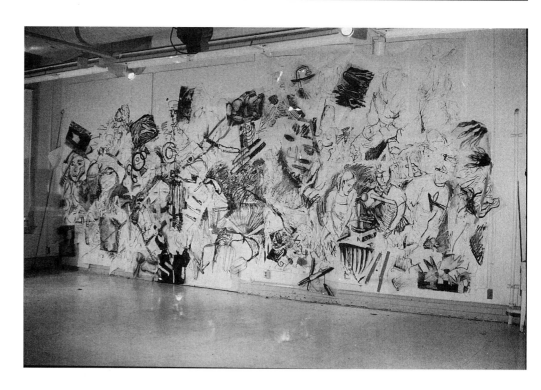

this mark-making approach can be extended to yield a finished work of great textural and spatial complexity.

The mark-making approach to drawing can also be easily adapted to an improvisatory workshop situation as in the very large mixed-media drawing illustrated in Figure 1–16.

Fundamental Methods for Creating Three-Dimensional Space

What you will have observed thus far is that although any collection of marks on a page will imply a space of some sort, strong differences in the character of marks intensify a drawing's spatial impact. The next step is to support this observation with basic information about how you can more decisively create and control an illusion of three-dimensional space in your drawings.

Most of the methods we describe below for creating space were used by artists before the advent of linear perspective in the fifteenth century. Although these devices were eventually united with linear perspective, they remain viable outside the strictures of that highly rationalized system.*

RELATIVE POSITION

In a spatial illusion, things located on the lowermost portion of the picture plane generally appear closest to the viewer. Conversely, the higher something is placed on the picture plane, the farther away it appears. Note, for instance, that the figures of Christ and the two Old Testament prophets in the upper section of Figure 1–17 are read as farther back in space by virtue of their position on the picture plane relative to the three kneeling Apostles below. A similar phenomenon occurs in the Thiebaud drawing (Fig. 1–18), in which the gradual upward disposition of the pastels suggests increasing amounts of depth.

*A full discussion of the rules of linear perspective appears in Chapter 5, "Linear Perspective."

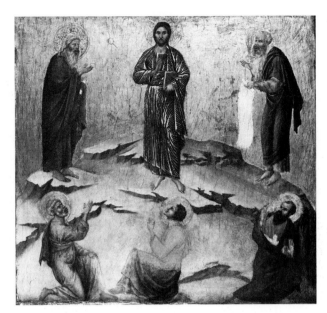

FIGURE 1–17
Duccio
Transfiguration
Reproduced courtesy of the Trustees,
The National Gallery, London

FIGURE 1–18
Wayne Thiebaud
Pastels, 1972
Pastel, 22⅛ × 30"
© *Wayne Thiebaud/Licensed by VAGA,*
New York, NY

DIAGONALS TO CREATE DEPTH

The diagonal is a simple but effective means for creating the illusion of depth in a picture. Its effect is, in part, derived from the fact that similar objects receding diagonally into space appear to diminish in size (see Fig. 1–19). But to best understand the diagonal's power, we must compare it with its directional counterparts in two-dimensional art, the vertical and the horizontal.

The vertical mark echoes our vertical condition as human beings, so we most readily identify with it (Fig. 1–20). A related issue is the somewhat confrontational effect of a vertical mark: It may function as an obstacle as well as a marker in our spatial field.

The horizontal mark opposes our orientation and thereby gives refreshed emphasis to our verticality. The thrill we experience before a sweeping landscape or ocean vista is due in part to the horizontality of its lines and planes. The

FIGURE 1–19
EDOUARD MANET
French (1832-1883).
La Rue Mosnier, (now La Rue de Barne), c. 1878
Brush and tusche, over graphite, on paper vegetal transfer paper, laiddown on creave wove paper, 27.9 × 44.2 cm
Given by Alice H. Patterson, in memory of Tiffany Blake, 1945. 15, reproduction, The Art Institute of Chicago

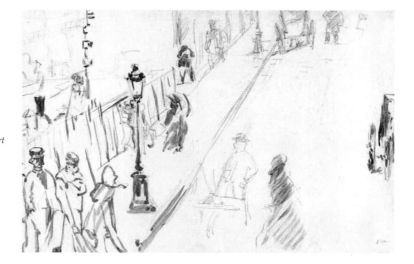

FIGURE 1–20
GEORGES SEURAT
Usines sous la lune
Conté crayon, 9 × 12"
The Metropolitan Museum of Art, gift of Alexander and Gregoire Tarnopol, 1976 (1976.243)

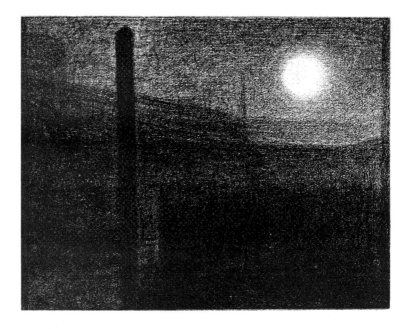

horizontal line often elicits a feeling of calm associated with an uninterrupted flow of space. A horizontal located overhead, however, can be oppressive or even ominous, as in Shinn's drawing (Fig. 1–21).

It is important to realize that vertical and horizontal marks, aside from their direct relation to our human posture, also repeat the vertical and horizontal axes of the paper on which we draw (Fig. 1–22). By virtue of this harmony, vertical and horizontal marks lend drawings a feeling of structural stability. We may validly sense, then, a relationship between our vertical condition, the rectangular or square orientation of our drawing paper, and the vertical and horizontal marks we make.

In contrast, the diagonal mark is more dramatic and suggestive of action. It is antagonistic to the stability of our bodily orientation and the orientation (horizontal and vertical) of our drawing surface. Lacking an axial equivalent, the diagonal mark creates tension as it transports us with great immediacy into an illusion of space (Fig. 1–23).

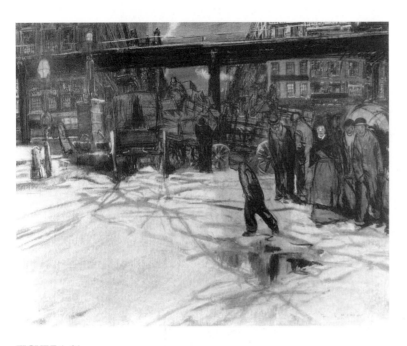

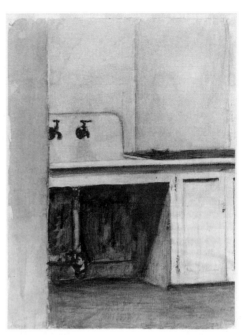

FIGURE 1–21
EVERETT SHINN
Under The Elevated
Pastel and charcoal on paper
21¼ × 27" (53.98 × 68.58 cm)
Whitney Museum of American Art, New York. Gift of Mr. and Mrs. Arthur G. Altschul. 71.230 Photograph by Geoffrey Clements

FIGURE 1–22
RICHARD DIEBENKORN
American, 1922-1993
Sink, 1967
Brush and wash and charcoal
The Baltimore Museum of Art: Thomas E. Benesch Collection BMA 1969.2

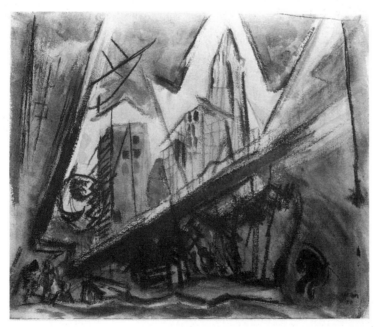

FIGURE 1–23
JOHN MARIN
(1870-1953)
Lower Manhattan, 1920
Watercolor and charcoal on paper,
21⅞ × 26¾"
The Museum of Modern Art, New York. The Philip L. Goodwin Collection. (104.1958) The Museum of Modern Art, New York, U.S.A. Digital Image © The Museum of Modern Art/Licensed by SCALA/Art Resource, NY. ©2003 Estate of John Marin/Artists Rights Society (ARS), New York

OVERLAPPING

Overlapping occurs when one object obscures part of a second object. Before the invention of linear perspective, overlapping was a very common and effective strategy for organizing space in art, as may be seen in Figure 1–24.

The phenomenon of figure–ground is made more complex by overlapping. When forms are overlapped, the relative nature of figure to ground becomes

FIGURE 1–24
NETHERLANDISH ANONYMOUS
Franco-Flemish XIV century
The Death of the Virgin, c. 1390
Silverpoint on blue-green prepared
paper, .291 × 400 (11½ × 15¾")
*Rosenwald Collection, Photograph © 2002
Board of Trustees, National Gallery of Art,
Washington, D.C.*

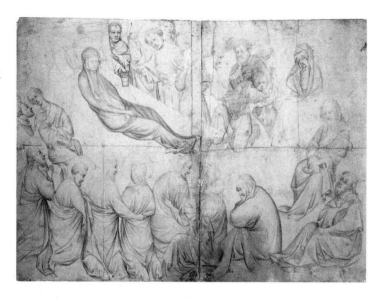

FIGURE 1–25
CHARLES SHEELER
(1883-1965)
Of Domestic Utility, 1933
Conté crayon on paper, 25 × 19½"
*Gift of Abby Aldrich Rockefeller. (147.1935).
The Museum of Modern Art, New York, NY,
U.S.A. Digital Image © The Museum of
Modern Art/Licensed by Scala-Art Resource,
NY*

evident. In Charles Sheeler's *Of Domestic Utility* (Fig. 1–25), for instance, the forms moving sequentially back into space may be seen to alternate their roles as either figure or ground. The circular pan, sandwiched between two logs, serves as a ground for both the pitcher and the log that are foremost in our field of vision. In its turn as figure, the pan is seen against a variable ground that includes the distant log plus floor and wall planes. Even the body of the pitcher may be seen as a ground, for against it we observe the form of the handle. This type of progression, in which figure and ground are relative designations, is often referred to as *figure–ground stacking*.

ATMOSPHERIC PERSPECTIVE

Atmospheric perspective (also called aerial perspective) has been employed by artists for a long time (the Chinese had mastered the technique by the tenth century). It is based on what any of us may observe by looking out the window: Objects close at hand are crisply defined; those at a greater distance lose their definition appreciably.

Technically, it is the moisture and particles of dust in the air that obscure our vision of distant things. The greater the amount of air between us and the forms we observe the less clearly are we able to perceive them. So, in general, atmospheric perspective is most apparent when we are confronted with deep space (Fig. 1–26) or when the atmosphere is made more dense by mist or fog (Fig. 1–27).

To be more specific, the effects of atmospheric perspective can be achieved in a drawing by paying attention to these two principles:

1. The clarity of forms diminishes as they recede into the distance. Surface detail and texture are less apparent; with very distant forms, detail and texture may disappear altogether.

2. When objects are viewed in deep space, the contrast between light and dark tonalities is reduced. Medium and dark tones often become lighter and may even blend into a uniform light gray.

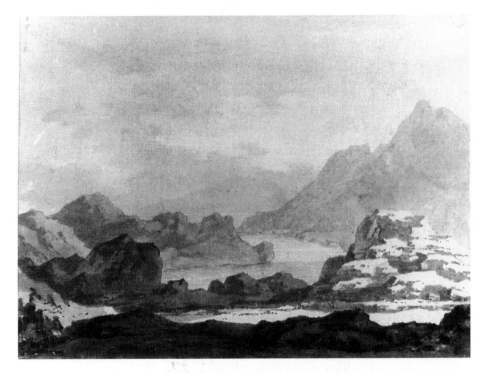

FIGURE 1–26
ALEXANDER COZENS
A Mountain Lake or River Among the Rocks, 1775–1780
Brush and black ink wash
Courtesy, Courtauld Institute Gallery, Somersot House, London

FIGURE 1–27
HASEGAWA TOHAKU
Pine Trees
Four details from a pair of six-fold screens, ink on paper, height 61"
Tokyo National Museum, Japan

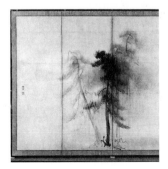
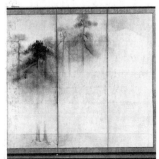
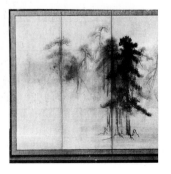
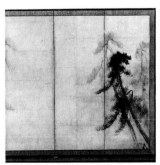

Sometimes this second principle misleads students into believing that only forms close to the picture plane should be drawn with the darkest tones. This is incorrect, since there are occasions in nature when the perceived tone of a more distant form will approach, equal, or even exceed the darkness of forms that are nearby. In this case, remember that it is the tonal contrast of a form (relative to its context) in comparison with other areas of a drawing that helps determine spatial position.

ORGANIZING A DEEP SPACE

The volume of air, or atmosphere, between us and the forms we perceive in the distance can be understood as a series of receding planes (as we discussed in the section on the picture plane). A convenient system for organizing these planes is to group them into three distinct zones of illusory space: foreground, middleground, and background.

In the Everett Shinn drawing (Fig. 1–28), all three zones are clearly present and are coordinated with the illusion of atmospheric perspective.

RELATIVE SCALE

The concept of relative scale is closely allied to notions of foreground, middleground, and background. Things that are larger in scale usually seem to be in the foreground, or closer to us. Conversely, when there is a relative decrease in the scale of forms, we judge them to be receding into the background. Note, for instance, the drawing by Emil Nolde (Fig. 1–29). The marks are uniformly black, and Nolde's broad approach expresses only a general impression of his subject. And yet the pronounced scale changes of the marks guide us convincingly through a deep space.

The use of relative scale is particularly effective when the forms that diminish are understood to be of similar size, as in the Goya drawing (Fig. 1–30).

FIGURE 1–28
EVERETT SHINN
Eastside Apartment Buildings, 1898
Pastel, 29½ × 21½"
Courtesy, Hirschl and Adler

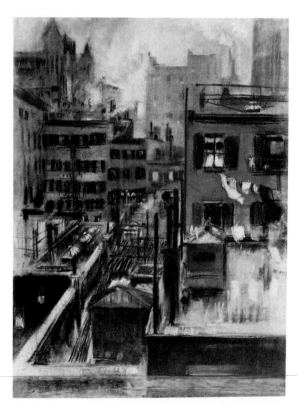

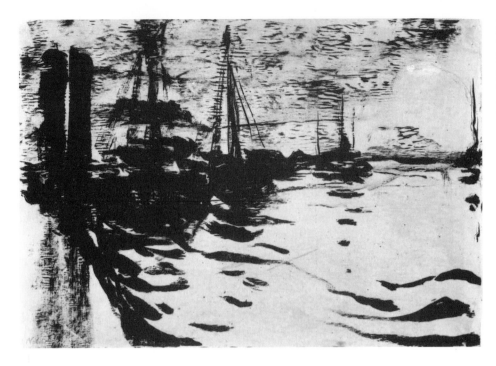

FIGURE 1–29
EMIL NOLDE
Harbor Scene, Hamburg, Germany, c. 1900, 1965.245 (D15656). Brush and india ink, 323 × 465 mm
The Art Institute of Chicago. All Rights Reserved. Gift of Stanley Freehling and Joseph R. Schapiro.

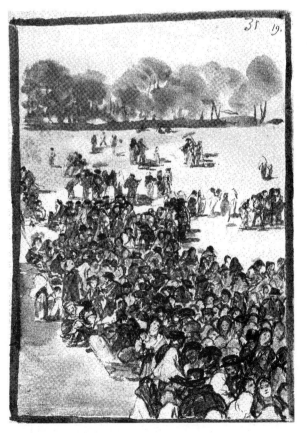

FIGURE 1–30
FRANCISCO DE GOYA Y LUCIENTES
A Crowd in a Park
Brush and brown wash
8⅛ × 5⅝"
The Metropolitan Museum of Art, Harris Brisbane Dick Fund, 1935 (35.103.19)

Consider as well Goya's use of relative position, atmospheric perspective, and the diagonal to achieve a convincing sense of space.

Exercise 1B *Armed with an increased knowledge of spatial concepts, you are now in a position to choose between representing deep illusionistic space or, if it better suits your expressive ends, a flattened type of space. The following exercises are an introduction to these two alternatives.*

Drawing 1. Set up to draw on one side of the largest room available to you. Spend a few moments letting your eye travel from point to point within this space. You might also try to imagine your drawing paper as a transparent window superimposed over your subject.

Now, select an object in the midst of this interior and put a mark on your paper representing it. Do not attempt to outline the object or depict any of its detail; your concern should be only with that object's location in space. Next, select an object or point that lies behind the first one. Indicate its position with another mark. You will probably wish to make this mark lighter in tone, or at least more diffuse, to have it appear farther away. Note also its relative position on the page. Is it closer to the top?

Next, look at an object that is close to you. Using a bolder and sharper mark, indicate this object. Continue to add marks to the page showing the relative locations of other objects in the room. Be sure to consider the intensity and clarity of your marks and their relative position and scale; make use of any naturally occurring overlaps to reinforce your illusion of space.

Figure 1–31 is an example of marks used to create a feeling of space in a room.

Drawing 2. Spread a number of small objects on the top of a table. Station yourself so that you are looking almost directly down at your subject. You will notice that the plane of the tabletop corresponds to the picture plane of your drawing surface. Notice, too, how the articles on the table appear to adhere closely to the plane of the tabletop. Your intent in this drawing should be to re-create the feeling of limited depth that you observe in your subject.

Draw the arrangement of objects so as to maintain the integrity of the picture plane; that is, avoid all the devices normally used to create depth, such as overlapping, atmospheric perspective, and relative scale. To further emphasize the literal flatness of the picture plane, you may even wish to use one of your objects as a stencil (Fig. 1–32).

FIGURE 1–31
Georgeanne Cooper, University of Oregon
Student drawing: using horizontal and vertical lines to depict the spatial positions of objects within an interior
Courtesy, the artist

FIGURE 1–32
WILL PEREIRA, University of
Montana
Student drawing: still life in which
a tabletop corresponds to the
picture plane
18 × 24"
Courtesy, the artist

Looking at Space

Now that you have some experience with the very basics of spatial illusion, let us go on to investigate the various conceptions we have of space. Science tells us that space is the dominant medium, whether we consider the ample spaces seen from a mountaintop or the microscopic dimensions of space within each atom. Perhaps the most basic idea of space is as an expanse of "empty" air. But this fundamental conception may be experienced and interpreted in ways that fall into three broad categories: distance, area, and volume.

Standing in a Kansas wheat field and looking at a corn silo on the horizon, you will experience a sense of distance, or what we might call a one-dimensional measure of space. But people most often experience space with boundaries of some sort. The space of your street, for instance, or by extension your town as a whole, can be thought of as a particular area of space. Each has boundaries, definite or implied, that delineate its length and width; and each is divided into sections of space by such things as city parks, buildings, and highways (note the term *subdivison* in the builders' lexicon). As an example, look at the drawing by Sidney Goodman (Fig. 1–33), in which the sensation of a bounded spatial area is heightened by the row of massive and dramatically represented trees.

Two interesting variations on the themes of area and distance are provided by Figures 1–34 and 1–35. The Joan Nelson drawing makes a dramatic visual statement by contrasting the limited security of a barricaded, pierlike platform in the face of a formidable expanse of ocean. The Rackstraw Downes affords an aerial view of the partitioned areas, or zones, of a modern urban landscape.

Moving down the ladder of magnitude from the Kansas wheat field and city park, our next stop is the interior space of a room. In a typical room, the space is enclosed on six sides, creating a spatial volume.

To develop an awareness of space as volume, you must learn to treat it as though it were a palpable substance. It may help to imagine the air as tinted with a color, clouded with smoke or vapor, or replaced with a substance such as water

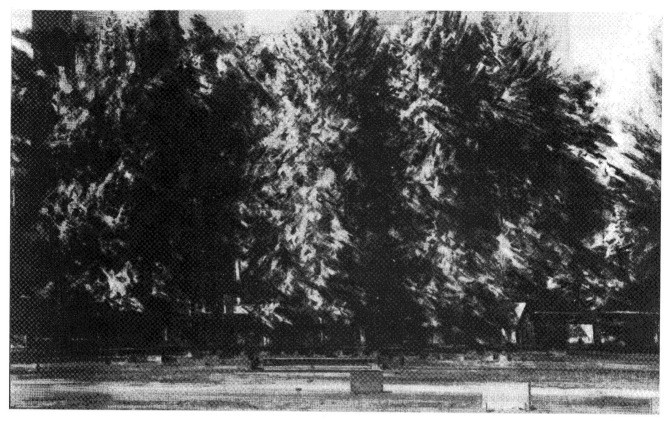

FIGURE 1–33
SIDNEY GOODMAN
Wald Park, 1970
Charcoal, 23½ × 41¼"
Acquisition Fund Purchase, Collection
Minnesota Museum of American Art, St. Paul

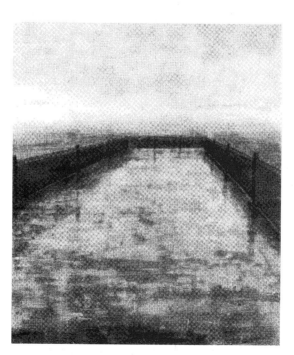

FIGURE 1–34
JOAN NELSON
Untitled, Summer 1985
Pigment and wax on board,
17⅞ × 15⅞" (45.4 × 40.3 cm)
Solomon R. Guggenheim Museum, New York.
Exxon Corporation Purchase Award, 1985.
(85.3333). Photographed by David Heald

or oil. Notice in this regard the density of atmosphere portrayed in the work by
Elyn Zimmerman (Fig. 1–36).

The sensation of spatial volume is maximized when objects divide a space
into yet more visually manageable and intimate volumes. As an example, look at
the drawing by William Wiley (Fig. 1–37), in which the depicted volume of space

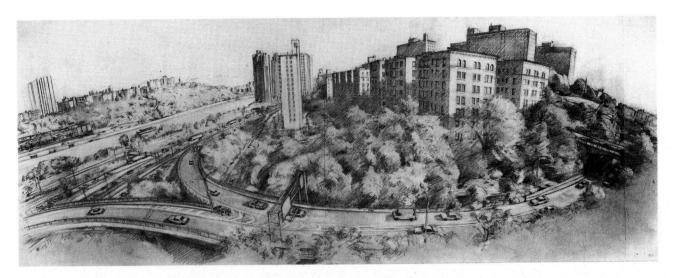

FIGURE 1–35
RACKSTRAW DOWNES
*The View Looking North-West from
the Washington Bridge*, 1983
Graphite on paper, 19 × 50¾"
Courtesy, Hirschl & Adler Modern, New York

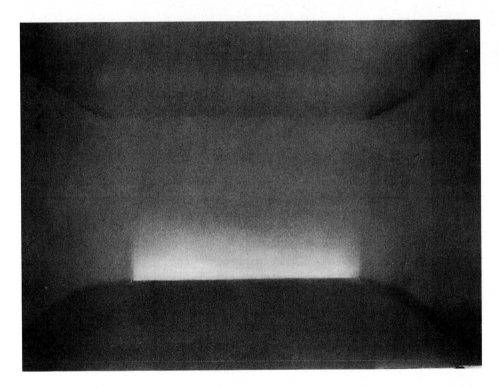

FIGURE 1–36
ELYN ZIMMERMAN
Untitled, 1976
Powdered graphite, 14¼ × 19¼"
*Courtesy of the artist and the Gagosian
Gallery, New York*

is pronounced. We want to poke about in the array of spaces scaled for human activity, but as we do so, we are rebuked by the centrally placed square, which serves as a reminder of the picture plane.

Our experience of space as a volume need not be limited to rooms designed for personal use. The presence of monumental masses of air pressing against the architectural framework of large halls, churches, and theater interiors can fill us with awe (Fig. 1–38). And this is not to say that our awareness of spatial volume cannot be stirred in an exterior setting. In Michael Mazur's untitled landscape drawing (Fig. 1–39), a volume of space is powerfully implied in the center, formed by the arching canopy of tree branches.

We urge you to take account of the different spaces you encounter in daily life. A good "out-of-the-classroom" exercise is to determine whether the spaces you see can be classified by their distance, area, or volume. How about combinations?

FIGURE 1–37
WILLIAM WILEY
Studio Space, 1975
Acrylic and charcoal on canvas,
83 × 80¾"
Courtesy, Wanda Hansen Gallery

FIGURE 1–38
PIRANESI
Large Architectural Interior
© *The Pierpont Morgan Library/Art
Resource, New York*

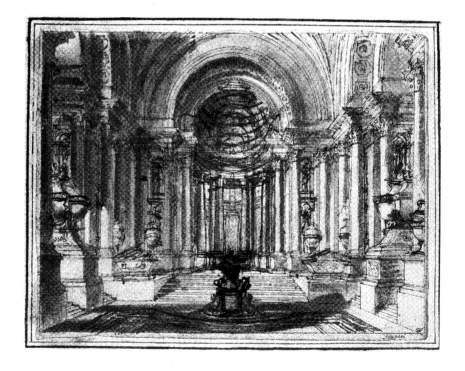

We have provided examples of area and distance combined; can you find spaces
that seem poised between, let us say, area and volume?

Concentrating on spaces instead of things will probably mean reversing
your normal visual habit. It is suggested you do this so you can intensify your
awareness of space. But this sort of activity will have an even broader application,

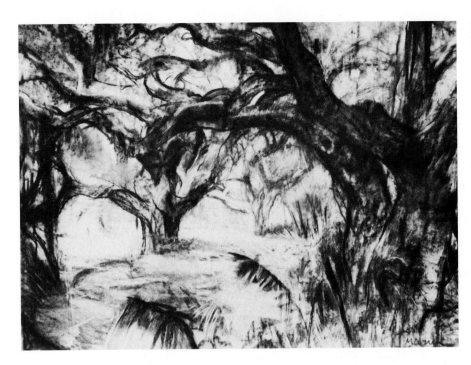

FIGURE 1–39
MICHAEL MAZUR
Untitled, 1985
Charcoal #4500, 42½ × 60"
Courtesy, Jan Turner Gallery

because when you shift your attention from what you are accustomed to seeing, you help yourself develop a new vocabulary of expectations and responses. This may be awkward at first, and it definitely takes practice. But it is good to break visual habits. Doing so makes you more receptive to, and eventually eager for, the challenge of new visual perceptions.

Gesture Drawing as a Means of Capturing Space

If you wish to address the essence of a set of spatial relationships with directness and immediacy, you will do a *gesture drawing*. In general, the term *gesture* refers to the expressive posture of a human being, and indeed gesture drawing is an ideal means for capturing spontaneous human actions (Fig. 1–40). For artistic purposes, however, gestural characteristics may be interpreted from most of what we observe. For example, the nose of the helicopter in Figure 1–41 appears to point like a giant forefinger to the target below, mimicking a common human gesture.

Gesture drawing is a rapid sizing-up of the primary physical and expressive attitudes of an object or a space. Description in the gesture drawing is limited to the subject's essentials, which are searched out intuitively. Quick by definition, gesture drawing urges the artist into a frame of mind where details are ignored in favor of a subject's basic visual character. For this reason, artists often do gesture drawing to warm up prior to an extended period of work (Fig. 1–42).

Gestural exploration may also serve as the basis for a drawing that is meant to be developed into a finished work.* But regardless of how gesture drawing is

*For information about the relationship of gesture drawing to design, see Chapter 4 "The Interaction of Drawing and Design."

FIGURE 1–40
PIERRE BONNARD
Sheet of Studies, *Woman with Umbrella*, c. 1895
Graphite, pen and black ink, brush and black wash and watercolor, on ivory wove paper, 31.2 × 19.9 cm
Bequest of Grant J. Pick. Photograph © 1994, The Art Institute of Chicago (1963.397 recto). All Rights Reserved

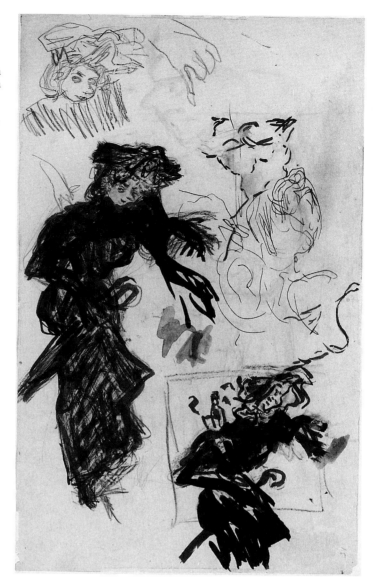

used by the artist, it is not, in itself, usually accorded the status of a "product," or final artwork. Instead, the emphasis is on process—a process of search and discovery whereby immediate visual experiences are translated into the medium of drawing.

The more specific term *spatial gesture* may be defined as the gestural movement implied by an imagined linkage of objects distributed in space. This approach may be seen in the drawing by Piet Mondrian (Fig. 1–43), in which the sweeping, full-page gestures forego detailed description so as to capture the spatial essence of the subject. In Giacometti's drawing (Fig. 1–44), a network of spatial linkages is created by lines that career from one point to another in the depicted interior setting.

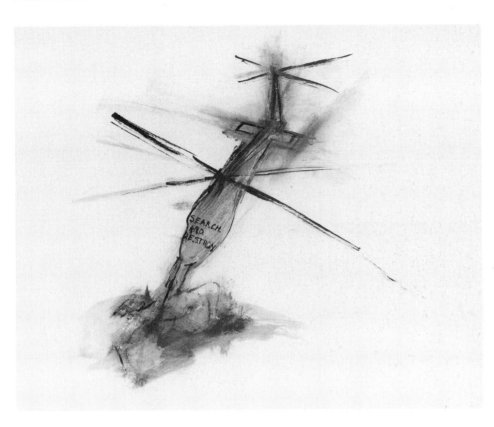

FIGURE 1–41
NANCY SPERO
Search and Destroy, 1967
Gouache, ink, 24 × 36"
Courtesy, the artist

FIGURE 1–42
EUGÉNE DELACROIX
Study of Lions
Graphite on buff laid paper,
22.8 × 34 cm
*David Adler Collection. Photograph © 1994,
The Art Institute of Chicago (1950.1411).
All Rights Reserved*

Seeing in terms of spatial gesture takes practice. Let us suppose that you are in a room that is filled with objects. To see the gesture in this room, let your attention bounce around from object to object. You may be immediately struck by a spatial relationship among some of the objects. You might, for instance, see how a bicycle, chair, and birdcage form an arc when viewed in sequence across a portion

FIGURE 1–43
PIET MONDRIAN
Dunes and Sea, 1909
Pencil on paper, 10.2 × 17.1"
© 2003 Piet Mondrian/Holtzman Trust,
c/o Beedrecht/Artists Rights Society (ARS),
New York

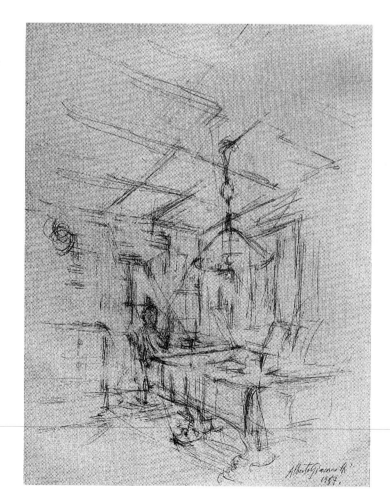

FIGURE 1–44
ALBERTO GIACOMETTI
Interior, 1957
Pencil on paper, 35¾ × 19¾"
© 2003 Artists Rights Society (ARS), New
York/ADAGP, Paris

of the room. Now, although these objects have different names and uses in every-day reality, you have found a way to group them. You have discovered a visual connection that hinges entirely on your personal organization of the space in the room before you.

The two drawings suggested in this exercise require you to concentrate on a particular linkage of objects in space. The purpose is to heighten your awareness of how space may appear to gesturally unfold.

Drawing 1. *From your easel or drawing table, choose a path through the objects in the room space before you. Take your drawing tool and re-create that path on your paper, using a simple, meandering line. It is advisable to look as much out at the space you are trying to represent and as little at your paper as possible. (Line drawings made without looking at the paper are frequently referred to as* blind-contour *drawings.)*

As you draw, you should be convinced that you are steering your line into *the space. Use sound effects as you (SQUEAL!) veer around one object to get to the next; or as you (GRUNT!) have to make several hard passes with your drawing media to get beyond an "obstacle" that is especially large, heavy, or dark in color (as in Fig. 1–45, in which a gathering of marks around a central form indicates the weight and solidity of its mass).*

Drawing 2. *Do a second gesture drawing using the same concept of a spatial route. But this time look at your paper and make an even more varied set of marks to express the character of what you see along this path and the feelings that are aroused in you as you proceed.*

Work quickly, but be alert to the need for exerting varying pressures on your medium to suggest weight, scale, and speed changes along your journey. Remember that by thinking of objects as things that slow down and divert your course through space, you will naturally become more aware of the space between these objects.

The greater variety of marks that you use in this drawing will help you and your viewer to empathize with your subject. Evidence of this physical identity with a subject can be seen in Figure 1–46, in which veering diagonals on the ground plane conflict with the heavily hatched and smeared verticals that bar our entry into the picture space.

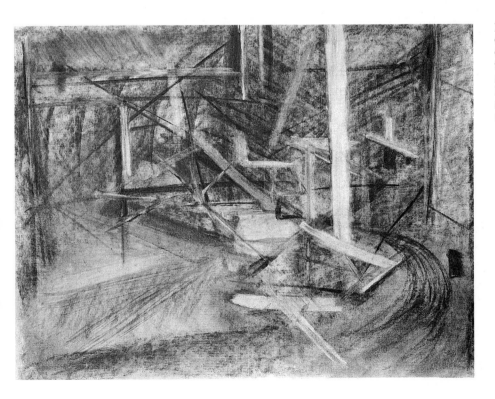

FIGURE 1–45
GEORGEANNE COOPER, University of Oregon
Student drawing: diagonal lines added to horizontal and vertical lines to represent obstacles in an interior
Courtesy, the artist

FIGURE 1–46
Fumiko Amaro, University of
Wisconsin at Stevens Point
Student drawing: use of a variety
of marks to encourage empathy
with the subject
Courtesy, the artist

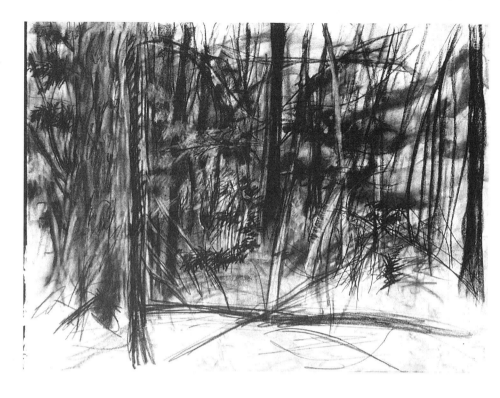

When you are finished, the expressiveness of these drawings might surprise you. But think of the personal decisions you had to make during the process. First, you singled out objects that divided the space in an interesting way; then, you had to choose what kind of marks would best express the responses you had as your eye followed along your selected path.

The Two-Dimensional Space of a Drawing

In Chapter 1, "The Three-Dimensional Space of a Drawing," we explored ways to create the pictorial illusion of three-dimensional space. The picture plane in this case was conceived as a window on nature. We also noted that the second definition of the term *picture plane* is the flat surface on which a drawing is made. That flat surface, usually a sheet of paper, represents the *actual* space of a drawing.

More specifically, this actual space of a drawing is two-dimensional. It is the *area* of the drawing, the product of the length times the width of the paper or support on which an image is drawn. And it is a space limited to the paper's surface and bounded by its edges.

So, flatness of surface is the fundamental property that links all the drawings you make. Indeed, even when you are concerned primarily with depicting an illusion of three-dimensional space, you also need to consider how best to lay out or divide the area of your page. This chapter stresses the primacy of the flat picture plane and introduces ways to address its two-dimensional space.

Two-Dimensional Space and Modern Art

Many twentieth-century artists have emphasized the actual two-dimensional space of the picture plane over its potential for three-dimensional illusion. Wishing to avoid what might be termed the "artificial" nature of illusionistic space, these artists have exploited the flat character of the drawing surface with the intention of "preserving the integrity" of the picture plane (Fig. 2–1).

Other artists have chosen to extend their images *out* from the picture plane into the spectator's space. Collage, assemblage, and relief (Fig. 2–2) are some of the ways artists have opted to incorporate the space in front of the picture plane into their two-dimensional art forms.

Later in this chapter (see "Ambiguous Space") we discuss other ways in which modern artists have asserted the integrity of the flat picture plane, but first we must define more fully the two-dimensional character of a drawing. We begin by emphasizing the shape of the surface on which we draw.

FIGURE 2–1
ROY LICHTENSTEIN
Electric Seascape #1, 1966
Collage (rowlax and paper),
22 × 28" (55.9 × 71.2 cm).

Solomon R. Guggenheim Museum, New York.
Gift, Mrs. Louis Sosland, Kansas City.
Photograph by Robert E. Mates, (79.2528)

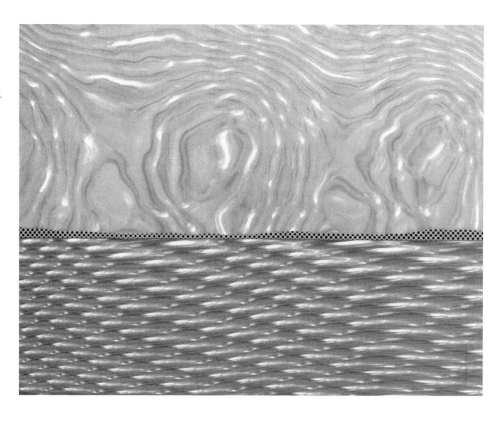

FIGURE 2–2
BRUCE CONNOR
Untitled, 1960
Mixed media (oil, wire, nail) on
canvas, 9¾ × 8⅛" (24.8 × 20.7 cm)

Solomon R. Guggenheim Museum, New York.
Gift, James J. Hanafy, 1976. Photograph by
Robert E. Mates, (76.2265)

The Shape of a Drawing

The paper we draw on has a shape. (By *shape*, we mean a flat area with a particular outer edge, or boundary.) Since a sheet of paper is itself a flat shape, it follows that any image we draw on it will be, first and foremost, a shape. Let us take, for example, the drawing of a banana flower by Georgia O'Keeffe (Fig. 2–3a). It looks quite "real," suspended in space and thrown into relief by strong lighting. And yet, common sense tells us that a banana flower does not really exist on that page. Instead, we respond to a drawn image of that object, an image that is convincingly modeled with charcoal to look round but is, nevertheless, in its truest physical definition a flat shape.

Positive and Negative Shape

From an artistic standpoint, subjects in the real world consist of two basic realities: the *positive forms* of objects and the *negative spaces* surrounding these forms or contained by them (such as the space between the handle and body of a coffee cup).

When you draw, the positive forms and negative spaces of your subject are converted into their pictorial counterparts on a flat surface: *positive* and *negative shapes*. To clarify this, let us look at Figure 2–3b (in which we have reduced the drawing by Georgia O'Keeffe to its simplest shape state) and consider the following two points:

1. The entire rectangular surface of the O'Keeffe drawing is divided into two distinct shape areas: no. 1 (positive shape) and no. 2 (negative shape).

2. The illusion of the banana flower as a positive sculptural volume and the space that surrounds it occur within the actual shape divisions of the flat picture plane.

In truth, then, whenever we represent an object or a space on a page, we are creating a shape. And the first shape that is made automatically creates one or

FIGURE 2–3a (left)
GEORGIA O'KEEFFE
Banana Flower, 1933
Charcoal, 21¾ × 14¾"
© 2003 *The Georgia O'Keeffe Foundation/Artists Rights Society (ARS), New York*

FIGURE 2–3b (right)

more additional shapes from the area of the drawing sheet. These shapes are designated as either positive or negative.

Implications of the Term Negative Shape

The term *negative shape* carries connotations that may interfere with an appreciation of positive and negative relationships in a drawing. Unfortunately, negative shapes are sometimes defined as the empty, or passive, areas of a picture that remain after the positive image has been drawn. This may lead students to believe that negative shapes are somehow "second-class" and thus do not require the attention given to positive areas.

A related problem is the tendency for students to label as "background" all the areas of their drawing that lack prominent object symbols.* Referred to in this way, *background* really means "backdrop," or the subsidiary part of a drawing against which the positive image stands out. This tendency is caused in large part by the material conditioning of our culture; those things we can name usually take precedence in our minds.

But negative shapes aren't simply a backdrop, or what's left over when a positive image is drawn. *They are an integral part of a drawing.* When beginning to draw, be sure to regard the *entire* shape area of your empty sheet of paper as important. So it follows that *all* the shapes resulting from a division of that surface are also important and deserving of careful attention.

Each time you draw a positive shape on your page, you are simultaneously shaping the negative areas of your drawing. This means that positive and negative shapes have an immediate and reciprocal influence on one another. Therefore, any approach that neglects the negative shapes of a drawing will flaw the wholeness of a work and its expression. It will also limit your ability to take advantage of the total visual potential in both your subject and its translation onto a sheet of drawing paper. In view of all this, we are inclined to say that decisions about how best to break up the surface of your picture plane into positive and negative shapes are among the most creative of the drawing process.

Accentuating the Positive or the Negative

In summarizing what we have established thus far in this chapter, we acknowledge that a drawing surface is flat and that all parts of an image, regardless of how convincingly they are modeled as volumes, are most essentially shapes. Thus, we may conclude that the substance of a drawing is crucially linked to the quality of its positive and negative shapes.

Furthermore, each of the shapes we make in a drawing exist apart from the forms and spaces they portray. So a positive shape that represents something we recognize from the natural world is not inherently more important than a negative shape that stands for an uninhabited plane or space. The way shapes *do* derive their level of importance in a drawing is from the specific artistic treatment they receive.

Although the five-bladed saw is the subject matter in Figure 2–4, it is the exchange between positive and negative areas in this drawing that confers meaning and compels our interest. Note how the negative zones switch from a recessive role in the upper portion of the image to a suggestion of mass and volume at the bottom. (The handle can be read as sitting at the threshold of a dark cavity with the effects of chiaroscuro illuminating the surfaces that curve away from it.)

*The term *background* as used here is not to be confused with its spatial application in Chapter 1, where it was grouped with the terms *foreground* and *middleground*.

FIGURE 2–4
JIM DINE
Untitled from "Seven Untitled
Drawings (5-Bladed Saw)," 1973
Charcoal and graphite on buff
paper, 25⅝ × 19¾"
© 2002 Jim Dine/Artists Rights Society
(ARS), New York
Gift of the Robert Lehman Foundation, Inc.
(484.1976.1)
Digital Image © The Museum of Modern Art/
Licensed by SCALA/Art Resource, NY
Museum of Modern Art, New York, NY

FIGURE 2–5
GEORGE SEGAL
1965–4
Conté on newsprint, 18 × 24"
© George and Helen Segal Foundation/
Licensed by VAGA, New York, NY

In the center of the drawing, the presence of the blades is implied by employing selective contours (observe the variety of marks and lines used to punctuate the edges of the blades). Visually, this bare-bones conception enables the flat planes of the blades to engage the back space, transforming the negative ground into positive form and convincingly placing the blades into the light and atmosphere of the spatial illusion. Expressively, the contrast between the sturdy, well-defined handle and the fleet gesture of the blades is directly associated with the differing functions of the tool. In this way, positive and negative treatment is inseparable from the drawing's content.

In the pastel drawing by George Segal (Fig. 2–5), it is the negative shape that presses for our attention. Thus, Segal heightens viewer fascination by providing what is least expected: a negative, "empty" shape occupying the central portion of the drawing, a place typically reserved for positive shapes.

As we have indicated in this chapter, many of us are so accustomed to looking at positive forms that negative spaces often go unnoticed. Yet by virtue of their unpredictability, the negative spaces of a subject can have greater visual and expressive potential than their positive counterparts (Fig. 2–6). By isolating them for interpretation as flat shapes, this exercise will heighten your awareness of the "hidden" resources of negative spaces.

Exercise 2A

FIGURE 2–6
CONSTANTIN BRANCUSI
View of the Artist's Studio, 1918
Gouache and pencil, 13 × 16¼"
*© 2003 Artists Rights Society (ARS),
New York/ADAGP, Paris*

Select some objects that have distinct negative spaces. Ladders, chairs, stools, tires, and the like make ideal subjects for this kind of drawing. Jumble and overlap these items to maximize the number and variety of negative spaces. If you turn some of these objects upside down you will find it generally easier to ignore their real-world function and concentrate instead on their shape potential. Negative spaces may also be accentuated by keeping the room light low while turning a strong spotlight on the setup.

Next, find a viewpoint that offers the best assortment of negative spaces and translate them into darkly toned shapes on your drawing paper. Avoid using an outline to describe these shapes; instead, select media that come in a block form (such as lecturer's chalk, compressed charcoal, or a graphite stick) and draw the negative shapes by applying broad, vigorous strokes (Fig. 2–7).

FIGURE 2–7
PAUL FLEMING, Arizona State
University
Student drawing: bold
positive–negative layout
Pencil, 18 × 24"
Courtesy, the artist

Ambiguous Space

At the beginning of this chapter we discussed how many modern artists have de-emphasized (or rejected entirely) the illusion of three-dimensional space, wishing instead to accentuate the two-dimensional character of pictorial art (Figs. 2–1 and 2–2). This does not mean to imply, however, that these artists abandoned spatial interplay in their work, but rather that they wished to achieve the sensation of space while maintaining for the viewer a firm awareness of the flat picture plane.

One of the most enduring ways for modern artists to accomplish this seeming contradiction of space and flatness in pictorial art is by creating what is often referred to as *ambiguous space*. Ambiguous space can be described as a visual phenomenon in which the spatial relationships between positive and negative shapes are rendered perceptually unstable or uncertain. To clarify this description, we turn now to a discussion of three kinds of ambiguous space: interspace, positive–negative reversal, and figure–ground shift.

INTERSPACE

The term *interspace* is sometimes considered synonymous with negative space, but in the work of many modern artists it is more appropriately defined as a subtle combination of negative shape and the illusion of positive form. To grasp this concept, look at a watercolor and pencil landscape by Cézanne (Fig. 2–8).

Can you detect in this work that each of the negative interstices appears to be a slightly rounded plane (think of a contact lens) through which the hints of space and atmosphere are seen?

To understand how Cézanne achieved this effect, allow your eyes to follow the contours that mutually describe tree forms and negative areas. Note that these contours vary in their sharpness and light and dark tonalities. This fluctuation in edge conveys the impression of negative planes that are alternately raised or lowered in relation to the cylindrical tree forms (the sharper darks may be seen as shadows cast on the tree forms by the negative shapes).

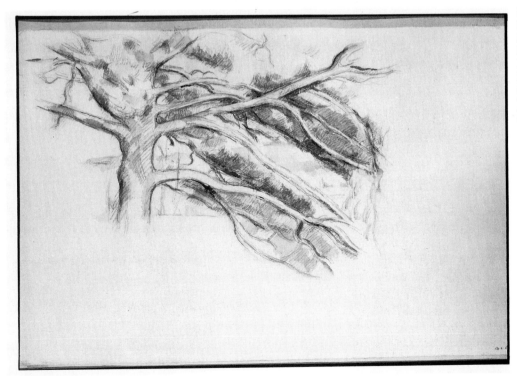

FIGURE 2–8
PAUL CÉZANNE
La Grande Arbre
Pencil and watercolor,
12 × 18⅛"
Bequest of Theodore Rousseau, 1974. Jointly owned by The Metropolitan Museum of Art and the Fogg Museum of Art, Harvard University (1974.289.1)

FIGURE 2–9
EDGAR DEGAS
Head of a Horse
Pencil on paper, 6⁵⁄₁₆ × 4¾"
*The Metropolitan Museum of Art. Gift of
A.E. Gallatin, 1923*

So, Cézanne provides enough visual clues in his treatment of the negative areas to give them the barest suggestion of volume. Although they do not compete with the more concrete tree parts, they are, nonetheless, more full than "empty" negative spaces are often deemed to be.

In other words, we have a *tactile* response to the areas of interspace in the Cézanne; that is, our visual reading of the negative shapes is influenced by how, in our mind's eye, those slightly curved surfaces would feel to the touch (think of buckled puzzle pieces). And by calling attention to the negative areas as *shapes*, Cézanne also reaffirmed the expanse of the flat picture plane.

Thus, the term *interspace* implies that instead of being merely flat and "passive," negative shapes may in fact be given a suggestion of volume and thereby assume a more "active" role in the spatial illusion of a two-dimensional work of art. Note in this regard, the drawing by Degas (Fig. 2–9), in which the negative area appears to swell and push against the horse's chin and down its neck, as if it were a cushion, to effectively bolster the quivering presence of the head.

POSITIVE–NEGATIVE REVERSAL

Ambiguous spatial relationships may also be achieved through *positive–negative reversals* which occur when shapes in a drawing alternate between positive and negative identities. These alternations make the artifice of illusion more apparent and thereby acknowledge the presence of the work's actual two-dimensional surface. A good example of positive–negative reversal can be found in Figure 2–10, in which the white shapes may, at first glance, appear to be positive "islands" floating forward against a dark ground. But stare at the central black zone for a moment and the reverse begins to happen: the black, formerly negative shape emerges as a positive "presence," and the white shapes seem to drop back like the

FIGURE 2–10
DONALD SULTAN
Menorca, August 17, 1978
Ink and graphite on paper,
12⅛ × 12⅛"
Solomon R. Guggenheim Museum, New York.
Gift, Norman Dubrow, 1984. Photograph by
David Heald, (84.3196)

FIGURE 2–11
SIGMAR POLKE
Physiognomy with Car, 1966
Ballpoint pen and gouache,
11⅜ × 8¼"
The Museum of Modern Art, New York. Gift
of the Cosmopolitan Arts Foundation

sides of a box. What we may conclude from this is that either the black or the white shapes in Figure 2–10 may be understood as positive or negative according to viewer perception.

This phenomenon may also be used to great effect in drawings that feature some level of representation. Look, for instance, at how the two dark shapes at the top of Figure 2–11 may be read as either positive cloudlike images on a gray ground or as negative cavities representing eyes on a face. The reversal of the right-hand shape is especially apparent; it seems to change its positive–negative identities continually. This is because one end of this shape coincides with the edge of the format, which heightens our variable reading of it as either an area drawn on the paper surface or the illusion of a shape cut out from that surface.

FIGURE–GROUND SHIFT

The two previous topics have indicated ways in which individual shapes in a drawing may have two different identities. This may happen either simultaneously (as in the case of interspace) or alternately (as in the case of positive–negative reversal). A third type of spatial ambiguity aggressively combines aspects of both interspace and positive–negative reversal. It is commonly known as *figure–ground shift*.

Figure–ground shift occurs when all or most of the shapes in an image are given a suggestion of volume, and when virtually all the shapes appear to be

FIGURE 2–12
WILLEM DE KOONING
Black Untitled, 1948
Oil and enamel on paper mounted
on wood, 29⅞ × 40¼"
*© 2003 The Willem de Kooning
Foundation/Artists Rights Society (ARS),
New York.*

constantly shifting, or slipping in and out of positive (figure) and negative (ground) identities.

In large part, figure–ground shift is the result of concentrating on the edges of shapes in a pictorial work of art. Varying the tone, thickness, and speed of edges can impart a positive, or figurative, weight to all the shapes in an image. And by making different portions of edges dip and rise, these variations also create an intricate webbing of overlaps that reinforces the physical existence of the flat picture plane. Consider, for example, *Black Untitled*, by Willem de Kooning (Fig. 2–12), in which each of the shapes interlock, with edges that twist back and then forward, to create complicated spatial puzzles that the viewer cannot rationalize or solve.

Exercise 2B *In this drawing you should attempt to create a sense of interspace by giving equal weight to positive and negative shapes.*

Choose a subject with a considerable number of framed negative spaces, such as a construction site, playground equipment, a large plant, or a still life. No special lighting is required.

As you draw, give simultaneous emphasis to both positive and negative shapes. It may help to think of all shapes, positive and negative, as shallow volumes. This is the case in Figure 2–13, in which the spaces between objects may easily be perceived as interspaces.

Exercise 2C *In this drawing you will again be looking at positive and negative shapes, but this time you will be weighting and distributing these shapes so as to effect a positive–negative reversal.*

Although traditional dry media such as charcoal or pencil will work well, you might consider as an alternative the use of black ink on paper or black and white paper collage.

Again construct a suitable still life or seek out in your environment a subject that suggests strong shape possibilities, such as a collection of items mingled with the drainpipes under your kitchen sink. Draw the objects using only black and white shapes. As you draw, be especially aware of how the shapes relate to each other and to the entire shape of your page. Your ultimate goal is to set up a relationship in which the dark and light shapes can be read as either positive or negative (Fig. 2–14).

FIGURE 2–13
DACEY VANDER WAL, University of Wisconsin at Stevens Point
Student drawing: negative areas emphasized to create a sense of interspace.
Courtesy, the artist

FIGURE 2–14
JAMIE GEISER, University of Wisconsin at Stevens Point
Student drawing: weighting and distributing dark and light shapes to create the effect of positive–negative reversal.
Charcoal on paper, 18 × 24"
Courtesy, the artist

Shape, Proportion, and Layout

In drawing from nature, you will be concerned with questions of proportion on several different levels. Perhaps foremost in your mind will be the problem of drawing your *subject* in proportion, by which we mean that you will want to observe and record correctly the relative sizes among the parts of your subject and the relationship of the parts to the whole. This problem is the focus of the first half of this chapter.

The second half of this chapter is devoted to the question of the proportional relationships *within the work of art itself*. In the most general terms, these relationships are established by how you choose to divide the two-dimensional surface of your drawing. Because these decisions are personal, they have a great impact on the expressive value of your drawing. Luckily, the same strategies for objectively observing proportion in your subject can be extended to aid you in the more subjective activity of determining the proportional relationships of your drawing as a whole.

Drawing in Proportion

Any subject you draw has proportional relationships. If the subject is a familiar one, such as a human figure, it is likely you will be able to tell when it is incorrectly drawn. In such cases, you may be able to correct the drawing using an educated guess, but in the vast majority of situations you will not have had sufficient familiarity with your subject to allow you to make intuitive judgments about its proportions.

Because artists since the Renaissance have been concerned primarily with depicting the *appearances* of their subjects, they have over time invented ways of using the picture plane to aid them in accurately measuring proportion. This chapter provides you with a number of devices, some traditional and others new, that will enable you to better judge the proportions of things as you see them.

Shape and Proportion

Take a moment and look at some common object before you. Notice the main shapes that make up the object and their proportions, or sizes relative to one another. Change your position, and you will find that those shapes have changed

right along with you. Clearly then, each time you alter your position in relation to any object other than a sphere, you will be presented with a new set of shapes and proportions. And in only a few views of a subject will the proportions of its shapes as seen correspond to that subject's *actual*, measurable proportions.

To better understand this, compare the drawing by Leonardo da Vinci (Fig. 3–1) with a painting by Andrea Mantegna (Fig. 3–2a). In the Leonardo, the

FIGURE 3–1
LEONARDO DA VINCI (1452–1519)
Drawing of ideal proportions of the human figure according to Vitruvius' 1st cent. A.D. treatise "De Architectura" (called Vitruvian Man"), ca. 1492
Accademia, Venice, Italy. © Alinari/Art Resource. New York

FIGURE 3–2a
ANDREA MANTEGNA (1431–1506)
Dead Christ
Pinacoteca di Brera, Milan, Italy.
Copyright Scala/Art Resource, New York

FIGURE 3–2b

figure is positioned so that its relative height and width may be easily judged. In the work by Mantegna, however, the relative dimensions of the shape of the figure do not match those of the subject's real dimensions, since the vertical dimension of the shape is only slightly longer than its horizontal measurement. This may be seen quickly when the human attributes of the figure are masked out, as in Figure 3–2b.

Shape and Foreshortening

When an object is situated so that its longest dimension is parallel to the picture plane, as in the Leonardo, the object is seen in its unforeshortened view. When the longest dimension of the object is at an angle to the picture plane, the object is said to be *foreshortened*. In the Mantegna, the longest dimension of the body is almost perpendicular (at a right angle) to the picture plane, making it an example of extreme foreshortening.

Leonardo's figure, comfortably circumscribed by circle and square, is not in conflict with the two-dimensional space of the page. In this case, the representation of the figure does not demand that we become involved with pictorial space. Mantegna, on the other hand, pushes this demand almost to its limit. The peculiar shape of the figure lets us know that we are seeing a body extended into space. And at the same time that we are made to acknowledge this deep fictive space, we may also become aware of the compression of the figure into a flat shape on the picture plane.

Herein lies the paradox of shape: It is in itself flat. Yet when we try to reconcile the peculiarities of its proportions with those of the object it represents, it becomes a powerful indicator of that object's spatial disposition in relation to us.

So when an image of an object is projected onto the picture plane, it becomes a shape. This shape has measurable proportions within itself. And as a unit of area on the picture plane, it may be compared in size with other shapes and with the shape of the whole page. Therefore, whenever you have difficulty seeing an object's proportions relative to itself or to its surroundings, it is helpful to ignore its three-dimensional character and concentrate instead on its shape.

Measuring with Your Pencil

Measuring with your pencil will assist you in seeing the proportions of a particular shape. To measure with your pencil, look at the shape of the object you wish to draw and decide which are the longest and the shortest of its dimensions, or axes. Then determine how many times the smaller dimension of the shape goes into its larger dimension by following the steps demonstrated in Figure 3–3.

This procedure may be used to compare any measurements in your drawing. The accuracy of the procedure depends on maintaining the pencil at a constant distance from your eyes (full arm's length is advised) and on keeping the pencil parallel to your imaginary picture plane.*

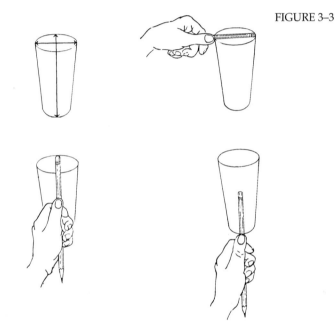

FIGURE 3–3

Using the Viewfinder to See Proportion

A viewfinder may be described simply as a framed opening through which you can view a selected portion of the visual field in front of you. More than likely, you have already had the experience of looking into the viewfinder of a camera to anticipate how your subject will look in the photograph.

When you are making a drawing, a viewfinder is helpful in selecting the exact subject you wish to draw, because the shape of the viewfinder corresponds to the shape, or format, of your drawing paper. In discussing a drawing, therefore, the word *format* is used to describe the total shape and size of the drawing surface.

You can make a viewfinder by cutting a window in a piece of lightweight cardboard. The proportions of this opening should correspond to the format of your paper. As an example, if the dimensions of your paper are eighteen inches by twenty-four inches, the ratio of the sides of the viewfinder window will be three to four, and the opening that you cut in your cardboard will be three inches by four inches (Fig. 3–4).

*See "The Picture Plane" in Chapter 1, "The Three-Dimensional Space of a Drawing."

FIGURE 3–4

You will probably find the viewfinder an invaluable aid when it comes to observing proportion, largely because it will enable you to instantly recognize the shapes inherent in your subject. This is because the (usually rectangular) opening of the viewfinder itself will impress you as a strong shape, encouraging you to readily perceive the objects seen framed within the opening as smaller shape divisions of the whole.

When using a viewfinder, imagine that its format edges match exactly the edges of your drawing paper. Then draw the shape of your subject so that it fills the page in the same way the image fills the viewfinder. It is helpful to pay special attention to the negative shapes lying between the subject's outer edge and the boundaries of the viewfinder because you may find it easier to judge the proportion of these abstract shapes than the shapes of nameable objects.

For the sake of greater accuracy, some students prefer to use a gridded viewfinder. This can be made by punching holes into the margins of the viewfinder at equal intervals and running thread from one side to the other, forming a grid. If you place the holes at one-inch intervals in a three-by-four-inch opening, you will divide the opening into twelve one-inch squares (Fig. 3–5a). To use this viewfinder effectively, you should also divide your eighteen-by-twenty-four-inch paper into twelve six-inch squares. What appears in each square of the viewfinder can then be transferred to the corresponding square on your drawing.

A simpler alternative is to divide your viewfinder into only four rectangles. This will keep you aware of how your composition is centered without requiring that you painstakingly copy exactly what you see in each square of the grid (Fig. 3–5b).

Spatial Configurations

Thus far in this chapter we have been discussing how seeing objects as flat shapes can aid you in drawing them in correct proportion. However, this process may also be applied to help you see proportional relationships between various points

FIGURE 3–5b (left)

FIGURE 3–5a (right)

in the spatial field before you. By connecting selected points on objects and surfaces distributed through a space, a distinctive shape is formed.

The best analogy to this activity is the practice of naming constellations. Constellations are actually three-dimensional configurations; in other words the stars making up a constellation are located at various distances from the earth, and the difference between these distances may be measured in thousands of light years. But we are generally unaware of the vast depth discrepancy between stellar positions in the deep space of the universe; consequently, we perceive the apparent groupings of stars as flat shapes. So when we see the shape of a big dipper or a scorpion in the night sky, we are actually seeing the *shape aspect** of a configuration of points in very deep space.

Angling and the Picture Plane

Our environment is full of horizontal and vertical lines. Linear elements from the environment that are vertical almost always appear as verticals on the picture plane. But linear elements that are horizontal (such as window sills, baseboards, and so forth) often appear as diagonals on the picture plane. To transfer the angle seen in the environment to the drawing surface, we use a technique called *angling*.

We have broken down the angling procedure into the following steps:

Step 1. Stand at about arm's length from your easel. If you are right-handed, position your easel so that you are looking at your subject past the left margin of your page.

Step 2. Face your subject. Now imagine that a pane of glass is at about arm's length in front of you. Grasping your pencil between thumb and fingers, move the pencil up and down to get the feel of this imaginary plane.

Step 3. Single out some item in the room that has a vertical line (such as a doorjamb). Still keeping your pencil pressed against the "glass," align it with the vertical line of the doorjamb. Now single out a line that is not vertical, such as one formed by the junction of the ceiling and the wall. Pivot your

*By *shape aspect*, we mean the shape of something seen from any one vantage point.

pencil on the imaginary pane so that it is lined up with that diagonal (or horizontal). Practice aligning your pencil with various linear elements in your environment, *taking care not to point through (or into) the imaginary pane of glass.*

Step 4. Station yourself at your easel. Choose one of the lines you have just practiced angling. Now swing your arm to your paper, keeping the angle of the pencil constant. Lay the pencil against the paper and draw a line parallel to it.

Step 5. Check the angle by repeating the process until the angle comes out the same each time.

A variation on the angling method is to pretend that the imaginary pane of glass in front of you is the face of a clock and that your pencil represents the hands of that clock. Grasping your pencil in the middle, hold it on a vertical—that is, six o'clock. The correct "time" for a horizontal is, you guessed it, quarter of three. When you apply this technique to angles in real space, first decide if the angle in question is closer to the vertical or the horizontal. If it is closer to the vertical, line up your pencil with the actual angle and, looking only at the top half of your pencil, determine how much before or after six that angle represents (five of six, ten after six, and so on). In the case of a horizontal, you will gauge the direction of the left half of your pencil to determine whether the actual angle is closer to two-thirty or three o'clock (twenty-five of three, or five of three, and so on). When you transfer the angle to your paper, check to see that it tells the same time as the actual angle you are drawing.

ANGLING BETWEEN SPATIAL POINTS

The method just described for angling linear elements in your subject may also be used to measure the degree of angle formed by any two points in your visual field.

First, select two easily distinguished points in the space before you (such as the corner of a table and the center of a clock). Next, angle these two points with your pencil (taking care not to point through the picture plane) and transfer that angle onto your drawing.

TRIANGULATION

Angling between a set of three points on the picture plane can be an invaluable aid in correctly positioning the overall image on your page. To triangulate, first angle between two points and then angle from these two points to locate the third.

The procedure for triangulation is shown in Figure 3–6. When you have followed this procedure, and if you have angled accurately, you will have established three widely spaced points in your drawing. You may then proceed to find other points in your picture by angling from any two points already determined.

TIPS ON TRIANGULATION

1. Always look for the largest possible triangle of points within your subject matter. The closer the points come to filling up your format, the more valuable the triangle will be in setting up the entire image.

2. Always try to find a roughly equilateral triangle. If your triangle is made of obtuse and very acute angles, any error in angling will throw off your proportions. If all legs of the triangle are about the same length, a slight miscalculation of angle will not make much difference.

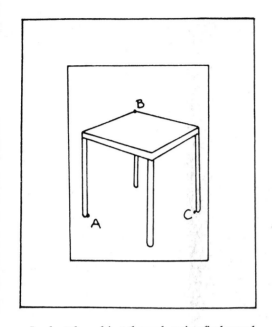

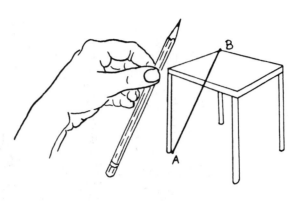

a. Look at the subject through a viewfinder and select three points that roughly form an equilateral triangle

b. Angle your pencil between A and B, record this angle, and mark the points

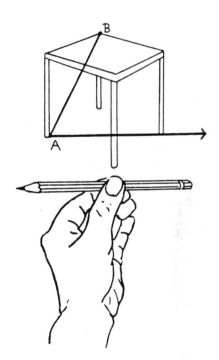

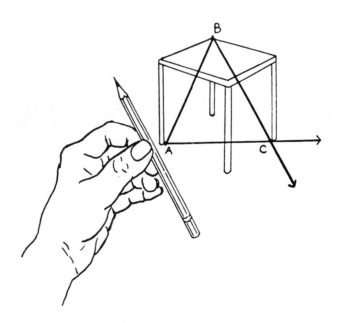

c. Now record the angle that goes from A through C. Extend the line from A beyond where you think C is located

d. Record the angle from B through C. Where this line intersects the previous one is the location of point C

FIGURE 3–6

3. If your pencil is not long enough to angle between the two desired points, you have two options: (a) find something longer to angle with, such as a ruler or yardstick; or (b) hold the pencil closer to your eyes.

4. If you have great difficulty picking up the technique of angling, try using the edge of a broad ruler or plastic triangle in lieu of a pencil. The plane of the ruler or triangle will remind you where your picture plane is so that you will have less of a tendency to point through it.

Advice on the Use of Proportioning Techniques

All the devices introduced in this chapter require that you make conscious use of shape and the picture plane to arrive at correct proportions. In many circumstances, the viewfinder will be the first proportioning device to which you will turn. Not only can it help you to select that part of your subject that you wish to draw, but its use will enable you to quickly lay out the overall proportions of your subject on your page. With the information you gather from observing the way in which the shape of objects fill up the opening of your viewfinder, you will be able to sketch in the skeletal structure of your drawing before concerning yourself with any fixed measurement.

Your second choice should be triangulation, the method used to fix the larger relationships between spatial points. It is a speedy and accurate way to proportion the overall image of your drawing. For more localized measurements, you may use the techniques of angling and measuring with your pencil.

Measuring with your pencil on the picture plane will give you a sense of the proportions of any individual shape you see and may also be used to determine the relative dimensions of separate shapes.

Although an overdependence on these mechanical devices can result in drawings that look stilted, the procedures described are beneficial beyond their immediate use for plotting proportions more accurately. First, they sensitize you to the presence of the picture plane. Second, these techniques will, through repeated use, become internalized, so that eventually you will begin to see shape relationships without actually having to go through the motions of angling, measuring, and so forth.

And anytime you are perplexed because a subject is unusual or overwhelming, you may be helped by recourse to one or more of these proportioning devices.

Exercise 3A

Drawing 1. This drawing will help you understand how the viewfinder may be used as a proportioning device for drawing complex subjects. Choose or set up a subject such as a large still life or a couple of live models in such a way as to yield an interplay of positive and negative spaces. Looking through your viewfinder, scan your subject until you find a good balance of positive and negative spaces. Do a series of quick studies that record the size, position, and shape of those spaces (Fig. 3–7).

Drawing 2. In this drawing you will be using triangulation to measure the relationship of points in your visual field.

Look for three widely spaced points in your visual field and triangulate between them. Remember that the three points that compose the corners of your triangle do not need to belong to the same object or be on the same plane, as illustrated in the example in Figure 3–8, in which the lowest rib and toe of one model are connected by triangulation with the groin of the second model, located closer to the viewer. Note also in this example that the student has combined triangulation with the use of a viewfinder, a practice that assists in determining the widest possible spacing of points.

FIGURE 3–7
Student drawing: image made
with the assistance of a viewfinder
Charcoal pencil

Laying Out Your Drawing

The basic arrangement of the parts of an image within a two-dimensional format is referred to as the *layout* of a drawing. Before you lay out the basic blueprint of your drawing, however, it is crucial that you spend some time considering the visual and expressive potential of your subject.

EXPLORING THE VISUAL POTENTIAL OF YOUR SUBJECT

Because almost any subject you choose to draw will yield a variety of shapes when regarded from different points of view, it is generally advisable to explore your subject's visual potential before you begin to lay out your drawing. Spend some time moving around your subject, sizing it up from various vantage points and generally experiencing how different orientations provide different visual aspects of the same source material.

FIGURE 3–8
JENNIFER O'DONOGUE,
Cochise College, AZ
Student drawing: proportion
achieved with the combined
assistance of viewfinder and
triangulation
Charcoal pencil
Courtesy, the artist

Avoid the all-too-common practice of taking the same seat or easel each time you enter the classroom and then remaining there as if anchored. On the face of it, this practice may seem harmless enough, but it amounts to allowing chance to determine what you will draw.

So as a beginner, you must consciously take the initiative to find a meaningful approach to your subject matter. And remember that the drawing process really begins as you look at your subject to see and weigh the aesthetic possibilities it offers. This process of personal exploration is vital because you will gain a sense of control over what may be a complex situation; your ambitions for your drawing will be more clearly formulated; and you will feel that whatever point of view you ultimately take is one you have chosen for its expressive potential.

PROPORTION AND LAYOUT

Until now we have been discussing proportion in terms of correctly observing and recording the size relationships within your subject. However, proportion is also an issue when you as an artist must decide how best to subdivide the surface area of your drawing.

Artists usually lay out, or sketch in, the major shape divisions of their drawing before working on any one area. But even before you put down the first mark, you are faced with the overall proportional relationship of your drawing surface, namely, the ratio of its length to its width. In standard drawing pads, the ratio of length to width is often three to four. But you do not have to accept the ratio dictated by the manufacturers of your pad. If you wish a particular drawing to have a square format (or a circular, triangular, or cruciform format, for that matter) you

can either cut your paper to the desired shape or even more simply, draw the new format border within the paper you have at hand.

Before you begin to draw you should also decide how to turn your pad so that it is best suited for drawing your subject. Because the standard pad is usually bound along one of its smaller sides, many students automatically set the pad with the bound side uppermost, so that the paper will not flop over. When the pad is in this position, with its longer dimension vertical, the format is called a *vertical format*. Turn the pad ninety degrees and you have a *horizontal format*. (If you customarily stand your pad at a bench or easel and wish to leave your paper in the pad while using a horizontal format, you can use clips to keep the paper from falling forward.)

SCALING THE IMAGE TO THE FORMAT

A major consideration of layout and proportion is how large you should draw a subject in relation to the page.

Some students draw a subject so large that it will not fit comfortably on their paper. But a far more common problem, especially for beginners, is that of drawing a subject so small that it resembles an island floating in the middle of the page. Aside from looking timid, such drawings suffer from a lack of illusionistic depth, since the drawn image in this case reads as a single figure in an unspecified ground. And the overall surfaces of these drawings remain visually inactive, as there is little or no tension between the drawn image and the edges of the format.

The process of adjusting the size of what you draw to the size of your page is called "scaling the image to the format." If you have difficulty scaling the image to your format, consider using the proportioning devices introduced earlier in this chapter.

When using triangulation as an aid in scaling your image to the format, choose three points from your subject which form an approximate equilateral triangle and then transfer them to your paper as described in the section on triangulation. To fill your format, locate these points as close to the edges of the format as possible.

By adjusting the distance at which you hold your viewfinder (anywhere from a couple of inches from your face to full arm's length) you can view a subject at various sizes in relation to the format. If the viewfinder is held very close, the subject may appear to dwindle in relation to the space around it; at half arm's length, it may appear to push insistently against the edges of the format, and at full arm's length you may observe only details of the object. The experience of changing the distance at which your viewfinder is held is akin to manipulating a zoom lens on a camera.

USING THE VIEWFINDER TO INFLUENCE LAYOUT

Scaling the image so as to most expressively utilize your format is just one of the major considerations related to the larger issue of the layout of your drawing. Another major consideration is the placement of the various parts of your subject in relation to the edges of your format. Just as the viewfinder is perhaps the single most helpful proportioning device for scaling your image to your format, so too will its use make you almost instantly aware of the range of possibilities for the placement of the image on the page.

Before you begin to draw, try studying your subject for a few moments through the viewfinder, not only holding the viewfinder at different distances from your eyes but also shifting it vertically and laterally so that you can see different areas of your subject in relation to a format. Note that when you can focus on details, some of the objects may not be seen in their entirety. This tends to make those objects less recognizable and therefore more easily perceived as abstract shapes.

FIGURE 3–9

Figure 3–9 shows different views of a subject as they might be discovered by experimentation with a viewfinder.

Tips on Selecting a Vantage Point

Generally, a subject seen in a foreshortened view will appear to engage space more actively than it will in an unforeshortened view. To demonstrate this, compare a drawing of a bicycle by Alan Dworkowitz (Fig. 3–10) with a catalog illustration of the same subject (Fig. 3–11).

Both drawings may be considered realistic in that they depict the subject in a fair amount of clear and precise detail. There are, however, some fundamental differences between the two. The catalog illustration presents the bicycle in an unforeshortened view so that the potential consumer may see at a glance the various

FIGURE 3–10
ALAN DWORKOWITZ
Bicycle II, 1977
Graphite, 20 × 18"
Courtesy, Louis K. Meisel Gallery, New York

FIGURE 3–11
Bicycle advertisement
Courtesy of Kuwahara USA and Everything Bicycles, Compton, California

components and accessories this model has to offer. Correspondingly, the illustration avoids a unique vantage point because any part of the presentation that calls attention to itself would detract from the primary intent of the drawing: to sell bicycles.

On the other hand, the intent of Dworkowitz's drawing is not to saturate us with facts but rather to captivate us *visually*. Depicted from a much less expected vantage point, the foreshortened frame of the bicycle enters the illusory space of the drawing in a very aggressive way. With the handlebars and front wheel turned out to the right-hand margin of the page, we may sense an invitation to mount the bicycle, straighten the wheel, and go off touring countrysides.

Tips on Laying Out Your Image

In Figures 3–10 and 3–11 we saw very different treatments of a bicycle in space. A further comparison will show how differently these two images have been laid out on the page. In both drawings, the bicycle is featured as a single isolated figure. But in the catalog illustration, the entire bicycle is depicted and there is no boundary between the picture space of the illustration and the printed part of the page. For the purposes of the illustrator, the ground has no character in its own right; it does not imply space, nor does it have any limits that define it as a shape.

In contrast, the drawing by Dworkowitz is made visually exciting by its layout. How the image is laid out is as important as its depicted spatial disposition and precise detail. The fact that the image is cut off so that we see only the front half of the bicycle directs our attention to the space beyond. The empty ground here is dramatically contained; like an empty stage, it anticipates action.

You can see, therefore, that while you are examining the subject from various angles, you should at the same time be thinking about how you are going to lay out that subject on your paper. Even when you are concerned primarily with the spatial aspect of your subject, the expressive potential of your page as a flat surface with a particular shape must be reckoned with. The flat piece of paper is all the two-dimensional space allotted to you for your statement; therefore, you should make the greatest possible use of it. If you respond fully to the presence of the drawing's entire surface, all the areas, positive and negative, will have meaning, as in the student drawing in Figure 3–12.

As this chapter suggests, such seemingly mechanical decisions about where to sit, which way to hold your pad, and the format to use are actually the underpinnings of your drawing's expression. This project is designed to guide you through these early stages of making a drawing, helping you to understand their sequence and their importance.

Exercise 3B

FIGURE 3–12
Student drawing: effective
subdivisions of the drawing's
surface into positive and negative
areas

Drawing 1. *Choose a subject that is visually diverse and also allows you to view it from a number of angles. Next, with viewfinder in hand move around your subject, carefully considering its visual potential from different vantage points. Narrow down your options and make a set of studies.*

Begin your studies by loosely (gesturally) describing your subject. Take into account the scale of the entire image in relation to its format and how the flat surface of your drawing is being laid out, or subdivided, into positive and negative zones (Fig. 3–13).

FIGURE 3–13
JACK LONG, Rhode Island School
of Design
Student drawing: layout study
Courtesy, the artist

FIGURE 3–14
ANGELA BURCH TINGLE,
Oklahoma State University
Student drawing: four studies,
two of which introduce
improvisation Pencil, 18 × 24"
Courtesy, the artist

Drawing 2. *Once you have become accustomed to the process of selecting portions of your visual field for their design potential, you might try improvising on what you see within your viewfinder. Look at the student drawing in Figure 3–14. In the left-hand side of the page, the student has started with some fairly straightforward details of a clothespin. In the remaining frames, she has let her imagination take control, bending the forms in space and repeating them out of scale.*

4

The Interaction of Drawing and Design

In previous chapters, we established the concept of the flat picture plane. This chapter enlarges on that discussion and in the process confirms that responses to two-dimensional organization are integral to the practice of expressive drawing, representational or otherwise.

Drawing and Design: A Natural Union

Design, on some level, plays a part in our everyday existence. But much of the order in our lives is taken for granted, from the simple matter of organizing daily routines to managing the more complex forces of, let us say, career and home life into a state of equilibrium.

Indeed, design is such a natural part of our consciousness that when we witness something that is superbly organized—as, for instance, the consummate execution of a double play in baseball—we recognize immediately how wonderfully all the parts had to fit together for that to happen. We are thrilled, and it feels good to witness something so well realized, perhaps because the order in our own lives seldom reaches that pitch of resolution.

In drawing, as in all the arts, design is just as natural and ever-present. In fact, you cannot draw *without* designing. Science revealed decades ago that visual perception itself is an automatic process of selecting and making patterns. This means that when we look at things our eyes and mind begin immediately organizing visual differences and similarities so that we might create order out of potential chaos.

So when you draw to represent your subject, you are simultaneously recording sensations of perceived order. By this we don't mean to imply that you will necessarily create well-designed drawings from the outset of your drawing practice but only that there is no mystery connected with the qualities of design; they are simply a part of common experience.

Principles of Design

When transferred to the art-making process, these qualities of order are generally referred to as the principles of design. They are given names such as *unity* and *variety, contrast, emphasis, balance, movement, repetition* and *rhythm*, and *economy*.

The principles of design are used by artists to organize the so-called *visual elements* (lines, tones, shapes, textures, and colors) into a unified drawing.

Distinguishing these design phenomena by name may give the impression that they can be set apart from one another and given fixed definitions. On the contrary, they are frequently inseparable and seemingly unlimited in their interactions. Thus, the descriptions below must, of necessity, be neither final nor precise. These summaries are offered only as a set of guidelines to reinforce what you will quite naturally discover on your own.

UNITY AND VARIETY

Imagine, if you will, a country with a population so diverse that it suffers from internal dissension. Its leaders, recognizing that such discord makes the nation vulnerable, look for ways to encourage unity, or a state of oneness, so that the nation's people may stand consolidated against external aggression.

The process of drawing is in many ways the same. A blank sheet of drawing paper, before you put a mark on it, is a totality. Make a mark and you have interrupted its unity of surface—and thereby created tension. Adding more marks increases the potential for variety, or difference, while also causing areas of potential agreement, or similarity, to emerge. Your goal when drawing is to find ways to harmonize the conflict of varied forces by building on those areas of agreement so that a sense of unity may be restored.

Thus, we may say that the major polarities in a work of art are unity and variety. Unity underlies a work's impact as a complete event; variety is the agent that enlivens a work and sustains interest. In this regard, look at Figures 4–1 and 4–2. Both are complete visual statements, and yet each in its own way has sufficient variety to leaven the experience. The variations in *Short Schedule* (Fig. 4–1) consist essentially of subtle modifications among the nail groupings; in comparison, the multiple images in Figure 4–2 differ more distinctly in their tonal and textural combinations.

FIGURE 4–1
JAMES ROSENQUIST
Short Schedule, 1972
Pencil, charcoal, pastel, 30 × 40"
© James Rosenquist/Licensed by VAGA, New York, NY

FIGURE 4–2
R. B. KITAJ (b. 1932)
Untitled: Cover of the Times Literary Supplement, 1963.
Cut and pasted paper, charcoal and pencil 15 × 10¾"

© Copyright of the Artist. John B. Turner Fund. The Museum of Modern Art, New York, NY, USA. Digital Image © The Museum of Modern Art/Licensed by SCALA/Art Resource, NY (414.1969)

CONTRAST

When aspects of variety in a drawing become more emphatic, contrast is the result. Contrast may refer to pronounced differences in, for example, scale, lights and darks, shape, handling of media, and activity (busy versus quiet).

In the drawing by Lee Bontecou (Fig. 4–3), look at the startling tonal contrasts and also how rounded masses are poised against larger stretches of flat, unbroken shape. As often happens when contrasts are this extreme, the areas in

FIGURE 4–3
LEE BONTECOU
Untitled, 1967
Pencil, ink on paper, 20 × 26"
Courtesy, Leo Castelli Gallery

FIGURE 4–4
CHARLES SHEELER
Interior, Bucks County Barn, 1932
Crayon on paper.
Board 20¼" × 24¼" (51.4 × 61.6 cm),
Image 15" × 18¹⁵⁄₁₆"
Whitney Museum of American Art,
New York; purchase 33.78

conflict animate each other. They form a relationship based on an attraction of opposites that intensifies their respective differences and helps to bind the drawing together.

EMPHASIS

Levels of emphasis in a drawing are achieved through aesthetic handling (giving certain areas more contrast or a prominent texture, for example) or through the unusual placement or scale of selected lines, tones, or shapes. In Figure 4–4, the silhouetted carriage acts as a focal point due to its stark value contrast, placement (just off-center), the slot-like shape of light, and the relative visual calm surrounding the canopy top. Emphasis in this area is reinforced by the series of squares that frame the carriage; the rhythms of their subtly varying axes help move the eye from the center of interest to the drawing's overall compositional architecture.

Without emphasis, the visual clues needed to establish the artist's expressive priorities would be absent. Emphasis assists viewer perception by calling attention to significant parts of a drawing. And by placing the elements in dominant and subordinate roles, emphasis lends a hierarchical structure to a drawing and thereby advances unity.

BALANCE

Balance refers to a sense of equilibrium among all parts of a drawing. Typically, drawings are organized on the basis of either symmetrical or asymmetrical balance. The term *symmetrical balance* applies to an image that is divided into virtually mirrorlike halves. Perfect symmetry imparts a formal bearing and is therefore usually reserved for works that are emblematic in character (Fig. 4–5). Many artists who wish to reap the unity that symmetry provides but avoid the ceremonious quality often attached to perfect symmetry employ instead what is sometimes referred to as *near,* or *approximate, symmetry* (Fig. 4–6).

FIGURE 4–5
CHARLES STIVEN
Do Opposites Attract?
Charcoal and conté pencil on
paper, 48 × 72"
Courtesy, the artist

FIGURE 4–6
JOHN VIRTUE
No. 32 1985–86. Ink on paper on
hard board mounted on wood,
50 × 56'"
Courtesy of Lisson Gallery, London

Ordinarily, though, your working drawings will exhibit a diversity of image characteristics—that is, different shapes, tones, textures, sizes, directions, and so forth—unevenly distributed across the picture plane. In this case you will want to use "asymmetrical balance." *Asymmetrical balance* entails adjusting the "visual weights" of what you draw (*visual weight* refers to how much an area attracts the eye) to bring these contrasting forces of your drawing into a state of equilibrium. For example, avoid clustering large, complex events on one side of your page without establishing areas on the other side that, although dissimilar in their visual impact, serve as a counterbalance. In Figure 4–7, for instance, note the

FIGURE 4–7
ANDREW WYETH
*The Bed, Study for Chambered
Nautilus,* 1956
Pencil on paper
*Private collection. © Andrew Wyeth. Courtesy
Brandywine River Museum*

prominent gesture to the left of the drawing that has its visual climax in the derailed basket and its shadow. This cantilevered weight is balanced by the intersecting forces of the dark, vertical bedpost and the diagonal, scrunched bedspread.

MOVEMENT

When selected lines, tones, and shapes are given emphasis in a drawing, they will often imply direction. These separate directions should be organized into a pattern of movement to fluidly guide the viewer's eye across the entire two-dimensional space of the drawing.

Look at Figure 4–8. Although there is a central focal point in this drawing, the artist has not allowed our eyes to remain idle. We are swept around the surface by a series of curves and opposing diagonals, which are given momentum by changing line weights and clusters of shaded, smaller shapes.

REPETITION AND RHYTHM

Artists often repeat similar shapes, lines, tones, textures, and movements to create organizational relationships in their drawings. Repeated elements do not have to reproduce each other exactly, nor must they always appear in an altogether obvious manner. In Figure 4–9, for example, the figure X on the horizon (representing a windmill) is echoed by a larger X in the foreground that is embedded in the landscape, as is made evident in Figure 4–10. This subtle use of pictorial repetition helps to unify both the two-dimensional and the illusory three-dimensional space of the drawing.

When a visual element, such as a line, shape, or unit of texture, is repeated often enough to make it a major unifying feature in a drawing, it creates what is referred to as a *motif*. In this regard, note the elliptical forms that populate Figure 4–11 in the guises of anatomical features, still-life objects, a light fixture, and a half mirror, the arcing shape of which is completed inside the figure. If a particular unit of a drawing is repeated extensively, a marked pattern will result. When a drawing is largely constituted of such a pattern, sufficient variation should occur

FIGURE 4–8
PIRANESI
Capriccio
*© The Pierpont Morgan Library, Art
Resource, New York (1966.11:19)*

FIGURE 4–9
EMIL NOLDE
Landscape with Windmill
Brush and black printer's ink on
tan paper, 17 ½ × 23 ¼"
*Private collection. © Nolde-Stiftung Seebull.
Reprinted by permission*

to avoid visual boredom. In Figure 4–12, two strong motifs create contrasting patterns that enliven the surface of the drawing.

Rhythm is based on the measured repetition of features in a drawing. The more these related elements are stressed, especially if the accents and visual pace (or tempo) are varied, the more pronounced the rhythm will be in a work of art. Look, for example, at Figure 4–13, in which both the similar movements of the tree trunks and the intervals of negative space between them are charged with an alternation of stronger and weaker accents.

Rhythm can also be used to invest an otherwise uniform pattern with a sense of pulse. In René Magritte's *The Thought Which Sees* (Fig. 4–14), the delicate tonal changes in the marks create a unified surface that optically vibrates. This

FIGURE 4–10

FIGURE 4–11
LUIZ JIMENEZ
Abuela, 1997
Lithograph, edition 100, 48 × 35½"
Courtesy, ACA Galleries, New York
© 2003 Luis Jimenez/Artists Rights Society
(ARS), New York

FIGURE 4–12
JACK BEAL
Fat Landscape, 1967
Charcoal with stamping on ivory
card paper, 501 mm × 650 mm
Photo courtesy of George Adams Gallery,
New York. Collection: The Art Institute of
Chicago (1968.42).

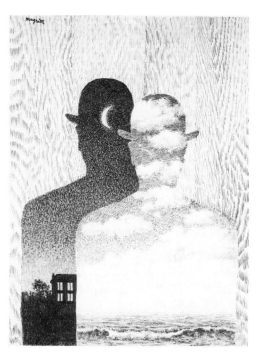

FIGURE 4–13
BILL RICHARDS
Fern Swamp, 1974
Graphite on paper, 17 × 21½"
Courtesy, Nancy Hoffman Gallery, New York

FIGURE 4–14
RENÉ MAGRITTE (1898–1967)
The Thought Which Sees, 1965
Graphite on paper, 15¾ × 11¾"
*The Museum of Modern Art, New York.
Digital Image © The Museum of Modern
Art/Licensed by SCALA/Art Resource, NY.
Gift of Mr. and Mrs. Charles B. Benenson.
© 2003 C. Herscovici, Brussels/Artists Rights
Society (ARS), New York (261.1966)*

work is also a prime example of how organizational properties in a drawing can extend meaning: The meter of the finely woven pattern of marks recalls the hypnotic rhythms of the depicted waves and rolling clouds.

ECONOMY

From time to time, you may find a drawing you are working on is too complicated and, as a result, appears disorganized. In that case, it will be important for you to rework certain aspects of the drawing, strengthening latent areas of similarity and eliminating nonessential areas of difference. By this means, you will clarify relationships so that a simpler arrangement is achieved, thus imparting to your drawing an economy of expression. Economy is not based on limiting the number of things portrayed, however. Instead it depends on each part of a work contributing to a larger system of order, as in Figure 4–15. In this drawing the visual chaos in the wake of a tornado has been organized into distinct passages, based on arrangements of tone, scale, and pattern. Note how the jumble of dissimilar forms in the center foreground along with the overturned Shasta trailer may be regarded as a single, consolidated shape occupying roughly the middle of the picture.

Exercise 4A *Here are three simple exercises that will provide countless hours of challenging drawing in your sketchbook.*

Drawing 1. *Choose a subject that clearly exhibits a particular design principle. A landscape, for example, may be perceived as having asymmetrical balance, and ivy growing on a wall may demonstrate the concept of pattern. Carefully observe and draw your subject, paying special attention to its particular design implications and how they may be extended. Refer to the drawing of a piano (Fig. 4–16), in which the contrast between large and small parts is emphasized.*

FIGURE 4–15
SCOTT WHITE
Shasta, 1999
Oil on canvas, 97 × 67.5"
Courtesy, the artist

FIGURE 4–16
CHEREEN TANNER, Arizona State
University
Student drawing: contrasting size
relationships as an organizing
device
Charcoal, 18 × 24"
Courtesy, the artist

Drawing 2. *Choose a common object as the source of a motif for your drawing. Repeat the object, or selected parts of it, across your paper. Provide some variety by, for instance, turning the object over to depict its other side, as in Figure 4–17, or overlapping some of the images. Alternatively, you may wish to draw your objects in different visual guises, that is, change their scale, clarity, positive—negative status, and so forth. Or perhaps as the drawing proceeds, you may wish to place more emphasis on certain areas to establish a center of interest and also to develop paths of movement to guide the eye through your drawing.*

FIGURE 4–17
GREGORY BOAS, Pratt Institute
Student drawing: peanut motif
4 × 4'
Courtesy, the artist

Drawing 3. *The goal of this drawing is to combine two or more design ideas without sacrificing either unity or variety. In Figure 4–18, the generally globular shape of the vegetables constitutes a unifying motif, a unity that is strengthened by the near-symmetrical arrangement. But note how the linear stalks of the beet top provide a strong contrast to the relatively broad, gleaming sides of the eggplant.*

Gesture Drawing as a Means to Design

In Chapter 1, "The Three-Dimensional Space of a Drawing," gesture drawing was presented as the primary way for artists to grasp the essential visual character of an object or a space. But a gesture drawing may also serve as the foundation, or "rough," for the more sustained development of a particular image.

At times, artists will divide a page into several formats to test, in a sort of gestural "shorthand," how a subject may best be laid out in preparation for a sustained work (Fig. 4–19).

But just as frequently, marks from gestural explorations serve as the underpinning for a work in progress and so are not apparent in the finished product. The gestural spirit of search and discovery remains embedded, however, in the naturalness with which the subject has been represented.

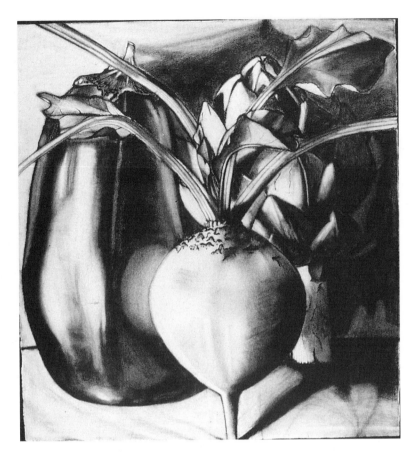

FIGURE 4–18
MARCIA SMARTT, Middle Tennessee
State University
Student drawing: still life
combining motif, contrast, and
repetition of forms
Charcoal, 28 × 22"
Courtesy, the artist

A particularly illuminating example of this may be found in Figure 4–20. In this drawing, Giacometti, the twentieth-century Swiss artist, has penetrated below the surface detail of a section of a fifteenth-century painting by Hubert and Jan van Eyck (Fig. 4–21) to expose the work's latent gestural energy and structural conviction.

The Giacometti is thrilling to look at not only because it is a beautiful drawing in its own right but also because it functions as a sort of x-ray, interpreting for the onlooker what takes place inside another work of art. This latter point is especially significant for us, since it suggests that artists may use gesture drawing as a tool to diagnose the basic state of their *own* works in progress. Let us suppose, for example, that after a drawing is well under way you decide that parts of your image are lacking in structure or that the overall design is in some way deficient. In response, you might very well make gestural studies on separate sheets of paper so as to analyze these shortcomings prior to resolving them in the actual work.

Giacometti's interpretive drawing has another far-reaching implication for the drawing student. You will notice that he deliberately made a format border to enclose the excerpt of the Ghent altarpiece he chose to draw. His awareness of the rectangular shape within which to conduct his search suggests that gestural activity may be intimately linked with the design conception of a drawing.

In fact, we may say that design in a drawing is often initiated when gestural responses to a subject are laid out and scaled to the limits of the drawing's format. Barlach's gestural study (Fig. 4–22) has admirably taken into account the overall proportions and rudimentary structural properties of this running figure. But what interests us most here is the way in which the figure's extension into space coincides with the paper's edge. This is significant because, while Barlach took

FIGURE 4–19
MAX BECKMANN
Study for the Night
Pen and ink

Allan Frumkin Collection of Prints by Max Beckmann. Photograph © 2003 Artists Rights Society (ARS), New York/VG Bild-Kunst, Bonn

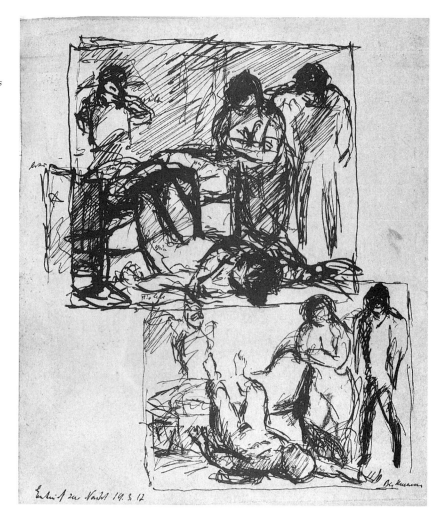

FIGURE 4–20
ALBERTO GIACOMETTI
Landscape
Pen on paper
© 2003 Artists Rights Society (ARS), New York/ADAGP, Paris

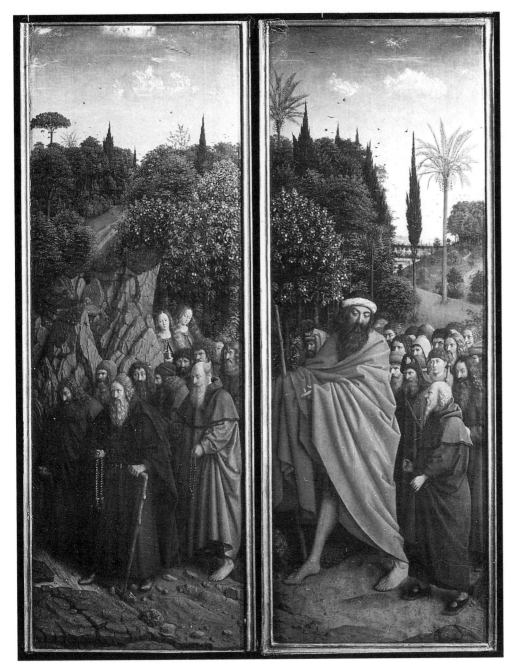

FIGURE 4–21
HUBERT AND JAN VAN EYCK
"The Adoration of the Mystic
Lamb," detail of *The Ghent
Altarpiece*, front right-hand
panels, 1432
Tempera and oil on wood
Giraudon, Art Resource, New York

visual possession of the man's image, he simultaneously took physical possession of his drawing surface.

This simultaneous seizing of the gesture of the subject along with the total engagement of the picture's surface is typical of gesture drawing at its best. In the heat of the moment, the artist's own eye and arm generalize the expressive attitudes and organization of parts that are characteristic of the subject. At the same time, the artist is intuitively aware of how the placement and directional energies of the emerging image relate to the rectangular page on which it is drawn. While in the act of drawing, the edges of the drawing constitute the boundaries of the artist's visually created world, so the artist feels the necessity of making the image within those bounds as absolutely real and immediate as possible. Consequently, we are often excited when looking at a gesture drawing, at seeing so much energy packed into a small, flat space. This principle applies even to the drawing of nonobjective images, as may be seen in the gestural study by sculptor

FIGURE 4–22
ERNST BARLACH
Running Man, 1918
Charcoal on white drawing paper,
22.8 × 30 cm

*Schult III, 1296. © Ernst Barlach
Lizenzverwaltung Ratzeburg, Hamburg,
Germany. Photo: Thormann*

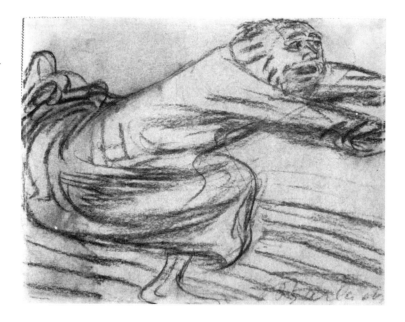

Richard Serra (Fig. 4–23), in which a quadrilateral form has been dramatically represented.

Beginners often start with single objects to get the feel of gesture drawing and its design implications (Fig. 4–24). But the gestural approach is equally appropriate for subjects comprised of multiple objects, such as still lifes, interiors (Fig. 4–25), and landscapes (Fig. 4–26). Drawing multiple objects challenges the artist to empathize with the unique gestural expression of each part of a subject. And as individual gestures are realized, the artist must be alert to correspondences that emerge between areas, since they will suggest larger gestural patterns, which may in turn point to options for organizing the drawing overall.

Look, for example, at *The Farm* (Fig. 4–27) by John Bennett. Each area has its own kind of gestural shorthand, producing a work that is fresh and altogether unstudied in expression. But as an outgrowth of its spontaneity, the trailing lines from each major division of the page create a zigzagging pattern that purposely binds together the spatial illusion and surface design of this drawing.

FIGURE 4–23
RICHARD SERRA
Zonder Titel

*Rijksmuseum Kröller-Müller, Amsterdam,
The Netherlands. © 2003 Richard
Serra/Artists Rights Society (ARS), New York*

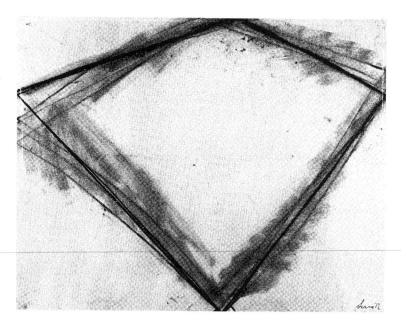

FIGURE 4–24
CRYSTAL BRAY, Arizona State
University
Student drawing: gesture drawing
of a single object
Charcoal, 18 × 24"
Courtesy, the artist

FIGURE 4–25
EDGAR DEGAS
Study for Interior
Pencil
Bibliothèque Nationale, Paris

It is interesting to see how the drawing by Gaspar van Wittel (Fig. 4–28) retains a similar gestural freshness. In this work, the slashing marks and abruptly brushed areas of wash summarize the major spatial planes. At the same time, they describe the edges of a mountain range, cuts in the landscape, and the underside of a mass of vegetation that advances toward the picture plane. But much as with Bennett's drawing, these same marks are also the agents of an inventive design strategy in which positive and negative zones are melded into a cohesive unit.

To clarify this last point, compare Figure 4–28 with Figure 4–29. Note that van Wittel divided his page into three major areas, and also see how he grouped the dominant dark masses into a tilted, rectangular shape that rests on the bottom edge of the drawing, poised, it would seem, to move into spectator space.

FIGURE 4–26
FRANK AUERBACH
Study for Mornington Crescent, 1967
Pencil, 9⅞ × 11¾"
Private Collection, New York

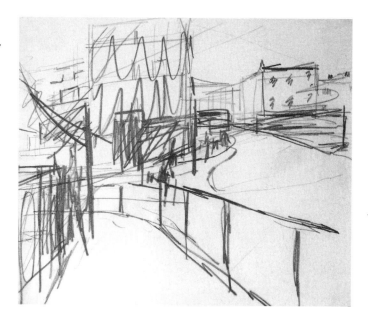

FIGURE 4–27
JOHN BENNETT
The Farm, 1981
Pencil, 9 × 6"
Courtesy, the artist

Exercise 4B *These two projects will urge you toward a more gestural conception in your work.*

Drawing 1. Using an interior as your subject, choose a viewpoint that offers a dynamic spatial movement. Taking a broad medium, such as lecturer's chalk or a good-sized brush charged with ink or paint, gesturally summarize the space of the room and the spatial points represented by objects, while at the same time taking possession of the entire drawing format (Fig. 4–30).

FIGURE 4–28
GASPAR VAN WITTEL
View of Tivoli, 1700–1710
Pen and brown ink
Courtesy, Courtauld Institute Gallery,
Somerset House, London

FIGURE 4–29

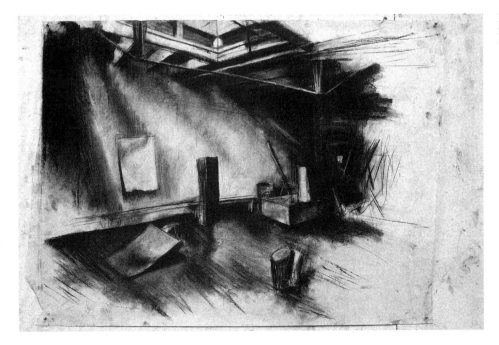

FIGURE 4–30
Student drawing: gesture drawing
used as a means to design

Drawing 2. Once again, draw from an observed subject, gesturally recording its major axes and spatial movements. Be sure to draw the image large enough so that your gestural marks are also responsive to the two-dimensional area of your paper.

 Finish your drawing, developing its design implications but without losing the spontaneous character of your initial gesture drawing (Fig. 4–31).

FIGURE 4–31
ANDREA HAGY, College of William and Mary
Student drawing: sustained gesture
Courtesy, the artist

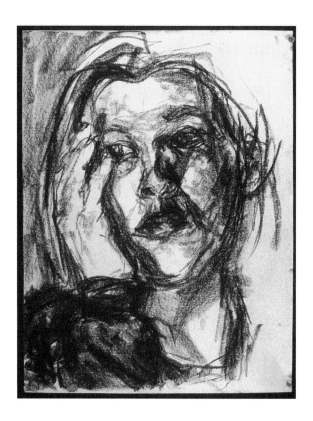

Linear Perspective

Because linear perspective has the aura of a technical subject, many students think it is difficult to understand. But while perspectival systems involving complex mechanical procedures have been developed for people who do technical drafting (such as architects, designers, and engineers), the basic concepts behind linear perspective are few and simple, and therefore easily within the grasp even of those who are not technically minded.

Point of View

In its broadest sense, perspective drawing refers to the representation of things as they are arranged in space and as they are seen from a *single point of view*. Therefore, what is central to the issue of drawing in perspective (whether we are employing linear or atmospheric perspective)* is the concept of the artist's bodily position in relation to the things represented.

When looking at a drawing or painting, we tend to identify with the implied point of view; that is, we instinctively know whether the artist was looking up, down, or straight ahead at the subject. In the drawing by Henry Schnakenberg (Fig. 5–1), for instance, there is no doubt about the artist's viewpoint. In consequence, our own inferred position is consistent and clear, perched as we are above this forest floor covered with leaves and needles.

Because a fixed viewpoint in a picture helps establish a convincing illusion of space, it is generally recommended that aspiring artists understand how to achieve a fixed viewpoint in their work. It is important to recognize, however, that an artist's choice to develop a consistent viewpoint in a particular work depends on the demands of subject matter and expression. In this regard, let us compare two works.

The multiple points of view in Mstislav Dobuzinskij's drawing (Fig. 5–2) serve to disorient the viewer and reinforce the work's phantasmagorical quality.

*See Chapter 1, "The Three-Dimensional Space of a Drawing," for a discussion of atmospheric perspective.

FIGURE 5–1
HENRY SCHNAKENBERG
Forest Carpet, 1924
Watercolor, 11¾ × 15¾"

*Collection of the Whitney Museum of
American Art, New York Photographer
Geoffrey Clements. (31.463)*

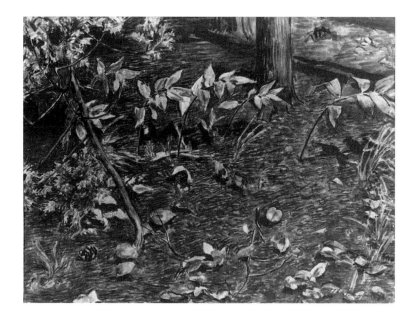

FIGURE 5–2
MSTISLAV VALERIANOVIC
DOBUZINSKIJ
The End, ca. 1918–1921
Brush and black and gray wash
with charcoal and graphite on
ivory wove paper laid down on
cream wood-pulp laminate board,
61.5 × 45.5 cm

*Tillie C. Cohn Fund. Photograph © 1994,
The Art Institute of Chicago (1968.465).
All Rights Reserved*

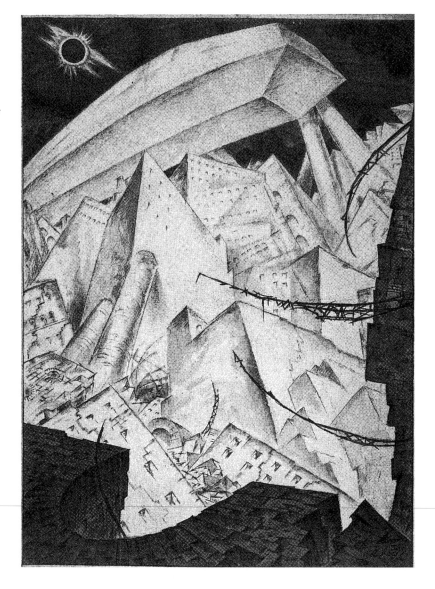

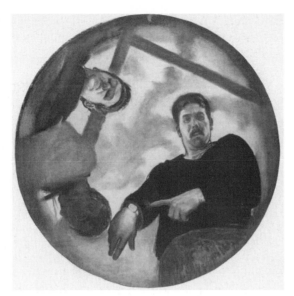

FIGURE 5–3
VINCENT DESIDERIO
Untitled (one of a series of four drawings dedicated to Salvador Allende), 1985
Charcoal on paper, 50" (diameter)
© 1994 Vincent Desiderio/Licensed by VAGA, New York. Courtesy, Marlborough Gallery, New York

On the other hand, the untitled drawing by Vincent Desiderio (Fig. 5–3) elicits a strong response from the viewer due to its unconventional, yet thoroughly consistent, point of view.

THE CONE OF VISION

To better understand the three-dimensional character of things you see, think of your field of vision as a conical volume whose apex is located at your eyes. Since this cone extends as far as you can see, there is no fixed or actual base to the cone, but when you imagine a picture plane (window on nature) intersecting this cone, its base lies within the plane (Fig. 5–4a).

Let us take a moment to investigate the cone of vision. If you were to lift your eyes from this book and look across the room, or better yet, out a window, you would note that your eyes can take in the entire image of something large when it is a fair distance away. For instance, you would be able to see the full image of a medium-sized building at a single glance if it were across the street from you. Something much smaller and yet far closer, such as this book held broadside against your nose, however, could more than fill up your cone of vision. This little experiment should make you more conscious that what we think of as a field of vision is actually a conical volume.

FIGURE 5–4

(a)
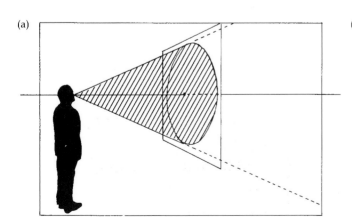

(b)
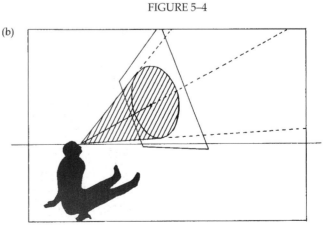

If you tilt your head back to look up, the cone of vision will be angled away from the ground. The picture plane, which contains the base of the cone of vision, will also be at an angle, as illustrated (Fig. 5–4b), but still in the same relationship to the eye.

FIXED POSITION

Students not trained to draw in perspective often combine what they *see* with what they *know* in such a way as to produce contradictory information. As an example, let us compare the freehand drawing a beginning student might make of a square-topped table (Fig. 5–5a) with the drawing the student would make if the image were traced on glass (Fig. 5–5b).

The student knows that the table has a square top and four vertical legs. But the top of the table is perceived as a square only when it is parallel to the picture plane (as when seen from directly above), and from this vantage point it is impossible to see any of the table legs. So, the student makes the compromise of drawing what is known (that the tabletop is square) with what can actually be seen from that vantage point (three out of four table legs). In effect, Figure 5–5a attempts to show two entirely different views of the table.

The drawing in Figure 5–5b, on the other hand, shows what the table would look like from a single point of view. Notice that you still have no difficulty recognizing that the tabletop is square, although it is not drawn that way. The irregular shape that represents the tabletop is, in fact, what we expect to see when a square is at that particular angle to the eyes. Furthermore, it is consistent with the position of the table legs.

A picture in which all elements are drawn so as to be consistent with a single point of view conveys a sense of fixed position. *Fixed position* may be defined as the exact location of the viewer's eyes in relation to the subject. To achieve a consistent point of view in your drawing, it is important to maintain a fixed bodily position in relation to your subject. In other words, do not move closer or farther to the left or the right, do not stoop down or stand on tiptoe, to obtain another view of what you are drawing.

THE CONCEPT OF EYE LEVEL

Eye level may be defined as the height at which your eyes are located in relation to a ground plane. So often taken for granted, an awareness of eye level is essential to the understanding of fixed position.

In respect to a three-dimensional space, eye level should be thought of as the horizontal plane in which your eyes are located. To get a better idea of this concept, it might be helpful to hold up a piece of thin cardboard horizontally to your eyes so that you can see only the edge of it. Since you can see neither the top nor the bottom of the cardboard, we can describe the cardboard in this position as a diminished horizontal plane.

FIGURE 5–5

(a)

(b)

If you are standing on level ground, the diminished horizontal plane will be parallel to the ground plane. But because of your vantage point, the ground plane will *appear* to tilt up to meet the diminished horizontal plane. The apparent intersection of these two planes forms what we will call the *horizon line*.

Eye level is described as high or low by virtue of its distance from the ground plane. We think of normal eye level as that of an average person when standing up—say about five and a half feet above the ground plane. Many representational drawings make use of this conventional eye level, but any time a drawing is executed from a vantage point radically different from the normal one, we are aware that its implied eye level is unusually high or low. In the Laurence Channing drawing (Fig. 5–6), the very high vantage point implied by the view of so much ground plane suggests that we are seeing this industialized landscape from a very tall building or low-flying aircraft.

When looking at works of art, however, we are generally more concerned with the implied eye level in relation to the subject than we are with the artist's actual eye level at the time of execution. In the Joel Janowitz drawing (Fig. 5–7),

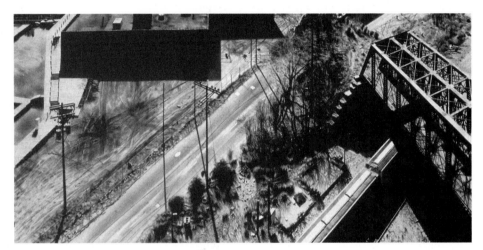

FIGURE 5–6
LAURENCE CHANNING
Gyre, 1996
Charcoal on paper, 80 × 40"

FIGURE 5–7
JOEL JANOWITZ
The Painter, 1974
Charcoal, 28 × 38¾"
Courtesy, the artist

FIGURE 5–8
MELISSA BARTELL, University of
Arizona
Student drawing: still life at three
different eye levels
Courtesy, the artist

the artist's actual eye level is unknown, but we have no reason to believe that it departs radically from the height of a standing person. What we do notice is that we seem to be looking almost straight up at the subject. So in this case, we would describe the eye level of the drawing as low because of its relation to the subject. Notice that in both this drawing and in the Channing, the eye level is so extreme that horizon lines do not even appear within their formats.

Establishing the eye level in a drawing means simply acknowledging that the things portrayed have been seen by looking up at them (they are above eye level, or seen from what is commonly referred to as "worm's-eye" view) or looking down at them (they are below eye level, or seen from what is commonly referred to as "bird's-eye" view). Sometimes artists draw a horizontal line across their paper to indicate their eye level. Placement of this line is discretionary; what does matter is that once the eye level is determined in a drawing, all descriptions of objects should be consistent with that viewpoint.

Exercise 5A *A consistent viewpoint in a drawing helps to establish a convincing illusion of space; it also immediately communicates to the viewer an important aspect of the way you perceived your subject.*
 For this exercise, draw a still life that consists of small objects, or even a single object, from various eye levels. Figure 5–8 shows a simple arrangement of objects from different points of view.

Convergence and Fixed Position

One of the concepts central to the study of linear perspective is that parallel lines in nature appear to converge (come together) as they recede. This phenomenon is such an integral part of common experience it has even been the basis of a popular cartoon (Fig. 5–9). If you followed the angling exercise in Chapter 3, "Shape, Proportion, and Layout," you probably verified the apparent convergence of parallels in your subject for yourself. And if you were very observant or already possessed some knowledge of linear perspective, you noticed that this convergence occurs at eye level.

Before the invention of the system of linear perspective, artists had recognized that receding parallels translate into diagonals on a picture's surface. The

FIGURE 5–9
WEBER
"Look here, men, shouldn't that be
the other way around?"
Cartoon
*Reprinted by permission of Esquire. © 1966 by
Esquire Magazine and the Hearst Corporation*

rules governing the use of these diagonals were very general. As you may see
in the Giotto fresco (Fig. 5–10a), there is an understanding that sets of parallel
lines should converge. But the idea is not extended to include all sets of parallel
lines. Notice, however, that if extended, all the parallel lines in this painting do
converge on a vertical axis (Fig. 5–10b).

Now, compare the Giotto fresco with the one painted by Masaccio in 1425,
shortly after the development of linear perspective (Fig. 5–11). We see a marked

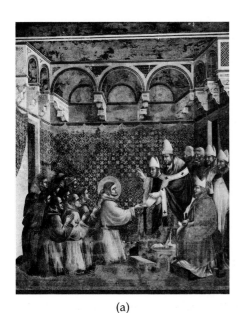

(a)

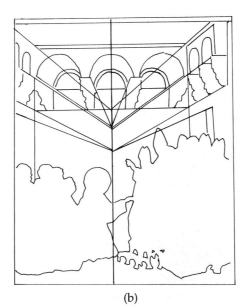

(b)

FIGURE 5–10
GIOTTO
*Innocent III Approves the
Rule of the Order*
Alinari/Art Resource, New York

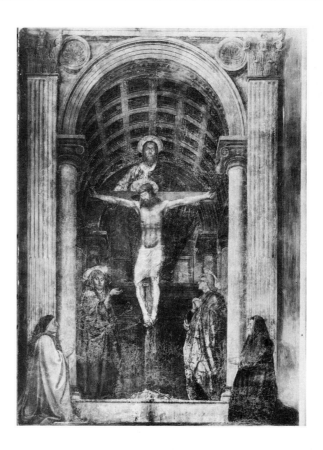

difference between the new system used here and the less complete system used by Giotto. Notice in Masaccio's fresco that all the diagonals in the architecture can be extended to meet at a single point located at the base of the cross. This point indicates the viewer's fixed position as centered laterally on the composition and at an unusually low eye level.

Our own culture has come to expect pictures to have a fixed point of view. The prevalence of photography in our society reinforces this expectation. (The forerunner of the photographic camera is in fact the *camera obscura*, an instrument that aided the artist in recreating a perspective view of a subject by funneling its image through a small aperture, thus simulating a single point of view.)

Artists in general, but especially filmmakers, often use perspective to make the viewer more aware of a specific viewpoint, with the intent of heightening the suspense of a scene. Look at the movie still in Figure 5–12. Although you may be disoriented by the tilted camera angle and the dramatic shadows, you can follow the converging lines so as to obtain a strong indication of the camera's position (just inside the lower left-hand corner of the frame). As a viewer, you naturally identify with the camera's "eye," and as a result you feel that you are a half-hidden witness to the scene. It is this sense of being a voyeur to terrifying or sordid events that the makers of psychological melodrama wish to exploit.

Having made these general observations about the artistic uses of two concepts central to linear perspective—fixed position and the convergence of parallel lines—we will now explain the whole system in greater depth.

THE DIMINUTION OF OBJECTS

The convergence of parallel lines on the picture plane is directly related to the phenomenon of more distant objects appearing smaller. This phenomenon can be

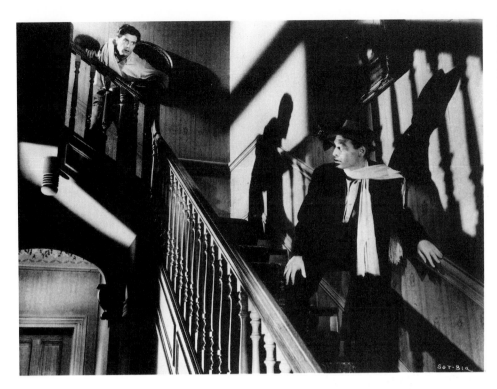

FIGURE 5–12
Film still from Peter Lorre's
Stranger on the Third Floor, shot
with Peter Lorre and John
McGuire on a staircase
*Museum of Modern Art, New York/Film Stills
Archive*

explained by examining how two things of identical size, but at different dis-
tances from the spectator, relate to the spectator's cone of vision.

Let us suppose you are standing in a position where you can see two ele-
phants in profile. One is perhaps thirty feet away from you, and the other only ten
feet. The closer elephant will be located near the apex of your cone of vision. In an
illustration of this (Fig. 5–13a), the trunk is barely included within the farthermost
right ray of vision. There is a space of about one-third of the elephant's body
length left between the tail and the left ray of vision. Therefore, in Figure 5–13b,

FIGURE 5–13

(a)

Station Point

(b)

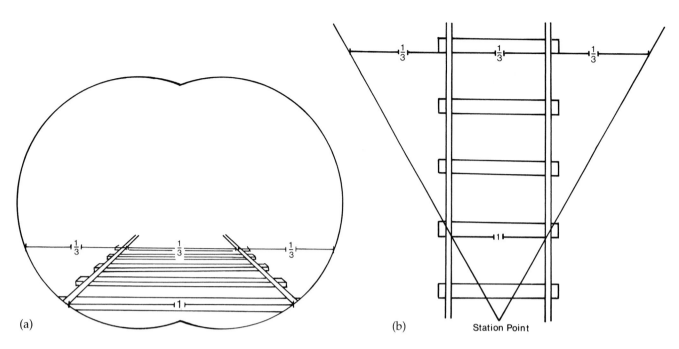

(a)

(b)

Station Point

FIGURE 5–14

the shape of the elephant fills three-quarters of the binocular shape that makes up the field of vision. Let us say that the second elephant is the same size as the first. As it is farther from the apex of the cone of vision, the length of its body takes up a far smaller proportion of the cone. The image will therefore take up correspondingly less area in the field of vision.

THE CONVERGENCE OF PARALLEL LINES

The principle of the diminution of objects can be used to explain the apparent convergence of parallel lines as they recede from the spectator's station point. We will use the familiar image of the railroad track disappearing into the distance to demonstrate the idea of convergence. (Note that when dealing with the system of linear perspective, the fixed position you occupy in relation to your subject is referred to as the *station point*, abbreviated SP in our illustrations.)

In Figure 5–14a, you are standing on a railroad track, midway between the two rails. The track a few feet ahead of you fills up the lower part of your field of vision. As the track recedes, it takes up proportionately less space in both your cone of vision and your field of vision (Fig. 5–14b).

One-Point Perspective

The example of the railroad track is a classic demonstration of *one-point perspective*. The "one-point" referred to is the vanishing point.

THE VANISHING POINT

The illustrations in Figure 5–14 depict only the near sections of the railroad track. If you were to stand at the center of a straight stretch of railroad track, you could look down the rails until they appear to finally converge. This point of convergence is called the *vanishing point* (abbreviated VP in our illustrations). Presuming that the ground we are standing on is flat, the vanishing point will be located on the horizon line.

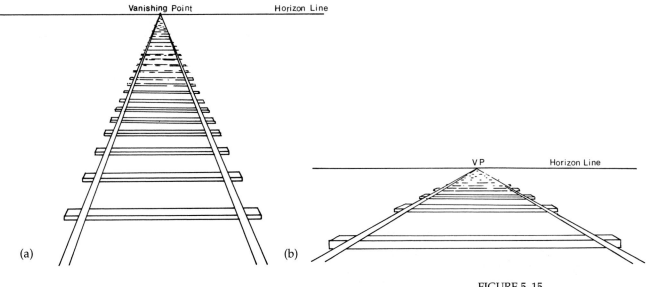

FIGURE 5–15

EYE LEVEL AND THE RATE OF CONVERGENCE

If you had a view of the track from the top of an engine, you would see the tracks converging at a slow rate toward a high vanishing point (Fig. 5–15a). If, however, you had the misfortune to be tied to the railroad track, you would see the tracks converging sharply to a low vanishing point (Fig. 5–15b).

DIMINUTION OF UNITS ON A RECEDING PLANE

In studying the preceding illustrations, you probably noticed that the spaces between the railroad ties became progressively smaller as the tracks converged. Refer to the illustration in Figure 5–16 and follow the three steps below used to arrive at the proper spacing of the ties.

1. Draw the first tie at the bottom of your page. Carry a line from the center of the first tie up to the vanishing point. This line will bisect the angle formed by the two tracks. Draw the second tie at an appropriate distance from the first.

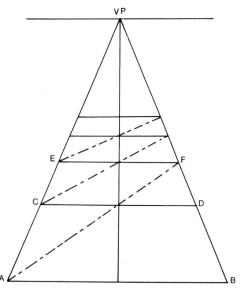

FIGURE 5–16

FIGURE 5–17

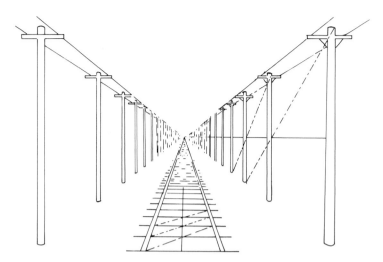

(If you were drawing from nature, you could arrive at this appropriate distance through angling or measuring with your pencil, as described in Chapter 3).

2. Draw a diagonal line from point A through the point at which the line bisecting the angle of the tracks intersects with tie CD. Where this diagonal line intersects the track on your right put another horizontal for EF.

3. Successive ties can be located by repeating the procedure.

THE RECTANGULAR VOLUME: INTERIOR VIEW

The preceding demonstration showed how to draw a railroad track from a vantage point above the center of the track. In this case, there was one set of parallel lines that appeared to converge at one point on our eye level. Now we will add a second set of parallel lines above the eye level (Fig. 5–17). A line of telephone poles running parallel to each track would carry cables that also vanish at the same point as the railroad tracks. (Note that in spacing the telephone poles we use a procedure similar to that described for placement of the railroad ties. In this case, the first operational line is extended from the midpoint of the first telephone pole to the vanishing point. This line will divide the height of each pole in half.)

If we were to enter a long, rectangular room from a doorway located at the center of one of its shorter walls (Fig. 5–18), we would see a space similar to that

FIGURE 5–18

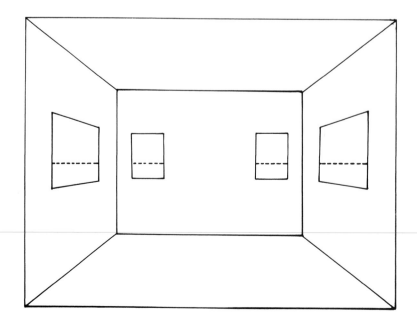

of the railroad track flanked by telephone poles. The perspective of the room is, of course, more subtle, since the vanishing point is obscured by the end wall. But note that in the illustration, the receding lines of the floor, wall, and ceiling, if continued, converge at one vanishing point located at eye level. The horizon line in this case may be observed through the windows.

Note also that all horizontal lines on the wall facing the viewer, and any other horizontal line parallel to the picture plane, appear as horizontal. Any horizontal line located at the eye level appears as a horizontal, regardless of its angle to the picture plane. All vertical lines retain their vertical aspect.

Exercise 5B

To apply what you've learned about one-point perspective, find a long, rectangular room or corridor. Station yourself at the center of one end. Notice that all the receding horizontal lines on the walls, ceiling, and floor converge at the same point.

Draw the corridor using your skills at angling to find the vanishing point. To achieve proportion, use a combination of triangulation and measuring with your pencil, as discussed in Chapter 3. Figures 5–19 and 5–20 are examples of spacious interiors drawn in one-point perspective. In both drawings, the low eye level is key to expressing the scale of the space. In the Bosboom figure, the drama of the massive architectural elements is heightened by the play of light and shadow.

THE RECTANGULAR VOLUME: EXTERIOR VIEW

Now that you have an understanding of the interior of a rectangular volume viewed from one end, the next step is to look at the volume from the outside. If the rectangular volume or box is held at eye level so that its front face is parallel to the picture plane, it will appear as a flat rectangle (see Fig. 5–21a). This view does not give any information about the three-dimensional nature of the box. If, however, the box is lowered slightly so that we see its top as well as its front, it will appear as it does in Figure 5–21b. Right away we have an indication not only of the box's three-dimensional nature but also of our own eye level in relationship to it.

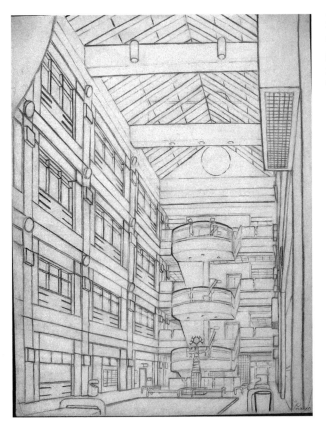

FIGURE 5–19
JACOB ETHEREDGE, Iowa State University
Student drawing: architectural interior in one-point perspective
Courtesy, the artist

FIGURE 5–20
JOHANNES BOSBOOM, Dutch
(1817–1891)
Church Interior
Watercolor and gouache over
graphite on cream laid paper, n.d.,
41 × 31.2 cm
Bequest of Irving K. Pond (1939.2243).
Photograph © 1994, The Art Institute of
Chicago. All Rights Reserved

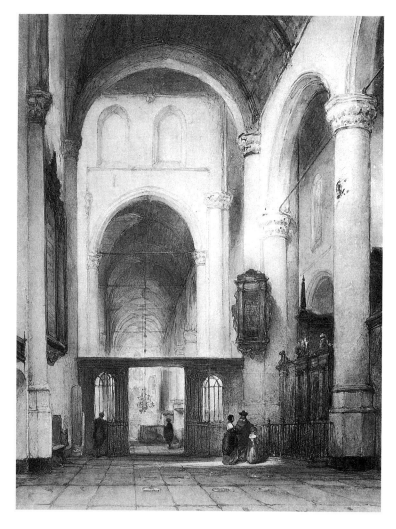

FIGURE 5–21

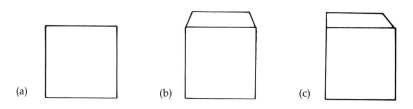

(a) (b) (c)

If the box is shifted so that it is not quite centered on your line of vision, but
not so far that you can see a third face (see Fig. 5–21c), you will still be able to
draw it in one-point perspective.

Study Figure 5–22 to understand how the concealed faces of these boxes
would be drawn if the boxes were transparent.

Exercise 5C *Find a rectangular volume of some sort. A box or block of wood will do. It may be a cube but it need*
not be.

Place it so that one face is roughly parallel to the picture plane. Draw the box at different
relations to your eye level. To determine the vanishing point, angle the converging lines.

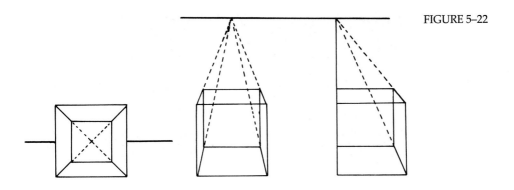

FIGURE 5–22

Two-Point Perspective

THE RECTANGULAR VOLUME IN TWO-POINT PERSPECTIVE

When a rectangular volume is positioned so that none of its faces is parallel to the picture plane, you will no longer be able to draw it using one vanishing point. Figure 5–23 shows three cubes positioned so that their vertical faces are at a forty-five-degree angle to the picture plane. Notice that in this schematic drawing, the cubes are stacked so that they all share the same two vanishing points.

In most drawing encounters with boxlike forms, you will make use of two-point perspective. But although all items in a given situation may require treatment in two-point perspective, they will not necessarily share vanishing points. Figure 5–24 shows a variety of boxes drawn in two-point perspective. As they are all positioned with their base planes on or parallel to the ground plane, the vanishing points will be located on the horizon line.

Notice that the cluster of boxes labeled A shares common vanishing points, whereas cluster B does not. Box C is drawn as if transparent. Box D is positioned so that we see a great deal more of one face than the other two. In such a case, the vanishing point for the greater face will be located farther away. (The placement of vanishing points is based on judgment. Sometimes you may find it necessary to locate either or both points outside the format of a drawing. What you want to avoid, however, is the distortion that occurs from placing the vanishing points too close together, as in box E.) The top of box F is located at eye level and is therefore not visible.

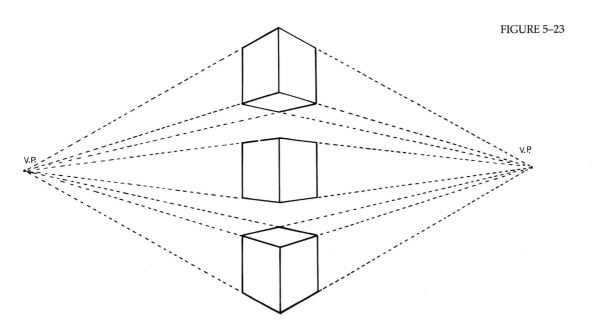

FIGURE 5–23

V.P.

V.P.

FIGURE 5–24

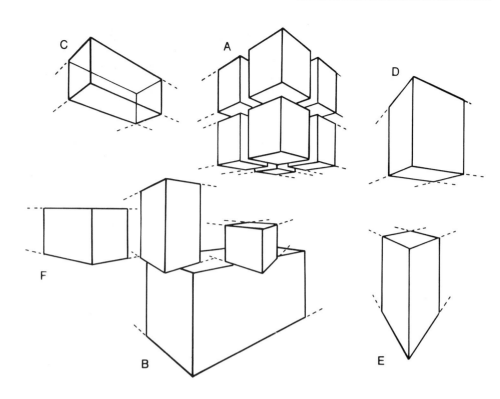

Exercise 5D *Try these two applications of two-point perspective.*

Drawing 1. Draw a group of rectangular volumes in two-point perspective. A bunch of cardboard cartons or an architectural setting would serve as good models for this exercise. The drawing in Figure 5–25 shows a two-point perspective rendition of a vise attached to a workbench.

FIGURE 5–25
NANCY WILKENS, University
of Montana
Student drawing: vise and
workbench in two-point
perspective
Courtesy, the artist

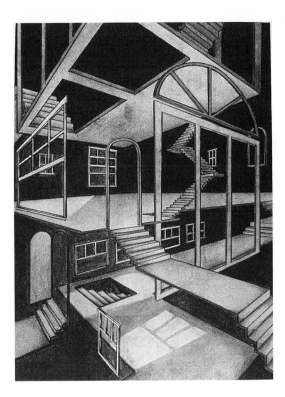

FIGURE 5–26
TONI SPAETH, Art Academy
of Cincinnati
Student drawing: imaginary
architecture in two-point
perspective
Ink and colored pencil
Courtesy, the artist

Drawing 2. *Design a piece of furniture or architectural conglomeration using your knowledge of two-point perspective. Your design may be practical, or fantastic, as in Figure 5–26, but make sure to apply the rules of linear perspective consistently.*

THE BOX TILTED AWAY FROM THE GROUND PLANE

So far we have been dealing with boxes that *sit on,* or *float parallel to,* the ground plane. The faces of these boxes are all either horizontal or vertical, and so all the vanishing points are located at eye level. If the box is *tilted* in relation to the ground plane, however, it will no longer have any horizontal or vertical planes, and none of the vanishing points will be located at eye level. Normally, a box positioned in this way will be drawn using two-point perspective (see Fig. 5–27). Later in this chapter, a case will be made for drawing some tilted boxes in three-point perspective.

The Circle in Perspective

Circles in perspective are drawn as ellipses. When it is necessary to find the center of a circle in perspective, the ellipse is drawn within a square in perspective. Figure 5–28 shows how this is done.

Figure 5–28a is an unforeshortened view of the circle within a square; its center is found at the intersection of the diagonals connecting the corners of the square.

If the square containing the circle is tipped away from the picture plane, the circle appears as an ellipse (Fig. 5–28b). We have added a dotted horizontal line to divide this figure in half. This has been done to show that the front half of the circle appears fuller than the rear half. Note also that the undotted horizontal line through the center of the circle does not correspond with the fullest horizontal measurement of the ellipse. This is indicated by the dotted line.

FIGURE 5–27

FIGURE 5–28

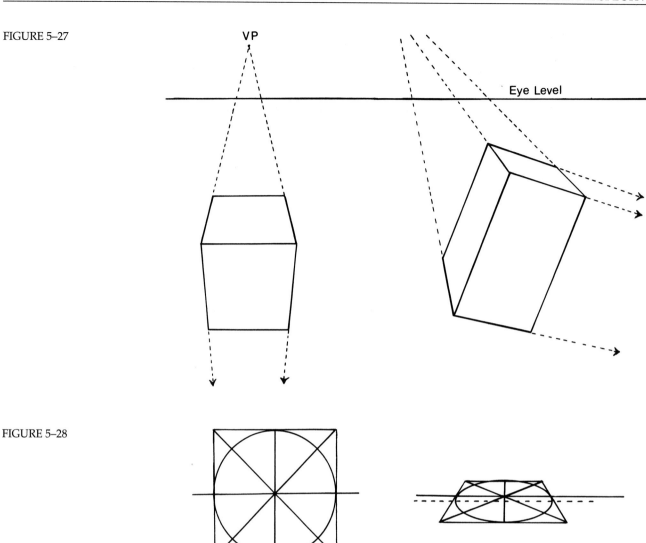

(a)　　　(b)

Figure 5–29 demonstrates what is happening to the circle in relation to the cone of vision. In Figure 5–29a, the center line of vision goes through the center of the circle. The rays of sight from the station point (SP) are tangential to the circle. A horizontal line connecting these two tangential points locates the fullest dimension of the circle that the eye will perceive. This line falls well below the horizontal through the center of the circle.

This fullest visible dimension of the circle seen in perspective (indicated by a dotted line) becomes the major axis of the ellipse when the circle is drawn on the picture plane (Fig. 5–29b). To locate the major axis of the ellipse, draw a rectangle around it and then draw diagonals connecting the corners of the rectangle. The major axis of the ellipse is drawn horizontally through the point where the diagonals intersect (Fig. 5–29c).

The minor axis of the ellipse coincides in this case with the vertical line going to the central vanishing point. *The minor axis of the ellipse is always drawn perpendicular to the major axis.*

This method of drawing ellipses pertains to any situation in which the major axis of the ellipse is horizontal and parallel to the picture plane.

Whenever the major axis of an ellipse is horizontal, the ellipse can be drawn within a square in one-point perspective. This is because the circle, unlike any other shape, appears the same when rotated within its plane.

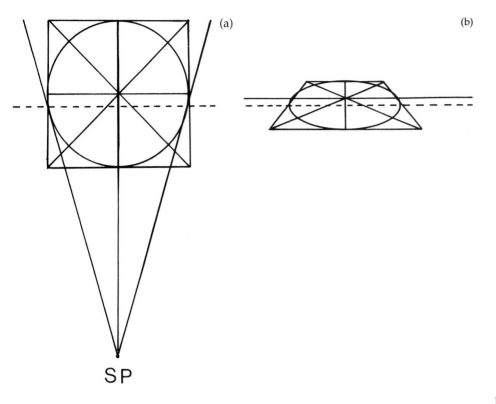

FIGURE 5–29

Other Geometric Volumes and Near-Geometric Volumes

You can apply your knowledge of drawing boxes and circles in perspective to drawing other basic geometric forms, such as cylinders, cones, pyramids, and spheres (Fig. 5–30). Many manufactured objects can be drawn with greater

FIGURE 5–30

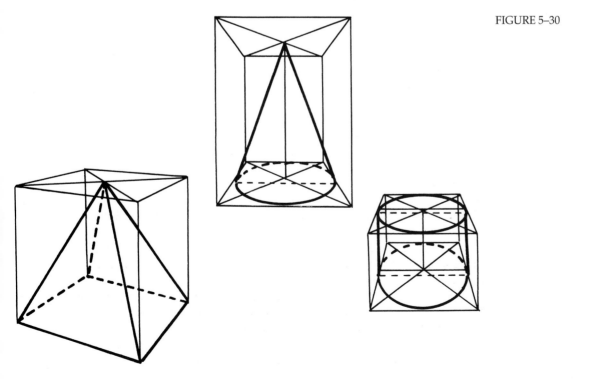

understanding if you try to relate them to the geometric forms they most closely resemble. Flowerpots, drinking glasses, and lampshades are basically conical; most furniture is rectangular; tree trunks and bottles are cylindrical; and many vegetable forms, such as fruits, flowers, bushes, and trees, are spherical.

The Advantages and Shortcomings of Linear Perspective

Throughout this chapter, we have stressed combining the use of proportional devices with a knowledge of linear perspective whenever you draw from a subject that suggests perspectival treatment. But it is entirely possible to draw a form such as a building correctly even without a theoretical knowledge of perspective, as long as you triangulate to find the angle and length of every single line.

Obviously this is a very tedious and time-consuming process, especially when a knowledge of linear perspective equips you to anticipate the angles of a good many of the lines and thus shorten your drawing time. Furthermore, this knowledge will enable you to quickly assess mistakes in a drawing and help you to determine which lines stand in need of correction. Therefore, many artists who have no interest in perspective as an end in itself feel that linear perspective has an important role to play in support of careful seeing.

At times, however, the information you gain through measuring and angling will be at odds with your knowledge of perspective. When this happens, you will probably want to check the measurements in your drawing to make them agree with your expectations. A beginner, given the choice of trusting either what is seen or the system of perspective, will usually opt to trust the system; the system is, after all, rational. This is a healthy response and in most cases will yield the desired result. But in some cases, a subjective hunch, fortified by careful angling, will turn out to be correct.

This is because in certain situations traditional one- or two-point perspective does not help to create an image that most closely resembles what is seen in the visual field. Although it will always yield an image consistent with its own logic, the sterile look typical of some perspective drawings is a result of using a system based in part upon some false assumptions.

The first of these false assumptions is the belief that fixed position is absolute. This notion may pertain to the more instantaneous medium of photography; but drawing involves a physical and mental activity, and because it takes time, it is virtually impossible for the artist to maintain an actual fixed position in relation to the subject. A quality missing from many strict perspective drawings is the sense of intimacy between artist and subject, an intimacy that is built up during that *duration,* however short, in which the artist is accumulating, recording, and sorting out visual impressions.

A related false assumption is that our vision is monocular (one-eyed), when in fact it is stereoscopic (two-eyed), meaning that what we see includes two separate cones of vision. Normal visual perception of an object therefore consists of two slightly different views of that object incorporated into a single image. The phenomenon of stereoscopic vision is especially apparent when you regard something very close to you, since in this case the discrepancy between the two images of the object is greater.

Another assumption on which the systems of one- and two-point perspective operate is that the picture plane is literally a vertical plane. But as we pointed out earlier in this chapter, the picture plane is not necessarily vertical; rather, it occupies a position perpendicular to your line of vision (Fig. 5–4b).

The box in Figure 5–31a is drawn in traditional one-point perspective, assuming that the front plane of the box is parallel to the picture plane. However,

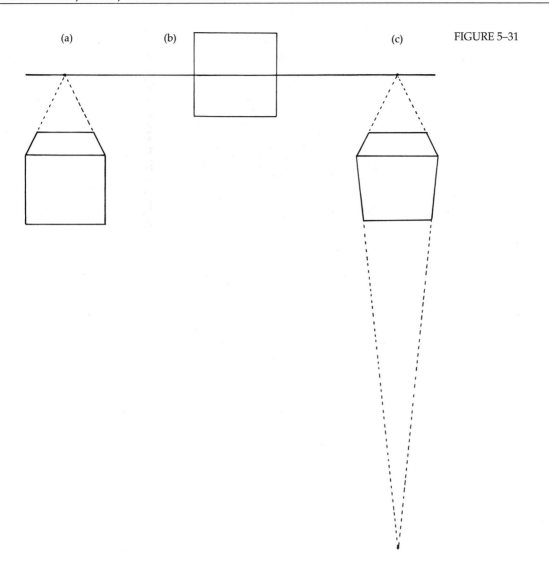

FIGURE 5–31

since the box is located below eye level, our gaze must be directed downward to see it. This means that the picture plane is tilted slightly off the vertical. In theory, then, the use of one-point perspective can be justified only when drawing an object or space that is truly centered on our line of vision, as in Figure 5–31b. As a consequence, the corrected perspective for Figure 5–31a would be as that seen in Figure 5–31c.

In most circumstances, the inclination of the picture plane is so slight that the convergence of the vertical sides of a box is imperceptible. If, however, the box were extremely large, or you were very close to it, you would notice the second vanishing point. Compare the Diane Olivier drawing in Figure 5–32 with Figure 5–31c. Note that the converging verticals in Figure 5–32 not only give you an indication of your low eye level in relation to the subject but also contribute to a sense of intimacy by implying that you are very close to it.

Three-Point Perspective

When you are situated so that you see two vertical faces of a very large (or very close) boxlike form, you may wish to draw it in three-point perspective. This means that when you stand at street level looking up at the corner of a skyscraper,

FIGURE 5–32
DIANE C. OLIVIER
Sansome and Battery
Charcoal on paper, 84 × 66"
Collection of the artist. Courtesy, Dorothy Weiss Gallery, San Francisco. Photo: Robert Haavie

you will see vanishing points not only for the horizontal lines but also for the vertical ones. In Figure 5–32, notice that the sides of the buildings converge at a point beyond the top of the page.

THREE-POINT PERSPECTIVE AND THE TILTED BOX

When a box is tilted away from the ground plane, a case can be made for drawing it in three-point perspective. The necessity for this treatment is especially clear when you tilt an oblong box toward or away from your picture plane, as in Figure 5–33.

Exercise 5E *These projects will enable you to apply the rules of three-point perspective.*

Drawing 1. Find an oblong box or block of wood. Prop it up so that it is leaning toward you. Draw it, taking care to angle all the sides carefully.

Drawing 2. Put a large cardboard box on the floor. Situate your easel as close to it as you can, yet retain a view in which you can see two side faces and a top face (or interior) of the box. Do the vertical sides of the box appear to converge at a point below the floor? Draw the box using a combination of angling and your knowledge of perspective.
 Any rectangular object or group of objects, such as the stack of books in Figure 5–34, can be substituted for a box in this exercise.

Drawing 3. Situating yourself cater-cornered to a very tall building, draw it in three-point perspective.

FIGURE 5–33

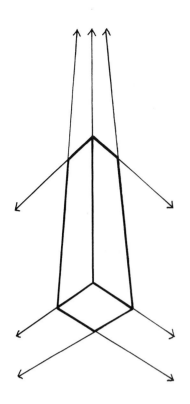

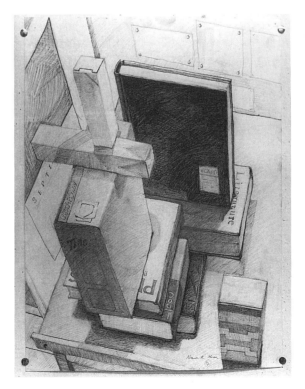

FIGURE 5–34
Nam Kim, Pratt Institute
Student drawing: stack of books in
three-point perspective, 18 × 24"
Courtesy, the artist

6

Form in Space

Have you ever had the experience of looking at an object and suddenly feeling that it possessed an extraordinary power? It may have been an intricately organized flower that you investigated carefully for the first time, a worn coiled rope glistening with tar and resins that you unexpectedly glimpsed along the railroad tracks, or a rusted, unidentifiable machine part that you picked off a vacant lot as a child and kept for years before throwing it out in a fit of spring cleaning.

The word *presence* is used to describe this mysterious power that is sometimes inferred from the forms of objects. Objects are said to command our attention in this way when they seem to be charged with hidden meanings or functions that, like some secret code, we cannot penetrate. This can hold true even for things we have seen and used and taken for granted, such as objects of common utility. Seen in a different context or from an unusual viewpoint, an otherwise ordinary object may suddenly assume a totally new identity.

From time to time, many people experience this rather romantic and usually fleeting impression that objects have a transcendental meaning. This is especially true of artists, who are accustomed to finding significance in form and who return to these experiences as models for the quality of presence that they wish to achieve in their own works.

Most artists, in fact, become so sensitized to visual experience that they regularly discern unnameable powers in forms they encounter. For them, the powers sensed in an object can be translated into expressive potential when they draw. But first they must complement these sensations with a more deliberate search for the prominent form characteristics of the object in question. For example, in his drawing of a screw (Fig. 6–1), Claes Oldenburg identifies spiraling movement and linear direction as those characteristics essential to the form. He exaggerates these properties by transferring to the shaft the movement that properly belongs to the threads themselves, thus greatly increasing the object's spatial gesture. Moreover, the monumental scale that he gives this most commonplace of small objects invests the image with all the fearsome torque of a tornado.

The Oldenburg drawing succeeds in evoking presence because it takes distinctive characteristics of "screwness"—spiraling movement, tensile strength, and linear direction—and gives them unanticipated emphasis. But to achieve this without resorting to caricature, the artist had to have a clear concept of the actual physical form of the screw.

FIGURE 6–1
CLAES OLDENBURG
Poster Sketch for Show in Japan of Giant Balloon in the Shape of a Screw, 1973
Charcoal, pencil, watercolor
29 × 23" (73.7 × 58.4 cm)
© Claes Oldenburg and Coosje van Bruggen. Courtesy, Leo Castelli Gallery

The Visual and the Tactile

We use two perceptual systems to acquaint ourselves with the three-dimensional condition of an object: vision and the sense of touch. Psychologists tell us that these two senses work in tandem and that knowing what one sees is to a great extent dependent on being able to verify it by the sense of touch.

Although drawing is a visual medium, those drawings that strike the deepest chord within us usually recall a memory of tactile sensations. In the portrait by Edwin Dickinson (Fig. 6–2), the illusion of the elderly woman's soft flesh and

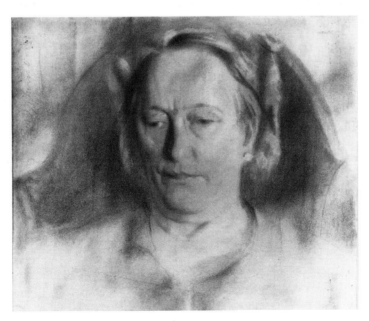

FIGURE 6–2
EDWIN DICKINSON
(American 1891–1797)
Portrait of Mrs. B., 1937
Graphite, with estampe and erasure, 10⅝ × 12⅝"
The Baltimore Museum of Art, Thomas D. Benesch Memorial Collection (BMA 1974.5)

FIGURE 6–3
MICHELANGELO
The Crucifixion
Ashmolean Museum, Oxford

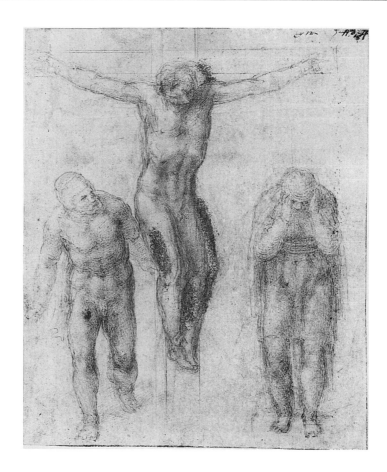

thinning hair evokes an almost physical response in the viewer. In the Michelangelo drawing, on the other hand (Fig. 6–3), the tactile stimulus is located in the concentric searching lines. The viewer empathizes with the artist's repeated attempts to recreate on the surface of the paper how it would feel to physically embrace each of these forms.

Form and Gestalt

All three-dimensional objects possess mass, volume, and form. For the purpose of the artist, *mass* can be defined as the weight or density of an object. In most cases, weight and density are experienced through tactile, as opposed to visual, means. The term *volume* expresses the sheer size of an object and by extension the quantity of three-dimensional space it occupies.

Form refers to the three-dimensional configuration of an object. Form sets the specific spatial limits of an object and also encompasses the notion of its structure or organization. Of these three properties, mass, volume, and form, it is the latter that interests artists the most.

Form is most easily grasped by visual means, and yet we can receive only a limited amount of information about an object's form from any single point of view. To get a more complete picture of a whole form, we must obtain several views of it and synthesize them in our mind's eye. The more complex and unfamiliar a form is, the more difficult this process will be. Figure 6–4 shows how Leonardo da Vinci gradually rotated an arm to assist his understanding of its musculature.

The term *gestalt* is used to describe a *total* concept of a form. Some objects have a strong gestalt; that is, when seen from a single point of view, their entire

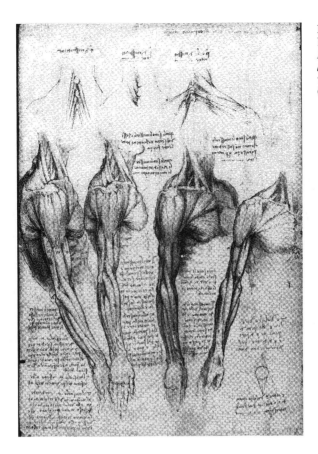

FIGURE 6–4
LEONARDO DA VINCI (1452–1519)
*Muscles of the Right Arm, Shoulder
and Chest*
*The Royal Collection © 2003 Her Majesty
Queen Elizabeth II*

three-dimensional character is readily comprehended, as is the case with simple structures, such as the basic geometric solids (the sphere, cone, cylinder, pyramid, and cube). The instant gestalt recognition of these forms is due in part to our familiarity with them. But they are also each defined by a set number of surfaces that are at predictable relations to each other.

Take a moment to try obtaining a gestalt (or total picture) of something with which you have daily contact—say, a coffee mug. Pick it up and get to know its various surfaces. Can you remember the motions you go through when washing it? How much coffee does it hold compared with other mugs that you use? After you have asked these questions, set the mug down and look away from it. You should be able to retain a concept of its three-dimensional form in your mind's eye and even be able to recreate different views of it. This exercise will greatly increase your ability to imagine forms in the round and draw them convincingly.

Approaches to General Form Analysis and Depiction

At some point you have probably had the desire to draw a highly complex form. Confronted with an object whose surface was characterized by a wealth of detail or numerous subtle turns, you may have felt at a loss about where to begin. But essential to a strong representation of any form is a feeling for its overall spatial structure. To assist you in depicting the overall structure of forms, we now present several simplified approaches to form analysis. While it may benefit you at the start to try these approaches separately, you will eventually wish to use them in combination to produce richer and more resonant drawings.

GENERALIZING THE SHAPE AND STRUCTURE OF COMPLEX FORMS

When setting out to draw a complex object, you should simplify your initial approach to its form. Such an approach might entail that you rely solely upon what you see to generalize the form; or you might try to understand the form through a combination of observation and imagination to visualize that part of its essential structure which you cannot actually see. Form summary and shape summary are two specific methods for summarizing the form of complicated objects.

Form summary is a technique that is used to describe a more complex or articulated (jointed) form in simpler terms. When summarizing such a form, you need not feel restricted to using boxlike volumes. In his drawing of a bull crouching, Reuben Nakian plays taut, rounded forms against each other to achieve an effect that is as virile as it is decorative (Fig. 6–5).

Shape summary is another means to generalize form. Shape summary does not entail an exact delineation of the outer contour of a shape. Rather, when making a shape summary, one first sizes up the major areas of a three-dimensional form and then records them in terms of flat shape. The Theo van Doesburg drawing of a cow (Fig. 6–6) is a good example of shape summary. Notice that the head is seen in terms of a series of rectangular shapes, the neck and shoulder as a triangle, and the haunch as an inverted triangle.

GESTURE AS A MEANS OF EXPLORING FORM

In previous chapters, we have discussed gesture drawing as a way to represent the general pattern of things as they are arranged in space (Chapter 1, "The Three-Dimensional Space of a Drawing") and also as a primary means of organizing a drawing's surface design (Chapter 4, "The Interaction of Drawing and Design"). Extended to the practice of depicting form, gesture drawing can be useful not only for revealing those aspects of a form that can be seen but also for suggesting something of the form's internal forces and stresses.

Gesture drawing necessarily involves a good measure of empathy on the part of the artist for the subject; that is, the artist must try to express with marks, tones, or lines the essential structure and energies of what is being drawn. To this end, Rodin let the gesture of his pencil line recreate the spirit of a dance (Fig. 6–7).

The subject in the Matisse (Fig. 6–8) is more static in nature. Here the outer contour of the figure seems to have been arrived at through a series of trials that

FIGURE 6–5
REUBEN NAKIAN
Bull Crouching, 1921
Crayon, 10 × 15"
*Collection of the Whitney Museum of American Art, New York. Photograph by Oliver Baker Associates Photography.
(31.562)*

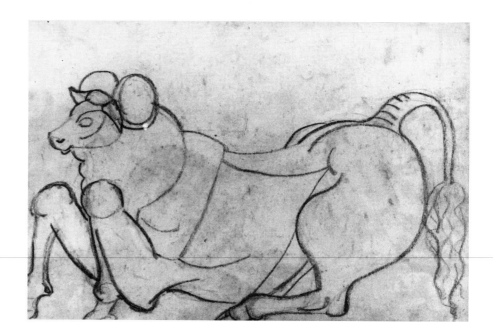

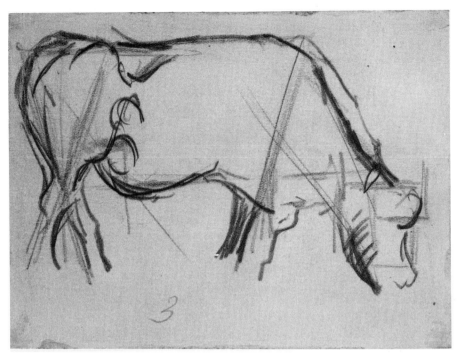

FIGURE 6–6
THEO VAN DOESBURG
Study for the Composition (The Cow),
1917
Pencil, 4⅛ × 5¾"
*Gift of Nelly van Doesburg. The Museum of
Modern Art, New York. Digital Image
© 2003 Aritsts Rights Society (ARS), New
York / Beeldrecht, Amsterdam. © The
Museum of Modern Art/Licensed by
SCALA/Art Resource, NY (31.562)*

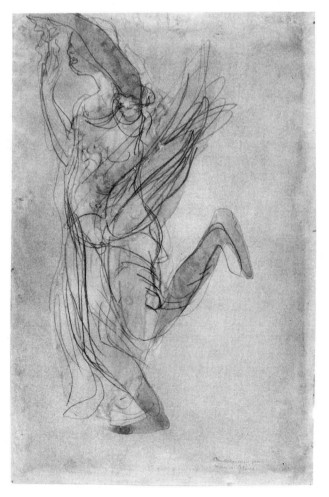

FIGURE 6–7
AUGUSTE RODIN
Isadora Duncan
Pencil and watercolor on paper
*Philadelphia Museum of Art. Gift of Jules E.
Mastbaum (F'29–7–151)*

have left a radiating energy about its form. But much of the gestural force of the
drawing is a result of the feeling for internal stresses expressed by the sharply
contrasting lights and darks in the weight-bearing leg. This plus the effect of the
other leg dragging through the shadows helps us to identify with the physical
gesture of the model.

Artists frequently use gestural marks to diagnose and express the relative
position and scale of an object in space. These marks are generally called
diagrammatic marks because they are often so direct and graphic, as in Figure 6–9.
Or look at the drawing by Wolf Kahn and see how his stroking, gestural marks
"feel out" his tactile impressions of a cow (Fig. 6–10). And note how the contrast
between the well-defined marks portraying the handlelike tail and the sketchier
ones indicating her head gives us a strong sensation of the way the cow is ori-
ented in space. This differentiation in clarity of marks is an example of aerial per-
spective used to show varying distance within a single object.

Gesture drawing is generally done rapidly and is thus admirably suited to a
moving subject, as in Figure 6–7. But the intense energy and level of identification
required for gesture drawing also make it a most important means for quick stud-
ies of inanimate objects. So, before undertaking a drawing of longer duration, an
artist will do a series of gesture drawings to invest the more prolonged drawing
of a stationary subject with greater energy (Fig. 6–11).

But even when drawing for a long period of time, a feeling for the subject's
gesture may be sustained. The Mondrian drawing (Fig. 6–12) is just such an exam-
ple of how a subject of considerable complexity can be accurately drawn without
sacrificing the gestural energy of its overall form. In this drawing, seemingly
countless petals come curling aggressively out from the center of the flower
toward the viewer. But notice that although each petal is individually modeled
and thus holds its own space, their unruly conglomerate adds up to a clearly felt

FIGURE 6–9
LOWELL BROWN
Dead Fish, 1996
Pencil, marker, pastel, correction
fluid, 11 × 8½"
Courtesy, the artist

FIGURE 6–10
WOLF KAHN
Prize Cow, 1955
Pencil on paper, 9 × 12"
© Wolf Kahn/Licensed by VAGA,
New York, NY. Courtesy, Grace Borgenicht
Gallery

spherical mass. Such a powerful illusion of a writhing mass would not have been possible unless the artist had had from the very start a clear idea of the overall form of the flower head. Thus, by combining an initial analysis of the general form with careful observation of the spatial activity of the individual petals, he gave to the insubstantial flower an immense spatial presence.

FIGURE 6–11
JAMES R. HAWKS
Student drawing: studies of a piano
Courtesy, the artist

FIGURE 6–12
PIET MONDRIAN
Chrysanthemum, 1906
Pencil, 14¼ × 9⅝"
© 2003 Mondrian/Holtzman Trust, c/o Beeldrecht/Artists Rights Society (ARS), New York

LINE AND SPATIAL STRUCTURE

You will find that line is an invaluable tool for analyzing the spatial aspects of form, and many artists recommend the practice of linear drawing as the most expedient way to improve perceptual skills (Fig. 6–13). What makes line so effective in showing the turn of surface on a three-dimensional form is, strangely enough,

its unidirectional character. By definition, line travels from point to point. To illustrate this, look at the drawing by Agnes Denes (Fig. 6–14), in which the delicate diagrammatic lines connect carefully plotted points to direct the eye around the form in a measured way.

FIGURE 6–13
C. Brent Ferguson
Student drawing: contour study of a houseplant
18 × 24"
Courtesy, the artist

FIGURE 6–14
Agnes Denes
Map Projection—The Snail, 1976
Lithograph, printed in color, composition, 24 1/16 × 30 1/16"
The Museum of Modern Art, New York. John B. Turner Fund

OUTLINE VERSUS CONTOUR LINE

Before we proceed to discuss the potential of line to depict form, it is necessary to differentiate between outline and contour line. Outline can be defined as a boundary that separates a form from its surroundings. Usually regarded as the most primitive of all artistic techniques, outline works best when it is reserved for depicting literal flat shapes, such as the illustrations of road signs in a driver's manual. The tendency for outline to direct the viewer's attention to the two-dimensional spread of the area it encloses confounds any power it might have to depict three-dimensional form. Additionally, the uniform thickness, tone, and speed of an outline does not distinguish between those parts of a form that are close to the picture plane and those that are farther from it. Thus, the outlined image of a man walking his dog (Fig. 6–15) looks as flat as the images of road signs.

Another long-held objection to outline is that in recording the outer edge of an object, one unavoidably draws attention to that part of the object farthest from the eye. Because of the dynamics of figure–ground play, this line tends to push forward, allowing the interior of the shape to fall back. Thus, a circle drawn to represent a sphere will look more like an empty hoop, especially if it is drawn with a line of consistent thickness.

An alternative to outline is the *contour* line, which can also be used to describe the outer edge of an object. But unlike the outline, which functions as a neutral boundary between the object and its surroundings, the contour line gives the impression of being located just within this border. So contour line more properly belongs to the form of an object, as we can see in the Picasso work *Portrait of Derain* (Fig. 6–16). When you look at the outer contour, you will see that the artist is alluding to this edge as the last visible part of the form before it slips away from sight.

It is its varying thickness, and often tone and speed, that gives contour line its capacity to suggest three-dimensional form. To demonstrate this, we have traced the Picasso drawing with a drafting pen so as to render the image with a

FIGURE 6–15

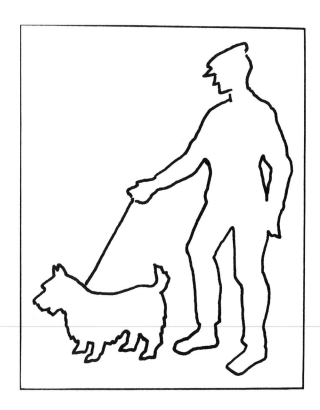

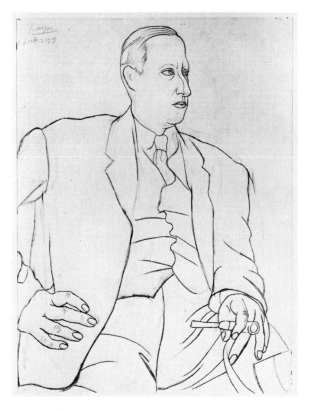

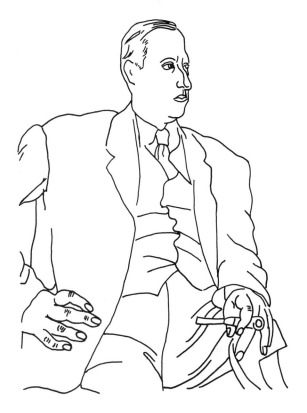

FIGURE 6–16 FIGURE 6–17
PABLO PICASSO
Portrait of Derain, 1919
© *2003 Estate of Pablo Picasso/Artists Rights*
Society (ARS), New York

line of uniform thickness. The result (Fig. 6–17) appears flat when compared with the original, in which no line retains the same thickness for long.

Contour line can also be applied within the outer borders of a depicted form. In the Picasso drawing, this use of contour is especially evident in the delineation of the folds in the sitter's jacket sleeve. An even more structural use of contour may be observed in the way the nose is drawn. Here contour is used to indicate a break in planes.

A further example of the modeling effect of contour can be found in the drawing by Jean Ipousteguy (Fig. 6–18). Here line is used with great economy; a single line, indicating the weighted outer contour of the belly, travels up into the form to reveal the structure of the rib cage. A dark smudge representing the shadow cast by the protruding hipbone feeds into a line that tapers as it travels away from the picture plane over the form of the body, disappearing finally where the curve of the breast melts into the underarm.

Blind contour is one of the best ways to get acquainted with how line may be used to express the* **Exercise 6A**
structure of forms in space. It is a tactic used by artists to heighten their awareness about how the
form of what they draw "feels" to the eye.

Drawing 1. Using a pencil, marker, or technical pen, do a series of blind contour drawings of some
fairly complex subject, such as a model's face (Fig. 6–19) or your own hand in different positions.
Remember that blind contour drawing entails letting your eye creep very slowly around the con-
tours of a form while your drawing hand follows the movement of your eye. Be sure to enter within
the confines of the form's outer contour to indicate major plane breaks.
Blind contour drawings will always look slightly imperfect, as if parts of the subject have been
somewhat jostled. Even so, these drawings have the appeal of the immediacy of optical perception.

*Blind contour drawing is also discussed in Chapter 1, Exercise 1C.

FIGURE 6–18
JEAN IPOUSTEGUY
White (Blanche), 1970
Charcoal on paper mounted on
board, 21½ × 29½" (54.9 × 74.9 cm)
Solomon R. Guggenheim Museum, New York.
Gift of the artist. (83.3026)

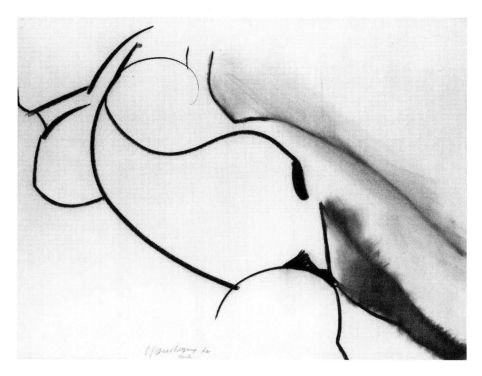

Drawing 2. *Arrange some objects that have a lot of curves into a simple still life. Vegetables such as cabbage or cauliflower, kitchen gadgets, and overstuffed furniture all make good subjects. Do a blind contour drawing of these objects, but this time change the thickness and value of the line more emphatically, exaggerating to some extent the principles of atmospheric perspective. In other words, where a form moves aggressively toward you, increase the speed and pressure with which you draw to thicken, darken, and add clarity to your line. But as edges begin to drop from sight, slow down and let up on the pressure so that your line becomes thinner and less distinct.*

Suggested media include a fountain pen or brush with ink, a sharpened conté crayon or graphite stick, or a carpenter's pencil.

FIGURE 6–19
JENNIFER BOGARD, Indiana State
University
Student drawing: blind contour
Courtesy, the artist

Drawing 3. *Use the insights you've gained from your second blind contour study to make a more precise contour-line representation of a still life, this time looking at your paper.*

Refer to Figures 6–20 and 6–21, both intelligent line drawings. Note that one uses line of uniform thickness to define the forms and their orientation in space, while the other expresses the weight of the bunches of bananas through variation in line thickness as well as a judicious use of smudges to indicate shadow.

FIGURE 6–20
RON FOX, Middle Tennessee State University
Student drawing: still life drawn with lines of uniform thickness
Charcoal, 22 × 30"
Courtesy, the artist

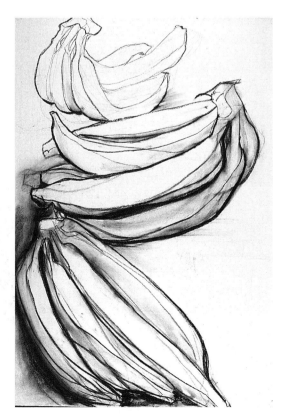

FIGURE 6–21
ANNE BAGBY, Middle Tennessee State University
Student drawing: still life with lines of varying weights
Charcoal, 30 × 22"
Courtesy, the artist

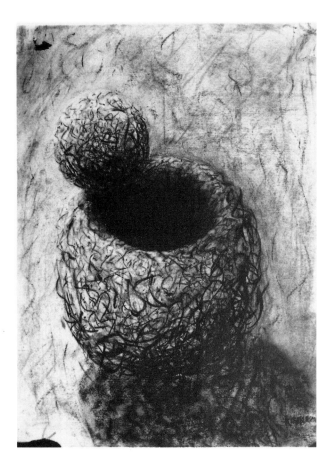

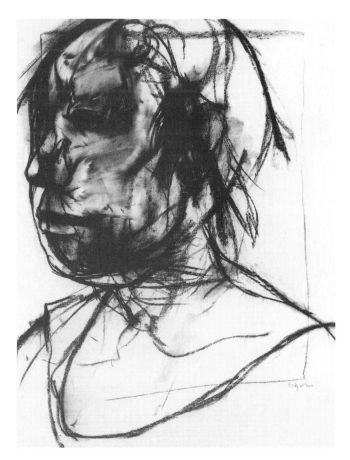

FIGURE 6–22
WILLIAM KESTERSON, University of
Arizona
Student drawing: mass gesture
Courtesy, the artist

FIGURE 6–23
MICHAEL MAZUR
Untitled (Head), 1965
Charcoal on paper, 25 × 19"
*New York University Art Collection, Grey Art
Gallery and Study Center. Gift of Paul Schapf,
1969.94 Photo: Charles Uht*

MASS GESTURE

We use the term *mass gesture* to describe a complex of gestural marks that expresses the density and weight of a form. Artists have several ways of communicating that forms have weight and spatial presence. Among them is the laying in of marks, one on top of the other, until a sense of impenetrable mass is achieved, as in the drawing of a clay form (Fig. 6–22). In the Mazur drawing (Fig. 6–23), dark gestural marks imply the bulk of a human head.

Exercise 6B *Prepare yourself for this exercise in mass gesture by imagining what it would be like to tunnel into a mountain or to bore a hole through a block of granite.*

***Drawing 1.** Using a stick of charcoal, draw from objects that are simple and compact in form (such as boulders, root vegetables, tree stumps, or stacks of books), concentrating on the sheer quantity and density of their matter. As you draw each object, begin by scribbling some tight, hard, knotlike marks to represent its core, or most active part. Ask yourself, if you had x-ray vision, where would your eyes have to pass through the most matter to come out on the other side? Without lifting your charcoal from the paper, build out from the core with random scribbling, gradually lightening your pressure on the charcoal until you have reached the outer surfaces of the form. Alternatively, use broad strokes with a soft medium such as chalk or charcoal to express the weight and general volume of a large form, as in the Rembrandt drawing of an elephant (Fig. 6–24).*

***Drawing 2.** Another way to indicate mass is through exploratory contour. Choosing a more complex subject this time (such as a human figure), indicate with a flurry of small marks those portions of the form that are turning away from the picture plane (Fig. 6–25).*

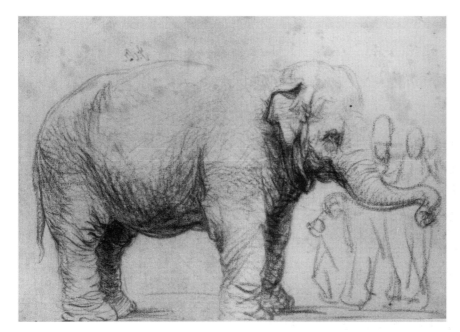

FIGURE 6–24
REMBRANDT
An Elephant, 1637
Black chalk, 17.7 × 25.5 cm
© *The British Museum*

FIGURE 6–25
TAMARA MALKIN-STUART, New
York Studio School of Drawing,
Painting and Sculpture
Student drawing: mass expressed
using an exploratory contour
Conté crayon, 22 × 30"
Courtesy, the artist

CROSS CONTOUR

Cross contours are lines that appear to go around a depicted object's surface, thereby indicating the turn of its form. You have already seen cross-contour lines in the drawing by Agnes Denes (Fig. 6–14).

Some forms have cross-contour lines inherent to their structure, such as the wicker beehives in Figure 6–26. In the Rockwell Kent drawing (Fig. 6–27), the natural contour lines existing on the ribbed surface of the lifeboat are visible in the small illuminated triangle on the right. On the other side of the boat, these lines are lost in shadow, but the artist indicates the shadow with lines that curve around the boat's surface in the way that the natural cross-contour lines do.

Cross-contour line need not be as precise or literal as in the above-mentioned illustrations. In the drawing by Ernst Barlach (Fig. 6–28), the cylindrical masses of the woman's body are forcefully shown by the gestural lines sweeping across her

FIGURE 6–26
Workshop of Pieter Brueghel
the Elder
The Bee Keepers
Pen and brown ink, 204 × 315 mm
The Fine Arts Museums of San Francisco,
Achenbach Foundation for Graphic Arts
purchase, William H. Noble Bequest Fund
(1978.2.31)

FIGURE 6–27
Rockwell Kent
The Kathleen, 1923
Ink on paper, 6⅞ × 7⅜"
(17.46 × 19.37 cm) Image 6½ × 7¼"
Whitney Museum of American Art, New York
Photograph by Geoffrey Clements (31.548)

FIGURE 6–28
ERNST BARLACH
Woman Killing a Horse, 1910–1911
Charcoal on paper, 10¹¹⁄₁₆ × 15⁵⁄₁₆"
(27.1 × 38.9 cm).
Solomon R. Guggenheim Museum, New York.
Photograph by Robert E. Mates,
(48.1172.X189)

form. These lines impart to her image an illusion of solidity and power that makes credible the idea that she is more than a match for the much-larger horse.

In his drawing of vessels, Figure 6–29, glass artist Dale Chihuly develops a strong sense of form with no recourse at all to outer contour. The heavily dimpled surface of the top study is amply indicated by a loose and varied collection of cross-contour lines and marks. In the two spherical forms at the bottom of the page, the lines weave about in a more continuous fashion, giving the impression of massive but transparent receptacles.

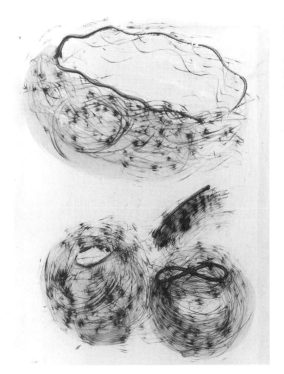

FIGURE 6–29
DALE CHIHULY
Untitled, 1983
Graphite and watercolor on paper,
22 × 30"
Courtesy of the Chihuly Studios

Exercise 6C *Cross-contour marks and lines reinforce the apparent solidity of depicted forms. To become more adept at executing cross contour, follow the steps of this exercise.*

Drawing 1. Find a subject with naturally occurring cross-contour lines. Objects such as birdcages or open-weave baskets make ideal subjects because their relative "transparency" allows you to trace their cross-contour lines around to the far side of their forms.

Observe how the cross-contour lines reveal the structure of your object. Avoiding the outer edges of your subject, draw lines that record the relative angles or sweeping curves of its cross contours. Be selective, especially if your subject is very detailed. In other words, draw only those lines that best give a sense of the form.

Drawing 2. Find an object with both swelling and indented surfaces. If possible, draw directly on the object, creating a series of parallel lines that circle around its form. (Think of them as the latitude lines on a globe.)

Represent your subject with a loose system of cross-contour marks, referring to the parallel lines on the form to better understand the major turns of direction of the form's surface. If your approach to this drawing is very gestural, use marks that appear to wrap around the entire form, as in the Chihuly drawing (Fig. 6–29).

PLANAR ANALYSIS

To investigate and give spatial definition to curvaceous forms, artists sometimes turn to planar analysis. Planar analysis entails a structural description of a form, in which its complex curves are generalized into major planar, or spatial, zones.

Planar analysis is especially helpful when the surface of the form is composed of numerous undulations or if the outer contour of the form gives no clue to the surface irregularities within its shape. A pillow, for instance, may have a geometric shape from some aspects, but this shape will not communicate the plump curves of its form. In Figure 6–30, the volume of a pillow has been expressed through planar treatment.

Artists frequently find planar analysis a valuable aid in portraiture, as it forces the artist to abstract the general forms of the face rather than be misled into making a "composite drawing" of individual features. Notice that in Figure 6–31, each facet has been given an informal "hatched-line" pattern that further defines the structure of the face. (The term *hatched line* refers to an area of massed strokes that are parallel or roughly parallel to each other.)

FIGURE 6–30
A<small>LBRECHT</small> D<small>URER</small>
(German, 1471–1528)
Six Pillows
Pen and brown ink; 10^{15}/₁₆ × 7^{15}/₁₆"
(27.8 × 20.2 cm)
Drawings. 15th C., 1493. The Metropolitan Museum of Art, Robert Lehman Collection, 1975. (1975.1.862 verso)

FIGURE 6–31
SEAN P. GALLAGHER
Interior (planar analysis self-portrait)
Graphite, 24 × 18"
Courtesy, the artist

FIGURE 6–32
LUCA CAMBRIASO
ITALIAN, 1527–1585
The Arrest of Christ, 1570–1575
Pen and ink
Courtesy, the Frederick & Lucy S. Herman Foundation and the Muscarelle Museum of Art

In Figure 6–32, planar analysis is used to make the spatial gesture of articulated forms more apparent. And in turn, the choreographing of these blocked-in figures dramatizes the depth of the stagelike space.

FIGURE 6–33
Brad Kuennen, Iowa State University
Student drawing: self-portrait using planar analysis and hatched line
Courtesy, the artist

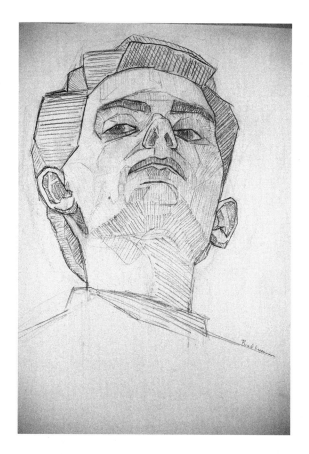

Exercise 6D *Planar analysis is an excellent way to uncover the large, more simple structure that underlies complex-looking forms. As a practical introduction to planar analysis, we have designed this exercise.*

Choose a soft or semisoft form to draw. A sofa cushion, a slightly dented felt hat, or a half-stuffed canvas or leather bag are all good subjects. If you are particularly ambitious, you may choose to make a planar analysis of a model's face, as in Figure 6–33.

Look at the curved surfaces of your subject. Can you consolidate them into a series of abutting planes? To help, look for any slight crease, raised or indented, that might be interpreted as a planar division. A small lamp or flashlight may help you see these subtle divisions. If possible, outline them by drawing directly on the surface of the object. Continue tracing these planar divisions until the entire form appears to be made up of small facets.

Do a drawing of your object, copying the planar structure that you have imposed on it. To indicate the changing inflections of the surface, you may wish to add a hatched line pattern to the individual planes, as in Figure 6–31.

Surface Structure of Natural Forms

In examining a natural form, you may want to consider whether its surface character is a result of the play of internal or external forces. The surfaces of living things are generally determined by internal forces and structures, whereas the surfaces of inanimate objects are generally determined by external forces, such as gravity or erosion.

Concavities in forms are often a result of erosion. In the landscape by Ruskin (Fig. 6–34), one sees a huge concave scar in the mountainside, evidence of the grinding passage of a departed glacier. Within a much shorter temporal span, we may witness the concave shapes caused by the action of wind on sand dunes or the pressure of wind on a sail.

Forms that are a result of natural growth rarely possess any true concavities. If you carefully scrutinize any apparently concave surface on a living form, chances are you will discover that it is actually made up of several convex areas. This is demonstrated well in the Segantini (Fig. 6–35), where there are many

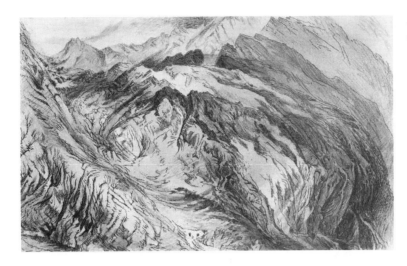

FIGURE 6–34
JOHN RUSKIN
Study of Part of Turner's Pass of Faido
Ashmolean Museum, Oxford

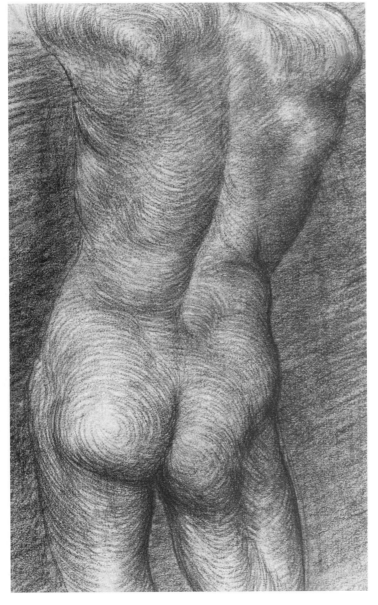

FIGURE 6–35
GIOVANNI SEGANTINI (1858–1899)
Male Torso
Black crayon and charcoal fixed on buff wove paper, 31.1 × 19.6 cm
Courtesy of The Fogg Art Museum, Harvard University Art Museums. Bequest of Grenville L. Winthrop (1943.542)

FIGURE 6–36
John Auguste Dominique Ingres
Three Studies of a Male Nude
Lead pencil on paper, 7¾ × 14⅜"
The Metropolitan Museum of Art, Rogers Fund, 1919 (19.125.2)

points at which the outer contour of the form becomes concave. Yet in all cases, these apparent concavities are explained by the coming together of two or more convex forms.

Convex forms give the impression of dynamic internal forces. Most organic forms possess an internal structure that thrusts against the surface at particular points. Bones protrude against the skin at the joints, contracted muscles bulge at specific places, peas swell in their pods, and so forth. The presence of internal force points is elegantly shown in Ingres's drawing of a male nude (Fig. 6–36).

Because the interpretation of the surface qualities of figures is dependent on an understanding of the underlying anatomical structure, figurative artists often devote considerable study to anatomy. If you expect that you will be engaged in work with the human figure, you ought to be familiar at least with the human skeleton (Fig. 6–37).

FIGURE 6–37
Christine McKay, University of Montana
Student drawing: study of a skeleton
18 × 24"
Courtesy, the artist

Whenever you draw a form that has compound curves, you should stop to analyze the forces that make them concave or convex. And remember that concave forms are generally caused by external forces and that organic forms, or those created by growth from within, are generally convex. (This holds true as well when you make sculpture. Convex surfaces seem to belong naturally to their volume, whereas concave forms suggest the hand or tool of the sculptor.)

TOPOGRAPHICAL MARKS

Topographical marks are any marks used to indicate the turn of a depicted object's surface. Cross-contour lines and the hatched lines that artists frequently use to show the inflection of planes are both topographical marks.

Topographical marks can be seen in the Kollwitz (Fig. 6–38), in which short, parallel strokes follow the surface curvature of the heads. This work is of special interest because the smaller sketch, in which the marks describe the general form of the head, appears to be preparatory to the larger one, in which the topography of specific facial forms as well as the texture of the hair are indicated.

A looser and more spontaneous application of topographical marks can be seen in the drawing by Marsden Hartley (Fig. 6–39). The speedy marks in this drawing clearly suggest the presence and turn of rounded surfaces but seem reluctant to pin them down, an effect well befitting a portrayal of human work rhythms.

Topographical marks can also be highly controlled, as in the drawing by Victor Newsome (Fig. 6–40). This drawing uses several different systems of marks to indicate the form of the head. The general form is built out from the picture plane by a set of concentric oval shapes, which function similarly to the contour lines showing relative altitude on a topographical map. A second set of lines crosscuts and circles the head, like the latitude lines on a globe. A third set includes the ribbed bands that wrap around the head turban-style and the fine lines running in general over the terrain of the skull, which indicate the play of light and shadow.

TEXTURE

Another topographical feature that you might wish to consider when dealing with the surface of an object is *texture*.

FIGURE 6–38
KATHE KOLLWITZ
Two Studies of a Woman's Head,
c. 1903
Black chalk on tan paper,
19 × 24¾"

The Minneapolis Institute of Arts. Donated by David M. Daniels. © 2003 Artists Rights Society (ARS), New York/VG Bild-Kunst, Bonn

FIGURE 6–39
MARSDEN HARTLEY (1877–1943)
Sawing Wood, c. 1908
Pencil on paper, 12 × 8⅞"
*Collection of the Whitney Museum of
American Art, New York; Gift of Mr. and
Mrs. Walter Fillin. Photograph by Geoffrey
Clements (77.39)*

FIGURE 6–40
VICTOR NEWSOME (b. 1935)
Untitled, 1982
Pencil, ink, and tempera,
22⅞ × 23½"
*Signed and dated upper left. Courtesy
Grosvenor Gallery (Fine Arts) Limited*

The texture of an object is sometimes directly related to its overall structure or organization, as in the convolutions of the human brain or the spiny, corrugated texture of a cactus. The texture of foliage, so skillfully rendered by Thomas Ender (Fig. 6–41), is a further example of texture that is inseparable from form.

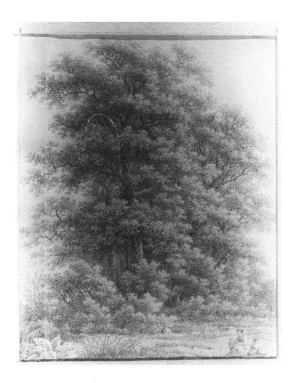

FIGURE 6–41
THOMAS ENDER
*Woman and Children in Front
of a Tree*
Pencil, 9 × 7¼"
*Courtesy, the Frederick and Lucy S. Herman
Foundation and the Muscarelle Museum
of Art*

At other times, texture is a mere surface effect that bears no direct relation to the internal structure of the form; fur on an animal, the clothes on a human body, and the shiny chrome on a car fender are all examples of texture that is "skin deep."

But even a superficial texture will sometimes provide you a valuable clue about the particular turn of a form, as can be seen by looking at Figure 6–42, in which the pencil strokes that indicate the fine texture of the hair and beard also model the volume of the head.

FIGURE 6–42
WILLIAM CONGER
Self-Portrait, 2000
Pencil on paper with gouche
touches, 13 × 10"
Courtesy, Kathleen Conger

FIGURE 6–43
GRANT WOOD (1892–1942)
Dinner for Threshers (Study for
rights section of the painting), 1933
Pencil 17¾ × 26¾"
*Collection of the Whitney Museum of
American Art, New York. © Estate of Grant
Wood/Licensed by VAGA, New York.
Photograph by Geoffrey Clements (33.80)*

PATTERN

Surface pattern helps a viewer grasp the curvature or shifting angles of a surface.

In the Grant Wood drawing (Fig. 6–43), note the pattern on both flat and rounded surfaces. On the angled flat surface of the dividing wall, the wallpaper pattern is drawn in perspective. The lattice pattern found on both the tablecloth and a farm woman's dress is an example of the way patterns can illusionistically wrap around a curved form, adding to its impression of solidity.

Exercise 6E *Explore the surface structure of a form by using topographical marks, pattern, or texture. In the drawing of a seashell (Fig. 6–44), the student has used a tight system of topographical marks to indicate the numerous protrusions on this natural form.*

FIGURE 6–44
KARI PATTERSON, Arizona State
University
Student drawing: topographical
marks used to represent a seashell
Pencil, 10 × 15"
Courtesy, the artist

Form in Light

The vivid impressions of form we receive through certain lighting effects have preoccupied Western artists for a long time. Consider the following observations recorded by Leonardo da Vinci in his *Trattato della Pittura:* "Very great charm of shadow and light is to be found in the faces of those who sit in doors of dark houses. The eye of the spectator sees that part of the face which is in shadow lost in the darkness of the house, and that part of the face which is lit draws its brilliancy from the splendor of the sky. From this intensification of light and shade the face gains greatly in relief . . . and beauty."

This admiration for light's descriptive and transformative powers persists unabated today. In the drawing by Claudio Bravo (Fig. 7–1), the dramatic use of

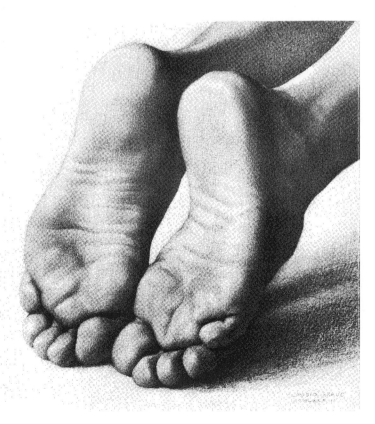

FIGURE 7–1
CLAUDIO BRAVO
Feet, 1983
Charcoal and pencil on paper,
15 × 15", signed and dated lower right
Private collection. Courtesy, Marlborough Gallery, New York

145

light and shadow has changed an unremarkable subject into a thing of great love-
liness. We are transfixed by the sheer voluptuousness of the form, and also by the
quality of light in which it is bathed.

The Directional Nature of Light

In the Bravo drawing, we have a strong impression that the light, diffused as it
may be, is nevertheless coming from one dominant direction. If we were to at-
tempt to pinpoint the source of the light within three-dimensional space, we
would say that it is located in front, above, and to the left of the subject. We make
this calculation by observing the position of the lights and darks on the form and
also by observing the angle of the shadow cast by the feet on the floor.

We can locate the light source in Figure 7–2 with just as much certainty. Since
the left-hand walls and portions of roofs in this drawing are illuminated, and the
shadows are cast in front of the buildings, we can assume that the light source is
fairly high and located off to the left and in back of the subject. (By observing the
length of the cast shadows, we can even conjecture that the subject is portrayed at
midmorning or midafternoon.)

Now, look at this drawing overall and you will see that a definite pattern
of light and dark emerges. Most of the planar surfaces that face left, most of
the ground plane, and all surfaces parallel to the ground plane (such as the tops of
the broken walls) are illuminated. All surfaces roughly parallel to the picture
plane and those portions of the walls that are under eaves are in shade.

As a last example, note the direction of light in the drawing by Wayne
Thiebaud (Fig. 7–3). In this case, the fairly high light source is located directly to
the right of the subject. That it is neither in front nor in back of the subject is clear
from the horizontal direction of the cast shadows.

Value Shapes

Value refers to black, white, and the gradations of gray tone between them. Fig-
ures 7–2 and 7–3 can be described as drawings that emphasize value over line.
Notice that in both of these drawings, the subject's lights and darks have been rep-
resented by value shapes; that is, each shape in the drawing has been assigned a
particular tone that is coordinated with the values of other shapes in the drawing.

Take special note of how the subject in Figure 7–3 has been restricted to
shapes of black and white, making it a two-tone drawing. Two-tone drawings are

FIGURE 7–2
VALENTIJN KLOTZ
View of Grave, 1675
Pen and brown and gray ink and
blue watercolor washes
Courtesy, Courtauld Institute Gallery,
Somerset House, London

FIGURE 7–3
WAYNE THIEBAUD
Pies, 1961
India ink on paper, 19 × 24⅞"
© *Wayne Thiebaud/Licensed by VAGA,
New York, NY.*
*Rose Art Museum, Brandeis University,
Waltham, Massachusetts. Gift of the Friends
of the Rose Art Museum Acquisition Society.*

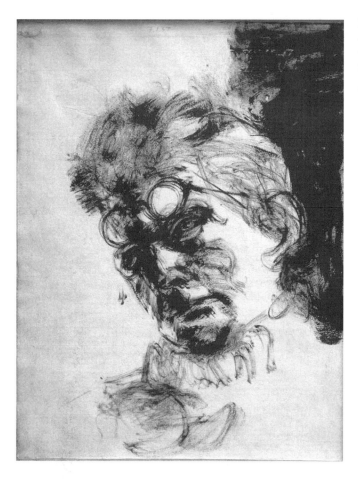

FIGURE 7–4
AVIGDOR ARIKHA
*Samuel Beckett with Glasses on
Forehead,* January 7, 1967
Brush and ink on paper, 10¹⁵⁄₁₆ × 8⁹⁄₁₆"
Collection, the artist

not limited to black and white, however; they can be made by pairing any two values from black, through the intermediate grays, to white.

As we have just seen, the use of value shapes is admirably suited to creating an illusion of light striking flat surfaces. But rounded surfaces can also be implied in a drawing if the value shapes correspond to the way areas of light and dark follow the curve of the form.* In the drawing of Samuel Beckett (Fig. 7–4), value

*The use of *chiaroscuro* to create the illusion of tones blended on a rounded form is discussed later in this chapter.

has been massed into semi-amorphous shapes that convey an impression of a rugged but melancholy visage.

Exercise 7A *This exercise in value shapes will assist you in expressing a convincing sense of form and light with a minimum of means. Appropriate media include charcoal, brush and ink, black and white gouache or acrylic, and collaged papers.*

Before proceeding, remember that when using value to distinguish between two planes that are located at different angles to a light source, you should be careful to carry the tone all the way to the edge of the shape. Notice that in Figure 7–5a, in which the boundaries between planes are indicated by lines surrounded by white margins, the illusion of abutting planes is not so clear as in Figure 7–5b.

Drawing 1. *This drawing will be done using two tones. In a somewhat darkened room, arrange some brown cardboard cartons so they are illuminated by one strong spotlight. Under this kind of lighting, the shadowed sides of the cartons, their cast shadows, and the darkened surroundings (or "background") will be converted into a single, uniform, dark tonality. The illuminated tops, sides, and ground plane will figure as the light value.*

Draw two squares in the margin of your paper. Fill one with the dark tone you see in your subject, the other with the light tone. If white is to be the lightest value and you are using gouache or acrylic, paint the one square white; otherwise leave it the tone of your paper.

Using the squares as your tonal key, draw the subject as areas of light and dark. Since a system of value shapes is the emphasis of this exercise, it is not necessary to make a preparatory line drawing. Remember that adjoining planes identified as all dark or all light should be consolidated into one shape (for an example, refer to Fig. 7–3).

Drawing 2. *This time you will use three values. Depict the cartons (or other angular objects) by making a collage of torn paper, in tones of black, white, and middle gray (Fig. 7–6).*

Drawing 3. *On a sheet separate from your drawing paper, make a row of five contiguous tones, from light through middle gray to dark. Note that tones two and four will be an average of the middle gray and, respectively, the lightest and darkest values in the end squares.*

Utilizing all five tones, depict a set of common objects against a ground plane of one constant value (Fig. 7–7).

Figure 7–8 shows a variation on this exercise employing collaged photocopies to achieve a greater number of values.

FIGURE 7–5

(a) (b)

FIGURE 7–6
Student drawing: torn paper
collage in three values

FIGURE 7–7
Student drawing: use of five
values to express light and form

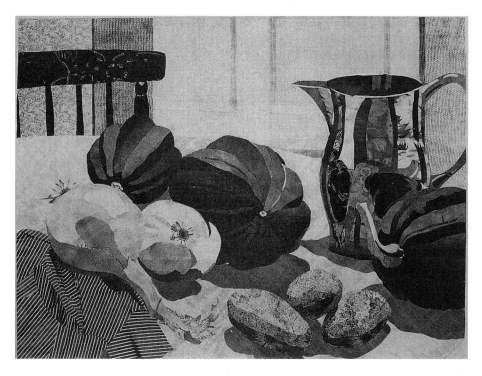

FIGURE 7–8
MILLY TOSSBERG, University of
Montana
Student value study: value study
using collaged photocopies
18 × 24"
Courtesy, the artist

Local Value

Two factors regulate the amount of light that is reflected off a surface. The first is the degree of illumination the surface receives. This is determined by the angle of the surface in relation to the light source: Surfaces perpendicular to the rays of light will appear the brightest; those parallel to the rays will be of middle brightness; and those turned away from them will be the darkest.

The second factor is the inherent color of an object's surface. The surface of an object that is dark in color, such as a desk with a deep walnut finish, will reflect less light than one that is equally illuminated but of a paler color, such as a powder blue telephone. So a basic attribute of any color is its relative lightness or darkness. Artists who work with traditional black-and-white drawing media analyze the lightness or darkness, or color tone, of objects and record them as value.

Often, artists squint at their subjects, concentrating on how the eye, much like the lens mechanism of a camera, admits the relative lights and darks of the colored surfaces they want to draw. This strategy allows them to more readily ignore the colors and identify the *inherent* tonality of each object's surface. This inherent tone, free of any variations that result from lighting effects or surface texture, is commonly referred to as the *local value* of an object.

Local values can be broadly translated into shape areas, as in Figure 7–9. In this early drawing by Picasso, the dark tone of the seminarians' robes contrasts sharply with the paleness of their faces and likewise with the delicate tones of the ground plane and surrounding walls. The middle gray of the trees has a calming and softening effect on this otherwise stark portrayal.

Picasso's decision to limit his tonal palette to the local value of each individual area in Figure 7–9 heightens the work's expressive impact. Frequently, though, artists wish to consider not only the local value of their subject but also the major variations of surface tone caused by light. In this case, the local value can function as a tonal center, or constant, to which artists can relate the variable lights and darks they interpret from an object. To clarify this point, look at Figure 7–10, in which the rectangular shafts of light are each divided into three carefully measured tones to register respectively the local values of the wall, molding, and blackboard.

Armed with an awareness of local value, you will gradually become more sensitive to the intimate alliance between the essential lightness or darkness of an

FIGURE 7–9
PABLO PICASSO
Priests at a Seminary
Pen, ink, watercolor
Private collection. Photo courtesy of the Museum of Art, Rhode Island School of Design. © 2003 Estate of Pablo Picasso/Artists Rights Society (ARS), New York

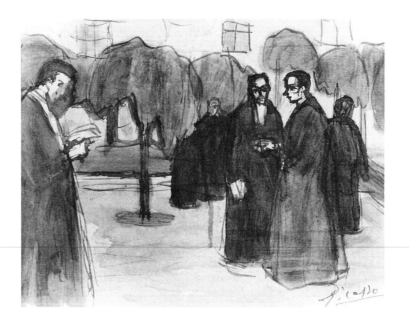

FIGURE 7–10
NORMAN LUNDIN
San Antonio Anatomy Lesson, 1982
Pastel and charcoal, 28 × 44"
Courtesy of Space Gallery, Los Angeles

object and the value variations that appear on its surface. As a consequence, any tendency to represent all light as white and all shadows as black will be moderated by personal observation. In actuality, such extremes of light and dark on a single form are rare under normal lighting conditions. More often you will notice that only objects with a local value of dark gray will approach black in the shadows, and the highlight on such a form will seldom exceed middle gray. Similarly, the local value of an egg simply does not permit a coal black shadow.

Directional Light and Local Value

In his watercolor *Houses in Gloucester* (Fig. 7–11), Edward Hopper indicates both a directed source of light and a range of local values. Although any sense of a tonal center in most of the roofs is obliterated by the powerful light of the sun, local values are clearly evident in the shaded portions of the houses. Compare this image with Figure 7–2, in which all the buildings and the ground plane are treated as if they were of identical local value.

When you combine an interest in directed light with the use of local value, it is best, whenever possible, to control the source of illumination. Strong lighting, such as that provided by direct sunlight or the use of a spotlight alone, produces a

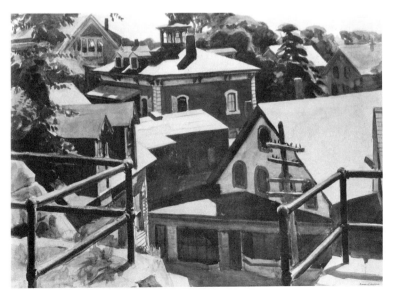

FIGURE 7–11
EDWARD HOPPER
Houses in Gloucester
Watercolor, 13½ × 19½"

*Collection of Mr. and Mrs. James A. Fisher,
Pittsburgh, Pennsylvania (APG 10044 d)*

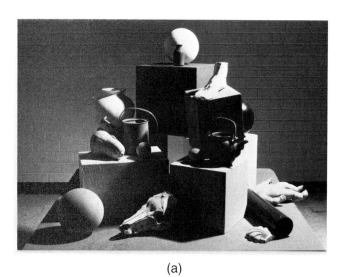

(a)

(b)

FIGURE 7–12

sharp contrast between lights and darks and thus makes it difficult to see local value (see Fig. 7–12a). An even light, such as found in a room well lit by fluorescent tubes, reveals local value very well, but since such light is nondirectional it does not show the form of an object to advantage. The ideal lighting condition for observing both the local value and the form of an object is one in which the light is directional but not harshly so, such as might be found by a window that does not admit direct sunlight (Fig. 7–12b).

To give the illusion of both directional light and local value, you need to have a command over a range of tones. To acquaint yourself with the tonal spectrum of which your medium is capable, we suggest that you make a scale of nine separate values. The value scale in Figure 7–13 is particularly useful because the dot of middle gray in the center of each square demonstrates the relative nature of value. The same middle gray that appears as a dark spot in the midst of light-toned squares appears as a pale spot within the context of the darker values.

In making a scale of this kind, we suggest that you start by lightly outlining nine adjoining squares with a circle in the middle of each one. Place the darkest and the lightest tones that you can achieve with your medium on opposite ends of the scale, taking care to leave the circles blank. Then proceed to fill the middle square and the circles with a middle gray. Finally, fill in the remaining squares so that there is an equal jump in tone between them. Remember to blend each individual tone thoroughly, leaving no white margin or black dividing line between the squares.

Exercise 7B *Representing a directed source of light in a drawing will lend a sense of authenticity to the objects you portray. Care in relating the variable tones of an object to a tonal center will give your interpretation of those objects a convincing sense of unity and wholeness and also add optical richness to your drawing overall. This project helps you to apply both of these concepts in drawings of relatively simple, common objects.*

Collect some boxes or other angular objects of different local values. You may even wish to paint these boxes black, gray, and white using a cheap brand of house paint. Experiment with both the intensity and the direction of your lighting so that both the local values and the forms of the boxes are seen to advantage. It is also advisable to view these objects against a medium-gray background so as to provide you with a constant reference point when gauging values in your subject.

In a row of squares along one margin of your paper, indicate the local value of each object in your subject, going from left to right. Now, depict the planes of each object as a value shape, making sure that the tones you put down are within a range of lightness or darkness appropriate to the tonal center, or local value, of that object.

You may want to establish the boundaries of the very lightest shapes first, that is, those you wish to have remain the white of your paper. Give the rest of the page a light gray tone and then proceed to fill in the very darkest and middle-gray shapes. After these have been drawn, move on to the remaining intermediate tones.

Here are some ideas for studies in local value that you can do outside the studio setting. Draw a set of buildings under different lighting conditions to experience the effect light can have on your perception of local value. Or do a portrait in value shapes with the aim of expressing the local value of skin and hair when illuminated by a direct light source (Fig. 7–14). Another option is to discover the visual presence that local value imparts to objects in the everyday world, perhaps in an object as mundane as the top of your stove seen by the glare of a kitchen light (Fig. 7–15).

FIGURE 7–13

Optical Grays

Certain dry media, such as pastel and charcoal, and wet media, such as ink wash, watercolor, gouache, and acrylic, are commonly used to make solid *actual* gray tones. Media more suited to a linear approach, such as pen and ink, pencil, felt-tip marker, and silverpoint, can be used to create *optical* gray tones. Optical grays are commonly the result of hatched or "crosshatched" lines, which the eye involuntarily blends to produce a tone. The term *hatched lines* refers to an area of massed strokes that are parallel or roughly parallel to each other. *Cross-hatching* is a technique that results when sets of these lines intersect one another.

Optical grays can be utilized to achieve the same ends as blended or actual grays. In the drawing by Gaspard Dughet (Fig. 7–16), hatched parallel lines indicate the relative tones of trees and sky. Notice that the hatched lines do not change direction in an attempt to show the topography of the form. Instead, their role is restricted to the depiction of light and dark. In spite of their mechanical look, hatched lines of this sort are well suited to drawing natural subjects. And in contrast to areas of subtly blended tone, the rapid laying in of hatched lines appears to allow a form to breathe.

A robust and gestural use of crosshatched lines to construct shadows can be seen in Figure 7–17. Notice how varying densities of hatched lines help to establish the spatial position of the forms and their gradual emergence from the shadows. This approach to value is an additive one; in other words, the artist began with some selective scribbling and continued to add marks here and there until the form was sufficiently developed.

An additive approach is particularly evident in Figure 7–18, which showcases an unorthodox technique for achieving optical grays. In this stamp pad ink drawing by Chuck Close, fingerprints of different intensities have been carefully dabbed onto a grid.

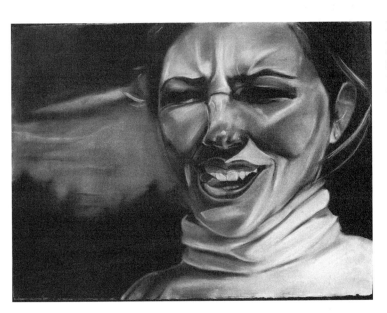

FIGURE 7–14
Aaron Wardell, University of Wisconsin, Whitewater
Student drawing: portrait using toned shapes to express local value
Courtesy, the artist

FIGURE 7–15
M. Austin Gorum, Pratt Institute
Student drawing: use of local
value to enrich the depiction of
common objects, 3.5 × 4"
Courtesy, the artist

FIGURE 7–16
Gaspard Dughet
Landscape
Red chalk, 27.4 × 41.3 cm
*Princeton University Art Museum, Gift of
Margaret Mower for the Elsa Durand Mower
Collection*

FIGURE 7–17
HENRY MOORE (1898–1986)
Women Winding Wool, 1949
Crayon and watercolor on paper
13¾ × 25"
*The Museum of Modern Art, New York.
Digital Image © The Museum of Modern
Art/Licensed by Scala/Art Resource, NY
Gift of Mr. and Mrs. John A. Pope in honor of
Paul J. Sachs (244/1962)*

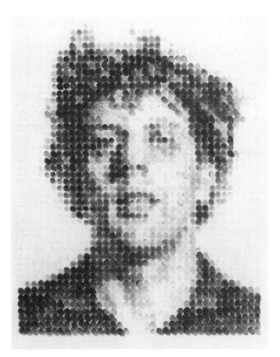

FIGURE 7–18
CHUCK CLOSE
Phil/Fingerprint II, 1978
Stamp pad ink and pencil on
paper, 29¾ × 22¼"
*Collection of the Whitney Museum of
American Art, New York. Purchase with
funds from Peggy and Richard Danziger
(78.55)*

Drawing with hatched and scribbled lines is an excellent way to record your spontaneous impressions of things observed. For this reason, scribbled-tone drawing is an especially useful sketchbook practice, so you will probably have ample recourse to it in the future.

 For this exercise, we suggest using a felt-tip marker, since it is ideal for fast renderings of objects. Start by making a value scale of nine optical grays (Fig. 7–19). This will help you to gain sufficient control with your felt-tip marker to begin making drawings of actual objects.

 Next, find an object that possesses a fairly complex system of concavities and convexities and place it where it will receive illumination from basically one direction. Draw the major shadows with your marker, using either a carefully hatched or scribbled line. Continue adding marks until the form starts to appear. Areas of darkest shadow will ultimately receive the most attention. Fig. 7–20 is an example of carefully controlled scribbled line used to build optical grays.

Exercise 7C

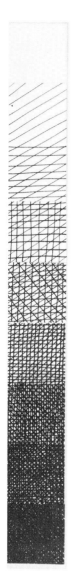

Chiaroscuro

Chiaroscuro is an Italian term that basically translates to mean light and dark. In the pictorial arts, chiaroscuro refers more specifically to a gradual transition of values used to achieve the illusion of how light and shadow interact on actual, three-dimensional forms.

However, only certain kinds of light adequately reveal the curvature of a rounded form. A very harsh light, for instance, tends to flatten areas of light and dark into value shapes, as the earliest masters of chiaroscuro knew. Leonardo cautioned against drawing under any lighting conditions that cast strong shadows. In his *Trattato della Pittura* he outlines specific recommendations for illuminating the head of a young woman so that it can be drawn with all its delicacy and charm: the model should be seated in a courtyard with high walls that are painted black, and direct sunlight should be excluded from the space by a roof fashioned of muslin. Whether or not Leonardo ever followed his own set of guidelines, the drawing in Figure 7–21 is certainly evidence of his fascination with the ability of light to model form.

Impractical as Leonardo's advice may be, the general point it makes is sound: A very strong light source must be avoided when the intention is to concentrate on the three-dimensionality of a subject. But, so too must the situation be avoided in which the subject is illuminated entirely by *ambient light*.

Ambient light is the opposite of a unidirectional light source since it appears to come from all directions. The familiar white-walled institutional room, lit with banks of fluorescent tubing, is drenched with ambient light. Although in some circumstances daylight can also be defined as an all-enveloping ambient light, the daylight that comes into a studio with north-facing windows is traditionally favored by people who draw. This is because it is sufficiently directional to reveal form yet not strong enough to cast harsh shadows.

Let us imagine that you are situated in a studio with north light and that the back of your left shoulder is pointed toward the window. The light source is therefore behind you, above you, and to the left. In front of you is a light gray sphere softly illumined by light coming in the window and by reflected light from the light gray tabletop.

The gradations of light that you would see on the sphere can be separated for convenience sake into five separate zones. A sixth zone is the sphere's cast shadow. These zones, illustrated in Figure 7–22, are as follows:

FIGURE 7–19

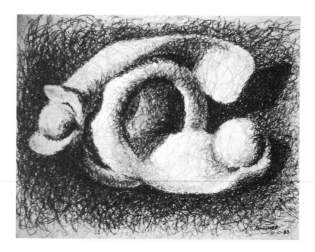

FIGURE 7–20
Student drawing: scribbled line to achieve optical grays

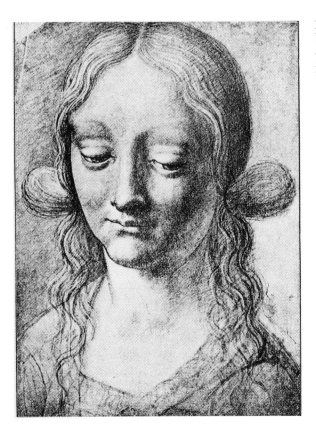

FIGURE 7–21
LEONARDO DA VINCI
Portrait of a Woman
Picture Collection, The Branch Libraries,
The New York Public Library

FIGURE 7–22

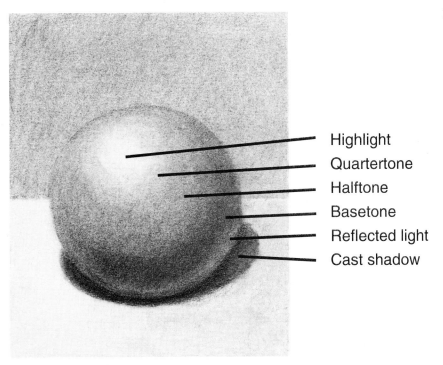

Highlight
Quartertone
Halftone
Basetone
Reflected light
Cast shadow

1. The *highlight*, or brightest area of illumination. The highlight appears on that part of the surface most perpendicular to the light source. If the surface is a highly reflective material, such as glass, the shape of the light source will be mirrored on the form's surface at the point of the highlight. If the surface of the sphere is very matte (dull, or light-absorbing, as is velvet) you may see no

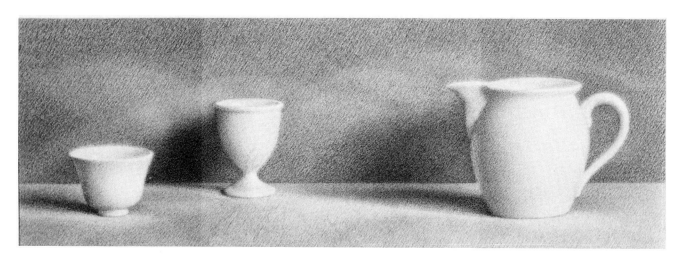

FIGURE 7–23
MARTHA ALF
Still Life #6, 1967
Charcoal on bond paper,
8½ × 24½"
Collection, Newspace Gallery, Los Angeles

highlight at all. In Figure 7–22, the surface of the form may be assumed to be semimatte.

2. The *quartertone*, or next brightest area. On a semimatte object, the highlight is blended well into the quartertone.

3. The *halftone*, which is located on that part of the surface that is parallel to the rays of light.

4. The *basetone*, or that part of the surface that is turned away from the rays of light and is therefore the darkest tone.

5. *Reflected light*, or the light bounced off a nearby surface. This light is relatively weak and will be observed on the shadowed side of the form just inside its outer contour.

6. The *cast shadow*, which is thrown by the form onto an adjacent or nearby surface in a direction away from the light source. Although there are rules of linear perspective governing the use of cast shadows, you would do best to rely on your own visual judgment to record the shapes of these shadows.

A similar organization of tones can be found in curved forms other than true spheres, as can be seen in the still-life drawing by Martha Alf (Fig. 7–23).

Exercise 7D *Set up a subject of a uniform color, such as a ball painted a flat light gray or a substantial piece of drapery (Fig. 7–24). Establish a light source a little behind you and off to one side.*
Using compressed charcoal or black conté crayon, do a chiaroscuro drawing of the subject, taking care to include all five areas of tone and the cast shadow. Use a piece of wadded newsprint or a store-bought paper stump to blend the areas of tone, thus achieving smooth transitions between them.
Avoid exaggerating the size and brightness of the highlight and reflected light. You will need to blend the edges of these areas into the surrounding tones; if you do not, they will have the illusion of pushing forward from the volume's surface.

CHIAROSCURO AND TOPOGRAPHICAL MARKS

Of all the techniques used to render form, the one traditionally favored combines the observation of the way that light falls on a form with a judicious use of topographical marks.* This technique requires that the lines or marks used to create

*See "Topographical Marks" in Chapter 6, "Form in Space."

FIGURE 7–24
MITOSH PATEL, Oklahoma State University
Student drawing: drapery study using chiaroscuro
Black and white conté, 18 × 24"

optical grays also follow the turn of the form's surface. A finely wrought example of this can be seen in Figure 7–25, in which lines of various sorts follow the turning surfaces of anatomical form and costume, while at the same time indicating a play of subdued light.

By analyzing the topography of a form simultaneously with recording the accidental play of light upon its surface, one can achieve a more convincing sculptural effect than would result either from the use of optical grays created by hatched line or by the use of topographical lines alone. This technique, after all, combines the knowledge of form that can be gained through the tactile senses with knowledge that is gained through our observation of light and shadow. And when employed in a highly controlled way, this technique is unsurpassed for its capacity to model forms of the greatest complexity and subtlety, as we have seen in Figure 7–1.

CHIAROSCURO AND LOCAL VALUE

From the High Renaissance to the early nineteenth century, chiaroscuro was considered virtually indispensable to the art of drawing. A premium was placed upon the modeling of form in the sculptural sense, as may be seen in Michelangelo's drawing of the Libyan Sybil (Fig. 7–26).

During this extended period, local value in drawing was not generally deemed important, although many artists used local color to great compositional effect in their paintings. In the nineteenth century, however, the Renaissance

FIGURE 7–25
MATHIS GRUNEWALD
*An Elderly Woman with Clasped
Hands*
Black chalk, 377 × 236 mm
Ashmolean Museum, Oxford

FIGURE 7–26
MICHELANGELO
Studies for the *Libyan Sybil*
Red chalk, 11⅜ × 8⅜"
*The Metropolitan Museum of Art.
Purchase, Joseph Pulitzer Bequest, 1924
(24.197.2 recto)*

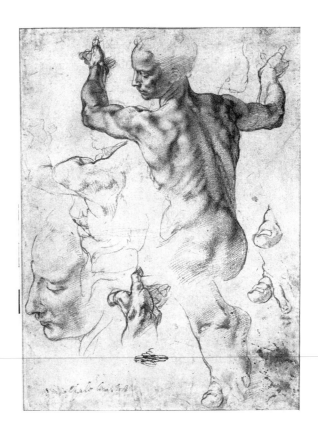

tradition of the picture plane as a window onto infinite space was replaced with a new concern for the flat working surface used by the pictorial artist. As a result of this concentration on the flatness of the picture plane, shape became a more primary means of expression than the traditional illusion of sculptural form. And with an emphasis on shape arose an increased preoccupation with local value.

By the end of the nineteenth century, artists had become adept at using local value shapes to arrive at striking compositions. Furthermore, they found that by controlling the figure–ground relationship of local values, they could achieve a graphic illusion of space, as we saw in the Picasso drawing (Fig. 7–9).

Artists frequently elect to concentrate on either the chiaroscuro modeling of a subject or its local value. This may be demonstrated by comparing the Degas study of drapery (Fig. 7–27) with the drawing of a Spanish dancer by Henri (Fig. 7–28). The drapery study lacks a sense of local value; whether the cloth portrayed is of the palest rose or the deepest purple we do not know. But since Degas' concern was to develop the intricacies of this draped garment in a sculptural manner, the tone of the actual color is of no account. In the *Spanish Dancer*, however, Henri found the play of relative local values essential to the portrayal of his colorful subject. We get a strong sense of boldly rouged lips and cheeks, dark hair, and fabric gaily splashed with a floral motif. But note that there is very little sense of chiaroscuro in this drawing.

That artists have often chosen to concentrate on either a chiaroscuro modeling of form or local value does not rule out that the two can be successfully combined in one drawing, as we see in Figure 7–29. To represent the play of light and shadow on his subject, Pearlstein employs the systematic changes of value identifiable with chiaroscuro technique. But instead of blending the tones, he records them as a sequence of value shapes that are carefully contoured to the form. The profusion of these lighting effects is always, however, kept within the boundaries of a tonal "home base," or local value. And when joined with a spectrum of clear and relatively unmodulated local values, as in the patterned rug, the almost clinical sensibility that emerges can be disquieting.

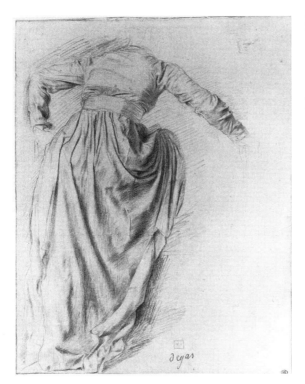

FIGURE 7–27
EDGAR DEGAS (1834–1917)
Study for Semiramis: Standing woman viewed from the back
Lead pPencil, 30.9 × 23.5 cm
Louvre, Paris. Copyright Réunion des Musées Nationaux/Art Resource, NY Photograph by Michele Bellot

FIGURE 7–28
ROBERT HENRI
Spanish Dancer
Watercolor, pencil, 10½ × 8"
*Phoenix Art Museum. Gift of Edward
Jacobson*

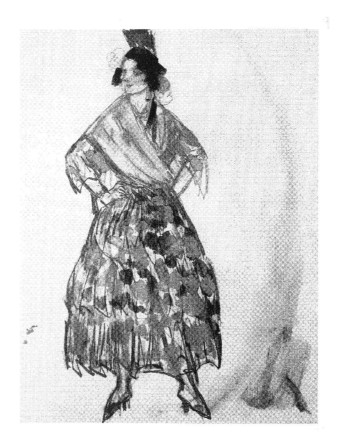

FIGURE 7–29
PHILIP PEARLSTEIN
Male and Female Mirrored, 1985
Conté crayon on paper, 32 × 40"
*© Philip Pearlstein. Courtesy Robert Miller
Gallery, New York*

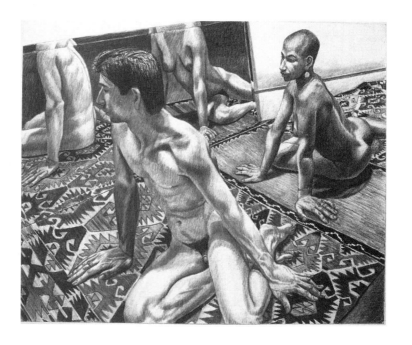

 When you wish to balance chiaroscuro and local value, you must be careful
not to let the chiaroscuro get out of hand. In the Vuksanovich drawing (Fig. 7–30),
note that the tonal identity of the model's skin is almost lost because of the wide
range of values used to describe harsh shadows, highlights, and reflected lights.

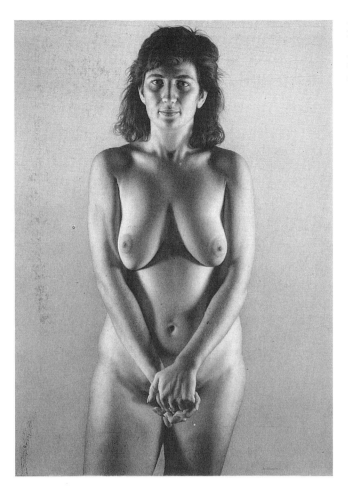

FIGURE 7–30
BILL VUKSANOVICH
Nude, 1990
60 × 44"
Courtesy, Struve Gallery, Chicago

The startingly glossy appearance that this application of value yields can in this case be explained by the artist's near-photographic rendering of the dual light source.

A related issue concerns the belief that value richness in a drawing is always dependent on the use of a full range of tones, including the high contrast of black and white. This is far from true, since many fine drawings in the history of art are composed of a limited series of closely related values that establish a dominant mood, or *tonal key*.

Tonal keys can be high (ranging from white to middle gray), middle (tones within the middle range of the value scale), and low (the dark half of the scale). *Tonal key* refers to the *overall* choices and effect of a coordinated group of values, so it would not preclude, for example, the use of dark accents in an otherwise high-key drawing.

Establishing a tonal key can be a means to both unifying the value schema of a drawing and expressing a distinctive condition of light and mood, as can be seen in Figures 7–31 (a low tonal key), 7–32 (a middle tonal key), and 7–33 (a high tonal key). Interestingly, artists sometimes transpose the actual values of their subject into another key, making sure to adjust each tonal area proportionately.

In summation, you can employ chiaroscuro without sacrificing the tonal identity of your subject as long as the range of tones used to model a form is responsive to that form's local value. Figure 7–34 demonstrates how chiaroscuro used within the confines of three different tonal keys—high, middle, and low— can give the impression of forms of distinct local values.

FIGURE 7–31
PHILLIP CHEN
Untitled, 1976
Lithograph, 15 × 22"
Courtesy, the artist

FIGURE 7–32
JOHN ROCKWELL, University of
Wisconsin, Whitewater
Student drawing: organization of
value to establish a mid-range
tonal key
Courtesy, the artist

CHIAROSCURO AND TEXTURE

The texture of an object can be drawn using chiaroscuro technique if you consider the various protrusions and indentations of the surface as form in the miniature. One example is the exposed grain of weathered wood, which, when held at the correct angle to the light, reveals itself as a pattern of shallow hills and valleys. An unusual application of this concept is found in Figure 7–35, in which an area of ocean has been conceived entirely in terms of chiaroscuro and texture.

As Figure 7–35 clearly shows, texture is best revealed by raking light, that is, a light that is directed from the side to throw textural details into visual relief. Therefore, you will find that texture is most apparent in the areas of halftone where the rays of light are most parallel to the surface of a form. This can be seen in the Claudio Bravo drawing, Figure 7–36, in which the wrinkled and pitted surface of each lemon is most visible where the form starts to turn away from the

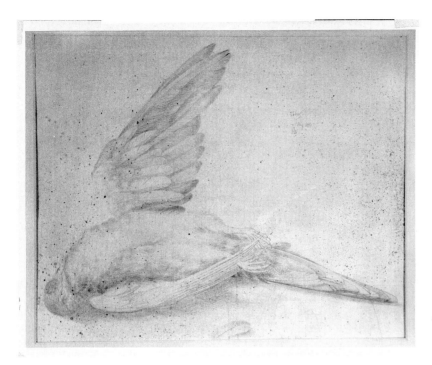

FIGURE 7–33
JOHN WILDE
Objecta Naturlica Divini, 1949
Silverpoint and ink on gessoed
paper
*Robert Hull Fleming Museum, University of
Vermont. Gift of Henry Schnakenberg
(1971.2.10)*

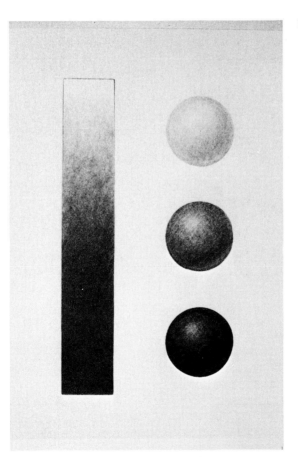

FIGURE 7–34

light. In the more illuminated areas of the surface, where the angle of the rays is
most direct, the texture is saturated with light. In the darker areas of the form, the
texture is lost in shadow.

 Texture includes the idea of the ultrasmooth as well as the very rough. When
a surface is so smooth that it is shiny, the normal guidelines of chiaroscuro do not

FIGURE 7–35
VIJA CELMINS
Ocean Image, 1970
Graphite and acrylic spray,
14¼ × 18⅞"
The Museum of Modern Art, New York.
Mrs. Florene M. Schoenborn Fund

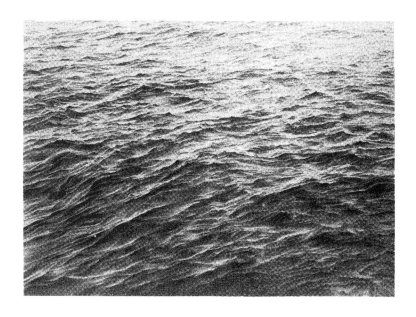

FIGURE 7–36
CLAUDIO BRAVO
Lemons, 1982
Drawing on paper, 15¾ × 13⁵⁄₁₆"
© Claudio Bravo. Courtesy, Marlborough
Gallery, New York

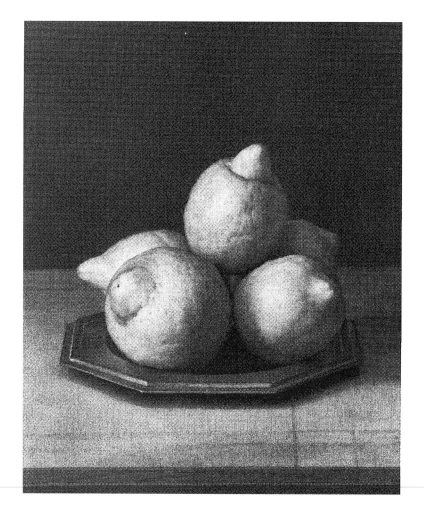

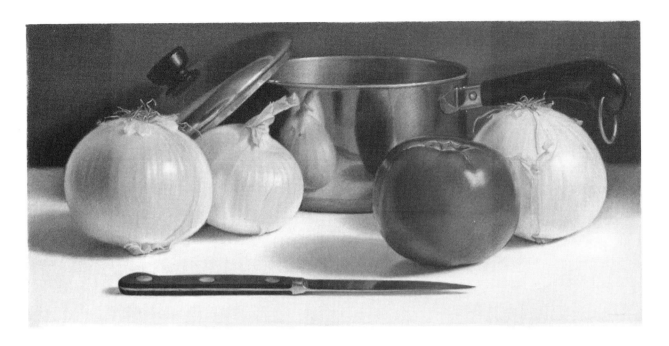

FIGURE 7–37
MARY ANN CURRIER
Onions and Tomato, 1984
Oil pastel on museum board,
26½ × 56"
Courtesy, Tatistcheff Gallery, New York

apply. In such cases, the surface reflects values from the surrounding environment, and frequently very light and very dark tones appear next to each other. An example of this can be seen in the reflective surface of the pot in the Currier drawing (Fig. 7–37).

Texture need not receive the literal interpretation seen in the last three illustrations. Instead, it can be approximated by a more spontaneous system of marks, as in the Arneson self-portrait, Figure 7–38. Notice that the light and dark marks in this drawing are graded so as to show the general turn of the form.

FIGURE 7–38
ROBERT ARNESON
Eye of the Beholder, 1982
Acrylic, oil pastel, alkyd on paper,
52 × 42"
© *Estate of Robert Arneson/Licensed by
VAGA, New York, NY. Courtesy of George
Adams Gallery, New York*

8

Subject Matter: Sources and Meanings

The preceding chapters of this book were designed to help you to master the basics of drawing. In the midst of learning these fundamentals, you may at times have wondered when you would be able to put your "basic training" aside and begin to make expressive drawings. But in truth, the drawings you have been making all along have been involved on some level with self-expression. Maybe you have even noticed that your drawings have consistently exhibited certain visual characteristics that are different from those of your classmates, even when a very specific assignment had to be carried out. Features that distinguish your drawings from those of your peers reflect your particular way of seeing and making visual order and, once recognized, will give you an inkling of your own artistic identity.

From this chapter forward, our emphasis is more fully on expressive issues in drawing. We examine how self-expression is rooted in *what* you draw and *how* you draw it and also how these two factors combine to affect the thoughts and emotions of a viewer. Or, in art terminology, we are speaking of what are often called the components of an artwork's expression: subject matter, form, and content. As an introduction to these terms, we provide the following definitions:

Subject matter is what artists select to represent in their artwork, such as a landscape, portrait, or imaginary event.

Form is the set of visual relationships that artists create to unify their responses to subject matter.

Content is the sum of meanings that are inferred from the subject matter and form of an artwork.

Subject matter, form, and content are indivisible in a work of art. To explore their expressive possibilities in depth, however, we discuss each component separately. We begin by focusing on traditional subject matter areas.

Traditional Subject Matter Areas

There are four major areas of subject matter—the human figure, landscape, still life, and the interior—that may be considered "classic" since they have survived the test of time. That all four categories are still viable today attests to the fact

FIGURE 8–1
SYLVIA SLEIGH
The Seasons, 1976
Pencil on paper, 36 × 60"
Courtesy, the artist

that they are both meaningful enough in themselves to have relevance for contemporary life and general enough to allow almost unlimited scope for personal expression.

Almost any subject you draw will in some way include the human figure, landscape, still life, or the interior. An awareness of the rich heritage of meaning attached to each of these subject matter areas should help you to consolidate your own emotional and intellectual reactions to any particular subject you choose to draw.

Although the four major subject matter areas were sometimes accorded separate treatment in Classical (Greek and Roman) art, in the Middle Ages they were for the most part subsumed into narrative works, which were usually religious but occasionally allegorical or historical. When these subjects were not essential to the story illustrated, they often appeared as incidental detail that nonetheless had allegorical content that reflected back on the larger meaning of the narrative.

Starting in the Renaissance, each of these formerly incidental areas began to reemerge as a subject in its own right. And as new symbolic content gathered around them, the set of meanings these subject areas carried from narrative painting evolved over the centuries. What follows is a brief survey of themes found within these four major subject matter areas.

THE HUMAN FIGURE

The figure as a subject in its own right was the first to reemerge from the narrative art of the early Renaissance. This happened at a time when the philosophy of humanism was initially taking shape. The humanist movement upheld the inherent dignity of the individual with the assertion that one could be ethical and find fulfillment without help or guidance from supernatural powers. The rationalist basis of this philosophy is embodied in the drawings of idealized nudes by Leonardo, and to a lesser degree in the earlier drawings of Michelangelo. This secular bent of humanism made possible a view in which human beings stand heroically alone and responsible for their own destiny. Today, the essential loneliness of the individual is a central theme around which many portrayals of the figure are constructed.

The male nudes by Sylvia Sleigh (Fig. 8–1) and Stephen Hale (Fig. 8–2) are contemporary variations on the notion of the ideal body. Although a genuine

FIGURE 8–2
STEPHEN HALE
Untitled, 1985
Graphite on paper, 40 × 30"
Private collection, NYC. Courtesy,
Bridgewater/Lustberg Gallery

FIGURE 8–3
PHILIP PEARLSTEIN
Male and Female Model with
Cast-Iron Bench and Rocker, 1982
Charcoal, 44 × 30"
Courtesy, the artist

affection and admiration characterizes the drawing by Sleigh, the prettifying of the young adult male seems to be a wry comment on the traditional depictions of the female odalisque as object of the male gaze. No such personal involvement is evident in the drawing by Hale, but rather the means for idealizing and even glamorizing the figure—the level gaze, the floodlighting that reveals the facial structure and musculature, the single prop, and the shallow space—are all appropriated from the field of fashion photography.

In contrast, the figures in the Pearlstein drawing (Fig. 8–3) are devoid of both idealized beauty and glamour, making them appear more naked than classically nude. Instead of stylizing the figures, this artist has more directly addressed the corporeality of the human body, a property that has been exaggerated by the way in which the figures fill the picture space.

In the Modern era, the idea of the lonely state of the individual found its extreme expression in the theme of alienation, of which the Georg Baselitz drawing is a contemporary example (Fig. 8–4). What is of particular interest here is the way in which the viewer is implicated in this topsy-turvy world. Common sense tells us that when we perceive the world upside down, it is our own bodily position, and not the world's, that is inverted. But common sense is absent from this drawing, for the figure is losing its head; and that head, detached literally and figuratively from the hysterical body, invites us to question whether it is we, as individuals, or the world that is insane.

FIGURE 8–4
GEORG BASELITZ
Edvards Kopf (Munch), 1983
Charcoal, 61.2 × 43.2 cm
Offentliche Kunstsammlung, Basel

FIGURE 8–5
JAN VAN EYCK
*The Marriage of Giovanni Arnolfini
and Giovanna Cenami*
Oil on panel, 33 × 22½"
*Reproduced by courtesy of the Trustees,
The National Gallery, London*

Portraiture, which may be considered a subcategory of figurative art, is often concerned with the rank or social position of the individual portrayed. In the Jan van Eyck painting (Fig. 8–5), the social rank and respectability of the Arnolfini household is alluded to by representing the couple in the context of the Sacrament of Holy Matrimony (the single candle signifies the all-seeing Christ; the little dog signifies fidelity; and the cast-off shoes signify the bridal chamber as holy ground).* In the Valerio drawing (Fig. 8–6), an updated version of this well-known image, the symbolic elements that conferred special status on the Arnolfini couple are conspicuously absent. Additionally, the shabby gentility evident in the clothing and hairstyles of this couple leaves us in little doubt about their social position.

Like Valerio, Alice Neel is concerned with depicting her subjects in the context of the *Zeitgeist*, or prevailing spirit of the times. Her drawing (Fig. 8–7) is an impassioned yet ironic portrayal of the conflict between her subject's image of himself and the way she sees him as a member of society at large. His angry and impatient glance and the furtive, admonishing gesture of his forefinger seem to

*H. W. Janson, *History of Art* (Englewood Cliffs, N.J.: Prentice-Hall, 1967), p. 292.

FIGURE 8–6
JAMES VALERIO
Mark and Barbara, 1972
Pencil on paper, 29 × 23⅛"
(73.7 × 58.7 cm)
Solomon R. Guggenheim Museum, New York.
Gift, Norman Dubrow. Photograph by
Carmelo Guadagno (83.3123)

imply that he is some kind of revolutionary. But the artist has played up the dandyish aspect of his hippy's garb so that he ultimately recalls the politically retrograde seventeenth-century cavalier.

The self-portrait is a category of figurative work to which many artists turn if for no reason other than the availability of the model. In addition, we are all curious about our own identities and often wonder how the perceptions others have of us might square with what we know about ourselves; self-portraiture can be used to explore this universal question. In expression, self-portraits range from idealized or romantic images to ones that are more insightful or even unsparing. In the multilayered self-portrait by Susan Hauptman (Fig. 8–8) the artist portrays herself in a meticulously detailed fancy dress while at the same time depicting her facial features with a hard-bitten realism.

LANDSCAPE

Landscape as a separate subject came into its own in the Low Countries sometime in the sixteenth or seventeenth centuries. The early Dutch landscape artists often found work as cartographers, and assuredly there was a crossover between the disciplines of mapmaking and landscape art at that time. Maps of countries were often decorated with topographic views of major cities, and maps of specific locations often included horizon lines (Fig. 8–9). So in the earliest phase, landscape was often a portrait, so to speak, of a particular place or region.

Looking more closely at Figure 8–9, note that the specific features of the place are portrayed in terms of their use by the region's inhabitants, including soldiers, farmers, and townspeople. Later this idea was enlarged and became an early romantic concept, that is, a feeling for the "genius" or resident spirit of a place.

FIGURE 8–7
ALICE NEEL
Stephen Brown, 1973
Ink on paper, 44 × 30"
(approximate)
Courtesy, Robert Miller Gallery. © The Estate
of Alice Neel

FIGURE 8–8
SUSAN HAUPTMAN
Silver Self-Portrait with Dog, 1999
Charcoal, pastel, and aluminum
leaf on paper, 85 × 36½"
Courtesy, Forum Gallery, New York,
Los Angeles. All rights reserved. Used by
permission of the artist

In romantic landscape, human existence is regarded as basically irrelevant, although today we may detect in such works the contrived human presence that results from an infusion of the subject with poetic spirit. All the same, the firsthand involvement that artists of this time had with nature, while they tried to catch its ever-changing spirit, often resulted in studies of surprising objectivity (Fig. 8–10).

FIGURE 8–9
C. V. KITTENSTEYN, after Pieter
Saenredam
The Siege of Haarlem
Etching
*Archiefdienst voor Kennemerland Haarlem,
The Netherlands (53–9219G)*

FIGURE 8–10
JOHN CONSTABLE
*Study of Clouds above a Wide
Landscape*, 1830
Victoria and Albert Picture Gallery

 In the work by John Virtue (Fig. 8–11), the ambition to capture the portrait of
a place has been achieved by including several views of a particular locale, in this
case a hamlet in Lancashire, England. Arranged on a maplike grid, these intimate
portraits may be presumed to be glimpses of a single group of buildings from a
series of different vantage points. Taken as a whole, the group evokes a sense of

FIGURE 8–11
JOHN VIRTUE
Landscape No. 32, c. 1985–1986
Ink on paper on hard board
mounted on wood, 50 × 56"
(127 × 152.4 cm)
Courtesy, Lisson Gallery, London

familiarity with place which grew out of the artist's day job as a postal carrier in this area of England.

We can consider the drawings by Bittleman (Fig. 8–12) and Lees (Fig. 8–13) to be concerned primarily with a romantic view of nature, since human landmarks are absent from both works. In the sultry landscape that Bittleman creates, everything

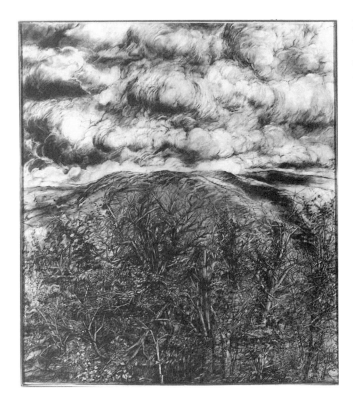

FIGURE 8–12
ARNOLD BITTLEMAN
View of The Green Mountains, 1977
Charcoal heightened with white
conté, 67½ × 60½"
Courtesy, Estate of Arnold Bittleman

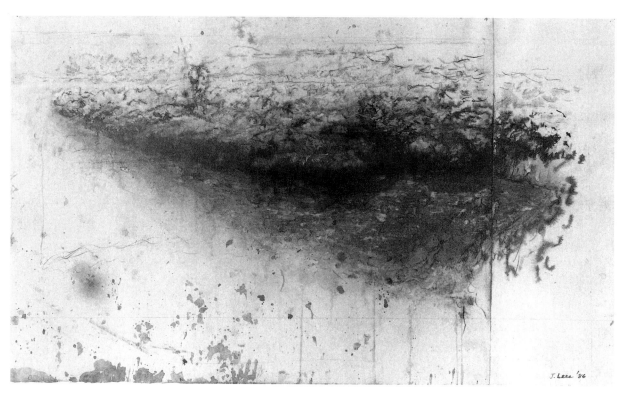

FIGURE 8–13
JOHN LEES
Bog, 1986
Ink, watercolor, pencil, and mixed
media/paper, 22½ × 37½"
Courtesy, Hirschl & Adler Modern,
New York. Photo: Pelka/Noble

appears in closeup. The minutely textured hedges in the foreground forbid entry into the space, while the boiling clouds overhead seem to rush forward. Even the horizon is brought disturbingly close by a series of not-too-distant hills. It is a landscape intimate in its detail, yet one that threatens to ensnare with twigs and smother with demonic clouds.

The image in the Lees drawing, on the other hand, seems more remote. The impenetrable mass of nondescript bushes coalesces into a shape that hovers quietly in the middle of the page. Here is nature at its wildest, with forms that are inexplicable to human understanding.

While the landscape of the Romantic tradition tends to focus on our desire to feel at one with nature, the drawing by Sean Gallagher (Fig. 8–14) reveals the relationship between humanity and nature to be more akin to an uneasy truce. This is no sunlit harbor filled with gallant merchant vessels or leisure craft, but rather an industrial dockyard. The great cranes we see silhouetted against a partially overcast sky seem to have fallen into disuse, so the regret we feel at seeing the natural shoreline disturbed by industrial structures is compounded by frustration at the wastefulness of modern commerce. In the foreground we note a blotch of white perhaps signifying the sun dancing on the water's surface. By drawing our attention to the receding plane of water, the artist reminds us of the immensity and long duration of nature when compared to the puny strivings of humankind.

The romantic conception of nature as being in a constant state of flux finds its urban counterpart in Figure 8–15. Here, commuters careen over precipitous Bay Area streets under a network of cables transporting invisible electrical impulses. The buildings, like the stunted trees, seem temporary in this cityscape, where yearnings for place and permanence are secondary to the imperatives of rapid transit and telecommunication.

STILL LIFE

Still life became a subject in its own right in the Low Countries at about the same time as the appearance of landscape. The still-life genre, more than landscape or

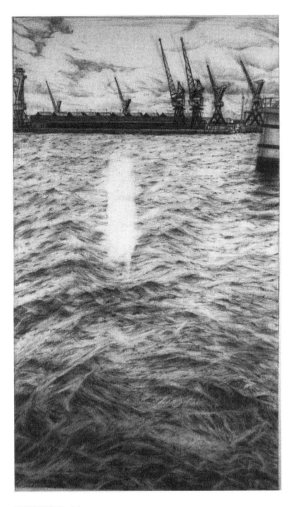

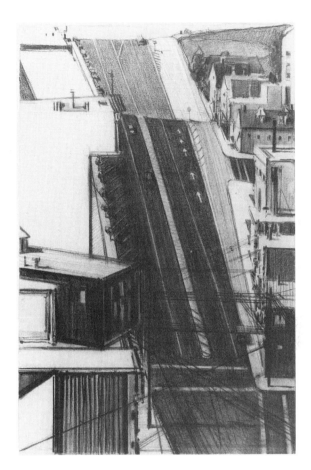

FIGURE 8–14
SEAN P. GALLAGHER
Renewed Presence
Pencil on paper, 22 × 14"
Courtesy, the artist

FIGURE 8–15
WAYNE THIEBAUD
Down 18th Street (Potrero Hill),
1974
Charcoal on paper, 22⅜ × 14⅞"
Photo courtesy of the Allan Stone Gallery,
New York. © Wayne Thiebaud/Licensed by
VAGA, New York, NY. Photo: Ivan Dalla Tana

the figure, retained a strong allegorical content long after it was removed from the context of religious narrative. Paintings and drawings depicted in detail both flowers and insects (Fig. 8–16) that were symbolic of the variety and also the impermanence of Creation. Vast piles of food—fruits, vegetables, dead poultry, game, fish, and raw flesh of all kinds—were not only evidence of the wealth and abundance of the bourgeois household but also a cheerful recognition of the transience of all life. The moralistic theme of the temporality of all material things finds its culmination in the *Vanitas* still life (Fig. 8–17). (The Latin word *vanitas* literally means "emptiness," but in Medieval times it became associated with the folly of empty pride.)

The vanitas theme is one that has survived to this day in still life. In the drawing by William Wiley (Fig. 8–18), the objects on the left-hand side are the memento mori so commonly found in Dutch vanitas paintings: The apple is a symbol of the mortal result of Original Sin; the dice and chess piece are symbolic of life as a game of chance; the steaming beaker suggests the futile search for the elixir of life; the jewels are symbols of earthly pride; and the knife, skull, and candle all belong to the iconography of human mortality. A framed mirror near the

FIGURE 8–16
AMBROSIUS BOSSCHAERT, The Elder
*Large Bouquet in a Gilt-Mounted
Wan-Li Vase*
Oil on panel, 31½ × 21½"
*Norton Simon Art Foundation
(M.1976.10.P)*

FIGURE 8–17
HERMAN STEENWIJCK
Vanitaspainting
*Municipal Museum de Lakenhal, Leiden, the
Netherlands*

FIGURE 8–18
WILLIAM WILEY
G.A.D., 1980
35½ × 53½"
Collection of Shelley and Ann Weinstein—G.A.D. Courtesy of Wanda Hansen Gallery–Studio Space

center of the drawing bears the fleeting inscription "What is not a bridge to something else?"—a reference to the passing of all material things. Below it is a long-stemmed pipe common to both Dutch and early American still life. The pipe and tobacco box (tobacco is a New World plant) act as a bridge between the fatalistic iconography of the Old World and the iconography of death by (mis)adventure of the American frontier. The items on the right side of the drawing—the pistol, the key, the pewter cup, the quill, and the American battle standard—are objects common to the already nostalgic trompe l'oeil ("fool the eye") painting of the nineteenth century.

The painstakingly detailed pastel by Massad (Fig. 8–19) is well within the traditions of a trompe l'oeil still life. The illusion of such depictions often hinges

FIGURE 8–19
DANIEL MASSAD
Columbarium, 1998
Pastel on paper, 24 × 21½"
Courtesy of Forum Gallery, New York, Los Angeles. All rights reserved. Used by permission of the artist

FIGURE 8–20
TOM WESSELMAN
Drawing for Still Life No. 35, 1963
Charcoal, 30 × 48"
© *Tom Wesselmann/Licensed by VAGA,
New York, NY*

on the relationship of the subject to the picture plane; in this case, the relationship is expressed in a beautifully realized expanse of stone running parallel to the picture plane. The artist appears to be playing with the literal meaning of still life (*Nature Morte* in French) by entombing the fruit, plucked from the living tree, in a shallow niche. His intention is underscored by the work's title, which refers to a wall pierced with niches for the commemorative storage of cremated remains. Note the ironic juxtaposition of the luscious fruit bathed in light, with the funereal aspect of the distressed stone, and note, too, the rigorous structure of the architectural niche in relation to the lively curves of the fruit. The raking light also plays a major role in the work, revealing detail with great lucidity while reminding us of a time of day (very early morning or early evening) that is particularly fugitive.

Larger-than-life portrayals of food and other consumable items locate the contemporary Pop Art movement within the vanitas tradition. The Wesselman drawing (Fig. 8–20) concentrates on the packaged nature of frequently consumed goods. It even goes so far as to equate the glamour and convenience proclaimed for name-brand foods with the glamour and convenience of jet travel (another packaged experience). The only natural foodstuffs in this drawing are the two lemons, the acerbic juices of which hardly promise the immediate gratification enjoyed by the Sunshine Girl on the bread wrapper. And the cigarettes, the cola, and the highly processed foods are presented as objects of questionable desire. They are not linked overtly to the issue of life and death, as are the poultry, fish, game, and so forth, of Dutch still life, but they are nonetheless icons of death, first because of their own throwaway identities and second because their consumption may prove more harmful than nourishing.

Glass drinking vessels, such as the overturned wine goblet in the Steenwijck painting or the ominous-looking liquor glass in the Wiley drawing, are common vanitas symbols. Among the characteristics that make them such a fitting symbol of temporality are: They can be drained of their contents; they are fragile; and they are transparent (as are ghosts), with surfaces that reflect an evanescent world in miniature.

Janet Fish exploits the theme of reflection in her depiction of glassware (Fig. 8–21). The shapes of the rather sturdy and commonplace restaurant glasses are subdivided into countless shimmering, splinterlike pieces. Just as the forms of

FIGURE 8–21
JANET FISH
Three Restaurant Glasses, 1974
Pastel on paper, 30¼ × 16"
*Acquisition Fund Purchase. Collection
Minnesota Museum of American Art, St. Paul*

the glasses are lost in the myriad reflections, so too are the forms of the immediate environment distorted almost beyond recognition in the reflections on the glass surfaces. In the end, we get a picture of a world that is composed of fugitive appearances.

THE INTERIOR

The domestic interior has long been associated with the contemplative life. In Medieval and Renaissance painting, meticulously rendered interiors appeared in such subjects as St. Jerome in his study or in Annunciation scenes in which the Virgin is usually depicted with a book. In the Romantic era, poets and artists became increasingly preoccupied with exploring the workings of an imagination that could have free rein only in solitude. In literature, the novel delved into the private thoughts of fictitious characters who had the middle-class leisure to reflect on all the petty intrigues of domestic life. Thus, the rooms to which a person could go to ruminate, reminisce, or daydream took on special significance.

The drawing by Lucas Samaras (Fig. 8–22) is in the tradition of the room as metaphor for the private mind. This interior is devoid of any personal domestic

FIGURE 8–22
LUCAS SAMARAS
Untitled, 8/18/87
Pastel on paper, 13 × 10"
Photograph courtesy of The Pace Gallery, New York

effects, but it is populated by memories or daydreams of amorous trysts that have left their imprint on the walls.

The drawings of empty interiors by Lundin (Fig. 8–23) and López García (Fig. 8–24) are far less confessional. Both may be regarded as images of the mind swept clean. The Lundin drawing shows a section of what appears to be a spacious empty studio. The softly polished floor and the slender shaft of weak sunlight that falls on it exude a meditative calm. In the López García drawing, the

FIGURE 8–23
NORMAN LUNDIN
Studio: Light on the Floor (small version), 1983
Pastel, 14 × 22"
Courtesy of Francine Seders Gallery, Seattle, Washington

FIGURE 8–24
ANTONIO LÓPEZ GARCÍA (b. 1936)
Cocina de Tomelloso (The Kitchen in
Tomelloso), 1975–1980
Pencil, 29⅛ × 24"
Courtesy, Marlborough Gallery, New York.
© Antonio Lopez Garcia

uncluttered kitchen contains several clues that attest to a life that is more austere than meditative. The only relief from the bare, brightly lit surfaces is the stark geometric pattern on the floor.

The high vantage point in the drawing by Robert Birmelin (Fig. 8–25) gives us a sense of a room as a deep, cavelike space steeped in melancholic darkness.

FIGURE 8–25
ROBERT BIRMELIN
Two Women on a Sofa, Rome. 1963
Watercolor, gouache, ink and
pencil on paper, 24¾ × 24½"
The Museum of Modern Art, New York.
Digital Image © The Museum of Modern
Art/Licensed by SCALA/Art Resource, New
York. Gift of Nancy and Arnold Smoller in
memory of Esta H. Josephs (917.1979)

FIGURE 8–26
HOLLIS SIGLER
Crawl Back to Safety, 1982
Craypas on paper, 28½ × 34"
*Courtesy, Printworks Gallery,
Chicago, Illinois*

The angles of the furniture and the arc inscribed on the floor counteract the quickly vanishing perspective lines so that the space appears to pivot around the two figures isolated in their weariness on the couch; and the protective darkness that seems about to envelop these figures suggests the slow winding down of daytime energies toward the ultimate refuge of sleep.

The Hollis Sigler drawing *Crawl Back to Safety* (Fig. 8–26) shows the interior as literally a place of refuge. The inner sanctum of the house or apartment is the bathroom, which in most homes is the only room with a lock on the door. Here a person can be safely alone; and in the revitalizing comfort of the warm bath that is being drawn, one can soak away the grime and tensions accumulated during the day. The discarded clothes on the floor and the neatly set-out bathrobe and slippers promise a cozy retreat from the crazy world still visible through the window.

Subject Matter as a Source of Meaning

That aspect of content that is derived from subject matter in a work of art is generally referred to as *subject-meaning*. Subject-meaning is most often literary in character; that is, it is meaning that is interpreted from the depiction of an event, story, or allegory.

The content that is taken from pictorial subject matter can be loosely categorized as inhabiting either public or private spheres of meaning. Artists interested in tapping content from the public domain often do so with the intent of addressing universal truths. The Daumier, for instance (Fig. 8–27), boldly engages the issue of crimes against humanity, portraying as it does the brutal murders of a household of innocent workers by the French civil guard in 1834.

FIGURE 8–27
HONORÉ DAUMIER
The Murder in the Rue Transnonain,
1834
Lithograph
Bildarchiv der Österreichischen
Nationalbibliothek

A more recent and reassuring example of topical content can be found in Red Grooms's *Local 1971* (Fig. 8–28). In this satirical narrative, Grooms's characterizations are not only amusing, they also betray the curiosity we all have about the facts and foibles of humankind.

Leaving the public side of life, let us now turn our attention to works with more private, or personal, content. The harrowing image in Figure 8–29 is a record

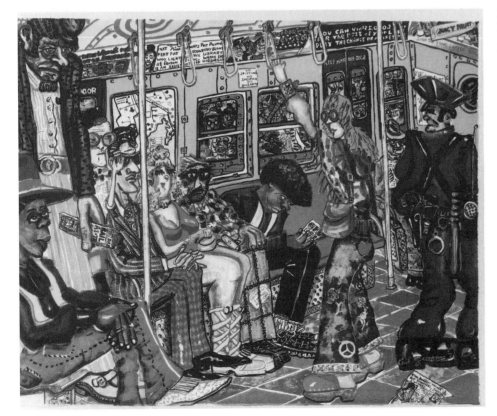

FIGURE 8–28
RED GROOMS (b. 1937)
Local 1971
Color litho from "No Gas"
portfolio, 22 × 28"

Courtesy, Marlborough Gallery. Photo: Eric Pollitzer. © 2003 Red Grooms/Artists Rights Society (ARS), New York

FIGURE 8–29
LUIZ CRUZ AZACETA
Self-Portrait: Mechanical Fish, 1984
Colored pencils, conté crayon on
paper, 103 × 44"
Courtesy, George Adams Gallery, New York

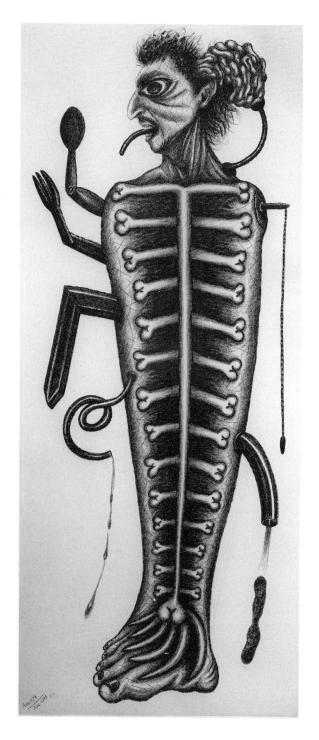

of this artist's intense personal vision. Yet, in its own eccentric way, it bespeaks of modern-day barbarism by inciting in us simultaneously the emotions of fear (of death and dismemberment) and compassion (for a victim).

But content in a work of art does not have to depend on spectacle, or subject matter that makes an aggressive appeal to extreme states of emotion. In the portrait by Mary Joan Waid (Fig. 8–30), for instance, meaning is insinuated

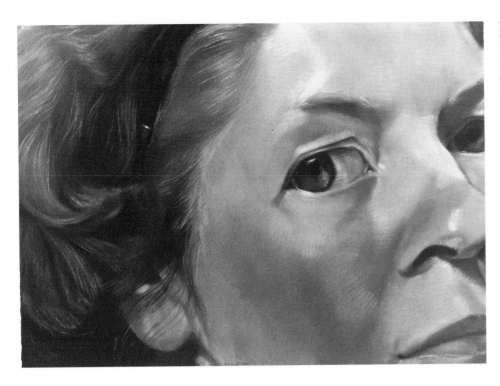

FIGURE 8–30
MARY JOAN WAID
Dream Series IX, 1984
Pastel, 29¾ × 41½"
*Collection David S. Brown. Photo:
Sarah Wells*

gradually. Presented with the most enigmatic of subjects, the gaze of another human being, we might be moved to wonder about this woman's particular story or what thoughts lie behind her melancholy glance. Content may also be effectively derived from humble subjects that the artist found personally moving, as in Figure 8–31, which depicts the mundane but beautiful event of sunlight streaming into a room.

FIGURE 8–31
ELYN ZIMMERMAN
Untitled, 1980–1981
Graphite on mylar, 18 × 24"
*Courtesy, the artist and Gagosian Gallery,
New York*

Thematic Variations

As a student working in the structured environment of the classroom, you may not always have free rein in your choice of subject matter. But even so, this should not put a damper on the expressive values of your work. One way to inject more personal excitement into your drawing is to cast the subject in a new thematic light. For an example of how a potentially banal subject can be charged by a reality existing outside the realm of ordinary studio surroundings, look at the still-life variations by Paul Wonner (Fig. 8–32) and Manny Farber (Fig. 8–33).

Art-historical context provides the guiding impulse for the Wonner drawing. The deep space and suggestion of ever-changing light, plus the flowers, delicate vessels, and comestibles that melt in the mouth all hark back to early Dutch still-life paintings. And lest we should be in any doubt about this allusion to an art-historical precedent, the artist has included a representation of a Droste chocolate bar (a Dutch brand).

In the Farber, the presence of space, form, and light is minimized. Seen from directly above, the unforeshortened matlike shape does not invite us into an illusionistic space but rather stops us short. The only recourse the viewer has is to follow the clockwise movement around the periphery of the square, a movement that recalls the advance of markers on a gameboard. Taken further, this clockwise motion suggests a hidden storyline in which the cheery pieces of confectionery and the more ominous cork, eyedropper, and cigar play out their dramatic roles.

So in the end, we have two works with basically the same subject matter but that stir up a very different set of associations. In the Wonner, we are taken up by the Dutch-inspired theme of the temporality of all earthly delights; in the Farber, *we* are the subject of the work, acting as sleuths trying to decipher inexplicable clues within the narrative.

FIGURE 8–32
PAUL WONNER (b. 1920)
Study for Still Life with Cracker Jacks and Candy, San Francisco, 1980
Synthetic polymer paint and pencil on paper, 44½ × 29⅞"
Gift of RLB Tobin in honor of Lily Auchincloss. © 2003 Paul Wonner and The Museum of Modern Art, New York. Digital Image © The Museum of Modern Art/Licensed by SCALA/Art Resource, NY

FIGURE 8–33
MANNY FARBER
Cracker Jack, 1973–1974
Oil on paper, 23¼ × 21¼"
*Courtesy, the artist and Quint
Contemporary Art*

Exercise 8A

The illustrations in this chapter are meant to indicate the vast storehouse of expressive potential inherent to the four subject matter categories: human figure, landscape, still life, and interior. It is important that you use this resource as a starting point for your own continuing personal research into subject-matter meanings. Look at monuments from art history on a daily basis, and to learn more about those works for which you feel an especial affinity, read about the social context in which they were created. An art-historical perspective will help you grasp how classic subject matter has been utilized and adapted over the ages as a basis for countless means of cultural expression.

The following projects are intended to help you begin assembling personal insights into subject-matter themes.

Drawing 1. *Draw an interior that clearly reflects the way that space functions for you on a daily basis. Do cramped quarters and clutter suggest that you live at a frenetic pace, as in Figure 8–34?*

FIGURE 8–34
BOBBETTE GILLILAND, University
of Arizona
Student drawing: animated
interior
Courtesy, the artist

FIGURE 8–35
CARTER GILLISS, University
of Cincinnati
Student drawing: meditative
interior
Courtesy, the artist

Or do you know of a place infused with meditative calm, as in Figure 8–35? Alternatively, you might look for a narrative within your interior. In Figure 8–36 the pet bowl and toys along with the spooky cast shadows make us look around for the absent cat.

Drawing 2. *Draw a diaristic or autobiographical still life using objects that have collected quite naturally, for example, on top of your desk, dresser, or television set. Alternatively, you might select objects thematically related, as in Figure 8–37, which retells some of the complexities of a long auto trip.*

FIGURE 8–36
TOM BENNETT, Arizona State
University
Student drawing: interior with
suggested narrative
Pencil, 18 × 24"
Courtesy, the artist

FIGURE 8–37
JENNIFER PLOURDE, Arizona State University
Student drawing: autobiographical still life
Charcoal, conté, 22 × 30"
Courtesy, the artist

FIGURE 8–38
DAVID LARSON, University of Montana
Student drawing: landscape detail enlarged
40 × 40"
Courtesy, the artist

Drawing 3. *Draw firsthand a portrait of a landscape that for you embodies a sense of genius or romantic spirit, free of the trappings and overtones of human existence. Create strong contrasts of marks and values to express the intense feelings this landscape elicits in you. Another option is to select from a landscape a detail that arouses those same feelings of awe you would experience when confronted by a vast panorama (Fig. 8–38).*

FIGURE 8–39
TIFFANY GOBLER, Kendall College
of Art and Design
Student drawing: self-portrait with
narrative elements
Courtesy, the artist

Drawing 4. *Do a portrait of an obliging friend or relative. Include some narrative elements to iden-tify who they are or how they would like to be perceived. On the other hand, you might wish to do a self-portrait that explains something about your current life situation (Fig. 8–39).*

Exercise 8B *Alternatively, try using subjects or themes belonging to more than one of the major categories. Such is the case in Figure 8–40, which may be considered a still life, since it consists of a skeleton and a*

FIGURE 8–40
SHERILYN HULME, University
of Arizona
Student drawing: still life with
psychological content
Courtesy, the artist

FIGURE 8–41
WANDA GAG (1893–1946)
Macy's Stairway, 1941
Lithograph
Sheet 11⅞ × 16⅟₁₆" (30.2 × 40.8 cm)
Image 9⅞ × 12¾" (25.1 × 32.4 cm)
Whitney Museum of American Art, New York. Purchased with funds from the Lauder Foundation, Leonard and Evelyn Lauder Fund (96.68.123)

draped piece of furniture. But the skeleton's gesture recalls a living figure, insinuating that the draped desk is more than a mere studio prop. In this context, it suggests something sinister, such as a shrouded tomb or a piece of furniture stored in a house after the death of its occupant. Or look at the stowed fire hose in Figure 8–41, which may be literally defined as a still-life object but visually connotes a threatening human presence.

The Form of Expression

In earlier chapters, we introduced ways to organize the two-dimensional space of a drawing, from the initial layout to the development of a more complex set of design relationships. This chapter enlarges on the topic of pictorial order by linking more fully the artist's orchestration of the visual elements to the creation of expressive *form* in a drawing. Also included is a set of strategies to help you troubleshoot problems of observation and design in your drawings.

The Two Definitions of the Term **Form**

As defined previously,* form may refer to the shape, structure, and volume of actual objects in the environment and to their depiction in a work of art. The second meaning of *form*, and the way in which we use the term in this chapter, refers to a drawing's total visual *composition*, or that quality of visual order that sets the drawing apart as a complete and unique object in its own right, independent of the real-world subject matter it represents.

In other words, form is the "visual reality," the lines, shapes, colors, tones, and textures, and their organization, that we actually *see* when looking at a drawing. And by virtue of its material existence, form distinguishes itself from both subject matter and content. In this regard, subject matter exists symbolically, but not actually, in a drawing, and content exists only as an interpretation made by the viewer.

To further clarify this second meaning of the term *form*, we shall examine the composition of a masterwork.

Studying the Form of a Masterwork

Our stress on the visual reality of form does not mean to imply that the form of a specific drawing can be comprehended at a single glance. On the contrary, the structural composition of a good drawing is often multileveled and requires some degree of study to penetrate.

*See Chapter 6, "Form in Space."

To illustrate this point, we shall briefly analyze the formal qualities of a drawing by Charles Sheeler, *Feline Felicity* (Fig. 9–1). We use a blurred state of the same work (Fig. 9–2) and the accompanying diagrams (Figs. 9–3 to 9–7) to aid us in our analysis.

Note first the two large shapes that make up the positive image (Fig. 9–3) and the way the edges of these shapes have been controlled so the eye moves over them at varying speeds—more slowly through complicated areas, more rapidly

FIGURE 9–1
CHARLES SHEELER
Feline Felicity, 1934
Conté crayon on white paper,
559 × 457 mm
Courtesy of The Fogg Art Museum, Harvard University Art Museums. Louise E. Bettens Fund

FIGURE 9–2

FIGURE 9–3
The major positive-negative
breakdown of *Feline Felicity*. Note
the implied interaction between
the two rodlike shapes in the
lower right-hand corner.

FIGURE 9–4
The major linear configuration in
this drawing is an X, formed by
diagonals 1 and 2. The arrows in
opposite corners indicate forms
pushing outward, making the
format edges more apparent.

over relatively uninterrupted stretches. Variety has also been achieved by con-
trasting round edges with more angular edges.

Figure 9–4 schematically depicts contrasts and similarities among the major
directional lines in Sheeler's work. The main configuration created by these linear
motives is an X, the foremost device for expressing an opposition of forces in
pictorial art. Figure 9–5 shows the major diagonal being echoed by a smaller

FIGURE 9–5
This figure shows how the repeating diagonals 1 and 2 subdivide the page into three unequal areas A, B, and C.

diagonal to its right, and how these movements in combination subdivide the page into three unequal zones.

Perhaps the most startling visual trait revealed by the blurred state of *Feline Felicity* (Fig. 9–2) is that the image of the cat is broken into three clear-cut sections. Starting on the right (Fig. 9–6), look at how the bold, arching pattern of light stripes on the cat's hindquarters creates a circular rhythm that includes the illuminated corner of the chair seat (as represented by the white V in the diagram).

FIGURE 9–6
The repeating V-shaped angles point the eye down the right chair leg 1 toward an imminent relationship with the chair rung 2. And the movement begun at the upper right-hand corner 3 is channeled diagonally through the cat's hindquarters 4.

FIGURE 9–7
1 continues the lateral diagonal
begun on the right side of the
drawing and joins the straighter
movements of the front edge of the
seat 2 and the nearly vertical
upright of the chair back 3, all
three of which intersect just below
the shoulder of the cat.

Now, let's turn to the cat's midsection, which can be seen as a single shape in Figure 9–7. (This shape is also evident in Figs. 9–2 and 9–11a). Note that the vertical stripes throughout this shape echo the uprights of the chair. In fact, this area possesses the most pronounced light-and-dark pattern of all three sections—and for good reason. It is the pivotal "central hub" of the drawing, acting as it does to join several important movements.

The head of this tabby cat differs in several important ways from the remainder of the body and from the visual character of the drawing as a whole, which for the most part emphasizes angular, flat areas of pattern. The drawing in general is also contrasty in its play of light and shadow and grainy in its surface texture. In comparison, the head is a more fully developed spherical volume. It also exhibits less tonal contrast and a sharper focus on topographical detail. Collectively, these differences distinguish the head as the drawing's focal point.

The Matter of Pictorial Invention

Although our analysis of *Feline Felicity* was far from exhaustive, it nonetheless revealed some of the compositional relationships, or interactions between parts, that underlie the almost photographic detail in this drawing. The next step is to acknowledge that the full complex of relationships in *Feline Felicity* has recast the subject matter into a new and invented totality of *pictorial* form.

We stress the word *pictorial* because the special network of lines, shapes, values, and so forth, that Sheeler created not only contributes to the form-unity of the drawing but it also has no reality outside of that two-dimensional surface. To understand this, you have only to look at the shapes plotted in Figures 9–3, 9–6, and 9–7 and realize that they have no names in the real world; or consider that the linear movements in Figure 9–4, which link up sections of the two-dimensional surface, are not bound to the contours of individually depicted objects. These lines and shapes are in the truest sense pictorial inventions that have grown from the master artist's imaginative reworking of subject-matter information, and as

such they are freed from the confines of everyday things and the everyday conventions of looking at things.

In view of all this, we may make two general observations:

1. That artists, in the process of making their ideas and emotions comprehensible to others, manipulate the visual elements beyond the service of pure description to create new pictorial entities, which for purposes of convenience are often referred to as *pictorial shapes, pictorial lines,* and so on.

2. That the sum of pictorial invention, that is, all the created shapes, linear movements, and orchestrations of value taken together in a particular drawing, constitute that sense of form that we experience in a fine work of art.

To summarize, we have established that the form of a drawing refers to its entire structural character; or to put it simply, form refers to that compositional reality of a drawing that we can apprehend with our eyes.

We have also determined that the form of a drawing has a visual and material identity that is distinct from its subject-matter source in the real world. In fact, we can say that what all artworks have in common, regardless of stylistic, media, or historical differences, is their separateness, or *abstractness,* from reality.

This matter of why the form of any artwork is undeniably abstract, and how this concept can be understood in relation to the common designation of an "abstract style" in art, is the focus of our next topic in this examination of form.

What Is Abstraction Anyway?

When applied to drawing, the term *abstraction,* like the term *form,* has more than one meaning. First of all, a drawn image is by definition removed or abstracted from a sensory experience of actual subject matter by virtue of its physical properties. In Figure 9–1, for example, no cat is present. What does exist is a visual symbol for a cat, a symbol that is embodied by a deposit of media on a flat paper surface.

Second, abstraction refers to a multilayered *process* that is inherent to the making of all visual art. Let us clarify this by simplifying the operation of making a drawing into three steps.

1. Out of the world of experiences, which has been described by the philosopher William James as a "blooming, buzzing confusion," the artist selects something to draw. This method of singling out or generalizing from concrete reality is an *abstracting process.*

2. Thereafter, each choice an artist makes while drawing continues to reflect the abstracting process of the mind. Such early decisions as format orientation, vantage point, plus the character of the initial layout wherein superficial detail is overlooked in favor of summarizing the proportional and gestural essences of forms and spaces are all part of this process.

3. As a drawing's specific form definition proceeds toward completeness, its existence as an independent object, governed by its own pictorial order, becomes more distinct. The basis for this abstract wholeness is the essential arrangement and unity of the visual elements. Consideration for the abstract function of the visual elements is a feature of all good drawing, even if the image is a representational one.

Third, the term abstraction also refers to certain styles in the history of art. The term *abstract art* gained currency in the early twentieth century when numbers of artists subordinated naturalistic representations of subject matter in

favor of formal invention (Fig. 9–8). But abstraction as an image "condition" was not unknown in earlier phases of art, as we can see from a page from the *Book of Kells* (Fig. 9–9).

Today, the designation *abstract art* is often used to describe not only quasi-representational imagery but also works of art that are completely devoid of subject matter. More precisely, though, when an image is solely the product of an artist's imagination, and is therefore without reference to an external stimulus (Fig. 9–10), the style of the work is *nonobjective*.

FIGURE 9–10
HANS HOFMANN
Red Shapes, 1946
Oil on cardboard, 25¾ × 22"
© 2003 Estate of Hans Hoffman / Artists
Rights Society (ARS), New York

The benefits of drawing from fine works of art cannot be overestimated. By making penetrating, analytic studies of a masterwork (as opposed to merely copying it), you experience more intimately why certain formal choices were made by the artist, which in turn expands your general understanding about formal organization in pictorial art. Studies of masterworks are also to some extent expressive endeavors, since the formal attributes you find in a work, and the way you represent them, depend on your own subjective values, as evident from the two student drawings of Feline Felicity *in Figure 9–11a and b (see Fig. 9–1 for the original).*

Using Tasley's Truck *(Fig. 9–12), let us review some of the steps you will want to take when making your own analytic drawings.*

Exercise 9A

FIGURE 9–11a
AMY MCLAUGHLIN, University of Arizona
Student study of *Feline Felicity*
Courtesy, the artist

FIGURE 9–11b
Kristin Kiger, University of
Arizona
Student drawing: study of
Feline Felicity
Courtesy, the artist

FIGURE 9–12
Matt Tasley
Truck, 1985
Charcoal on paper, 60¹⁄₁₆ × 84¼"
Courtesy, The Arkansas Arts Center,
Foundation Collection

FIGURE 9–13

FIGURE 9–14

1. *Sketch out the fundamental layout, or subdivision, of the work's surface (Fig. 9–13).*

2. *Determine the major positive-negative arrangement (Fig. 9–14).*

3. *Locate repeating shapes, patterns, or textures that build relationships between different areas of the work (Fig. 9–15). In this case, note the integration of round and angular shapes that are varied in size and tonality and are at times fully delineated and at other times only suggested.*

4. *Examine the linear movements and accents that guide the eye (Fig. 9–16). Note that in Tasley's drawing, the flowing movements on the left side contrast with the relative congestion of marks on the right.*

In summary, when drawing from a masterwork, uncover as many compositional relationships as you can. Part of your goal should be to discover how any one area of a work may have several organizational roles to play. If you are analyzing a work from a book or magazine, placing a sheet of

FIGURE 9–15

FIGURE 9–16

translucent paper over the reproduction will suppress subject-matter detail sufficiently to allow you to concentrate on the work's organizational virtues.

Exercise 9B *For this exercise, you will apply what you have discovered in a masterwork to a drawing of your own.*

When you have completed an analysis of a masterwork (see the four steps outlined in Exercise 9A), find a subject in your immediate environment that exhibits some of the abstract form qualities of that masterwork. Note that the subject of the masterwork and the subject matter you choose to draw do not have to be the same.

Lay out your drawing so that its arrangement recalls the basic surface organization of the masterwork. And as you proceed to define the subject matter in your drawing, keep in mind the major compositional themes of your source material. But once this groundwork has been established

FIGURE 9–17a
KRISTIN KIGER, University of
Arizona
Student drawing: still life
Courtesy, the artist

FIGURE 9–17b
KRISTIN KIGER, University of
Arizona
Student drawing: abstraction from
a portion of still-life drawing
Courtesy, the artist

and your drawing is fully underway, concentrate more on its emerging form and less on the particular design qualities of the masterwork. Finish your drawing with the aim of creating a variation on the formal themes of the masterwork.

Many artists prefer working abstractly because doing so allows them freedom to invent with the visual elements of line, shape, value, texture, and color. This two-step project will guide you toward working in a more abstract style.

Exercise 9C

Drawing 1. *Select a subject that possesses a variety of forms, patterns, and textures. Emphasize these contrasts as you develop your drawing into a full-page composition (Fig. 9–17a).*

Drawing 2. *Using your viewfinder, scan your first drawing. Find a section that strikes you as the most visually appealing on the basis of its overall layout, spatial illusion, and its particular combination of marks, tones, shapes, and so forth. This section will serve as the subject, or point of departure, for your second, and this time more abstract, drawing.*

Gesturally sketch in the layout of this section on another full sheet of paper, blowing up the image so that it fills the entire format. Proceed to define the forms, but as you do so, manipulate them to intensify both their differences and the relationships that bind them together.

By focusing on a small part of your first drawing, you have already moved a step away from recognizable imagery. Continue this process by altering and simplifying the forms according to the design dictates of your drawing. Work until you have achieved a finished drawing (Fig. 9–17b).

The Primacy of Form in the Visual Arts

Form is often considered to be at the heart of the artistic enterprise. One reason for this belief is that form is an artwork's single visual reality. In other words, and as stated earlier, form is what you see in an artwork—its lines, shapes, colors, and tones, which have been organized in a particular way. This means that in a work of art, the subject matter is inevitably seen through the filter of form. Or, to put it

FIGURE 9–18
JEAN-FRANÇOIS MILLET
The Sower
Oil on canvas, 40 × 32½"
Gift of Quincy Adams Shaw through Quincy A. Shaw, Jr., and Mrs. Marian Shaw Haughton. Courtesy, Museum of Fine Arts, Boston

FIGURE 9–19
VINCENT VAN GOGH
Sower at Sunset
Reed pen
Vincent Van Gogh Foundation/National Museum, Amsterdam, The Netherlands

another way, the depiction of subject matter in an artwork (or *what* has been represented) cannot be divorced from its form (or *how* the subject matter has been treated). This is why versions of the same subject by different artists may vary in content so dramatically, as in Figures 9–18 and 9–19.

Form is what the artist manipulates when giving expression to ideas and emotions, so it may also be regarded as the primary source of content in a work

of art. In fact, properties of form are thought so essential to the meanings we take from an artwork that, for many, the terms *form-meaning* and *content* are synonymous.

Form as a Source of Meaning

That aspect of content that is derived from the form of an artwork is commonly referred to as *form-meaning*. Form-meaning is provoked by the visual character of a work of art; so in contrast to the literary character of subject-meaning,* the content taken from form, by its very nature, cannot be expressed adequately in words.

The meanings we attribute to form in art have their origin in our experiences and associations from birth with qualities of form in the real world. For example, jagged forms belong to a large class of objects that have the potential to inflict pain and injury, such as teeth, claws, thorns, and knives. Similarly then, jagged lines or shapes in a drawing (Fig. 9–20) may well give rise, at least on the subconscious level, to feelings of anxiety.

In Figure 9–21, Graham Nickson has effectively capitalized on form-meanings that are commonly attributed to horizontal, vertical, and diagonal movements. The figurative image in this work echoes our upright human condition in opposition to the flat plane of the landscape. The stability of this relationship is heightened by the way in which the clear and simple intersection of the standing figure and the horizon line repeats the geometry of the format. However, this static harmony is interrupted by the diagonal direction of the outstretched arms; a direction that in everyday life signifies action that is often unpredictable. Note that the diagonal creates a similar effect in Figure 9–22, which is nonobjective in style.

FIGURE 9–20
ED PASCHKE
His and Hers, 1977
Graphite, colored ink on paper,
29 × 23⅛" (73.66 × 58.74 cm)
Whitney Museum of American Art, New York. Purchase with funds from the Drawing Committee. Photograph Geoffrey Clements (84.46)

*See "Subject Matter as a Source of Meaning" in Chapter 8, "Subject Matter: Sources and Meanings."

FIGURE 9–21
GRAHAM NICKSON
Bather with Outstretched Arms III,
1983
Acrylic on canvas, 100 × 120"
Courtesy, Hirschl & Adler Modern, New York

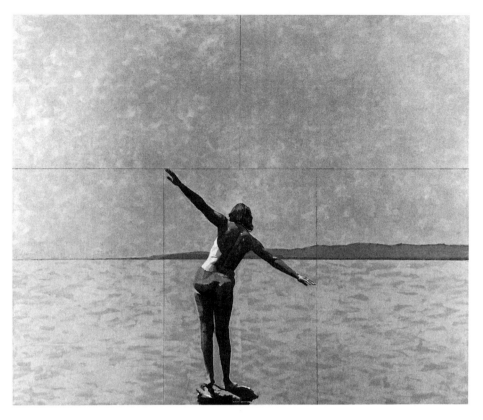

FIGURE 9–22
JOEL SHAPIRO
Untitled, 1984
Charcoal on paper, 43 × 30¾"
Courtesy, Pace Gallery of New York.
Photo: Geoffrey Clements
© 2003 Joel Shapiro/Artists Rights
Society (ARS), New York

Let us conclude our discussion of form-meaning with three more examples of contemporary drawing. Looking at the Alex Katz (Fig. 9–23), we are immediately struck by its simplicity of line, overall paleness of tone, and general lack of strong visual contrast. Line is reduced and understated. The eye provides the single dark accent, but even this, seen as it is in profile, is nonconfrontational. So by carefully limiting visual differences, the artist sustains a mood of genteel contemplation.

FIGURE 9–23
ALEX KATZ (b. 1927)
Thomas, 1975
Pencil, 15 × 21¾"
© *Alex Katz/Licensed by VAGA, New York.*

FIGURE 9–24
ROBERT ROHM
Untitled, 1975
Graphite on paper, 19¾ × 26½"
*Collection of Whitney Museum of American
Art, New York. Gift of Dr. Marilynn and
Ivan C. Karp (75.50)*

Meaning in Figure 9–24 is heightened by masking out, or cropping, all but one small section of a wall. This intensifies our recognition of aspects of the subject's form, such as its density and rough physical texture, and the irregular rhythms of the bricks and mortar. From so vivid a depiction of a lively surface, we might interpret an allusion to organic growth and change, perhaps going so far as to sense an inner life within something ordinarily thought of as mute and inanimate.

The structural motif underlying the nonobjective drawing by Eva Hesse (Fig. 9–25) is the grid, which we may think of as connoting order, measure, and reason. The disclike shapes, built up with beautifully graded values, continue this

FIGURE 9–25
EVA HESSE
Untitled, 1966
Pencil and wash, 11⅞ × 9¼"
The Museum of Modern Art, New York. Gift of Mr. and Mrs. Herbert Fischbach

theme of measure and control. But taken as a whole, we may see that these delicate tonalities and subtle variations are also the means to express a very different kind of content. Viewed together, the discs begin to pulse or vibrate, resulting in the illusion that the entire field is fluctuating before our eyes. This unpredictably expanding and contracting movement upsets the stability and harmony first observed in the drawing and makes the surface appear to breathe.

In conclusion, form-meaning is significant in art because it is based on memories that are innate to virtually all human beings, regardless of their geographic or ethnographic differences. That is to say, people in general are able to find meaning that they cannot express verbally in, for example, contrasts between light and dark, sharp and fuzzy (Fig. 9–26), and so on. In comparison, the communication

FIGURE 9–26
DAVID SMITH
Untitled, 1962
Spray paint on paper, 27 × 39⅝"
© 1994 Estate of David Smith/Licensed by VAGA, New York. Collection of Whitney Museum of American Art, New York. Purchase, with funds from an anonymous donor (79.40)

FIGURE 9–27
MICHAEL ANANIAN
Quid Pro Quo, Graduating with the art students, 1999
Charcoal on paper, 23 × 25"
Courtesy, the artist

of subject-meaning in a work of art is most often dependent on a viewer's ability to identify the depicted subject matter. We may, for example, admire the form in Figure 9–27 and yet from the standpoint of the subject matter be left to wonder, "What does it mean?"

Troubleshooting Your Drawings

This last section of the chapter raises questions you may want to ask when you are evaluating or troubleshooting the form of one of your drawings in progress.

CRITICIZING YOUR DRAWINGS

Almost everyone who takes a drawing class is familiar with the "class critique," when members of the class comment on each others' work. Class critiques are valuable for many reasons, perhaps the most important of which is that they enable you to distance yourself from your own drawing and see it with a critical eye. However, it is also important that you extend this critical outlook beyond the class critique and apply it during the process of making your own drawings.

While a drawing is in progress, you should step back from it periodically to ask critical questions about its development. This is a natural and constructive part of the drawing process. Without this activity, you run the risk of making drawings that are structurally or expressively weak, or both. Also remember that the critical assessments you make about a drawing are always to some extent personal value judgments and are therefore expressive of your subjective life experiences.

Finally, it can be argued that each time you examine the form of one of your drawings (or a work made by another artist), you are feeding your "intuitive bank." In other words, what you put into your consciousness through a deliberate learning process you will in the future be able to tap as if by second nature. This relationship between self-conscious learning and the ability to react unerringly is common to scores of other disciplines: Think of the concentration necessary to first learn the basics of how to bat a baseball, or how countless hours of practice come to fruition in a dazzling musical performance.

Critical Questions to Ask About Your Drawings

The criteria employed when studying the form of a drawing in progress usually fall into two categories. On the one hand, you will be assessing how well you have observed and depicted the subject matter. On the other hand, you will need to determine whether the organization of the visual elements best serves your aesthetic and expressive ends.

The following is a set of questions to assist you in these two categories. Your use of these questions (or any other questions you might ask) should always be considered against the overall objectives you have for your drawing. Moreover, it is advisable to combine the process of asking critical questions with the practice of making diagnostic studies from your drawing. Studies of this sort can often be of invaluable assistance in getting to the crux of a formal problem and in making design alternatives more apparent.

Questions pertaining to observation and depiction:

1. Do areas that you want to read as three-dimensional volumes appear flat? Are they bounded by either an outline or an unmodulated dark tone that has the effect of making them look cut out? Are the tones not organized according to spatial planes or are they too inconsistent in their application to build a convincing volume? Figure 9–28 successfully avoids these pitfalls.

2. Is the spatial illusion consistent? Check to see whether some areas of your drawing "pop," that is, advance ahead of their desired spatial position.

3. Is your depicted light source consistent?

FIGURE 9–28
CHRISTOPHER SICKELS,
Art Academy of Cincinnati
Student drawing: convincing
spatial planes
Courtesy, the artist

4. Are all objects seen from a consistent eye level? Do the converging lines of your depicted objects conform to a vanishing point (Fig. 9–29)?

5. Are the scale and part-to-part proportional relationships accurate when compared with the actual subject matter?

6. Does each depicted object have tonal integrity (Fig. 9–30)? Or, are they splintered into too many tones to establish in each case a local value? Have you expressed light with essentially the same tone throughout (a common error

FIGURE 9–29
TAYLOR HSIAO,
University of Arizona
Student drawing:
effective use of
perspective
Courtesy, the artist

FIGURE 9–30
NOELLE FRIDRICH, Arizona State
University
Student drawing: still-life objects
rendered with tonal integrity
Pencil, 22 × 30"
Courtesy, the artist

is to have the untouched surface of a light-colored paper stand in for all the varying qualities of light in a subject), and have you made all the shadows equally dark?

Questions pertaining to the organization of the visual elements:

1. Is the format subdivided so that all areas, positive *and* negative, have been given definite or implied shape (Fig. 9–31)? Generally speaking, a layout that divides the page into equal or near equal areas will reduce a drawing's impact, no matter how much attention is given to its imagery.

2. Are there enough variations among the visual elements to create tension?

3. Have the visual elements been orchestrated sufficiently to create unifying relationships? Is there a cohesive pattern of emphasis and de-emphasis that leads the eye at varying speeds across the surface and through the illusion of space (Fig. 9–32)?

4. Is the value range sufficient to furnish your drawing with a dynamic tonal character (as opposed to a sameness among values that may cause visual boredom)?

5. Do the marks and lines function in expressive as well as descriptive roles (Fig. 9–33)? Are linear elements grouped to form larger motives in the drawing?

6. Finally, where is your drawing going? Does it register clearly your aesthetic and expressive intent? Or has your intent become muddled because, for example,

FIGURE 9–31
DAVID ANDREWS,
University of Wisconsin,
Whitewater
Student drawing: bold positive
and negative layout
Courtesy, the artist

FIGURE 9–32
MATTHEW KRUSE, University of
Arizona
Student drawing: guiding the
viewer's eye across the surface
Charcoal, 18 × 24"
Courtesy, the artist

FIGURE 9–33
Bob Graham, University of
Arizona
Student drawing: self-portrait
employing a variety of expressive
and descriptive marks and lines
Courtesy, the artist

you've concentrated too heavily on the detail of a few areas? Moreover, does
your drawing contain visual clues that, if developed, could lead to unexpected
richness in form and content? For example, could you intensify the mood of
your drawing by consolidating the values into a lower or higher tonal key, or
could you tighten its design by stressing a particular motif that was formerly
not apparent to you in either the actual subject matter or your drawing?

COMMON ARTISTIC BLOCKS AND THEIR SOLUTIONS

At times when you are drawing, a problem may arise that you cannot seem to
solve. As a result, you may feel frustrated and even suffer a loss of confidence.
Being stymied by a drawing in this way is one example of a syndrome often re-
ferred to as an *artistic block*. Artistic blocks of one kind or another are common to
the experience of most artists, beginners and professionals alike. Some typical
artistic blocks and some possible solutions for them are as follows:

1. *You can't get an idea.* Ideas for drawing are everywhere. You may find expres-
 sive potential in the most modest of circumstances—your unmade bed, the
 dishes collected on a countertop, the visual diversity that has accumulated in a
 closet, or an otherwise inconspicuous coffee cup seen from an unusual point of
 view (Fig. 9–34). With domestic or otherwise mundane subject matter, try
 working at unconventional hours and see if those settings you normally take
 for granted do not take on a wealth of mystery and narrative (Fig. 9–35).

2. *You have an idea but don't know how to get it down.* Try a two-pronged attack for
 this one. First, to inspire yourself, find examples by other artists who have
 dealt with a similar idea. Second, since many of the problems will work them-
 selves out in the act of drawing, break the ice and start to draw.

3. *A problem arises in a drawing and you can't figure out how to correct it.* Put the
 drawing aside for a few days, even a week, and go on to another. Working on a

FIGURE 9–34
IRVIN TEPPER
(American, b. 1943)
Third Cup of Coffee, 1983
Charcoal and oil pastel, paper
43¾ × 51½"
*Arkansas Arts Center Foundation
Purchase: 1984 84.043*

FIGURE 9–35
TOM BENNETT, Arizona State
University
Student drawing: mundane subject
at night
Charcoal, 18 × 24"
Courtesy, the artist

new drawing will bolster your confidence, and when you return to the earlier drawing you will probably find that your "mental distance" from the work enables you to more clearly diagnose and act on its deficiencies.

4. *You like one area of your drawing and don't want to change it.* Trying to adapt a drawing overall to fit one area that you don't want to lose usually results in a fragmented image and an artistic block. To restore healthy forward movement in your process, it will be necessary to manipulate or change the blueprint of that part of the drawing. Once you start to see ways to integrate that area into the drawing as a whole, the preciousness attached to it will subside, and you will be prepared even to completely reconceive the area if necessary.

10

Using Color in Drawing

Color is one of the most powerful visual elements that artists have at their disposal. Color may be used objectively to record observed appearances with great fidelity (Fig. 10–17). Frequently, however, it is the subjective, expressive impact of color that grabs our attention (Fig. 10–6). Color affects us involuntarily—and we take it personally. Color harmonies, or the associations they waken, can cheer us up or darken our mood. We may even notice our pulses quicken in the presence of some colors, while the clash or intensity of other color combinations may make us avert our glance.

The pervasive use of full-blown color in drawing is a modern phenomenon. Before the advent of modern art in the mid-nineteenth century, color drawings were infrequent; most drawn images either celebrated the use of line or were conceived on the basis of a *grisaille*, an arrangement of varied steps of gray values. Interestingly, in seventeenth-century France, a commonly held opinion identified drawing with reason and color with irrationality. The gradual emergence of color drawing as we know it today is the result of many influences that have occurred during the Modern epoch. What follows is a brief and less-than-exhaustive summary of some of those contributing factors.

In one sense, technology set the stage for uniting color with drawing. By 1856, the first synthetic aniline dyes were manufactured, producing an array of brilliant colors previously unavailable to artists. The new dyestuffs also impacted the clothing industry. The availability of more vibrant, high-key color apparel, coupled with the introduction of the more brilliant kerosene and gas lamps, conspicuously changed the artist's environment.

The proliferation of new colors coincided with studies about the nature of color. From approximately 1850 until the turn of the century, numerous theories and principles of color organization were pioneered by prominent theoreticians and leading painters of the day, including Eugene Delacroix, Georges Seurat, and artists belonging to the schools of the French Impressionists and Neo-Impressionists. Their efforts were augmented by several scientific treatises on the relationship between color and the behavior of light, published during the same period.

The revival of printmaking in Europe during the last quarter of the nineteenth century, inspired in part by brightly colored Japanese prints, was an important stimulus for the use of color in the graphic arts. This is especially true of lithography as practiced by Toulouse-Lautrec, Edouard Vuillard, and Pierre Bonnard,

who by the end of the century were achieving color effects in lithography not possible in painting. Lithography is the printmaking medium most akin to drawing, and the success of the color lithographs by the above artists was probably in large part responsible for the new interest in color drawing in the twentieth century.

The twentieth century was characterized by exuberant explorations of polychromatic images in all the visual arts. Gifted colorists like Matisse and Josef Albers, and entire art movements, from the Fauves during the first decade of the century to the color field painters in the 1960s, have concentrated on abstract color interactions, free from the limitations of subject matter and objective references to nature. But as the century progressed, perhaps the most vital influences on color awareness were the new palette of colors made available by technology and the mass media.

Today we are immersed in color images. Not as in touch as our ancestors with the colors of our natural environment, we nonetheless are saturated daily by literally thousands of artificially generated colors through print and electronic media, home and office decor, packaging, industrial design, and fashion. Entering the classroom or studio from this kaleidoscopic profusion of color, it is no wonder that the professional artist and student alike often gravitate toward full-spectrum color in drawing.

The purpose of this chapter is to inspire you to discover your own color aesthetic, while providing you sufficient introduction to the fundamentals of color so that you have a solid basis for experimentation. Before we proceed, there are two points to keep in mind: First, color is relative. Similar to the interrelationships of value in a drawing, our perception of a color is influenced, to a greater or lesser extent, by the other colors around it. Second, there are no "bad" colors. Any color can be used successfully, depending on your ability to integrate that color into a work of art as a whole.

Basic Color Theory and Terminology

The three basic properties of color are hue, value, and intensity. We discuss all three in relation to the diagrams in Figure 10–1.

HUE

Hue refers to the common names used to distinguish colors, such as red, green, and yellow-orange. Mixing one color with another changes its hue. For example, blue added to red in gradually increasing amounts changes the hue of red to red-purple, then to purple, and finally to blue-purple. The term *chromatic* is sometimes used to refer to the property of hue.

The opposite, *achromatic*, means without hue and refers to the so-called *neutrals:* black, white, and gray. At times, artists selectively introduce hue into an otherwise black-and-white image to add another dimension of visual interest or meaning, as in Figure 10–2.*

Figure 10–1a arranges the twelve major hues into a color wheel. These twelve hues can be divided into different categories of color relationships that are useful to the artist. The *primary colors*, red, yellow, and blue, cannot be made by mixing other colors.** When mixed in pairs or in admixtures of all three, the primaries are the source for all other hues on the color wheel. The *secondary colors*, orange, green, and purple, are each the result of mixing two primaries; for example, yellow and blue create green. The remaining six *tertiary* colors are obtained by

*For more discussion of this work, see "Color Economy" (p. 227).
**We are discussing color mixing in terms of the mixture of pigments traditionally used by painters. In contrast, printers' inks use a primary palette of cyan, magenta, and yellow. Colored light is a mixture of red, green, and blue.

combining a primary and a secondary color: Mixing yellow with green produces the tertiary yellow-green, and so on.

The farther apart colors are from one another on the color wheel, the more their relationship is based on hue contrast. Hues that are directly opposite one another represent the strongest hue contrast and are called *complementary colors*. The three basic pairs of complements are red and green, blue and orange, and yellow and purple.

The closer colors are to one another, the more they exhibit hue concord. Hues that are adjacent to one another on the color wheel represent the strongest hue similarity and are called *analogous colors*. One set of analogous colors is red, red-orange, orange, and yellow-orange.

VALUE

Value refers to the lightness or darkness of a color when compared with a gray scale (black, white, and the steps of gray between). Look at the pure colors displayed in the color wheel and try to determine their relative values. To help you get started, observe that yellow is the lightest hue (closest to white on a gray scale), red and green are approximately middle gray, and purple is the darkest (closest to black). Squinting may help you to see the value differences more readily.

The value of a color can be lightened by adding white to produce a range of *tints* or darkened by adding black to produce a range of *shades*. Adding white or black to a color will not change its hue: Pink, created by adding white to red, is a light-red hue; maroon, achieved by adding black to red, is a dark-red hue (Fig. 10–1b). But mixing a hue with either of these neutrals will diminish its purity to some extent, depending on the proportions of the admixture. (The purity of a color is discussed in more detail in the next section.) Creating tints and shades of a color is useful, for example, when dramatic effects of form through chiaroscuro are desired (Fig. 10–3). (For a related discussion, see the use of monochromatic color under "Color Schemes" on page 221.)

A color can be lightened or darkened, without being neutralized, by mixing it with a second pure color that is analogous and lighter or darker in value, as needed. Mixing two pure, analogous colors, however, will produce a hue change (the steps in Figure 10–1c move from yellow through yellow-green and green to blue-green and blue). In contrast to the use of tints and shades, adjusting color value in this manner has the advantage of creating colors that express a greater sensation of color light across a form, not only in the most illuminated passages but also in the most shallow to deepest shadows.

INTENSITY

The term *intensity* refers to the saturation, or purity of a color. The purest colors, sometimes referred to as *parent colors*, are represented on the color wheel.

Students often experience difficulty at first in distinguishing between the concepts of color intensity and color value. Keep in mind that the parent hues vary in their values (blue-purple is darker than red, yellow-green is lighter than red-orange), but all parent hues are equally intense. The idea that hues on the color wheel are the same intensity may initially confuse you since yellow can appear more intense than purple. That distinction is a matter of perception and subjective interpretation. (We associate yellow with bright light and activity while purple may suggest cool shadows and rest.)

From a perceptual standpoint, the reason that dark, transparent pigments appear almost black when a glob of paint is squeezed out of a tube is that light is trapped in the paint film. If you apply a thin layer of such paint to a white support, light can bounce off the particles of pigment and the intensity of the color becomes evident. Some practitioners will add a small amount of white to a dark

color in an effort to make it more intense. Although adding white to dark, transparent colors will perceptually brighten them (thalo blue looks almost electric when modified in this way), this practice actually decreases the intensity of a dark pigment by converting the pure color into a tint.

Two concepts sometimes associated with intensity are color brilliance and luminosity. *Brilliance* refers to the *quality* of light that is reflected from a color pigment, as distinguished from value, which designates the *quantity* of light reflected. To test this difference, place a swatch of pure yellow paint next to a light gray of the same value and observe how the yellow appears much brighter. (In a black and white photograph, the swatches would appear identical.) In making judgments about color intensity and brilliance, bear in mind that while the most brilliant colors are always fully saturated, not all fully saturated colors possess brilliance (consider once again our earlier comparison of the parent hues of yellow and purple). Note that you will alter both the brilliance (vividness) and the intensity (purity) of any single color by mixing it with white, black, or another color.

Luminosity refers to applied uses of color to achieve certain visual effects, rather than to basic color theory. The word luminosity may be used to describe the illusion of light emanating from *inside* a color area, as in the large central shape of the drawing by Margaret Lanterman (Fig. 10–4). The effect of a mysterious emission of light from this area is achieved by juxtaposing its cool light yellows and greens with a series of warm colors and darker values that make up the remainder of the image. Also observe how the delicately modulated colors in the luminous area create the sensation of a translucent gaseous medium in contrast to the surrounding opaque and comparatively heavy masses. To help you grasp this concept, compare the luminous color light coming from within the major form in Figure 10–4 with Figure 10–5, where the objects are bathed by an external light source.

The concepts of hue, value, and intensity cross over when an artist mixes chromatic grays. The term *chromatic gray* refers to a gray created by adding hue to a neutral or by mixing complements to achieve a neutralized color. Achromatic grays are uncommon in nature; chromatic grays are not. Line up a series of small stones in daylight and you will probably be surprised by the number of color grays you see. There are several ways to make a chromatic gray. Mixing a hue with an achromatic gray of a different value will neutralize the intensity of the hue and change its value. Mixing a hue with an achromatic gray of the same value will diminish the intensity of the hue without altering its value. Chromatic grays obtained by mixing a hue pigment with an achromatic gray are generally flat and dull in appearance and are, for example, excellent for depicting the opacity of surface and weight of solid forms.

Chromatic grays of a different order can be achieved by mixing two complementary colors. When made with complements, these chromatic grays appear as though they are permeated with light, and they are coloristically richer than grays arrived at by mixing achromatic neutrals with color. As Figure 10–1d illustrates, when complements are mixed, they generally result in neutralized color tones. However, if the mixture is carefully adjusted, a chromatic gray will result, as demonstrated in the middle box of our example, where a slate gray appears. (The richness of a chromatic gray will be more apparent if a small amount of white is added, as in our illustration, but that will further neutralize the color intensity.) The hue and value of the gray that results depends on which of the two complements was used in the larger amount. With some commercially available pigments, a pure gray can be achieved by scrupulously mixing equal amounts of both complements.

In Figure 10–6, color grays are obtained by using what is often called optical color. *Optical color* refers to the eye's tendency to mix small strokes of color that are placed side by side or overlapped. For example, adjacent strokes of red and yellow in a drawing will be perceived as orange from a normal viewing distance.

Note, however, that complements applied this way will cancel each other's intensity as they blend in the eye to produce vibrant chromatic grays. In Figure 10–6, red, orange, blue, and yellow were applied in a dense tangle of strokes, dabs, and dragged lines, with the addition of white, to produce neutralized complementary relationships of red-purple with yellow and yellow-green, and blue passages flecked with orange.

Color Schemes

The term *color scheme* refers to an association of selected colors that play a major role in the organization of a work of art. A color scheme also establishes a principal color harmony or color key in an artwork and in so doing is an important carrier of content. Two or more color schemes can coexist in a work, usually in a dominant–subordinate relationship.

The inventory of color schemes is large, but five in particular can be considered fundamental, since they are used most often, either individually or in combination, and they form the basis from which more personal color schemes can be improvised. They are the monochromatic, triadic, analogous, complementary, and discordant color schemes.

A *monochromatic* color scheme is limited to the value and intensity variations of one hue. A monochromatic work can be achieved by adding white and black to a hue, as in Figure 10–3, in which the monochromatic color scheme is effectively used in creating the illusion of three-dimensional form and space. A second means for producing a monochromatic color scheme is to dilute a hue pigment to various strengths, as in Figure 10–7. Here, the monochromatic red ground, extremely harmonious and consistent in its visual dynamic, establishes a subdued backdrop for the smaller, more intricately colored image.

Triadic color schemes are based on three hues that are equidistant from one another on the color wheel. There are three categories of triadic relationships: the primary triad (red, yellow, blue); the secondary triad (orange, green, purple); and two sets of tertiary triads (red-purple, blue-green, yellow-orange; and yellow-green, red-orange, blue-purple). The primary triad is the most common, not only in fine works of art, but also in mass-media advertising. This is because the bold, elemental potency of this triad, as in the high-key color work by James McGarrell (Fig. 10–8), has broad appeal.

The secondary and tertiary triads tend to produce more subtle relationships. One reason for this is that in contradistinction to the primary triad, which consists of hues that are unique and basic, each of the hues in the secondary and tertiary schemes shares a color with the two other hues of the triad. For example, in the secondary triad, orange shares yellow with green and red with purple; in one of the tertiary triads, red-purple shares red with yellow-orange and blue with blue-green.

So although each of the triads is based on contrasting hues that can enliven the surface of a drawing, the colors that constitute the secondary and tertiary triads have built-in bridges that shorten the intervals of difference. Artists frequently capitalize on the unifying potential of secondary and tertiary schemes, as in Figure 10–9, in which roughly the upper half of the drawing is pulled together by a secondary triad.

As alluded to earlier, artists often use a particular color scheme to establish a dominant harmonic key or mood, without precluding the coexistence of other colors in the work (as in Fig. 10–9). A more rigorous application of the triadic concept can be found in Figure 10–10, in which all of the colors have been mixed by using the same three hues of red, yellow, and blue in conjunction with black and white.

Analogous color schemes involve several hues (usually three or four) that are adjacent to each other on the color wheel. Yellow, yellow-green, green, and

blue-green constitute one analogous color scheme. Analogous hues create extremely harmonious color relationships because of the short intervals between the neighboring hues on the color wheel and also because one common color links the hues in any analogous sequence (yellow is the common color in this example).

The dominant colors in the Jim Nutt drawing (Fig. 10–11) lie within the analogous scheme of red-orange, orange, yellow-orange, and yellow. This warm set of colors* expresses an almost claustrophobic sense of intimacy and heats up the tension in the farcical female/male relationship. Smaller areas of the comparatively cool hues of blue-green, blue-purple, and red-purple act as color accents to jangle the nerves of the viewer. This group of colors skips over blue and purple, demonstrating that an analogous color scheme does not necessarily depend on all the colors in a contiguous series on the color wheel being represented.

Figure 10–12 more strictly follows a series of analogous steps across orange, yellow-orange, yellow, yellow-green, and green. Note in this work the striking illusion of colored light achieved by mixing analogous hues in varying proportions to adjust intensities and values.

Complementary color schemes employ hues that are directly across, or opposite, from one another on the color wheel. For example, red/green, orange/blue, and yellow-green/red-purple are all pairs of complementary colors.

A complementary color scheme can be built around one pair of complements, or pairs of complements can be used in combination. In the watercolor and colored-pencil drawing by Lostutter (Fig. 10–13), three pairs of complementary hues are used: red-orange/blue-green, red-purple/yellow-green, and yellow-orange/blue-purple. A variation on the complementary color scheme may be achieved by employing three hues in a "split-complementary" relationship. Split complements are obtained by using a hue in combination with the colors on either side of its true complement. In Figure 10–24, for example, the intense yellow shapes in the center and on the right of the drawing are juxtaposed with blue-purple and red-purple areas.

A *discordant* color scheme is based on hues that compete or conflict, resulting in a relationship of disharmony. There are no absolute rules for creating discordant color schemes, but generally speaking, a combination of hues that are far apart on the color wheel (except complements) will achieve discord. Also, an already discordant relationship can be heightened by equalizing the values of the colors or by reversing their natural value order.

The clash of some discordant schemes can agitate, even shock, an audience, grabbing its attention. The content embodied in such a combination of colors is valued by artists who wish to create visual metaphors for extraordinary phenomena, as in Figure 10–14. Here, a boisterous early morning sky is expressed through the contrasts of red-orange, yellow-green, and blue-purple. These three colors, which are in a triadic relationship on the color wheel, are set on edge in this work by several color and design factors. First, each of these colors is in high saturation, creating a visually biting, or acidic, effect. Second, the rapid color-value contrasts divide the surface of the work into agitated positive-negative divisions. Third, the scale, velocity, and diagonal direction of the cloud formation at the top adds immeasurably to the perceptual violence of the image. (Relief from the visual noise of the sky is found in the interval of cool, blue-gray water.)

Looking more deeply at the color ideas in this image, note that the pH of the red-orange is intensified by the presence of its complement, the blue-green of the wedge shape on the upper left. This blue-green may also be seen as part of an analogous progression which includes the yellow-green bands and the occasional spots of pure green. Similarly, look for the stepped relationship among the red-purples, purples, and blue-purples. Both of these analogous systems furnish the

*For more discussion on this concept, see "Warm and Cool Color" on p. 224.

image with a foundation of coloristic order upon which a highly expressive statement of visual discord has been recorded.

More gentle discord can still arouse unsettling feelings. In Figure 10–15, the reversed tonal order of the light purple strokes to the left of the figure in relationship to the darker greens of the ground, together with the passages of yellow interspersed among areas of blue-green, are visually unpleasant (the viewer may feel subtle waves of queasiness). In the final analysis, the color discord in this drawing is inseparable from the content associations it evokes: the self-absorbed, anguished characterization of the figure and its stale, sickly aura of decadence.

Using Color to Represent Space and Form

A spatial dynamic is inherent in the perception of color. In the world around us, color is light, and light reveals the dimensions of space and form. It is up to the artist to control the interactive energies of color pigments to convincingly depict the volume of individual forms and the impression of depth. This section concentrates on four concepts that are basic to representing space and form with color: local color, warm and cool color, color value, and the optical phenomenon of push–pull.

LOCAL COLOR

Local color refers to what is generally understood to be the actual color of an object's surface, free of variable, or unnatural, lighting conditions. The yellow of a lemon, the blue of a swimming pool, the fluorescent orange of a Frisbee are all examples of simple local color.* Local color, as the readily identifiable color characteristic of an object, provides a conceptualized home base for more complex local-color explorations.

Complex local color refers to the natural range of hues of some objects that, seen under normal light, constitutes the overall impression of a dominant local color. In Figure 10–16, for example, many of the green peppers include several hues of green and blue-green with subtle patches of yellows, and reds, and oranges. (The peppers that are half green and half red represent a variation on this idea in that they do not possess a dominant local color. A red-and-white-checkered tablecloth and a plaid shirt are two more examples of objects with more than one local color.)

An allied concept is perceived color. *Perceived color* refers to observed modifications in the local color of an object because of changes of illumination or the influence of colors reflected from surrounding objects. Dramatic changes in the color of objects can occur, for example, at twilight, under artificial illumination, or during volatile atmospheric conditions, such as stormy weather. Figure 10–17 records the darkened colors of crops, grasses, and earth under an overcast sky. In Figure 10–25, we see on the apple a combination of complex local color (the oranges, greens, and yellow-greens on the illuminated side) and perceived color (the bronze-green mixture on the shadowed side, the result of reflected color). And in Figure 10–16 observe the varied muted colors that make up the shadowed sides of the cardboard box and paper bag.

So on the one hand, the problem posed for the artist is to render sufficiently well the rich colors that appear on an object so that its image in the drawing rings with authenticity. On the other hand, there should not be such a profusion of

*For a discussion about a similar concept in black-and-white drawing, see "Local Value" in Chapter 7, "Form in Light."

hues describing an object that the integrity of the local color is compromised. Furthermore, the colors selected to describe an object should serve the needs of the illusion of three-dimensional form *and* the design motives of the work.

WARM AND COOL COLOR

In addition to the qualities of hue, value, and intensity, colors are perceived to have temperature. Colors are usually classified as either "warm" or "cool" (of course, the visual mercury may rise to a hot color or dip to a cold one). Dividing the color wheel in half provides an easy means for general identification: In our color wheel (Fig. 10–1a), the top half is occupied by the warm colors yellow, yellow-orange, orange, red-orange, red, and red-purple; the bottom half by the cool colors yellow-green, green, blue-green, blue, blue-purple, purple. This division should serve as a reference point, not a formula. Warm blues and cool yellows are common phenomena in works of art, and color interaction can cause the temperature of any hue to change, or appear to change, depending on its color context. A yellow-green, for instance, will look cool when surrounded by reds, oranges, and warm browns but look downright hot in the context of gray-blues and blue-violets.

Related to the definition of warm and cool color is the broader concept of *color climate*, which associates sensations of moisture or aridity with color temperature. In Figure 10–12, for example, there is a conspicuous difference between the more baked-dry sections of yellow-orange scaffolding illuminated by sunlight and the neutralized orange and green shadowed spaces where, it would seem, algae could flourish.

We instinctively identify temperature differences among hues; as an example, think how we instantly comprehend a colored weather map, quickly distinguishing between cold fronts expressed in blue and warm fronts expressed in red, orange, or yellow. Based on deep-seated sensory experiences, we associate the warmer colors of the spectrum with sunlight, fire, or the stove burner that was too hot to touch. Conversely, on a hot day, who is not tempted to wade into a stream or lake rippling with blue and green reflections or to collapse on a carpet of cool, green grass?

Generally, warm colors appear to advance and cool colors to recede. But this does not mean that we should not depict blue, green, or purple objects in the foreground of our drawings, since the illusory advance or retreat of any color depends on its intensity and value in relation to the surrounding colors as well as on the spatial structure of the image as a whole (note the blue arch in the upper left of Fig. 10–23). All things being equal, however, if two objects, identical except that one is orange and the other green, are placed at an equal distance from an observer, the orange object will seem to be closer.

What this general rule also refers to is the effect of atmospheric perspective, the same phenomenon we discussed in Chapter 1 "The Three-Dimensional Space of a Drawing" in relation to value. Atmospheric perspective has two effects on our perception of color. First, because the wavelengths of warmer colors have less energy than those of cool colors, the light rays of warm colors are absorbed more quickly by particulate matter in the atmosphere. This is why objects perceived at a great distance appear to have a blue cast. Second, the farther objects are away from us, the more the atmosphere disperses the rays of colored light reflected from them. As a result, the color intensity, brilliance, and contrast of all objects, regardless of whether they are warm or cool in hue, are reduced as we perceive them at increasing spatial depth, as can be seen in Figure 10–19.

COLOR VALUE

When using color to create the illusion of three-dimensional volume and weight, apply the same rules of atmospheric perspective discussed above, although on a smaller scale. Keep in mind, however, that convincing depictions of form are much more dependent on adjustments of color value and intensity than on hue selection.

And do not underestimate the power of monochromatic images or the use of a reduced number of hues to express mass and form. The fine-tuning of value relationships when working with a limited palette not only can sensitize you to a structural use of color but it can also help you to avoid being visually seduced by an array of local color in a complex subject.

Figure 10–5 exhibits an effective use of color value to represent the illusion of three-dimensional form. Particularly effective is the way chromatic grays render the play of light and shadow on the yellow-green material under the sewing needle. The shadowed left side changes from a neutralized yellow-green to a warm color gray with the admixture of red-purple (complement of yellow-green) to a cooler blue-gray as the cloth recedes. Note as well the cooler-color light in the shadow under the cloth, the very subtle shifts of color neutrals along the background plane, and the strategic use of flecks of saturated color at various pitches of brilliance (yellow to orange to red) that act like jewels sparkling out from under encrusted surfaces.

In comparison to the macabre interpretation in Figure 10–5, Figure 10–18 is more literal in its execution. Note how controlled color values emphasize the planar forms and spatial illusion in this photographically-derived work. Stark tonal contrasts emphasize the architectural geometry of the crisscrossing overpasses vivid, while the subtler gradations of color value, in the distant trees, register the effects of atmospheric perspective.

Squint your eyes to reduce hue contrast, and the orchestration of values employed to represent form and space will be more evident. (This is made easier by the work's relatively simple local color.) Turn the reproduction upside down and squint, and you will also see that the design unity of the drawing is helped by relationships among large abstract shapes of similar value.

Since the structural information in this work is bound up in value and perspective, you might be prompted to ask why it was not executed in monochrome. In response, we note that apart from color used as value there are two other important functions of color in this drawing. First, consider the crisp contrast of warm and cool hues which suggest time and temperature (the stretches of delicate warmth and pockets of refreshing shadow recall an invigorating autumn day). Second, note that saturated color, combined with some full-strength darks, is reserved for selected areas that demarcate a rectangle framing the main image, in effect pulling together dislocated segments of the drawing. Clearly then, the artist wished a more expansive statement than a monochromatic palette would allow.

PUSH–PULL

Up to this point, we have focused on the use of color in image-based drawings to clarify volume and space. Colors by themselves, however, have dynamic energies that can create a sensation of space that is free of both subject-matter connotations and the traditional methods for achieving three-dimensional illusion (perspective, chiaroscuro modeling, etc.). Spatial tension created purely on the basis of color interaction is often referred to as *push–pull*.

Push–pull can be loosely described as shifting relations among colors that appear to attract or tug on one another as if magnetized, with one color seeming to pull forward and another to push back. This refers to a manipulation of color that creates an "optical space" that, remarkably, appears to exist within the flat picture plane. Optical space is not a space that we understand rationally; it is a space that we react to as the result of our involuntary sensory response to color. So, optical space exists as a physiological fact. This is in contrast to the representation of three-dimensional space in a two-dimensional work, creating the illusion of a space you can walk through inhabited by things you can touch.

Controlling the push–pull dynamic depends on many coloristic factors. The intensity, value, and temperature of an individual color must be considered

relative to other important influences on the creation of color space, such as texture, placement, context, and the shape and area of a color (intense warm colors generally appear to expand, intense cool colors to contract).

Typically, artists achieve push–pull energy by working with relatively pure areas of color in a shallow or flat space. The Heizer drawing (Fig. 10–20) combines aspects of linear perspective with push–pull activity to create a limited but compelling layered space. The black-and-white photo image provides an illusion of depth through converging parallel lines receding diagonally from the picture plane. A series of intense color splashes and gestural scrawls superimposed over this image, like graffiti on a window, creates a second spatial arrangement based on push–pull. These areas establish a sequence of color planes that, because of their dazzling spatial shifts, make it difficult to locate the drawing's picture plane. For example, observe the progression from the green in the upper left, which appears to be well behind the transparent picture plane, to the large blue and red shapes which seem to have been sprayed and smeared on the back of the picture plane. The runny white splotch toward the bottom seems to have clotted on the front of the work, while the scribbled yellow lines right of center appear to have lifted off the surface to float in spectator space.

A selective use of push–pull color action serves up surprises in the otherwise consistent spatial fabric of the Colescott drawing (Fig. 10–21). Push–pull is most pronounced in the purple-edged blue area at the center, which, rather than receding as we would expect a cool color to do, appears to balloon upward to assert the flat picture plane. Similarly, in the upper left-hand corner, the cerise smear advances, again contrary to our expectations of this portion of a picture, which we normally associate with sky or distance. However, the strategic placement of such a warm color there firmly anchors that corner to the drawing's surface. Note also that the near-complementary relationship of the red and yellow-green forge a bold, diagonal cross-tension. This is in contrast to the series of overlapping shapes, starting at the lower left-hand corner, that march counterclockwise around the margin. Finally, observe how further advancement of the blue and red areas is thwarted by the shapes of the yellow-green shirt and yellow hair, which pull forward to hold their slightly more frontal planes.

Color and Design

Color should be wedded to design from the early stages of a drawing's conception. In a successful work, it is impossible to separate the contributions of color from the organizational relationships that constitute an image; but when color is added as an afterthought, the result is often as disjointed as a colorized photo.

The remainder of this section focuses on design concepts already introduced in Chapter 4, "The Interaction of Drawing and Design," but our purpose here is to suggest the mutuality of color and two-dimensional design in a drawing.

UNITY AND VARIETY

Since color adds the potential for greater variety in an artwork, it is important to find patterns of coloristic similarity to unify an image. For this reason, many artists find that preparatory studies are particularly crucial when working in color. Figure 10–22 reproduces an example of a student's process of laying out a color drawing. After the initial blue pencil sketch was completed, two color variations were made to test approaches to orchestrating the drawing's color and design. In the first color variation, a series of analogous reds, yellows, and oranges organizes most of the major planes of the image, with cooler blues and greens used judiciously as contrasting accents to guide the eye and open up the spatial illusion. The

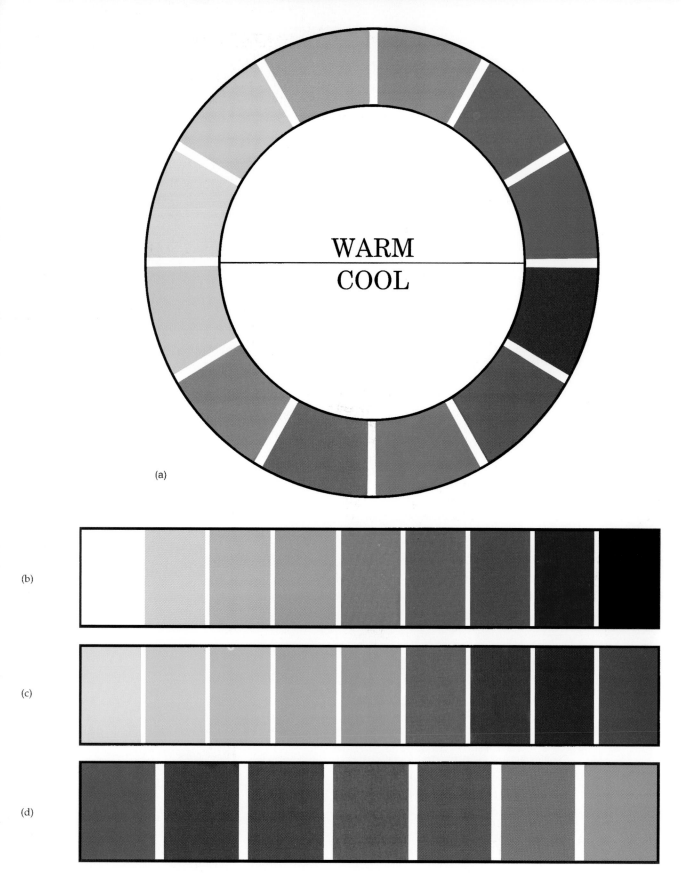

FIGURE 10–1
10–1(a) Twelve-Step Color Wheel,
10–1(b) Tint/Shade Scale,
10–1(c) Color Value Scale,
10–1(d) Complementary Color
Scale (middle gray heightened
with white)
Courtesy, The Color Wheel Co.

FIGURE 10–2
MICHIKO ITATANI
Untitled, 1991
Mixed media on paper,
22 × 30"
*Courtesy, Deson-Saunders Gallery and
Printworks Gallery, Chicago*

FIGURE 10–3
TIM JOYNER, University of Montana
Student drawing: monochromatic
color
Courtesy, the artist

FIGURE 10–4
MARGARET LANTERMAN
Chair for Don Juan, 1983
Pastel on paper, 26 × 36"
Courtesy, Roy Boyd Gallery, Chicago

FIGURE 10–5
JIM BUTLER, Middlebury College
Sewing Machine, 1986
Pastel on paper, 12 × 16"
Courtesy, the artist

FIGURE 10–6
ARNALDO ROCHE RABELL
We Have to Disguise, 1986
Oil on canvas, 84 × 60"
*Courtesy, George Adams
Gallery, New York*

FIGURE 10–7
ED SHAY
Myth, 1991
Watercolor, 36¼ × 29¼"
Courtesy of Roy Boyd Gallery, Chicago

FIGURE 10–8
JAMES MCGARRELL
Entry to the Gypsy's Tent, 2000
Oil on panel, 23 × 31"
Courtesy, Sonia Zaks Gallery, Chicago

FIGURE 10–9
TADD TRAUSCH, University of
Wisconsin at Stevens Point
Student drawing: use of secondary
triad as a unifying factor
Pastels on paper
Courtesy, the artist

FIGURE 10–10
JEFF NEUGEBAUER
Arizona State University
Student drawing: primary triad
Courtesy, the artist

FIGURE 10–11
JIM NUTT
Really!? (thump thump!), 1986
Color pencil, 14 × 16"
*Courtesy of the Phyllis Kind Gallery, Chicago
and New York. Photo: Wm. H. Bengston*

FIGURE 10–12
JAN GREGORY
University of Arizona
Student drawing: analogous color
Courtesy, the artist

FIGURE 10–13
ROBERT LOSTUTTER
Indian Forest Kingfisher, 1992
Watercolor, pencil on paper,
41½ × 31"
*Courtesy of the Phyllis Kind Gallery, Chicago
and New York. Photo: Wm. H. Bengston*

FIGURE 10–14
GRAHAM NICKSON
Red Dawn: slide, Great Island Series,
1999
Watercolor on paper, 18 × 24"
Courtesy, Salander O' Reilly Galleries

FIGURE 10–15
FRANCESCO CLEMENTE
Untitled, 1987
Pastel on paper, 26¼ × 19"
Courtesy, Sperone Westwater, New York

FIGURE 10–16
ED ROLLMAN SHAY/
CHARLOTTE ROLLMAN SHAY
Pepperbox, 1979
Watercolor, 40 × 60"
Courtesy, Roy Boyd Gallery, Chicago

FIGURE 10–17
GEORGE ATKINSON
East of Heywood, 1987
Pastel on paper, 25 × 45"
Courtesy, Struve Gallery, Chicago

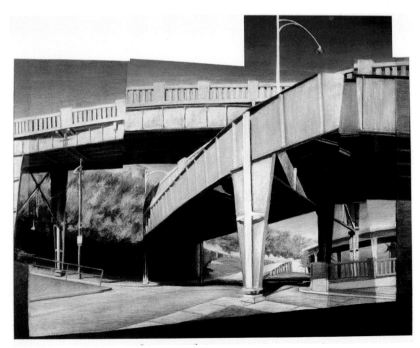

FIGURE 10–18
NEAL MCDANNEL
"5 in the *Highway to Heaven*
Series," 1992
Pastel, 27 × 35"
Courtesy, the artist

FIGURE 10–19
NELL BLAINE
Grey Skies, 1992
Watercolor and pastel on paper,
12 × 16"
Courtesy, Fischbach Gallery, New York

FIGURE 10–20
MICHAEL HEIZER
Mausoleum, 1983–1987
Silkscreen, oil pastel, colored
pencil, gouache, 48 × 48"
Courtesy, the artist

FIGURE 10–21
ROBERT COLESCOTT
A Letter Home, 1991
Artist's proof, acrylic on paper,
40½ × 26"
Courtesy, the artist

FIGURE 10–22
JAN GREGORY, University of Arizona
Student drawing: preparatory
color studies
Courtesy, the artist

FIGURE 10–23
BILL CASS
The Good Man, 1988
Watercolor on paper, 25½ × 37"
Courtesy, Roy Boyd Gallery, Chicago

FIGURE 10–27
WILL MENTOR
Water Management, 1995
Mixed media on bookpage,
11¾ × 8¾"
Courtesy of P.P.O.W Gallery, New York

FIGURE 10–28
ADOLF WOLFFLI
Untitled, c. 1920
Color pencil on paper, 12¾ × 20"
*Courtesy of the Phyllis Kind Gallery, Chicago
and New York. Photo: Wm. H. Bengston*

FIGURE 10–29
DAN LEARY
Self-Portrait XXIII
Pastel and powdered pigment
on paper, 22½ × 17½"
Courtesy, Printworks Gallery, Chicago

FIGURE 10–30
MARY FRISBEE JOHNSON
*The Heartland Narratives:
Radon*, 1990
Pastel on paper, 30 × 44"
Courtesy, the artist

second variation reorganizes the pictorial shape formations in conjunction with a general muting and cooling of the color scheme. Note how the triangular deployment of yellow-orange shapes in this variation unifies the entire composition.

VISUAL EMPHASIS

A powerful way to create or strengthen visual emphasis in a work of art is to use simultaneous color contrast. *Simultaneous contrast* refers to the enhancement of contrast that occurs between two different colors that are placed together. Color contrasts are created by differences of hue, value, intensity, brilliance, and temperature. The artist may opt for different degrees of simultaneous color contrast. For example, a grayed red-purple appears relatively intense against a neutral gray ground, but it seems more charged against a chromatic gray ground that has a yellow-green cast. On the other hand, that same mixture appears less intense if surrounded by a saturated red-purple.

Hues in a complementary relationship produce the most striking effects of simultaneous contrast (Fig. 10–23). When two complements are unequal in saturation, the hue of the lower intensity color will seem strengthened, as is the case with the recumbent figure in the middle of Figure 10–23, which appears more decidedly green than it would in a context of less color opposition. When high-intensity complements of equal, or nearly equal, value are used, the pair of colors will appear to vibrate, as can be seen with the smaller, blue archlike shape against the red-orange ground in the same drawing. Remember that complementary contrast depends on at least one of the pair of colors occupying an area in the artwork that is comparatively large. As mentioned earlier, small adjacent shapes or strokes of complements will neutralize each other.

Figure 10–24 is a good example of how diverse gestural energies and color ideas in a drawing can be ordered into a hierarchy of visual emphases based on color contrast. Observe first the larger framework of similarities consisting of a geometry of facades and flattened cubicles colored with a series of generally close-valued, darkish hues.

The large blue-purple facade with its bright-yellow doorway is the main focal point of the image. The near-complementary contrast of these two colors, heightened by their differing quantities and stark contrast in value and color brilliance, creates a nucleus around which the smaller, congested areas circle and group. The larger yellow rectangle to the right moves us out of the center and adjacent to the red-purple square that completes the split-complementary relationship (yellow to red-purple and blue-purple). All three yellow shapes create an area of emphasis at strategic points in the drawing. Notice also the secondary network of accents that enliven the surface, which is based on relatively subtle changes in value, hue, and saturation (the lime green rectangle in the lower left, situated against a ground that slips from orange to pink, is especially rich).

COLOR ECONOMY

Related to visual emphasis is the economic use of color in a drawing to achieve dramatic expressive or aesthetic effects. Refer back to the drawing by Itatani (Fig. 10–2) and note how the introduction of muted red-orange charges the emotional relationships among a group of figures that, by virtue of their almost stereotypical heroic bodies and achromatic depiction, might otherwise seem distant from each other and from the viewer. Color economy can also contribute to formal clarity, as in the Currier drawing (Fig. 10–25). Notice here how expanses of cream and light-yellow contrast with the subtle handling of gradually more saturated hues (climaxing in the intense yellow-green of the apple). These differences are united at diagonally opposed corners by russet triangles that, like wedges, hold everything in place.

BALANCE AND MOVEMENT

The quantity and quality differences among colors, and the way in which they are consolidated or divided, affect our perception of balance and movement in a drawing. In Figure 10–26, a nearly symmetrical image is created by the massing of color into large planes that are roughly equivalent in size and emphasis on either side of a vertical axis and by an essentially even distribution of visual accents across the field of the drawing. The sense of color balance is strengthened by the use of complementary colors, which by their very definition as complements give the impression of "completing" each other.* In terms of movement, the color contrasts among the shapes along the border create an almost hypnotic series of irregular beats. In the lower half of the main image, the movement is more regular, sustained by the comparatively subtle hue contrast of the muted-green tree trunks against the pink sky; the graduated progression of analogous colors across the landscape; and the evenly spaced value contrasts represented by holes in the ground, mounds of dirt, and saplings to be planted. And note that when you arrive at the illuminated center of the drawing, the resting place of the lamp cannot be viewed without a peripheral awareness of the color "noise" on the edges. This is a canny color movement strategy used by the artist to express the conflict between the yearning for inward calm to better marshal one's forces and the insistence of outward distractions.

Discussion of two asymmetrical images is in order. Figure 10–23 demonstrates how small proportions of color in a large, differently colored field have the power to attract our attention and counterbalance other types of visual weight in a drawing. In Figure 10–27, two counterbalancing forces are particularly demonstrative. From a form standpoint, the initial impact of the two pieces of fruit in the upper left is harmonized by pairings of flowers on the right and globs of paint at the lower left. The gestural sweeps from one form couplet to another is stabilized by a color system based on repetition of hue, intensity, and value. Most particularly, note how the saturated yellow-oranges and reds, in conjunction with the achromatic whites, are cross-referenced in a series of triangles. (Do not miss the white halo around the peach that serves as the apex of that triangular configuration.) Additionally, observe how the delicate balance in the work depends upon adjusted proportions of saturated hues in relation to contrasts of value. (The rounded passages of neutral orange-browns, including the peach pit, are roughly organized into yet another triangular formation.)

Color and Expression

The potential of color in art to evoke associations and express feelings, from the most powerful of emotions to the most delicate of aesthetic insights, is incalculable. Correspondingly, since color perception is grounded primarily in the deep structures of personal experience, each artist will capitalize on color's expressive potential in a different way.

Color used to expressive ends is not the domain of a particular artistic style. It would be a mistake to conclude that the expressive values of a highly representational, or naturalistic, artwork are necessarily any less rich than those of a more blatantly expressionistic image. Representational artists do not necessarily copy the color relationships they see in the world before their eyes but rather use some combination of reason and intuition in interpreting those relationships. Even when using color to capture the particulars of light, space, and form of a subject, you will find that the abstract processes of color selection and the orchestration of

*The notion of complements completing one another is based on physiological fact. Staring at any intense hue tires the eye, and to compensate, the eye perceives in that intense color the flicker of the color's complement. Also, less intense or neutral colors adjacent to an area of intense hue will appear to have the cast of that color's complement.

color with compositional motives inevitably infuse your so-called naturalistic work with a sensibility unique to you. What is important, regardless of the style in which you work, is to use color in a way that contributes to the content and structure of your drawing.

Having said that, it is important to note that throughout the twentieth century to the present day, the visual arts in Western society have been characterized by the coexistence of two fundamental streams of color conception: One stream continues the Renaissance practice of descriptive color based on references to nature; the second stream has liberated color from its purely descriptive role, broadening the artistic inventory of expressive response. The remainder of this section focuses on the latter, that is, the more overt manipulation of color for subjective purposes, as distinct from a more objective approach aimed at emulating nature. (We distinguish between the terms *subjective* and *objective* for the sake of clarity only. Once again, we acknowledge that the application of these terms is as relative as color itself.) Accordingly, we begin with a definition of subjective color.

Subjective color refers to arbitrary color choices made by the artist to convey emotional or imaginative responses to a subject, or to compose with color in a more intuitive or expressive manner. Note that the use of the word *arbitrary* in this context is not meant to imply superficial motives for deciding on an arrangement of colors. Instead, it suggests deeply felt impulses or convictions about color that are not dependent upon references to the natural world.

In the drawing by Adolf Wolffli (Fig. 10–28), subjective color is used both to promote the design and to serve decorative rather than spatial purposes. The evenly applied, pleasing colors have an ornamental, almost ceremonial splendor. Carefully plotted into active zones, the intense hues are balanced against the gray areas of rest to enhance sensations of order and harmony. Note the brilliant yellow accents that seem to confer status upon the variously scaled human and animal heads. Marching clockwise around the central swirl of black, brown, and purple shapes, these yellow accents establish a motif that imbues the image with an air of stately formality.

Heightened or exaggerated color can strengthen our emotional identification with a subject. The color in Dan Leary's self-portrait (Fig. 10–29), for example, expresses a radiance that transcends realism. Certainly, the facial expression together with the vulnerable gesture of the head and neck contribute to the poignancy of this image. But it is the scalding intensity of the color that is paramount in creating an immediacy of emotional impact; we cannot help but respond to the suggestion of such an acute state of mind without attributing our own subjective feelings to the plight of the subject.

The central role of color in setting the mood of Leary's work is instructive. In general, color can stimulate a wide range of psychological and associative responses, consciously or unconsciously. It is not uncommon, for example, for a viewer to associate certain colors and properties of colors with specific feelings (warm colors get our attention and can inspire a robust, aggressive, or hopeful temperament; cool colors are more withdrawn, suggesting a serene, reserved, or melancholy disposition—"I've got the blues"). Associations can also be made with sensory experiences (red is often equated with a sweet taste and things hot to the touch, green with outdoorsy smells, and orange with brassy sounds).* Particular hues may also trigger symbolic associations with abstract concepts: For instance, we are culturally conditioned to associate yellow with treachery or cowardice and purple with royalty; we may even have a red-letter day because of our green thumb!

*Having a subjective sensation accompany an actual sensory experience, such as hearing a sound in response to seeing a color, is known as "synesthesia," a phenomenon explored by many, particularly nonobjective, artists during the twentieth century.

Returning to the Leary drawing, note that the face is an island of intense oranges, a color that often symbolizes irradiation, surrounded by dark values that connote brooding or introspection. In comparison to the naked emotion displayed in Leary's drawing, the substitution of a fanciful color system for local color in Roche Rabell's self-portrait (Fig. 10–6) results in a concocted image of ritualistic power that conceals the sitter's identity. A dead giveaway is the flamboyant color of the hair. Looking as if it has just ignited, with curls of flame licking the edges of the face, this badge of an assumed persona might summon responses of fear, amazement, or even irreverence, but it is not easily ignored. The claylike grays of the face suggest inertia and depersonalization and as such are the perfect foil for the animated, intimidating stare of the eyes, the only clue to the true personality behind the disguise.

The symbolic connections the mind makes with a particular color can be contradictory (red can mean sanctity or sin). Interestingly, the color green is most frequently associated with nature, and by extension it symbolizes the positive concepts of life and growth. Given that, how effective and startling is the negative representation of this hue in Figure 10–30. Here, a fluorescent green, made to look radioactive against the dark blue ground in the lower third of the drawing, creates a compelling symbol for the silent but lethal effects of radon poisoning.

Although there may be a level of shared response to color within a society, the attribution of meaning to colors is highly variable among individuals and across cultures (contrary to American practice, in China, green means stop and red means go). For this reason, it makes sense for you as an aspiring colorist to periodically analyze for content your own color preferences, as gleaned from your personal work and from masterpieces that strike you as particularly effective in their use of color. The reactions that color in an artwork provokes from an audience are, of course, impossible to predict. What is important is that the subjective color choices that an artist makes possess the *authenticity* to move viewers toward responses that are similarly strong, if not identical in kind, to the artist's expressive intentions.

Drawing the Human Figure

Why Draw the Figure?

A summary look at the history of Western art since the Renaissance reveals striking changes in the depiction of the human figure. While representations of the human form from the fifteenth through most of the nineteenth century tended to be highly naturalistic, treatment of the figure became suddenly much more abstract in the first half of the twentieth century. You can verify this for yourself by comparing the early Renaissance painting of the dead Christ by Mantegna (Fig. 3–2a) with the Henry Moore drawing of women winding wool (Fig. 7–17).

Even more radically, as twentieth-century Modernism progressed, not only the human likeness, but imagery of any sort, became endangered. With the advent of so-called Postmodernism late in the twentieth century, interest in the figure was revived but that was, and remains, just one stream of activity among many practiced today. More recently, the necessity for first-hand study of the body has been thrown into question by the availability of software that furnishes options other than freehand drawing for representing the figure.

You may find it curious that in spite of the move away from figurative concerns by professional artists of the twentieth century, the study of the figure in university art departments and art schools has continued. Why, you might ask, is an academic tradition started in the Renaissance still relevant today?

For students who continue to be interested in the human body as a subject, the study of figure drawing is still important in spite of all the technological means for inventing and manipulating figurative imagery. Drawing remains the best route to an understanding of human form, and practice at drawing will eventually invest your figurative images with a sense of authenticity, whether or not you choose to take advantage of advanced technologies. But even for those students who have no particular interest in figurative imagery, working from a life model accrues benefits that cannot be obtained any other way. Most pointedly, insights gained from rigorous figure drawing equip the artist with a profound grasp of the world of natural form. And the lessons learned about the form and structure of complex organic subject matter can be applied to virtually any artistic discipline.

Body Identification

The human body is a subject unparalleled in its scope for empathy. Your strong identification with your own body makes it possible for you to wince if you see another person hit a finger with a hammer, or to feel a sense of relief in your own shoulders when you see someone set down a heavy suitcase. That same natural empathic capacity can be put to valuable use when it comes to drawing the human figure. Our approach throughout this chapter is founded upon the concept that, as an artist, your identification with your own body is key to understanding and expressing the figurative subject. By referring you to the experience of your own body, it is our intention that you will learn the basics of figure drawing "from the inside out."

In keeping with this emphasis on the influence of internal structure on exterior appearance, we urge you to take a few minutes to become acquainted with some of the most evident characteristics of human form. Figures 11–1, 11–2, and 11–3 will serve as visual guides. Using your own body as a primary reference for understanding anatomy will increase your sense of "body identification." By this we mean that you will become more attuned to deep-seated associations that will help you to identify with the life model you are drawing.

To begin, assume a "stand at attention" posture, looking straight ahead, shoulders back, arms at your side, spine slightly arched, knees straight but not locked, and with feet slightly apart. Now, using your head as a starting point, begin an orderly tour down your body to the bottom of your feet, pausing to size things up at five key stations.

FIGURE 11–1
BERNHARDUS SIEGFRIED ALBINUS
Tabulae Sceleti et Musculorum
Corpus Humani
London, Knapton, 1749
Tab I
Courtesy of the Malloch Rare Book Room of
The New York Academy of Medicine

FIGURE 11–2
BERNHARDUS SIEGFRIED ALBINUS
Tabulae Sceleti et Musculorum
Corpus Humani
London, Knapton, 1749
Tab III
Courtesy of the Malloch Rare Book Room of
The New York Academy of Medicine

FIGURE 11–3
BERNHARDUS SIEGFRIED ALBINUS
*Tabulae Sceleti et Musculorum
Corpus Humani*
London, Knapton, 1749
Tab II
*Courtesy of the Malloch Rare Book Room of
The New York Academy of Medicine*

1. The head, neck, and backbone.

Place the heels of both hands over your eyes, and rotate your palms outward so that your spread fingers wrap lightly around your head. With the fingertips of your forefingers and middle fingers extended toward the back of your head and the little fingers lying across your forehead, note that the front of your skull is narrower than the rounded volume of the cranium in back. Run your fingers back along the cranium to the base of the skull. Tipping your head forward, continue moving the fingers of one hand down the back of your neck until you find a bony protrusion. This prominent bump is one of the cervical (or neck) vertebrae and provides evidence of a deep structure inside your body: the spinal column, which unites the skull, rib cage, and pelvis. Note the natural curvature of the spinal vertebrae in our illustration (Fig. 11–2), then bend and twist your torso to experience the flexibility of your own backbone.

2. The collarbones and shoulders.

Touch the pit of your neck at the base of your throat. On either side of this point is a symmetrical bony system, often referred to as the shoulder girdle, which consists of the collarbones and shoulder blades. Since the axis of this girdle is perpendicular to the spinal column, it represents a major intersection of your body. The shoulder joint is one of the most flexible joints in the human body. If you extend both arms and swing them in windmill fashion, you should get a good idea of the unique range of motion available to this ball and socket joint. As you do so, lightly grasp one shoulder joint with the opposite hand so that you can feel the changing relationships of the collarbone and shoulder blade as your arm bone rolls in its socket.

3. The rib cage.

The shoulder girdle is attached to the rib cage. Remaining at attention, bend your arms at right angles toward your body and locate two pronounced sharp points at the bottom of your rib cage; they are on each side of the frontal plane of your torso, just above your stomach. Using both hands, trace inward from

both points to outline the upside down V of your thoracic arch. Next, spread your fingers and feel the rib cage's curvature around the sides and down to the front of your body. This tactile searching out is meant to impress upon you the volume of the rib cage and its pivotal role in shaping the voluptuous three-dimensional form of your upper body.

4. The pelvis.

The intersection of the spinal column and the hipbones is another skeletal landmark. Using an architectural analogy, one might think of the bones of the hip as a transfer beam, or lintel, helping to distribute the single-load weight from the upper body across the pelvis and down the two posts of the thigh-bones. Carefully balancing on one foot, gently rotate your opposite thigh noting that the fluid motion is similar to what you experienced when moving your arm in its shoulder socket. However, if you attempt to swing your leg in a wide circle, as you did your arms, you will discover that the mobility of this joint is more limited than that of the shoulder joint.

Before we move to the next station, change your posture by shifting your weight to one leg. Notice that the shoulders and hips, parallel a moment ago, are now at opposite angles. Lean the other way and the angles reverse. What has happened is this: In the static, at-attention pose, the major masses of your body were in alignment to effect a relatively simple balance. With the shift in weight, your stance has become asymmetrical, and the tilt of your pelvis had to be counteracted by the equivalent opposing swing of your chest and shoulders in order for you to keep your balance. This asymmetrical stance, with shoulders and hips in a contrary relationship, is referred to as a *contrapposto* gesture. Not only visually graceful, but revealing of the numerous cause-and-effect relationships inherent in weight shift, the *contrapposto* stance has been a feature of classic figurative form since the early Classical period of Greek art.

5. The legs and feet.

Stand again with your weight equally distributed on both feet. Tensing your thigh muscles, feel the compactness of the musculature that forms these pillars (interestingly, the muscles of the upper leg are sometimes referred to as *anti-gravitational*). Balancing on one foot again, test the hinge joint at the knee of your opposite leg, which permits only backward mobility. Finally, try to perceive a line of tension that runs from your hip joints, through your thighs and down the backs of your calves to the anchoring force of your heels. These downward forces are resolved in the end by the displacement of your weight forward as both feet hug the ground plane. (See Fig. 0–4 for a visual expression of these forces inside the lower leg.)

The sensory excursion you just completed was meant to accomplish two things: to imprint upon you a firsthand impression of the longitudinal and latitudinal wholeness of your body and to initiate an elementary working knowledge of major parts of human anatomy. The next step is to look at the relative sizes and organization of those parts, or what is commonly called proportion.

Proportion

Rules of proportion have been developed by different cultures since antiquity. The drawing by Leonardo in Chapter 3, "Shape, Proportion, and Layout," (Fig. 3–1) applies the classical canon of the Greeks as recorded by Vitruvius. A contemporary example of the use of the classical system of human proportions may be seen in the work of Martha Erlebacher (Fig. 11–4). Wholesale application of a code of idealized proportions, however, is a matter of artistic choice. Other

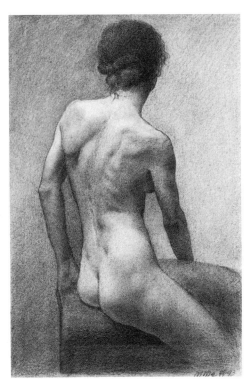

FIGURE 11–4
MARTHA ERLEBACHER
Cindy Seated, 1993
Graphite on paper, 19½ × 14"
Courtesy of The More Gallery Inc.

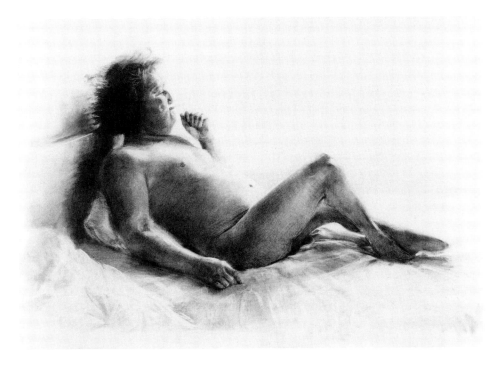

FIGURE 11–5
MYNKE BUSKENS
Number One, 1998
Pencil, graphite, eraser on paper,
150 × 200 cm
Courtesy, the artist, www.drawings.nl

options include a naturalistic approach, which emphasizes individual bodily idio-
syncrasies (Fig. 11–5) or an exaggeration of figurative form for expressive pur-
poses (Fig. 10–11). Nowadays, it is uncommon for artists to correct a life drawing
by using a strict, conceptualized canon of proportions. Instead, adjustments in
such a drawing are based on further visual observation and analysis, measuring
the sizes and angling the orientations of specific bodily regions. Still, awareness of
selected guidelines for part-to-whole relationships of the human body can estab-
lish a comparative norm from which you can analyze more complex proportional

FIGURE 11–6

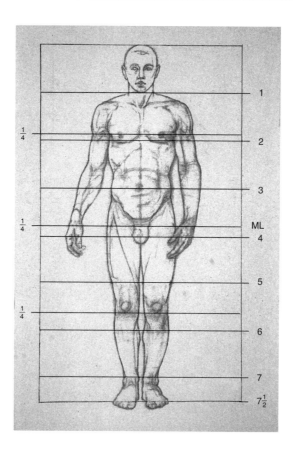

events. As diagrammed in Figure 11–6, common benchmarks of proportion are the following:

1. Using the head as a unit of measurement, the typical human figure is seven and one-half heads tall.

2. Subdivided into halves, the midpoint of the figure occurs at the hips just above the pubic triangle.

3. Subdivided into fourths, the length from the bottom of the foot to the middle of the knee equals the distance from the knee to the midline at the hips. The upper body is bisected at the nipples.

4. With arms held straight at the sides, extended fingers reach almost to the middle of the thigh.

Since human bodies are not uniform, this set of proportionate divisions should be understood only as a rough guide. Besides, such divisions are of limited use once the figure deviates from a symmetrical, standing position. Yet, with poses of short duration, when there is no time to be persnickety about proportion, these conventions can act as a convenient shorthand to lay out the relative dimensions of a figure.

Gesture Drawing as a Means to Interpret the Figure

The power of a gesture drawing is rooted in the artist's empathy for a subject. For this reason we strongly recommend that prior to beginning a gesture drawing, you take the model's pose yourself. Concentrate on what the pose feels like. Where is your body under tension? Where is it relaxed? What is the spatial relationship of your head, your torso, and each of your limbs? In addressing these

questions you will gain a physical understanding of the pose as you are sorting it out visually and conceptually.

To maintain your sense of bodily involvement and freedom while drawing, we suggest that you maintain an active posture by standing at an easel or kneeling in a hovering position. If possible, use paper no smaller than 18 × 24" so that you may employ the full kinetic sweep of your arm to echo the gestures of the model. In general, we also suggest that you use comparatively large drawing instruments such as sticks of charcoal, lecturer's chalk or graphite, or a carpenter's pencil sharpened to a flat, not a pointed edge. Grasp your tools not as if you were writing, but as you would a conductor's baton. In fact, when making gesture drawings we advise you to be two-fisted in your attack: Hold your drawing tool in one hand; in the other hand have at the ready an eraser or chamois. Be prepared to smear or soften your marks as necessary with the fingers or the sides of either hand.

Start by drawing the figurative image large on the page. Beginning with the head, record the major axial sweep of the pose by swiftly traversing, like an electrical current, through the body to the feet (Fig. 11–7). Encompass the entire figure in your drawing; cropping its image will stymie your ability to express the sequence of anatomical linkages that unify the body. Make sure to indicate the relative placement of head and feet early on in your drawing. In most standing

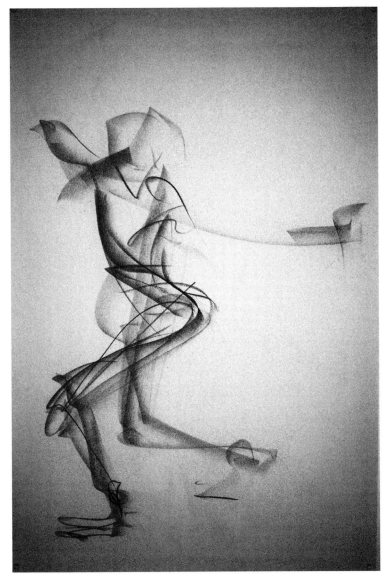

FIGURE 11–7
COLIN KILIAN, Pratt Institute
Student drawing: gesture drawing of the figure
Courtesy, the artist

FIGURE 11–8
REGINALD MARSH
*(Nude Male Figures) and Sketch
for Prometheus*
Graphite on paper, 12 × 9"
(30.48 × 22.86 cm)
*Collection of the Whitney Museum of
American Art, New York; Felicia Meyer
Marsh Bequest (80.31.27) © 2003 Estate of
Reginald Marsh/Art Students League, New
York/Artists Rights Society (ARS), New York*

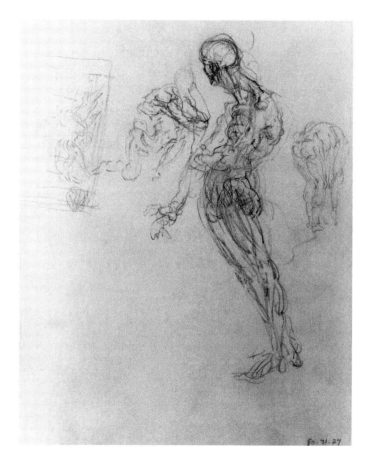

poses the head will be centered above the feet if the model's weight is on both legs, and if the model's weight is primarily on one leg, the head will be located above the weight-bearing ankle. Next, locate the secondary and tertiary axes, and record them with sweeping gestures. To assist you in analyzing the angles in a pose, look for vertical lines in the architectural environment against which to compare the major axes of the model.

If you work quickly, you will have time to adjust the image. Do not be afraid of errant marks, for these marks will serve as valuable reference points against which you can begin to make corrections. Evidence of corrections will also invest your drawing with the excitement that went into making it by revealing the physical energy and thought processes involved in gesture drawing. As you record movement in the figure with flowing gestures, vary the dynamics of your marks and lines to suggest "hot pockets" in the pose (pressure points due to stretching, compression, or weight-bearing duties). You may wish to express the magnetism of these events in the body through mass gesture or by scribbling a coiled line (Fig. 11–8).

As you proceed, avoid excessive outlining. During short poses, an emphasis on outlining is inefficient: The model will likely change position before you have recorded much of the figure, and more importantly, you will have missed the fundamental structural and thematic values of the pose. There is nothing wrong with indicating selective outer contours in a gesture drawing, so long as they are responsive to internal events of the body. So, where bony protrusions or bodily twists drive the energy to the outer contour, register them there; but whenever a force goes inside and through, or across, a part of the body, follow that route. The simple rule of thumb is, Earn your edges!

Exercise 11A *We have just walked you through a basic approach to figurative gesture drawing. It is one that can be applied to poses as short as thirty seconds or as long as five minutes in duration. The following exercises are variations on conventional gesture drawing.*

Drawing 1. *This exercise is based on the assumption that conceptually retrieving information you have seen and felt will help to accelerate your knowledge of the figure. First, assume the pose the model has taken and hold it for twenty seconds. As you prepare to draw, the model will break from the pose, challenging you to reconstruct the figure gesturally using your visual and sensory memory banks. At thirty-second intervals the model will again assume the pose. During those intervals, you must stop drawing and instead study the figure with the intent of fixing the figurative image in your mind. Use this time also to evaluate your drawing and plan your corrections to it. Repeat the steps until you have completed a two-minute gesture drawing.*

Drawing 2. *A variation on this retrieval exercise is called the* strobe light *method. Once again, assume the model's pose for twenty seconds. Next, sitting with your eyes closed, begin a blind gesture drawing of the model. After thirty seconds, open your eyes and cease to draw for ten seconds while you gather additional impressions of the pose and assess your drawing. Repeat until you have completed a three-minute gesture drawing (Fig. 11–9).*

Drawing 3. *A more dramatic method for sensitizing yourself to essentials is to collaborate with a peer on gesture drawings from a life model, using the following arrangement: First, both members of the team should take the pose for twenty seconds. Then, standing (or sitting, if necessary) side by side, one person (drawer one) will hold the drawing instrument; the second person (drawer two) will firmly grasp the operative wrist of drawer one. Drawer one then begins to work, with drawer two in accompaniment as described. At the first sign that the drawing is proceeding incorrectly, it is drawer two's responsibility to maneuver drawer one's hand toward a different course of action. Physical give-and-take should be accompanied by comments from both partners as they cooperate in summing up the pose (Fig. 11–10). When the model changes poses, switch roles and repeat.*

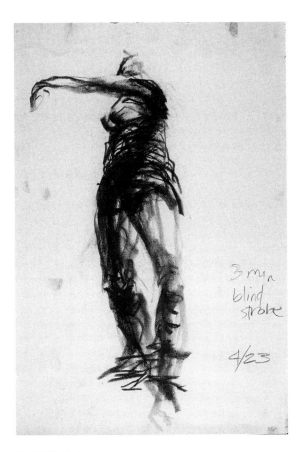

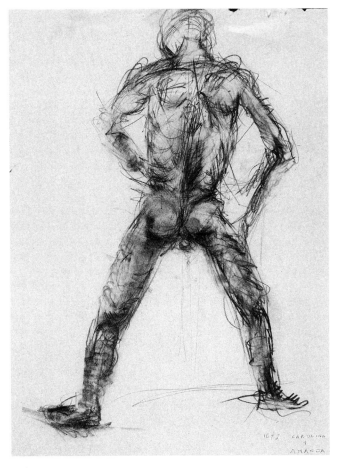

FIGURE 11–9
SARAH WILISCH, University
of Cincinnati
Student drawing: Strobe-Light
gesture drawing
Courtesy, the artist

FIGURE 11–10
CAROLINA CURRAN AND
AMANDA NEAL, University
of Cincinnati
Student drawing: collaborative
gesture drawing
Courtesy, the artists

Anatomy in More Depth

There are 206 bones and over 600 muscles in the human body. Since relatively few have names that pop up in daily conversation, the prospect of learning them can be intimidating. Happily, it is also true that artists are not automatically expected to acquire a comprehensive knowledge of human anatomy. You do not have to be an anatomist to successfully depict the human body, and the degree of anatomical knowledge you need is ultimately a matter of personal choice.

It could be argued that students who have mastered the basics of drawing should be able to represent any observed object, the figure included. And it is true that skilled use of form analysis based on outward appearances will enable an artist to draw the figure in proportion and to accurately angle the major axial directions in a life-model pose. Representing the human body only on the basis of external features, however, may be considered a flawed approach, since most bodily structure is subsurface. Failure to account for interior factors that play a major role in what is observed can result in figure drawings that bog down in a welter of disconnected, superficial detail. For this reason, we recommend that you attain at least a rudimentary understanding of human anatomy. Figures 11–11 and 11–12 are general references for the discussion that follows.

BASIC SKELETAL STRUCTURE

The Skull

The skull is the bony foundation of the head (see anatomical illustrations, Figs. 11–13a, b, and c). It consists of two main sections: the cerebral cranium and

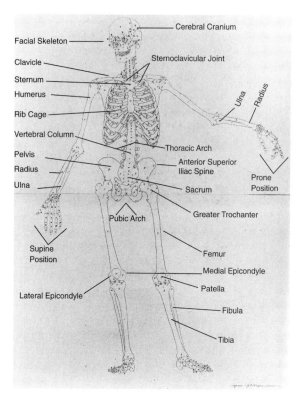

FIGURE 11–11
BERNHARDUS SIEGFRIED ALBINUS
Tabulae Sceleti et Musculorum
Corpus Humani
London, Knapton, 1749
Tab I (line rendering of figure)
Courtesy of the Malloch Rare Book Room of
The New York Academy of Medicine

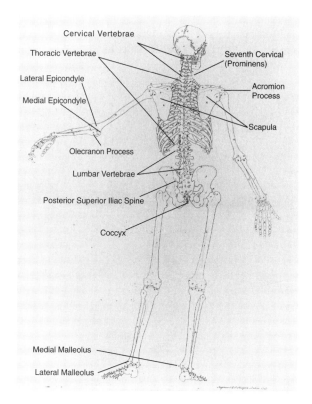

FIGURE 11–12
BERNHARDUS SIEGFRIED ALBINUS
Tabulae Sceleti et Musculorum
Corpus Humani
London, Knapton, 1749
Tab II (line rendering of figure)
Courtesy of the Malloch Rare Book Room of
The New York Academy of Medicine

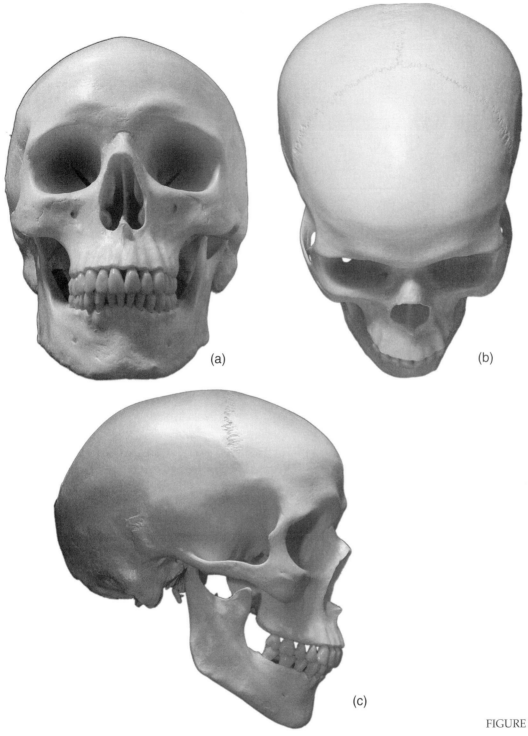

(a)

(b)

(c)

FIGURE 11–13

the facial skeleton. Be aware that the credibility of your figure drawings will be undermined to some extent if you omit the cranial portion of the skull. A simple summary of the skull can be achieved by using two intersecting ovals, foreshortened as appropriate, to represent the facial and cranial masses (Fig. 11–14a and b).

A close look at the skull will reveal the overall three-dimensional form of the head and help you to understand the relationship of the face to the cranium. That the human face is widest across the cheekbones, or zygomatic arch, is something easily observed in the frontal view of the skull (Fig. 11–13a). Looking at the skull from above (Fig. 11–13b), you will see that the face constitutes the narrowest part of the head's mass, a fact that may surprise you.

(a)

(b)

FIGURE 11–14
(a) ANDREA DEL SARTO
Profile of a man's head, red chalk
Louvre, Paris, France
*Copyright Réunion des Musées Nationaux /
Art Resource, NY. Louvre, Paris, France*

A view from the side (Fig. 11–13c) shows the extent to which the face wraps around the front of the skull. Although the joint of the jawbone (mandible) is set about halfway back from the front of the face, the back molars are less than a third of the way back and the eye sockets are forward of that. Compare Figure 11–14a with the side view of the skull and note that the frontal bone of the forehead is set back from the ridge of the brow.

Figure 11–15 provides a rough guide to the proportions of the human face. The eyes are located halfway between the top of the cranium (do not include the hair) and the bottom of the chin. Measuring from the top of the forehead at the hairline (before the skull starts to recede), horizontal divisions in thirds fall at the eyebrows and the top of the ears, the bottom of the nose and ears, and the

FIGURE 11–15

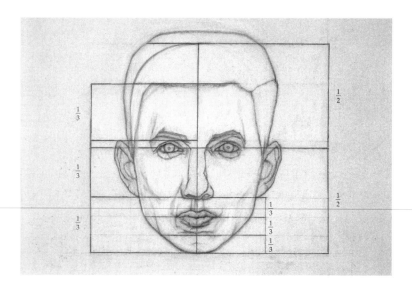

lowermost portion of the chin. The center of the closed mouth is one-third the distance from the bottom of the nose to the bottom of the chin. (Observe that the straight lines that horizontally divide the frontal view of the face change to curves when the head is turned to a three-quarter view, as in Figure 0–6.)

Drawing 1. Working either from a real skull, a plastic casting, or from anatomical illustrations, **Exercise 11B**
make a sheet of studies of the skull from a number of different angles. Be especially aware of the relationship of the back of the skull to various facial features (the base of the cranium in back, for instance, is located on the same horizontal plane as the base of the nose in front).

Drawing 2. Draw a portrait head seen from an unusual angle. If possible, use a model with little hair. Studying the model for bony landmarks and using the knowledge you just gained from working directly from the skull, begin to lay in a drawing of the skull within the portrait. You will, as it were, be trying to draw with X-ray vision.

The Vertebral Column

The *vertebral column* is also known as the *backbone*, the *spinal column*, or simply the *spine*. Made of stacked units, the vertebral column is rigid enough to provide stable support for the head and thorax, yet flexible enough to allow the trunk to bend and rotate, most notably at the waist. The flexible portion of the spine consists of twenty-four vertebrae, which are arranged from top to bottom into the cervical, thoracic, and lumbar regions of the column. The lower end of the spine is made up of five fused sacral vertebrae and four partially fused vertebrae that form the coccyx. One of the chief visual hallmarks of the vertebral column is its sinuous gesture, achieved by four reversing curves of varied lengths (Fig. 11–2). The weight-bearing role of the vertebral column is more easily understood by studying a frontal view (Fig. 11–1); note that the vertebrae become progressively heavier further down the spine as they need to support greater weight.

The backbone connects head, rib cage, and pelvis, the three major masses that communicate a good deal of the figure's gesture. It is therefore essential that you have a mental image of the backbone in order to determine the distribution of these major masses in relation to any given pose. Your ability to form this image will be hampered, however, by the fact that the backbone is buried deep in the body and consequently offers few surface clues to its physical characteristics.

The spurs (or projecting parts) of these vertebrae represent some of the few outer guideposts to the vertebral column (Fig. 11–4). Lined up as a bumpy ridge along the midline groove of the back, they are thrown into relief on a figure bending forward. The spur of the seventh cervical vertebrae (*prominens*) is most noticeable. Located at the lower limit of the back of the neck, the prominens establishes the point at which the axes of the neck and shoulders meet.

The Rib Cage

The rib cage, as its name implies, is an open-framework enclosure within the *thorax*, or chest cavity (Figs. 11–16, 11–17, and 11–18). Shaped like an oval flattened at the lower end, the rib cage consists of twelve pairs of ribs. Joined at the back of the chest wall to the spinal column, the ribs wrap around at a downward angle and turn the corner toward the front of the body. At the point where the ribs curve upward toward the breastbone (sternum), ten of them have their bony composition replaced by bands of cartilage.

The symmetrical, outward curves of the rib cage conclude at the *thoracic arch*, a conspicuous structural landmark on the front of the body. If you take a deep breath or raise your arms, mimicking the gesture in Figure 11–19, the thoracic arch will be more noticeable. At the same time, locate your breastbone, which sits on the vertical dividing line extending from the top of the thoracic arch to the pit of the neck. In Figure 11–16, note that as a result of the downward curve of the upper ribs, the base of the neck in back is higher than the pit of the neck in front. In Figure 11–17, observe that the rib cage is flatter in back, allowing us to lie on our backs without rolling over.

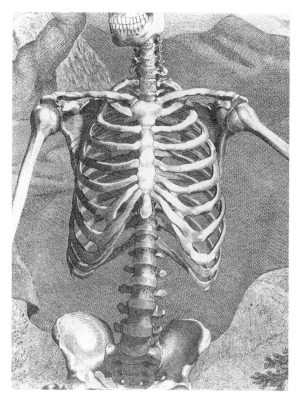

FIGURE 11–16
BERNHARDUS SIEGFRIED ALBINUS
Tabulae Sceleti et Musculorum
Corpus Humani
London, Knapton, 1749
Tab I (detail)
Courtesy of the Malloch Rare Book Room of
The New York Academy of Medicine

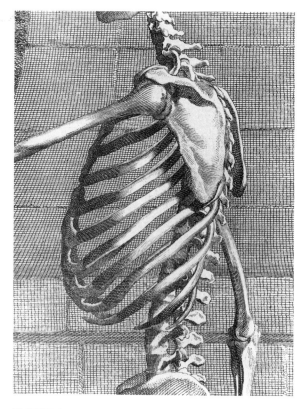

FIGURE 11–17
BERNHARDUS SIEGFRIED ALBINUS
Tabulae Sceleti et Musculorum
Corpus Humani
London, Knapton, 1749
Tab II (detail)
Courtesy of the Malloch Rare Book Room of
The New York Academy of Medicine

FIGURE 11–18
BERNHARDUS SIEGFRIED ALBINUS
Tabulae Sceleti et Musculorum
Corpus Humani
London, Knapton, 1749
Tab III (detail)
Courtesy of the Malloch Rare Book Room of
The New York Academy of Medicine

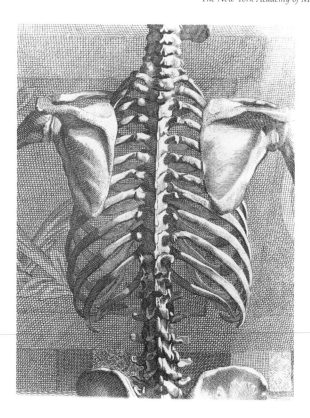

Drawing 1. *When drawing the rib cage, more important than a count of ribs is that you obtain a strong impression of its three-dimensional form. Making studies of the rib cage from three different viewpoints (front, side, back) will assist your grasp of its structural gestalt (see Figs. 11–16, 11–17, and 11–18). Begin each drawing with a gestural shape summary of the rib cage. Convert its form into a cubic volume in perspective if that will make its overall planar organization easier to understand. Notice the stepped expansion of the cage as you progress down its vertical axis and how it bulges most prominently at the eighth rib. To capture its shell-like curvature, be aware not only of its positive shapes but also of the oval void the rib cage encircles. (You might imagine yourself at a potter's wheel forming the interior of a wide-mouthed clay vessel with your hands.)*

Exercise 11C

Drawing 2. *When you feel confident, repeat the three drawings from memory. Before you draw, rotate in your mind's eye the full volume of the rib cage as if you were turning a virtual reality form on a computer screen. Start drawing the ribs at their junction with the spine where the rib cage is comparatively flat, and then circle its full horizontal and vertical circumferences.*

The Shoulder Girdle

As a symmetrical unit, the shoulder girdle fits over the rib cage and is comprised of paired collarbones (*clavicles*) and shoulder blades (*scapulas*). This set of fragile bones forms a nearly closed loop around the axis of the shoulders.

Parts of the shoulder girdle are evident on the surface even when the upper body is relaxed. In Figure 7–30, the shafts of the collarbones clearly show. Another landmark on the front of the body is the pair of small bumps made by the heads of the collarbones where they meet the breastbone to form the *sternoclavicular joint* at the pit of the neck. (These bumps are more evident when the shoulders are pushed slightly back.) On thinner persons particularly, the inner edges of the shoulder blades will be evident even when the arms hang loosely at the sides.

FIGURE 11–20
MICHELANGELO
Study of Man Rising from Tomb
11½ × 9¼"
© *The British Museum*

When the shoulders are tensed, the triangular shape of the shoulder blades will be more noticeable (Fig. 11–4). Other bony landmarks include the top ridge of the shoulder blade and the bump at the outer end of that ridge (*acromion process*) where the shoulder blade meets the collarbone to form the cap of the shoulder (Figs. 11–4, 7–26, and 8–3).

The mobility of the shoulder girdle and the variety of shapes it assumes in response to arm motions will challenge your powers of observation. So long as the elbows remain below shoulder level, the shoulder girdle may be seen to square the upper torso. When drawing the figure with arms down, think of the pair of shoulders as forming the ends of an oblong box perpendicular to the spinal column. This box can be rotated independently of the rib cage. When the shoulders are pushed back, the shoulder blades are thrown into relief and almost meet (Fig. 11–20), and on the front of the body the collarbones hug the rounded armature of the rib cage. Shoulders drawn or hunched forward force the shoulder blades to glide apart as the collarbones become especially pronounced, as can be seen in the Rubens drawing of a man raising himself (Fig. 11–21.)

Compare the Rubens with the Michelangelo study for the Libyan Sybil (Fig. 7–26) and note the striking difference in the appearance of the shoulder and upper back caused by different arm positions. Lifting an arm high and across the body modifies the shape of the trunk by rotating the shoulder blades upward and over toward the side of the rib cage (Fig. 11–22; note the varied formations of the shoulder blades on the three standing figures in this illustration).

Upper Limbs

The upper limbs are divided into two segments: the arm and the forearm. The arm bone, or *humerus,* is longer, thicker, and heavier than the two bones of the forearm, the *ulna* and the *radius.* The ball-like head of the humerus sits in the shallow socket of the shoulder blade, forming the shoulder joint. The rounded head of

FIGURE 11–21
PETER PAUL RUBENS
Nude Man Study of Leg
Black chalk, 8³⁄₁₆ × 11¹¹⁄₁₆"
V&A Picture Library

FIGURE 11–22
RAPHAEL
A Combat of Nude Men
Red chalk over preliminary
37.91 × 28.1 cm
Ashmolean Museum, Oxford

the humerus can occasionally be seen, as when, for example, the pressure of body weight leaning on an upper limb pushes its mass out to the surface (Figs. 1–11 and 11–21). At its bottom end, the humerus unites with the ulna and the radius to construct the elbow.

Two separate movements occur at the elbow. The hinge joint that enables the forearm to bend up and down on the humerus is the result of a concave surface on the head of the ulna swinging on a spool-like form at the base of the humerus. For drawing purposes, note that when the forearm is extended, the tip of the elbow (formed by a projection on the ulna called the *olecranon process*) is visible from side and back views (Fig. 11–23). When the forearm is bent, the tip of the elbow becomes an even more pronounced point; this bony point, together with projections on either side of the humerus (medial and lateral *epicondyles*), form a distinctive inverted triangle at the back of the elbow (Fig. 11–20).

The second movement that occurs at the elbow is the rotation of the forearm, by which the hand is turned either palm up (the *supine position*) or palm down (the *prone position*). These are common movements that occur, for instance, when you use a screwdriver or turn a doorknob. To accomplish this movement of the forearm, the radius circles on its axis, in a notch of the ulna, and crosses over the ulna to turn the wrist a half revolution, as can be seen in the left forearm of the skeleton in Figure 11–1. Notice that this rotary motion can be performed simultaneously with the bending of your forearm.

FIGURE 11–23
RAPHAEL
Aneas and Anchises
Albertina, Wien

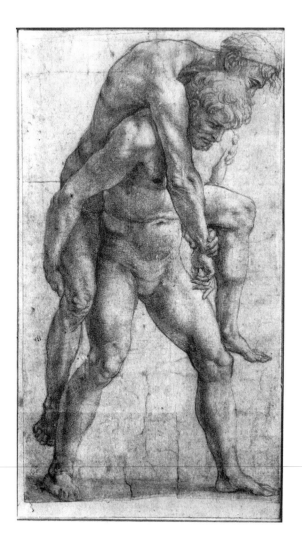

Be aware of surface landmarks in conjunction with the position of the fore-arm. When the hand is turned palm-side up, the radius and ulna are parallel, and you will observe the relative flatness of the forearm. When you rotate your hand to the prone position, the radius crosses over the ulna, and you will see that the forearm appears more rounded and bulky. With your forearm in the prone posi-tion, notice the prominent bump of the ulna's *styloid process* on the little finger side of the wrist.

The Pelvis

The *pelvis* is a ringlike mass, scooped out at the center, similar to a shallow basin. Among the components of the skeletal system, the pelvis varies most in form ac-cording to gender. Overall, the male pelvis may be summarized as a more acute triangle than its female counterpart. The female pelvis is also more shallow and broad. (This explains the typically wider hips on a female figure.)

Understanding the structure of the pelvis and the angle it assumes in rela-tion to any given pose is essential to the success of your drawing. Be aware of the forward or backward slant of the pelvis when a figure bends and the tipping of the hips when a figure shifts its weight to one leg. Such awareness is crucial to vi-sualizing the axial directions at a figure's midpoint and the structural and expres-sive implications this orientation has for the rest of the body.

But how do we go about seeing the angle of the pelvis? Covered by layers of tissue, surface sightings of pelvic structure are limited. Fortunately, two sets of points provide us some clues. Seen on the front (Fig. 11–25b) or sides of the figure, the forwardmost projections of the *anterior superior iliac spines* make their appear-ance as bumps near the top of both hips. These two bumps are most conspicuous when the body is lying prone. On the back of the body (Fig. 11–25a) the two pro-jections of the *posterior superior iliac spines* appear as two dimples flanking the base of the vertebral column. These two depressions can be seen as the upper points of the *sacral triangle* at the base of the spine (Fig. 11–24). At the origin of the cleft of

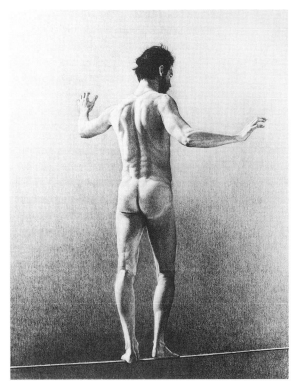

FIGURE 11–24
JAMES VALERIO
Tightrope Walker, 1981
Pencil on paper, 29 × 24"
Courtesy of George Adams Gallery, New York.
Collection of Ambassador and Mrs. Edward
E. Elson

the buttocks, the triangle is completed by a slight depression caused by the lowest vertebrae of the sacrum. (Because the female sacrum is wider, the dimples on a woman's body are farther apart, making the shape of the sacral triangle on the female broader.) When analyzing the axes of a pose seen from the front, a line drawn (or imagined) through the projections of the anterior superior iliac crests will help you assess the angle of the pelvis. Correspondingly, when drawing the figure from the back, a line through the pair of dimples at the top of the sacral triangle will assist you in determining this angle.

Exercise 11D　*Because an understanding of the structure and role of the pelvis is so pivotal to your understanding of the figure, we recommend that you make studies of the pelvis to commit to memory its overall shape from several viewpoints (see Fig. 11–25). Begin each study with a gestural summation of the pelvis. With sweeping gestures, draw the two, symmetrical, ear-like lobes of the pelvis, from the flared upper segments, down and around to the pubic arch (see Fig. 11–12). Use diagrammatic lines to steer around the oval space of the pelvic cavity.*

The Lower Limbs

The lower limbs are divided into two sections: the thigh, which extends from the hip joint to the knee; and the portion from the knee to the ankle, which is referred to as the leg.* The thighbone, or *femur*, is the largest and strongest bone in the human body. At its upper end, the rounded head of the femur sits deep in a pelvic hollow, forming a ball and socket joint of sufficient stability to accommodate the weight-bearing function of the hips.

Between the head and shaft of the femur is an extended neck that cantilevers out from the pelvis and ends in the *greater trochanter*. When visualizing the skeletal arrangement of a model's hips in a drawing, be sure to draw the ends of the femurs jutting downward and outward from the pelvis rather than hanging from its sides (see Fig. 11–1). Note too that in a normal standing position, the femurs angle inward from the greater trochanters down to the knees. The greater trochanter is often visible as a bony protrusion on the side of a weight-bearing thigh, as can be

FIGURE 11–25
JACQUES GEMELIN
Nouveau recueil d'ostéologie et de myologie . . . Part II
Toulouse, Declassan, 1779
Courtesy of the Malloch Rare Book Room of The New York Academy of Medicine

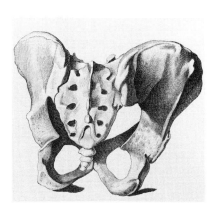

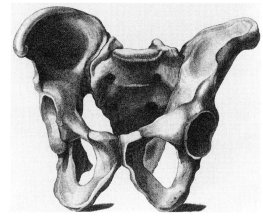

(a) Back view of pelvis showing the sacrum.

(b) Front view of pelvis showing the anterior superior iliac spines and the pubic arch.

*While in everyday usage, the word "leg" refers to the lower limb from the hip to the ankle, we use the word in reference to the section between the knee and the ankle in keeping with current anatomical terminology.

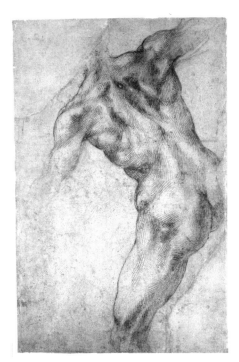

FIGURE 11–26
MICHELANGELO
Nude Male Torso
Pen, brown ink, black chalk,
262 × 173
Ashmolean Museum, Oxford

observed in Figure 11–26. The greater trochanters are considered valuable structural landmarks, because locating them will help you establish both the widest point of the hips and the midpoint of the figure along its vertical axis.

At its lower end, the femur joins the head of the *tibia*, one of the two major long bones of the leg, to form the hinge-like knee joint. Bony projections (*epicondyles*) on the inner and outer sides of the base of the femur are visible landmarks at the knee. Their presence is more obvious on the leg bent at a right angle, as can be seen in Figures 11–21 and 11–23. Also at the base of the femur, on its front side, is a shallow cavity. When the leg is extended (straight), the flat, triangular kneecap (*patella*) sits in this cavity and is visibly pronounced at the joint of the thigh and the leg. When the leg is flexed (bent), the kneecap recedes from view as it moves along the length of that cavity on the underside of the femur.

The tibia runs along the inside of the leg. Seen from a frontal or three-quarter view, the thin and conspicuous frontal plane of the shin (or tibial shaft) provides a linear guide for drawing. It runs from the knee to the inner ankle, as may be seen on the left leg of the slumped man in Figure 8–27. The other long bone of the leg, the fibula, is on the outside of the leg. The expansion at the lower end of the fibula may be observed as the outside ankle bone, properly called the *lateral malleolus*. Just above this protrusion you may also observe a bit of the shaft of the fibula, which will appear as a short vertical line. Seen from front or back views, the outside ankle bone appears more prominent and lower on the axis of the ankle joint than its counterpart on the inside of the ankle (the *medial malleolus* of the tibia), as can be seen on the left leg in Figure 11–24.

BASIC MUSCULAR SYSTEM

Although there are three different kinds of muscles in the human body, we will focus on skeletal muscle, the most abundant muscle mass in the body. Attached to the body's skeletal armature, these muscles contour the form of the human figure and furnish its capability for movement.

Muscles are actually fibrous tissues, specialized to alter in length by contraction, thereby pulling on bone to make action possible. The number of muscles

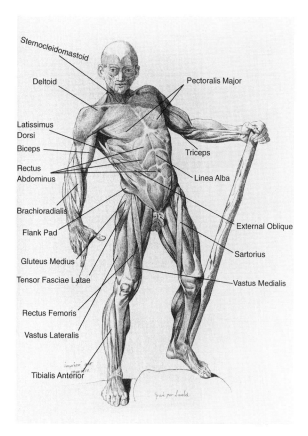

FIGURE 11–27
JACQUES GEMELIN
Nouveau recueil d'ostéologie et de myologie . . . Part II
Toulouse, Declassan, 1779
Courtesy of the Malloch Rare Book Room of The New York Academy of Medicine

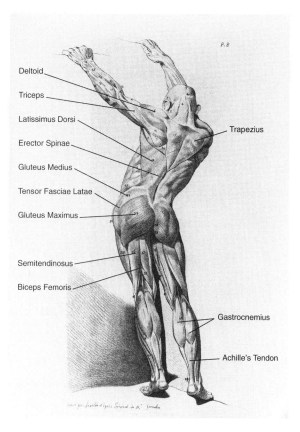

FIGURE 11–28
JACQUES GEMELIN
Nouveau recueil d'ostéologie et de myologie . . . Part II
Toulouse, Declassan, 1779
Courtesy of the Malloch Rare Book Room of The New York Academy of Medicine

encountered in figure drawing far exceeds the limits of this chapter to describe. Perhaps the most practical way to become conversant with the superficial muscles of the human body is to pore over anatomical illustrations (such as Figs. 11–27 and 11–28), in combination with many clocked hours drawing from life. In the next section, we present twenty-two muscles we consider to be most useful to artists beginning a study of human anatomy.

The Twenty-Two Muscles You Need to Know

The neck. The *sternocleidomastoid* is the most prominent of all muscles on the front and the sides of the neck. At their upper ends, both sternocleidomastoids insert behind the ear (Fig. 11–14a), and at their lower ends, they divide on both sides of the neck into two strap-like segments (Fig. 6–4). Seen from a front view, the more prominent of these segments attaches to the breastbone; together they define the familiar V-shaped indention of the pit of the neck (Fig. 7–30). The other two segments attach left and right to the inside face of the collarbone; they are often visible when the head is turned to one side (Fig. 11–29; note the triangular hollow between the divided straps of the muscle on the side of the model's neck.) The function of the sternocleidomastoid is to move the head. Contracting one of these muscles will pull the head to that side. If the two muscles contract together they flex the neck allowing the head to nod up or down.

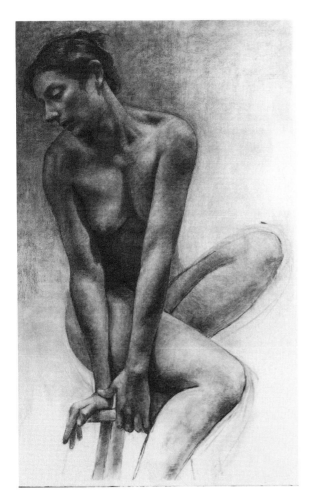

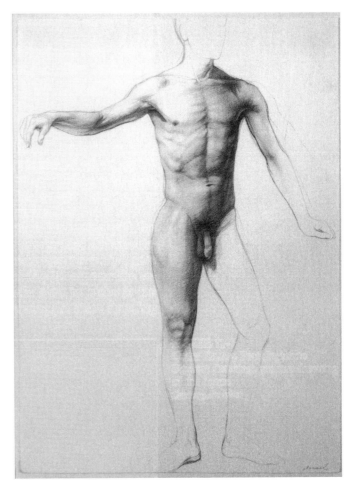

FIGURE 11–29
DANIEL LUDWIG
Figure on Stool, 2000
Charcoal/paper, 40 × 26"
Courtesy of Allan Stone Gallery,
New York City

FIGURE 11–30
STEVEN ASSAEL
Male Figure Study

The torso. The two principal muscles occupying the front of the torso are the *pectoralis major* and the *rectus abdominis*. The large pectoralis major forms the upper chest and the front wall of the armpit. In the male, the wedge shapes of the paired muscles give the chest its characteristic windshield-like sweep (Fig. 11–30). In the female, the breasts cover the lower and much of the outer borders of the muscle. This muscle moves the arm forward, down, and toward the body.

The *rectus abdominis*, a long flat band of muscle situated on either side of the body's midline, forms the central plane of the abdomen. Its chief function is bending the upper body forward. This muscle is divided into eight segments, four on each side of the midline of the torso. On muscular individuals, the upper six make a distinctive pattern (clearly visible in the image of the crucified Christ and the male nude on the left, in Figure 6–3). A more valuable drawing landmark is the *linea alba* ("white line"), since it may be seen on the average human figure. A shallow channel of connective tissue, it runs along the midline of the body from the breastbone to the navel. The linea alba is conspicuous on the male torso in Figure 11–30; note also the partial description of the rectus abdominus in this illustration.

The *external oblique* is a thin muscle that slants downward and forward from the sides of the rib cage to form a border with the rectus abdominus (Figs. 11–19

and 11–23). At the hips, the external oblique contributes slightly to what are sometimes referred to as "flank pads" (Fig. 11–19). These pads are predominantly a buildup of fatty tissue, although on very thin individuals the slight bulge of the external oblique may be seen. Nonetheless, these pads just below the waist are useful structural guideposts when sketching a shape summary of the figure. In conjunction with the groove of the groin, the raised masses of the flank pads lend the lower boundary of the abdomen its gently curving, quarter-moon termination, particularly in the male figure (Figs. 11–19 and 11–30). Connecting the sides of the lower eight ribs to the anterior (front) crest of the pelvis, the external oblique contracts and twists the trunk on top of the hips. When the external obliques on both sides of the body contract, they compress the abdomen and fold the body.

One muscle that is physically prominent on the surface of the trunk from any viewpoint is the *deltoid* (Figs. 6–4, 11–27, and 11–28). A cushionlike mass, the deltoid may be described as a three-sided pad that significantly determines the form of the shoulder. The chief action of the deltoid is to move the arm away from the body, up to shoulder height.

The three large muscle masses layered on the back of the torso are the *trapezius, latissimus dorsi,* and *erector spinae.* The flat sheets of the trapezius (uppermost of the three) and latissimus dorsi constitute most of the superficial muscle coverage of the back, from the base of the skull to the sacrum. The erector spinae is subsurface.

The trapezius is an eccentric four-pointed star-shaped muscle. It moves the shoulders back, up, and down; bends the neck from side to side; and pulls the head back as well as turns it. The vertical axis of this muscle coincides with the seam of the spine. Viewed from the back, the top of the trapezius shapes the nape of the neck, and its flared wings establish the line of the shoulders (Fig. 11–31). In front, the trapezius joins with the outer third of the collarbone, forming the visually explicit triangular masses that define the edge of the shoulders from the neck to the shoulder cap (Fig. 7–30). Viewed from above, the neck appears to be firmly embedded in the diamond-shaped space framed by the collarbones and the fleshy wedges of the trapezius (Fig. 11–29).

Shoulder actions alter the appearance of the trapezius. When the shoulders are pulled forward so as to stretch this superficial muscle across the rib cage, its lower, V-shaped contour may be seen. When the shoulders are pushed backward, the trapezius bunches into fleshy heaps on both sides of the spine in the thoracic region (Figs. 11–20 and 11–24; note that in the Michelangelo, the lower, V-shaped portion of the muscle is sketched in).

Although the large latissimus dorsi covers half the back of the human torso, it appears as an explicit surface landmark only on the front or side of the body. When the arm is extended (particularly if there is some exertion) or when it is raised, the latissimus dorsi takes the form of a long, convex mass that descends from the back of the armpit and gradually becomes more slender before curving backward just above the waist (Figs. 11–19 and 11–21). This muscle functions mainly to extend the arm, pulling it backward and into the body. For drawing purposes, the latissimus dorsi represents a transitional bridge between the arm and the torso of the human figure.

Situated on both sides of the indented seam of the spine are several separate muscles, grouped under the umbrella term erector spinae. As the name implies, their chief function is to stabilize the torso. Although they are deep muscles, they nonetheless provide an important clue to the location of the vertebral column. A surface effect of the erector spinae may be seen in the moundlike masses that appear on both sides of the spine in the lower back (Figs. 11–24 and 11–26).

The hips. Three superficial muscles that largely form the hips are the *gluteus maximus,* the *tensor fasciae latae* (or tensor muscle), and the *gluteus medius.*

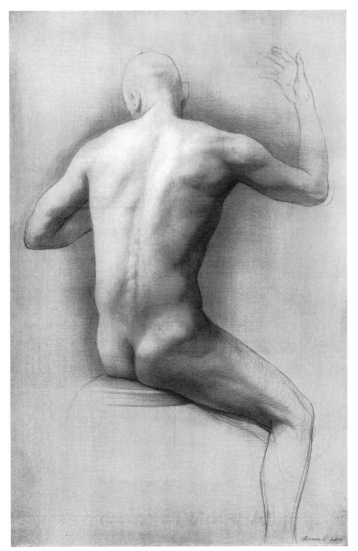

FIGURE 11–31
STEVEN ASSAEL
Male Back

The large, powerful muscle that defines the mass of the buttocks is the glu-
teus maximus. It straightens the thigh and raises the trunk (as when you get up
from a seated position). Most of the gluteus is visible on the surface of the figure.
A useful structural guidepost when drawing is the indentation on either side of
the buttocks coinciding with the location of the greater trochanter, as is shown in
Figures 6–36 and 11–26.

The tensor fasciae latae, situated on the forward plane of a figure's side, is a
small, scoop-shaped muscle running diagonally downward and backward. Its
chief actions are to bend the thigh and rotate it inward. The tensor is most visible
in its contracted state (for instance, when the thigh is bent) as it forms a rather
thick knob at the juncture of hip and thigh. In Figure 11–26 the tensor can be seen
just to the fore of the depression caused by the greater trochanter.

The gluteus medius, which moves the thigh outward, sits between the ten-
sor and gluteus maximus muscles, squarely on the side of the body and at a slant
similar to the tensor. Observable from directly front or back views as the bulge
above the shallow indention of the greater trochanter (the tensor is the swell just
below), the gluteus medius is thrown into high relief when tensed (Fig. 11–26).

The thigh. The muscles playing a prominent role on the surface of the thigh can be
generally categorized by function and location. Quadriceps that straighten the leg

at the knee and bend the thigh at the hip are located on the front or side of the thigh; hamstrings that bend the leg at the knee joint and extend the thigh at the hip are located on the back of the thigh.

The quadricep muscle group comprises more than half the muscle mass of the thigh. Proceeding from the outside of the thigh, this group of four muscles includes the *vastus lateralis*, the *rectus femoris*, the *vastus intermedius* (a deep muscle located under the *rectus femoris* which is not a visible landmark), and the *vastus medialis*.

The vastus lateralis contours most of the outer thigh from a few inches above the knee all the way up to the tensor muscle at the hip. From the front, there is often a small crease or dimple in the surface terrain above the knee, where the lateralis muscle changes to a tendon, as may be seen on the left leg of the female nude in Figure 11–32. From a front view, the vastus medialis sits on the inside of the top plane of the thigh, where its characteristic teardrop shape swells from just above the knee to about mid-thigh (see the right leg of the central warrior in Fig. 11–22). From a side view, this muscle fleshes out the inner thigh just above the knee joint, as on the left leg of the male warrior just mentioned in Figure 11–22.

The rectus femoris is positioned between the vastus lateralis and the vastus medialis. Seen from the front or side, this convex muscle lends the top of the thigh its characteristic sloping curvature downward to the knee, as in the study in the upper right of Figure 11–21. Originating at the anterior inferior iliac spine and ultimately tying into the tibia, the rectus femoris is a two-joint muscle, and has the dual function of flexing the thigh at the hip and extending the leg at the knee.

One additional muscle that is visible on the front and inside of the thigh is the *sartorius*. Belt-like in form, and the longest muscle in the body, it takes a diagonal route from the outside of the pelvis down to the inner surface of the leg. Multifunctional, the sartorius strongly flexes the thigh at the hip joint and helps to rotate the thigh and pull it away from the body. It also assists in flexing the leg at the knee. Its upper boundary at the pelvis visibly emerges when tensed, for

FIGURE 11–32
William Beckman
Scale Study for Woman and Man,
1988
Charcoal and crayon on gessoed paper, 90 × 71¼"
Arkansas Arts Center Foundation Purchase:
1988.88.043
Courtesy of Forum Gallery, New York

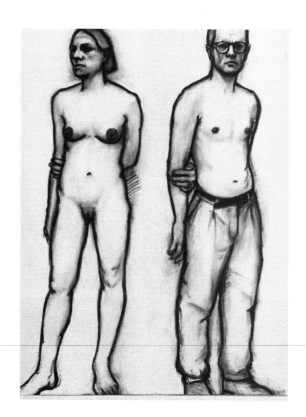

instance, when a model turns his or her leg and foot inward or sits cross-legged. On the front of the hip, level with the pubic triangle, you may also see a dimple that marks a slight crevice between the forking sartorius and tensor muscles. In the left leg of the central staff-wielding figure in the Raphael (Fig. 11–22), a break in plane running from the hip to the inside of the knee indicates the presence of the sartorius.

The two hamstring muscles that flesh out the back of the thigh are the *semitendinosus* and the *biceps femoris*, both of which extend from the hip to the leg. On the back of the thigh the two muscles are most often seen as a unified mass (Fig. 11–24). At the back of the knee, however, the muscles separate, with the semitendinosus veering to the inside of the thigh and the biceps femoris passing to the outside. When the knee is bent, the edges of both muscles are easily detected (the semitendinosus is the most apparent), and their separation causes the distinctive depression at the back of the knee. When the knee is straightened, the hollow is replaced by a mass of fatty tissue, as may be seen in Figure 11–24.

The leg. The three major muscles of the leg flex the ankle and toes. Seen from the front, the *tibialis anterior* is situated along the outer edge of the shin bone; when the leg is seen from the side, this muscle defines its front contour. The tibialis anterior flexes the foot upward; note that when the foot is bent in this manner, the tibialis swells prominently. About midway down the leg, the tibialis switches to tendon; as it descends from that point, the tibialis jogs toward the inside of the leg, where, at its lower end, it crosses the ankle and attaches underneath the foot. The route of this long tendon may be observed when the leg is tensed, as in Figure 11–19.

The form of the back of the leg is dominated by the plump mass of the calf muscle, or *gastrocnemius*. The chief action of this muscle is to flex the foot downward. It is divided into roughly two halves, with the longer inside portion dropped lower on the leg. At the middle of the leg, the gastrocnemius binds with the Achille's tendon, a strong tapering band that is most visible just above the ankle and down to its attachment on the heel bone. The junction of the gastrocnemius with the Achille's tendon is pronounced when the calf is stressed; look for the reversed V-shaped notch that signals where the sheet of tendon and bulk of muscle fiber meet, as in Figure 11–24.

The arm. Movements of the forearm are governed by two large muscle masses of the arm, the *biceps* and *triceps*. The biceps flexes and supinates the forearm, and the triceps extends it.

The *biceps* is located on the front of the arm, but slightly off center toward the inside edge. Attached at its upper end to the shoulder blade, the muscle shifts to tendon at its lower end, where it curves over the elbow to join with the radius. Tense your biceps, and its tendon will be evident to sight and touch on the inside of the hollow (*cubital fossa*) on the front of the elbow.

The *triceps* constitutes virtually the entire body of muscle on the back of the arm. The mound of the triceps is especially apparent when the upper limb is torqued toward the body. When the arm is tensed, look as well for the inverted V-shape where the surface of the back of the arm dips slightly from a convex muscle mass to a flatter tendinous plane. This landmark is apparent in the right arm of the male nude in Figure 11–20.

The forearm. With one exception, no muscles of the forearm emerge as major surface landmarks. Instead, it is the overall form effects of the thirteen superficial forearm muscles that interest us for drawing purposes. These can be categorized as the flexors (which bend the hand forward) and extensors (which straighten the hand and fingers). The flexors are located for the most part on the front of the forearm, and the extensors are on the back.

FIGURE 11–33
FEDERICO BAROCCI
Martyrdom of San Vitale
Courtesy of Kuferstichkabinett-Berlin;
Staatliche Museen zu Berlin. © 2003
Bildarchiv Preussicher Kulturbesitz.
Foto: Jorg P. Anders

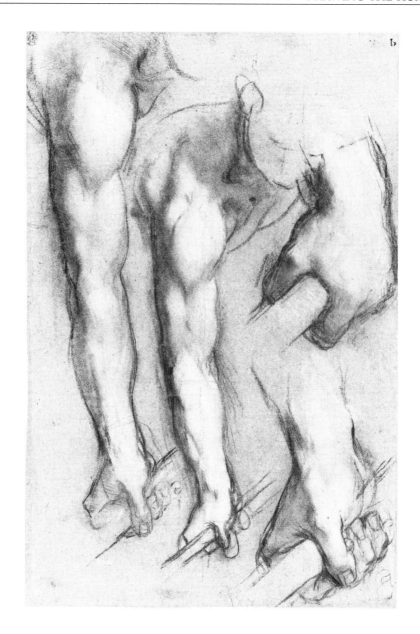

The one flexor muscle that is located on the thumb side of the forearm is the *brachioradialis*. The brachioradialis, attached to the humerus a couple of inches above the elbow and to the lateral (thumbside) surface of the radius, bends the forearm at the elbow. Visible as an asymmetrical fleshy bulge just below the elbow, it is the one muscle that exerts a marked influence on the surface terrain of the forearm (Fig. 11–20).

With your hand palm side up, the brachioradialis may also be visually traced along the inside contour of the forearm (Fig. 11–33). If you bend your forearm slightly and tighten your fist with your thumb pointed toward your shoulder, you will see the brachioradialis swell up on the outside of the depression on the front of your elbow joint. It runs parallel to the tendon of the raised biceps. Rotate your hand to a prone position, and the diagonal twist of the brachioradialis toward the inside of your forearm (as it follows the turn of the radius) will be evident, as on the extended arm at the center of the composition in Figure 11–34.

Looking at the same extended arm in Figure 11–34, note the extensors graphically evident on the back of the forearm. They appear as a broad, rounded plane with a shadowed groove along their bottom edge where the flexors wrap around to peek out on the extensor side of the forearm.

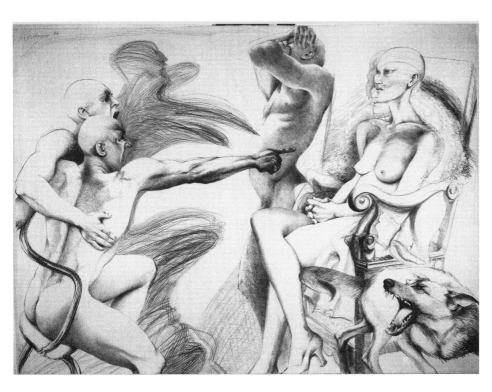

FIGURE 11–34
NANCY GROSSMAN, American,
b. 1940
Five Figures, 1984
Pencil and graphite on paper,
61 × 84"
*The Arkansas Arts Center Foundation
Collection: The Tabriz Fund, 1993.93.23.2
© Nancy Grossman, Courtesy of Michael
Rosenfeld Gallery, New York, NY*

The Importance of Gesture Drawing in Longer Poses

The role of gesture drawing in developing completed figurative imagery is commonly misunderstood by beginning life-drawing students as an activity confined to the first part of a life-drawing session. In fact, gesture drawing may also be regarded as the most important foundation for a more finished figure drawing.

Sustaining the general-to-specific process demanded by gesture drawing will assist you in avoiding common pitfalls associated with working from longer poses. The failure to progressively analyze major-to-minor information often results in "finished" drawings in which the figure is axially incorrect, woefully out of proportion, or lacking in the unity, grace, and vitality of the living form. Figurative images of any style that grow from a gestural conception will more successfully convey the natural rhythms of the human body and the life force they express. What you want to avoid once a figure drawing is finished is the realization that despite all the attention you gave to subtleties of sculptural modeling, the image appears lifeless or wooden.

We recommend that you begin an extended drawing by investigating the pose from several viewpoints. Find at least two angles that strike you as spatially dynamic. Remembering to first take the pose yourself, do a two-minute gesture drawing from each location. Once you are ready to commit to a specific view of the model, rough out the figure large on your format, maintaining the same gestural energy you have used for shorter poses. (You will want to work with a forgiving medium, such as vine charcoal or medium-soft graphite stick so that later on the record of your early explorations may be softened or even expunged.) Use curvilinear lines to respond to supple parts of the body. Use straight lines and angles to mark major axial divisions at the shoulders, rib cage, pelvis, and knees. You might also use straight lines to indicate where the feet contact the floor or where sightings of the bony skeleton occur.

As the image of the figure begins to take shape, you will need to respond more specifically to the structure and expression of the pose. Considerations of

the body as a field of related events (not separate parts), basic anatomical insights, and your sympathetic memory from having taken the pose, will help foster your sense of the linkage between surface appearance and the action expressed by the model. In our student example (Fig. 11–35), note the interplay of forces. The greatest pressure in the pose is where the heel of the model's left hand is pushed against her outswung hip to stabilize the twisting of her upper torso. That focus of great pressure, not coincidentally, is also the visual focal point of the drawing toward which lines of force in the spine, the shadowed left arm, compressed buttocks, and braced right leg converge.

Identifying the gestural continuity of key, active zones in a pose will prove invaluable in organizing the visual priorities of your drawing. Rodin's drawing of St. John the Baptist (Fig. 11–36) is a stunning example of a drawing united by a hierarchy of actions. While the scissorlike movement of the striding legs may be identified as the figure's primary gesture, a moment's study will reveal two sets of second-tier gestures that circuit through the figure. The first of these two gestural loops may be discerned in the forward part of the body. Note the energy passing down the left arm, arcing out the pointing forefinger to the toe of the right foot, up the right leg and through the shoulder girdle, to start the loop again at the left shoulder. Trace the second loop by starting at the left sternocleidomastoid,

FIGURE 11–35
EMILY KELLY, University
of Cincinnati
Student drawing:
sustained-gesture study
Courtesy, the artist

FIGURE 11–36
AUGUSTE RODIN (PARIS, FRANCE
1840–1917, MEUDON, FRANCE)
St. John the Baptist
Black ink with touches of graphite
on light tan wove paper,
32.8 × 23.9 cm

traversing the pectorals through the right flexed arm and out the forefinger, then jumping through the head and back down to the left sternocleidomastoid. These looped gestures seem to recycle the energy within the figure.

The clear organization of sequenced gestures in Rodin's figure of St. John has its roots in the artist's profound understanding of anatomical mechanics. By cultivating an awareness of the interrelation of human form and anatomical function, you too can become more discriminating about what information to include from a pose and the order of importance to give that information. It will naturally follow that the notion of recording details in a drawing will be replaced by decisions about levels of *form definition*.

Fleshing Out Your Drawing

Once you have drawn the model's gesture, start fleshing out your drawing by blocking in major masses, beginning with the chest and hips. You may find it easier at first to simplify large forms of the body into circular and elliptical shapes (Fig. 11–37). A variation on this approach is found in Figure 11–38. Here, the

FIGURE 11–37
PAUL CADMUS
Gilding the Acrobat, 1930
Pen, ink, and white chalk on paper,
15⅜ × 9¾"

*Collection of the Robert Hull Fleming Museum,
University of Vermont. Schnakenberg Bequest
(1971.2.69)*

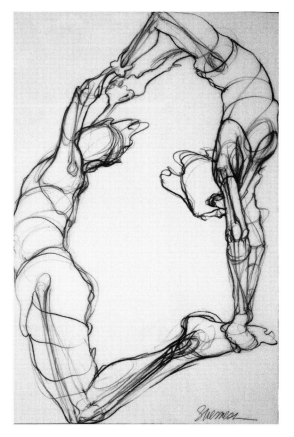

FIGURE 11–38
LORRAINE SHEMESH
Lasso
Courtesy of Allan Stone Gallery, New York City

body is gesturally divided into sections that are suggested by plane breaks along the figure's outer contour. If you prefer, represent the torso seen from front or back as a rectangular volume; smaller parts, such as the chest or buttocks, may be drawn as cubes; and you may translate legs and arms into faceted cylinders. Masses that have their long axis turned at an angle away from the picture plane have to be conceived in perspective. Whether the anatomical forms you are drawing are foreshortened or not, indicate major plane changes (located generally in line with the longitudinal axes of forms) and block in major areas of shadow.

When drawing foreshortened areas, remember that the actual dimension of any part of the body is apparent to the eye only from an unforeshortened viewpoint. Consequently, you will want to draw what you see, not what you think should be there. This is particularly important in cases of extreme foreshortening, as when you are seated in front of a reclining model and all the normally recognizable parts of the body appear distorted. To analyze the relative lengths of different parts of a foreshortened figure, first draw key latitudinal cross contours that divide the foreshortened form into segments. Then carefully measure the relative lengths of those segments. Comparing Figures 11–39a and b, for instance, note the implied series of arcs crossing the body at major plane breaks that help organize the figure into progressively diminishing segments. Utilizing visual references outside the figure, in addition to part-to-part internal measuring, can also be invaluable in gauging proportions under conditions of extreme foreshortening.

Once the main masses of the body are spatially oriented, search out the principal surface planes. This is key to lending the illusion of volume to figurative forms. Using planar analysis, change complex curves into facets following the gestural cross-contour lines that you made earlier. Be selective about the number of planes you include (Fig. 11–40) so as to avoid fussiness that obscures the larger structural relationships of a pose. As you use planar analysis to solidify the bulk of the figure, take into account the inherent geometry of its curves. The ability to discern angularity in curvature will help you express the body's underlying structure.

In seeking to express the roundness of human form, be cautious in your use of line. Given the liberties that long poses offer, students will often spend large amounts of time drawing the outer contours of the body, since it is their shape that makes the figurative image recognizable as a nameable thing. Keep in mind, however, that when you draw outer contours, you are actually representing planes that are turning away from view. Flat outlines tend to compromise recognition of the body's volume by illusionistically pushing the edges of a figurative image forward and emptying the body in between. That is a difficult phenomenon for beginners to overcome. In order for an outer contour to succeed as a descriptive element, it must carry powerful implications of the body's overall convexity. A persuasive example in that regard is Figure 11–32. This drawing employs contour lines of subtly varying weights, plus an angularity that firmly acknowledges the geometry of curved planes, all of which convince us that the shape of the outer contour is completely a consequence of interior form.

Figure 11–32 also includes blushes of tone to support the contour work in creating the illusions of roundness and of receding planes. Value, used structurally, is an important resource in figure drawing. Tone, in support of line, may be built up optically, through hatching, to infer volume, light, and surface movement, as in Figure 11–22. It may also be modulated to express the play of light and shadow over the three-dimensional forms of the figure, as in Figure 11–41, where the effects of chiaroscuro persuade us of the massive bulk of the back.

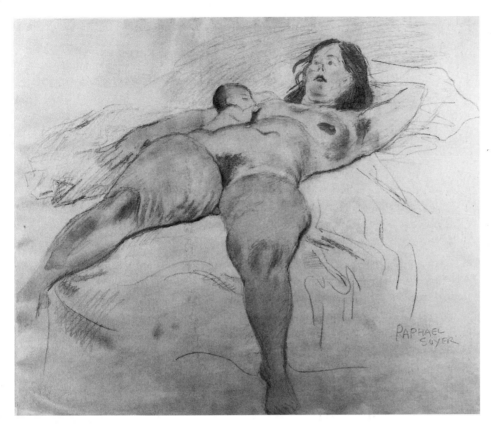

FIGURE 11–39a
RAPHAEL SOYER
Mother and Infant, 1967
Watercolor and graphite on paper,
15¼ × 20" (38.74 × 50.8 cm)
Whitney Museum of Art, New York. Gift of Bella and Sol Fishko (76.25)

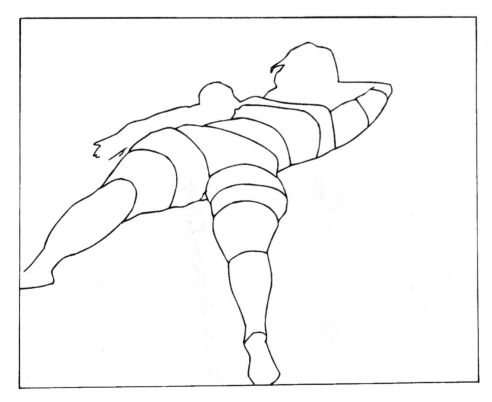

FIGURE 11–39b

FIGURE 11–40
GORDON CHASE
Nude in an Environment, 1967
Bamboo pen and ink,
23¾ × 18"
Courtesy, the artist

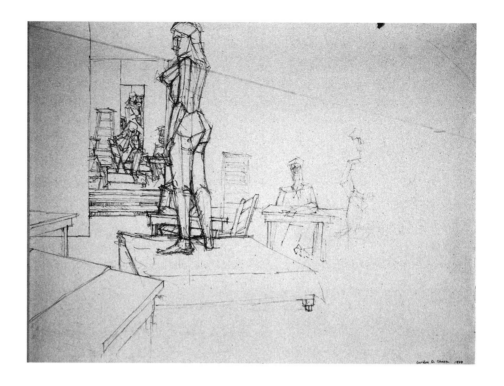

FIGURE 11–41
JACOPO DA EMPOLI
Young Man Seen from the Back,
IV, 172
Red chalk, 16 × 10⅝"
*Copyright The Pierpont Morgan Library / Art
Resource, NY*

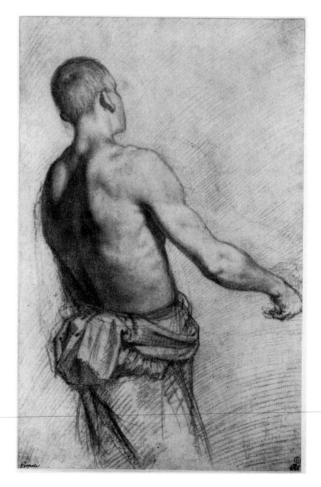

Drawing 1. *Draw a model at an extremely foreshortened angle, analyzing the orientation of figurative forms on a measured, part-to-part basis, using a series of elliptical shapes (Fig. 11–42).*

Drawing 2. *Again drawing a model from a foreshortened view, add value to convey a strong sense of atmospheric perspective to support the linear analysis of severe recession (Fig. 11–43).*

Drawing 3. *Using the side of a stick medium, build the figure out of decisive value shapes. Create edges through abutting planes of light and dark (Fig. 11–44).*

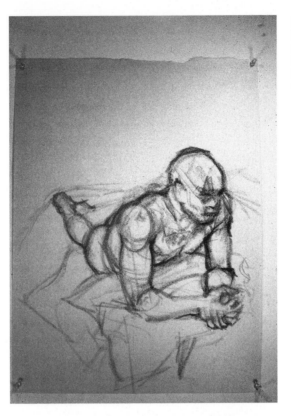

FIGURE 11–42
MICHAEL COLBERT, University of Cincinnati
Student drawing: foreshortened figure study
Courtesy, the artist

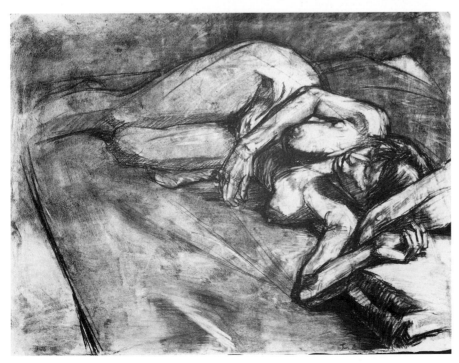

FIGURE 11–43
JODY MIDDLETON, Edinboro University of Pennsylvania
Student drawing: foreshortened figure study with value added
Courtesy, the artist

FIGURE 11–44
ERICA BECKER, University
of Wisconsin, Whitewater
Student drawing: figure study
using value shapes
Courtesy, the artist

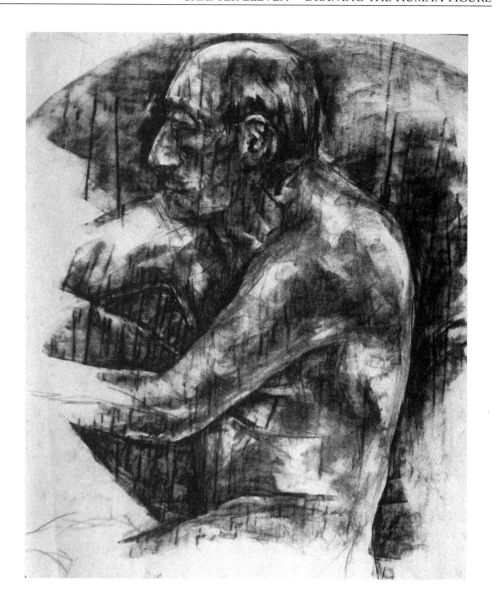

Drawing Hands and Feet

Because hands and feet present such an array of small forms, your best initial approach may be to generalize their overall appearance through the use of shape summary and planar analysis. Summarize the foot seen from the side by drawing a triangle (Fig. 11–45a). To soften the geometry, round off the outer contour of the back of the heel so it projects out from the foot. Using a modulated line, suggest the meeting of the foot with the ground plane. Observe that the outside of the foot hugs the ground more evenly than the inside, where the curvature of the arch of the instep is more pronounced. A triangle may be used to summarize the foot from many viewpoints, as in Figures 7–1 and 11–46, including a foreshortened view, front or back (Fig. 11–45b).

Turning to the hand, observe that with fingers extended and closed, both palm and back views may be summarized as an oval shape. To establish the proportions of the back of the hand, draw three crosswise arcs to represent the segmented joints of the fingers. (Fingers and toes each have three bones; when flexed, they each represent a separate plane.) Begin the series of arcs with one that curves across the knuckles, dividing the hand in half, and note that from this back view

FIGURE 11–45a

FIGURE 11–45b

the middle finger is approximately one-half the length of the hand. The next two arcs should increase slightly in degree, and the segments should be progressively shorter. Draw the thumb with simple, parallel curves. Held snugly against the hand, the thumb's rounded tip should reach almost to the first crease below the knuckle on the index finger.

To draw the palm side of the hand, repeat the oval-shaped summary and the arcs at the joints. In contrast to the back view, however, note that the finger segments appear more evenly divided on the palm side, and correspondingly, that the middle finger from this view measures less than one-half the length of the

FIGURE 11–46
JAMES VALERIO
Feet, 2000
Pencil on paper,
28⅝ × 25"

Courtesy of George Adams Gallery,
New York. Collection of Kenneth Spitzbard

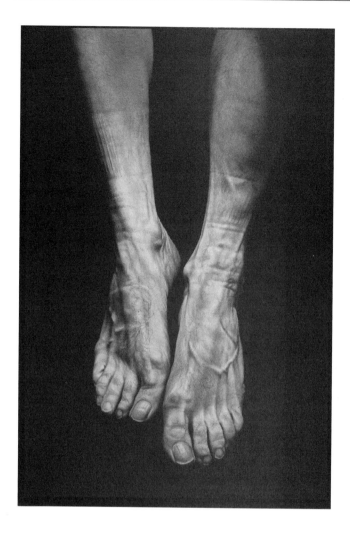

hand. This apparent structural discrepancy is due to the crease of skin folds and webbing of fatty tissue at the juncture of palm and fingers, which conceals one-half of the first bony joints of the fingers. (Conversely, on the back of the hand, the presence of the knuckles seems to increase the length of the fingers.) Generalize the palm of the hand as a circle, and block in the muscles at the base of the thumb and along the heel of the small finger (you may wish to add a few topographic marks to account for the shallow depression in the middle of the palm).

The hand, as the most mechanically specialized part of the body, has a potential for communication that rivals facial expression (Figs. 8–5 through 8–7). Indeed, as these three examples suggest, many figurative works of art portray the human body clothed, with only the heads and hands exposed. Once the fingers are flexed and assume gestures in different directions, the hand becomes quite challenging to draw. Regardless of viewpoint, however, generalize the fingers first as a simple mass to consolidate their form. Drawing arcs across the hand connecting each set of knuckles will help you to see the totality of the hand's structure and gesture. It will also assist you in organizing the fingers into planar sections, beginning with the largest facets. Observe the planar underpinnings of the hands depicted in Figures 8–7 and 11–33.

The Figure as Narrative

In Chapter 8, "Subject Matter: Sources and Meanings," we discussed some of the major themes traditionally associated with figurative subject matter. In Chapter 9, "The Form of Expression," we talked extensively about the ways in which formal

considerations lend meaning to a drawing. In this section we look at three drawings in order to focus on the ways in which formal considerations and specifics of subject matter can be combined to boost expression in a figurative image.

To begin, let us reiterate the importance of the abstraction process in drawing. (Remember that the verb *to abstract* implies the act of boiling down information from a subject for presentation in another form, such as a drawing.) When artists draw from subjects in nature, the process includes not only selecting what information to represent, but also deciding how much importance each area of the drawing will be given. Typically, as a drawing develops, an artist will devote increasing amounts of attention to organizing a compositional hierarchy of major and minor emphases, much as an author arranges characters and events into main and subordinate plots. Out of the totality of these abstract choices emerges the artist's personal visual statement.

So, the meanings of *what* you draw are inescapably bound up in the *way* you draw. That association of form and subject to produce meaning may be described more clearly by looking at what we might call the formal and thematic narratives of an artwork. Formal narrative refers to the compositional relationships created in a drawing; thematic narrative refers to meanings derived from the personal treatment of subject matter within a drawing's compositional structure.

In Figure 11–36, the formal decisions are crucial to the communication of subject matter themes. In this work Rodin dispenses with all the subject attributes that traditionally identify St. John the Baptist—the emaciated body; the long, tangled hair and beard; the rough camel-skin tunic; and the lamb. This St. John exudes a lean but muscular good health, his beard is well groomed, and he is obviously a modern man. It is the formal device of his stride that finally identifies this figure as the saint. Rodin, by his own account, conceived of his St. John as the forerunner, the man who went forth to announce the coming of the Christ, so he used the gestural energy of the forward stride to signify this concept.

Drama is concentrated in the upper part of the body where the saint appears to be leaning toward the picture plane. Note especially the shortened muscles in the neck, upper chest, and upper arms, all of which are given more definition and tonal contrast than the rest of the body. The intensity of all that muscular activity alerts us to the ferocious energy of St. John. Moreover, the focus on the upper torso and limbs powerfully conveys a use of body language to express deep emotion while preaching. Finally, note how the artist furthers the thematic narrative through the gesture of the extended index finger, which in religious iconography refers to the act of teaching.

Let us now revisit the Valerio drawing (Fig. 11–46) to consider how a highly naturalistic figurative image can be organized so as to elicit a strong viewer response. Starting with broader compositional concerns, see how the whole image is conceived in terms of two intersecting V-shapes. The larger V, following the outer contours of the calves and converging at the big toes, descends from the top of the format; the smaller inverted V is suggested by the outer contours of the two feet. Notice how our attention is directed to the lower half of the page by a combination of ploys, including the intersection of the V-shapes, increased focus, and greater tonal contrast. Having arrived at this area, we find ourselves mesmerized by an abundance of clinical detail pertaining to a part of the body generally covered from sight. We may also perceive a morbid stillness in the image, due largely to the equilibrium of forces in the opposing V-shapes. All this prompts us to ask, Why are we looking at these feet, and to whom do they belong? To a man living or dead?

Moving from the larger composition to smaller surface activity, note that the unsentimental depiction of small bones, raised veins, and fragile digits elicits an acute realization of the body's vulnerability. The indented impressions left on the shins by the ribbing on recently removed socks quietly magnifies the realism of the image (making the feet more uncomfortably naked than nude), and complements the drawing's emphasis on the transience of flesh by adding the suggestion

FIGURE 11–47
EDGAR DEGAS (1834–1919)
The Tub, 1886
Pastel
*Réunion des Musées Nationaux / Louvre,
Paris, France. © Reunion des Musees
Nationazux / Art Resource, NY*

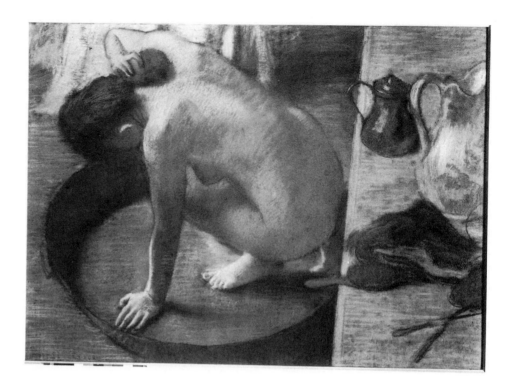

of time elapsed. Ultimately, we may identify the drawing as dealing with a theme we normally shy away from—that of our own mortality.

A quick comparison of Valerio's depiction of feet with that by Bravo (Fig. 7–1) confirms our claim that it is *how* rather than *what* you draw that finally determines content. Although in the Bravo we again see only a fragment of the figure, we are not troubled by that; the feet, beautifully bathed in light, suggest ease and fulfillment. They are comfortably nude.

The Rodin and Valerio drawings restrict their imagery to a figure set against an empty ground, and each demonstrates how the functional design peculiar to human anatomy may be translated into a drawing's visual structure. Figure 11–47 integrates the figure into a fully realized spatial environment. From a formal standpoint, what impresses most about this drawing is its compositional economy; every mark and tone performs a pictorial function. Notice first the vertical divisions of the picture plane that begin with the edge of the tabletop on the right side of the drawing. That crisp line is repeated by a second implied line that runs from a sliver of drapery in the background, across the high points of the shoulder blade, over the ridge of the deltoid and acromion process on the left shoulder, and down the braced left arm. This is but one example in the drawing where selected anatomical features under stress are coordinated with (or give rise to) principal design motives.

Figure-derived design in this work can also be seen in the almost horizontal accent where the groove of the model's spine leads to the base of the skull. This internal linear force is extended on either end of the composition by the rhyming shapes of the pitchers on the right and the model's hair and sponge on the left. Observe next how this bather's darkened face and hair blend into the dark inner curvature of the basin, creating a new pictorial form. Following that curve through the illuminated hand and foot, and their long shadows, your eye will automatically pick up on the mirror and stacked belongings on the table. Put all those gestural segments together, and a large unifying rectangular shape emerges that echoes the proportions of the format.

By repeating the format within the larger image, and in providing an abrupt spatial shift with the tabletop, Degas zooms in on the image of the bather. As a

result, the model's pose has a choreographed appearance, as if she were the main character in a mise-en-scène with psychological undertones. On the one hand, the theatrical artifice of the drawing distances observers and invites them to look, much as they would at a play. On the other hand, the intimacy of the subject, depicted in a private chamber-like setting, combined with the privilege conferred by the drawing's high vantage point, casts doubts on the propriety of our admittance and places us in the disquieting role of voyeur.

Drawing 1. *To formally integrate a figure into an environment, begin with a three-minute gesture drawing in which you scan and construct the space and the figurative image simultaneously. Start by stating the main axis of the pose, followed by a major axial division from the surroundings. As you proceed, find correspondences and contrasts in shape, direction, tone, and pattern, scanning back and forth between the figure and its setting. (Features surrounding the model will serve the dual function of measuring and angling references and potential design forces.) Make use of linear and atmospheric perspective so as to infuse even this brief study with spatial dynamism (Fig. 11–48).*

Exercise 11F

Drawing 2. *If you have difficulty building the figure and its environment simultaneously, try first doing a three-minute gesture drawing of the spatial setting without the figure, sizing up the setting's two-dimensional design potential and three-dimensional organization. Instead of rendering the environment in uniform lines and tones, vary your touch to create different levels of definition as well as to suggest major and minor compositional motives and important spatial relationships. When you do introduce the figure, you may happily find that the relationships you have stressed in the environment function as cues for seeing the structural properties of the figure more quickly and comprehensively. (This alternate exercise can be done in a life-drawing studio simply by ignoring the model for the duration of the initial three-minute study.)*

Drawing 3. *Once you have settled on a viewpoint, do ten-minute, intermediate, sustained-gesture studies that expand upon the correspondences and contrasts found in the briefer studies. Try to forge relationships between the figure and its environmental field (Fig. 11–49). Organize values into shaped patterns of light and dark, and experiment with line versus mass, making sure to include*

FIGURE 11–48
CAROLINA CURRAN, University of Cincinnati
Student drawing: gesture study of figure in an environment
Courtesy, the artist

FIGURE 11–49
ANDREW CASTO, University
of Cincinnati
Student drawings:
sustained-gesture figure
composition studies
Courtesy, the artist

FIGURE 11–50
ANDREW CASTO, University
of Cincinnati
Student drawing: final figure
composition
Courtesy, the artist

FIGURE 11–51
HEATHER CONVEY, University
of Cincinnati
Student drawing: two-figure
composition
Courtesy, the artist

linear pathways that cross the boundaries of nameable objects. Find rhyming elements in different guises (positive/negative, large/small) to create unifying motifs. You may want to use a viewfinder to help you compose.

Drawing 4. *Conceive of the two-hour final drawing as a more deeply plumbed variation of your ideas rather than as a large copy of what you achieved at the intermediate step. Continue to refine your selection process, editing to establish levels of definition and consolidating passages to strike a balance between real and abstract attitudes in your drawing. With these issues in mind, observe how in Figure 11–50 the lines of the reclining model repeat architectural themes. Note also how the figure has been organized triangularly, with the main design tension occurring where the diagonal of the right arm and leg interrupt the opposing diagonal of the sheet.*

As a more ambitious alternative, repeat the steps of this exercise using multiple figures. In Figure 11–51, note particularly the areas of dark and light patterns that do not strictly follow known body shapes. Together with the implied three-way gaze between the two models and the viewer, the contrast of graphic marks and lines with the sensuous modeled forms gives this drawing a decidedly psychological edge.

Visualizations: Drawing Upon Your Imagination

Our brains are active places, and among the flow of information and snatches of verbal thought appear mental pictures of things remembered or imagined. These mental pictures often crop up quite unexpectedly and, like dreams, may recur uninvited. Most people are happy to simply live with their personal repertoire of mental images and manage to shove them aside in order to get on with their lives. But an artist may find these images harder to ignore.

Have you ever had a mental image be so persistent that you felt the only way to put it out of your mind was to draw, paint, or sculpt it? This is a common experience among artists and is perhaps one of the things that best differentiates us from other people; we experience a drive to give outward form to our personal experience. For some artists, a single memory or obsession may serve as their primary subject matter for many years. Such is the case for H. C. Westermann (Fig. 12–1) for

FIGURE 12–1
H. C. WESTERMANN
USS Enterprise, ink on paper
© *Estate of H. C. Westermann/Licensed by VAGA, New York, NY*

FIGURE 12–2
PIETER BRUEGHEL, the Elder
Temptation of St. Anthony, 1556
Pen and black ink on
brownish paper, 216 × 326 mm
Ashmolean Museum, Oxford

FIGURE 12–3
SUE COE
Scientists Find a Cure for Empathy,
1997
Graphite, gouache, and watercolor,
53½ × 52½"
*© 1997 Sue Coe. Courtesy Galerie St. Etienne,
New York*

whom the horrors experienced while in service on a battleship during World
War II could only be purged by repeatedly drawing crucial scenes from memory.

Even artists driven by concerns that are more public in nature delve deeply
into their private store of imagery in order to express a moral or political stance.
Consider the fantastical scene by Brueghel in Figure 12–2, in which bizarre crea-
tures performing inexplicable antics serve as allegories of various types of church
corruption. In our own day, artists moralizing on current social or political issues
continue the satirical tradition, mixing a dark, bitter humor with their messages
and using exaggerated and sometimes fantastic form (Fig. 12–3).

Fortunately, our culture still treasures personal vision despite our constant
bombardment by images from the mass media. While the imagery produced by
the advertising industry is often undeniably clever, we generally perceive it as

shallow and lacking the meaning we hunger for. So, the role of the artist today includes recharging the vast pool of imagery around us with images that are at once personal and recognizable as pertaining to a more universal human condition (Fig. 12–4).

Representations that are based on imagined or recalled material are commonly referred to as *visualized images*. Visualized images can range from the humble sketch someone makes prior to buying lumber for a bookcase to such bizarre artistic conceptions as Figure 12–2. And in complexity and degree of finish, envisioned images can span the gamut from the gestural drawing of a sphinx by Leon Golub (Fig. 12–5) to the much more elaborately detailed drawings by Brueghel (Fig. 12–2) and Coe (Fig. 12–3).

FIGURE 12–4
MADDEN HARKNESS
Untitled, 1988
Mixed media on vellum,
47 × 36"
Courtesy, Roy Boyd Gallery, Chicago

FIGURE 12–5
LEON GOLUB
Untitled (Sphinx), 1963
Conté on vellum, 23¾ × 39"
Courtesy, Printworks Gallery, Chicago

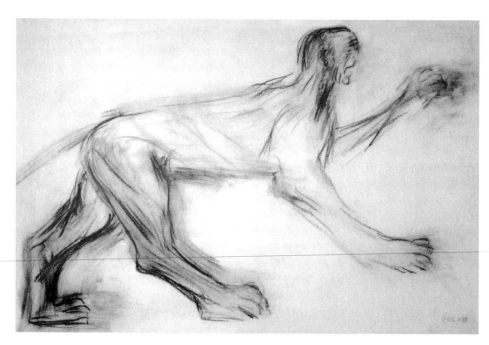

Visualizing with a Purpose

To demystify to some degree the practice of visualized-image drawing, we will start with its practical application. When planning a project that involves an investment of time and materials, we naturally draw up a plan. In Figure 12–6, for example, the Swiss sculptor Jean Tinguely has made a series of spirited studies of a machine propelled by waterpower. Notice the casual look of these studies, the rapid strokes and fervid written notations. The artist, we assume, was particularly concerned with getting down a series of ideas as quickly as possible before he lost his train of thought.

All of the images in the Tinguely are drawn in profile view (the view described in the design fields as the *side elevation*). There is no attempt at illusionistic depth here, as the drawing's purpose was to record information. In a more finished drawing, made perhaps to communicate information to a fabricator, Buckminster Fuller also resorted to a side elevation, but in this case he has provided a cutaway view allowing us to see the inner workings of his visionary vehicle (Fig. 12–7). The sculptor Robert Stackhouse, on the other hand, is primarily concerned with the spatial disposition of his frail wooden structures, so linear perspective is well suited to the development of his concepts (Fig. 12–8).

Creative brainstorming is equally a feature of the commercial art and entertainment worlds. Alfred Hitchcock, a filmmaker long admired for the way in which he composed his frames, habitually planned his takes in storyboard form (Fig. 12–9). Although the images shown here are hastily sketched, the individual frames are well composed, and the series communicates a sense of narrative urgency.

Drawing can also assist in giving form to more broadly philosophical or even literary ideas. In casting about for images that would serve as a model for

FIGURE 12–6
JEAN TINGUELY
Fontein, 1968
65 × 50 cm
Rijksmuseum Kröller-Müller, Amsterdam, The Netherlands. © 2003 Artists Rights Society (ARS), New York/ADAGP, Paris

3

FIGURE 12–7
BUCKMINSTER FULLER
Dymaxion Transport, 1934
Ink on silk, 30 × 63½"
Courtesy Ronald Feldman Fine Arts, New York

FIGURE 12–8
ROBERT STACKHOUSE
Inside a Passage Structure, 1986
Watercolor, charcoal, and graphite on paper, 89½ × 120"
Arkansas Arts Center Foundation: Purchased with a gift from Virginia Bailey, 1987, 87.024.002

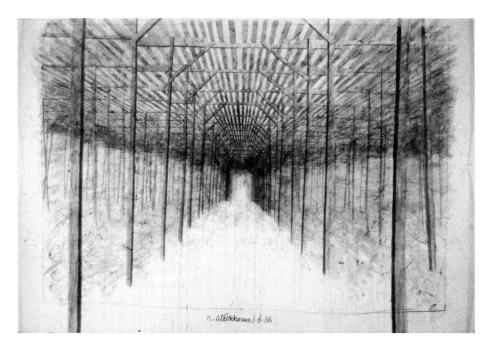

FIGURE 12–9
Storyboard image from *The Birds*
© 2003 by Universal Studios. Courtesy of Universal Studios Publishing Rights, A Division of Universal Studios Licensing, Inc. All Rights Reserved. Courtesy of the Academy of Motion Picture Arts and Sciences

FIGURE 12–10
ROBERT SMITHSON
Entropic Landscape, 1970
Pencil on paper, 19 × 24"
*© Estate of Robert Smithson/Licensed by
VAGA, New York, NY
Courtesy, James Cohan Gallery, New York*

his ideas of entropy, the earthworks artist Robert Smithson produced drawings of fantastic landscapes (Fig. 12–10). Victor Hugo's drawing of the legendary Eddystone lighthouse (Fig. 12–11) is another example of visualized-image drawing in service of an idea. Written descriptions and historic etchings describing this wildly excessive structure had intrigued the famous French novelist. Piecing what information he could gather into this drawing was actually a preparatory step to his writing long descriptive passages in one of his novels about a similar but fictitious lighthouse.

Practical Advice for Drawing Visualized Images

Usually when drawing from the real world, we choose subjects that are stationary and clearly defined by actual light and shade. This allows us to measure the success of our depiction against the concrete objects and spaces before us. When drawing things in motion (such as a pacing zoo animal or people milling about in a public terminal), we are forced to retrieve and generalize information from a continually changing subject. But even in these circumstances, we still may test, to some degree, what we've made against what we see.

Drawing from images we visualize is another matter altogether. In this case, we do not have the luxury of directly comparing our effort with the source material. And in order to rough out and develop what we have imagined, we must try to capture what is often a fleeting and vaguely formed mental picture, the particulars of which may seem to disappear in translation. This is why drawing invented forms and spaces, especially when they are complex, can be a test for any artist. But in spite of the demands, the execution of visualized imagery should not be beyond the capability of anyone who has a command of fundamental drawing skills.

FIGURE 12–11
VICTOR HUGO
The Lighthouse of Eddystone
Pen and brown ink wash,
890 × 470 mm
© *Réunion des Musées Nationaux/Art
Resource, NY*
Musée Victor Hugo, Paris, France

Drawing images from your mind depends first of all on a utilization of the basic facts of seeing as gained from drawing real things. This is because even the process of drawing the structural properties of objects you can literally see is usually organized around an internalized image or gestalt. In other words, each surface change recorded from an actual subject in a drawing is measured against what this gestalt feels like in the mind's eye.

So how, you may well ask, does one go about plugging into the half-formed picture in one's mind? Probably the best advice we can give is not to be afraid but to go ahead and start making thumbnail sketches—lots of them. Don't be critical, but keep improvising from one thumbnail sketch to another. Try drawing your imagined subject from different vantage points or in different positions, as in Daniel Quintero's *Sketches of Pepele* (Fig. 12–12). Following this procedure, you will find that you are gaining greater understanding of your subject and are becoming more confident of its form with each drawing. Bear in mind, though, that at any time in this process you may alter the form if you have ideas for its improvement. Let the image evolve at the same time as you are drawing it, as if it were revolving in space. Eventually you should find an image that seems true to your expressive purpose.

Once you have an image roughed out in thumbnail scale, try developing it by applying many of the same techniques you would use in perceptual drawing, keeping focused at all times on the three-dimensional gestalt of your imagined subject. No matter what approach you employ (e.g., cross-contour lines, mass gesture, planar analysis), you will in effect be "sculpting" or discovering

the structural specifics of your visualized subject as you draw it. Look again at the Golub sphinx (Fig. 12–5) and note the slashing topographical marks that indicate the tactile surfaces of its powerful and quivering hindquarters. In Figure 12–13, cross-contour marks give a feeling of solidity to the jumbled vase-like objects.

Thus, many of the factors you have to consider when recording your impressions of actual space and form can be used as building blocks to guide the emergence of something recalled or imagined. The most important of these factors are:

1. The vantage point from which to draw what you have envisioned.

2. The gestural essence of visualized forms, which includes their overall proportions.

3. The spatial relationships of imagined objects. Note how spatial clarity has been imparted to the envisioned scene in the Ananian drawing (Fig. 12–14) by the use of relative scale, overlapping, foreshortening, and even a suggestion of sun angle.

4. The surface structure of imagined forms, which includes an understanding of their major planes and topography (see Figs. 12–5, 12–13, and 12–14).

FIGURE 12–12
DANIEL QUINTERO
Sketches of Pepele, 1974-75
12 drawings on paper,
each 4¾ × 4¾"
© Daniel Quintero. Courtesy, Marlborough Gallery, New York

FIGURE 12–13
SUSAN CHRYSLER WHITE
Untitled 2
Dayglow, gouache, and charcoal,
48 × 42½"
Courtesy Rutgers-Camden Center for the Arts

FIGURE 12–14
MICHAEL ANANIAN
Quid pro quo—Vagrant, 1999
Charcoal on paper, 38 × 25"
Courtesy, the artist

FIGURE 12–15
CHARLES WHITE
Preacher, 1952
Ink on cardboard, 21⅜ × 29⅜"
*Whitney Museum of American Art,
New York; purchase 52.25*

Another thing to bear in mind when drawing a visualized image is the positioning of its form in relation to the picture plane. When drawing from life, it is a good practice to select the view of your subject that best reveals its spatial character (unless flatness is a specific aim of your work). Typically, beginners visualize their images in an unforeshortened view, that is, the view in which the form's profile most readily identifies the subject. But imagined forms appear more impressive and more natural if they engage space fully by confronting the picture plane (Fig. 12–15). If you find that you are not able to overcome the difficulty of drawing your visualized subject in a foreshortened view, try fashioning a small three-dimensional model of it from clay or cardboard. Look at your model from a number of angles to find the view that is most expressive of what you wish to communicate.

Before we conclude this section, it is important to point out that the two extremes of drawing from life and drawing from your imagination can be mutually beneficial. Rigorous scrutiny of things seen through the act of drawing can help you realize envisioned images by increasing the reserve of forms that you have committed to memory. And the exercise of your powers of conceptualization during the practice of visualized-image drawing will make you more adept at rapidly grasping the essential gestural and structural qualities of the real subjects you draw.

Freeing Up Your Imagination

So far in this chapter we have discussed ways in which to draw images you already have in mind. Now let's suppose you have the desire or need to come up with original images, but your brain is simply not volunteering any mental pictures. To compound the problem, when looking at the work of others, you may surmise that the images have poured out spontaneously, making you feel in comparison as though your imagination has completely dried up.

While some artists, such as Cuevas (Fig. 12–16), create invented imagery of the highest order in a seemingly effortless manner, most of us have to prod or

"crank up" our imaginations before visualized images of merit begin to emerge. Fortunately, there are some fairly universal ways to free up the imagination.

To begin with, since you'll always be using aspects of the real world to kindle your creative thoughts (no one can get outside of nature), we recommend that you get into the habit of playing uninhibitedly with what you see in your daily life. Personify a group of parked cars, making them good or evil characters, or imagine that for a change, a fire hydrant soaks a dog with a stream of water. Picture looking out your window only to see an amorphous mass of throbbing protoplasm in the backyard (Fig. 12–17). Imagine changing the proportions or scale of some object, or perhaps distorting it in some significant way. In this regard, look at Figure 12–18, a self-portrait in which the ceramic artist Robert Arneson kneads his head as if it were a great lump of clay, with a result that is both humorous and gruesome. Yet another approach is to concoct composite images in your imagination that could never occur under normal circumstances, as in John Wilde's *Portrait of Emily Egret* (Fig. 12–19).

FIGURE 12–18
ROBERT ARNESON
Wedging the Head, 1988–00
Mixed media on paper, 48 × 31¾"

© Estate of Robert Arneson/Licensed by VAGA, New York, NY. Courtesy of George Adams Gallery, New York. Collection of Kenneth Spitzbard

FIGURE 12–19
JOHN WILDE
Lady Bird Series #9—Portrait of Emily Egret, 1982
Silverpoint on paper,
8 × 10¼" (sight)

Courtesy, Arkansas Art Center Foundation Collections: The Tabriz Fund (83.24.2)

Uninhibited play with media can be another springboard for visualized images. Experimenting with unfamiliar media will introduce the element of chance to your work and may give you ideas for future directions. Otto Piene, for example, let process dominate his image-making when he passed smoke from a flickering candle through a screen to create the pattern of sooty deposits in his *Smoke Drawing* (Fig. 12–20). Similarly, Lucas Samaras sacrificed some artistic control when he transformed his Polaroid SX-70 self-portrait by manipulating the photo emulsion as the image was developing (Fig. 12–21). Taking rubbings of surfaces to obtain textures or transferring images of current events from the popular press can be a catalyst for new drawing adventures. Or you might overlay onto the ground of your drawing found materials, such as menus, posters, or sheet music.

FIGURE 12–20
OTTO PIENE
Smoke Drawing, 1959
Smoke/soot on paper,
50 × 60 cm
Courtesy, the artist

FIGURE 12–21
LUCAS SAMARAS
Photo Transformation, 1973
SX70 Polaroid, 3 × 3"
© 2003 Lucas Samaras. Courtesy of the Artist and Pace Wildenstein Gallery, New York

FIGURE 12–22
June Moss
Pillory
Monotype, 26 × 20"
Courtesy, the artist

Another possibility is to involve yourself with drawing related techniques from other artistic disciplines, such as monoprinting (Fig. 12–22), a technique tradition- ally associated with printmaking.

Perhaps the best-known way to spontaneously generate visualized imagery is to doodle. Doodles are usually thought of as idle scribbling that helps to pass the time or vent nervous energy. Artistic approaches to the doodle vary.

Some artists practice an elevated form of doodling called *automatic drawing* in order to stimulate an outpouring of intuitive imagery. Typically, artists who practice automatic drawing neither consciously plan ahead nor pause while drawing to redirect their course. For some artists, automatic drawing is the sole means by which they create their imagery. This is especially true for artists like Jackson Pollock, who credit the unconscious as the source for their art. Inter- estingly, Pollock's astonishing ability to channel his subconscious feelings onto paper is confirmed by the fact that his psychoanalyst used many of his innumer- able sheets of studies as a therapeutic aid for him (Fig. 12–23). Other artists de- velop their doodling into refined images, as in Figure 12–24, which appears to have been arrived at through an accretion of doodled passages, most of which seem to refer to an invented vegetable kingdom.

FIGURE 12–23
JACKSON POLLOCK
Sheet of Studies, 1941
Pencil and charcoal pencil on
paper, 11 × 14"
© 2003 The Pollock-Krasner Foundation/
Artists Rights Society (ARS), New York

FIGURE 12–24
JONATHAN BOROFSKY
Untitled at 2,784,770 n.d.
Ink and charcoal pencil on paper,
11 × 14"
Private collection. Photo: James Dee

Categories of the Visualized Image

This chapter has taken a straightforward look at the topic of visualized imagery. With our commonsense approach, we have endeavored to reassure you that the basic building blocks for representing observed form and space provide the underpinning for even the most complex of visualized images. In making the working process more comprehensible, however, we run the risk of implying that visualized-image drawing is formula bound and mechanical.

Nothing could be further from the truth. On the highest level, the creative drawing act is a magical and unpredictable process that resists analysis and rigid formulas. Nowhere is this more evident than with the creation of envisioned images, which are conceived from scratch, so to speak, using the resources of the artist's imagination. The practical insights in this chapter are meant to empower you in discovering your own creative resources; it is our hope that the reproductions of old and new master drawings throughout this book will communicate the depth of innovation and expressive impact commonly associated with drawings of visualized imagery.

To reinforce our theme that inspiration can be taken from studying the visualizations of other artists, the last part of this chapter categorizes and briefly examines a select group of drawings by modern artists working with visualized imagery. The categories are arbitrary; they are used purely to lend temporary structure to the seemingly endless array of envisioned images in pictorial art. We encourage you to combine these categories or even invent new ones.

Images Based on Memory

The artist's memory is perhaps the most common source for visualized images. Some artists rely heavily on the remembrance of things past for their subject matter. Artists who work this way often take great pains to reconstruct the memory pictures that inspire them. For example, they might do a substantial amount of photo research to augment their powers of recall, visit sites that are similar to the one imagined, or make studio models of a remembered scene to retrieve structural detail and lend their work an air of authenticity.

For the most part, however, artists do not so intentionally take advantage of the opportunities their active memories may provide. Instead, they react intuitively to overtones in a developing work that trigger their memory of, let us say, the peculiar physiognomy of someone glimpsed in a bus, the striking pattern of shadow shapes under restaurant tables, or even an unusual pairing of colors. The contributions of things impulsively remembered and acted on can greatly enrich a drawing or any work of art.

But whether you are consciously mapping out the visual coordinates of an event that has haunted you for years or simply responding to whatever at the moment you are provoked to recall, it is important that you trust your memory and go wherever its unfolding narrative takes you. This is not to imply, however, that the images you draw must be rigorously controlled by your memory. The drawings you make will have their own momentum; what you recall should be considered a basic script, or scenario, to get at deeper meanings. The woodland scene by Hyman Bloom (Fig. 12–25) nicely illustrates the relationship between memory and visualization. At first glance we may react to this scene as if it were drawn directly from life, but a closer look reveals that the forms depicted here do not conform to what can be literally seen. The branch-like forms are more expressive and beautifully composed than anything you would actually encounter in nature. This is a forest fantasy that could only have been drawn by an artist who has an extensive background in drawing both from observed reality and memory.

FIGURE 12–25
HYMAN BLOOM
Landscape #14, 1963
Charcoal, 41½ × 35"
Collection of Peter Moses Freedberg and Rie Ichikawa

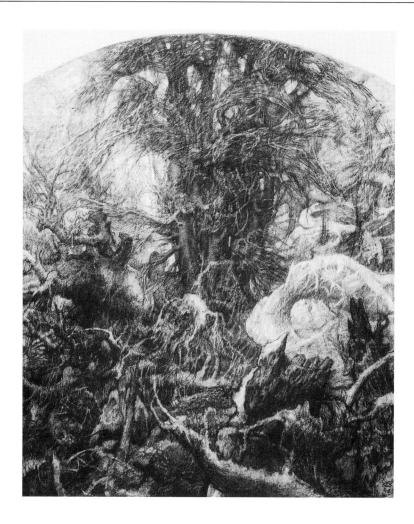

The eerie scene by Charles Stiven (Fig. 12–26), plainly a visualized image, is composed of elements simple enough to be drawn from memory. Even the use of light, which imbues the strange scene with much of its believability and mystery, is something that, once learned, can be practiced without the benefit of an immediate model. Notice that while many envisioned images are rather sketchy in their particulars, the forms here are crisp, even pristine, a quality that only adds to the surreal effect.

Another contemporary narrative artist, Sandow Birk (Fig. 12–27), seamlessly combines material from diverse sources with images drawn from memory. His anachronistic scenes often show contemporary disasters composed in the heroic manner of Romantic history painting. Note that although his forms are sketchy and generalized, he does not skimp on the use of shadow or deep space. Comparing this image of devastation and waste to that of Stiven (Fig. 12–26) will give you an idea of the enormous scope of visualized images based on the depiction of real objects.

TRANSFORMATIONS

In everyday life, transformation refers to a change in the outward form or appearance of a thing. There are two basic states of transformation. One is the alteration of something as we know it—think of a densely forested tract of land altered by a fire. Transformation may also mean a more complete and essential change, as in the metamorphosis of a caterpillar into a butterfly.

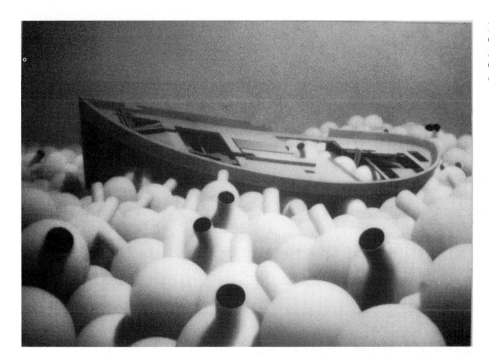

FIGURE 12–26
CHARLES STIVEN
Still Life with Septic Tanks
Charcoal and conté pencil, 34 × 46"
Courtesy, the artist

FIGURE 12–27
SANDOW BIRK
Arriving Too Late at The Great Battle of LA, 1998
Ink and pencil on paper, 17 × 19"
Courtesy, Koplin Gallery, Los Angeles

For artists who transform reality to make an envisioned image, the same two orders of change apply. At their best, transformed images seem to be the result of artistic alchemy. And as is the case with actual living matter, the central feature of artistic transformation is a sense of process or movement from one phase to the next, which is either apparent or felt.

FIGURE 12–28
CHARLES LITTLER
Self Portrait, 1977–85
Charcoal, 36 × 30"
Collection of Arnold and Marilyn Nelson

The transformed self-portraits by Lucas Samaras (Fig. 12–21) and Charles Littler (Fig. 12–28) are striking examples of how an altered exterior can act as an extension of the psychological self. Both of these drawings exhibit a mastery of form improvisation that, in view of the subject matter, can be considered to have resulted in images of grotesque abnormality. But the intent of both artists was to communicate certain interior feelings more forcefully than would be possible with an objective rendering. And as you compare them, note how different is the expression in these two works: The snarling visage of Samaras is diabolical; the Littler is marked by gentility and repose in the presence of change.

The startling imagery in Figure 12–29 depicts the metamorphosis of beggars into dogs. These mutational forms are modern parallels of the human-animal hybrids that abound in the mythologies of ancient peoples. But in spite of their fantastic bearing, these images seize and hold our attention because they seem structurally plausible and because their swift tracer-like lines express energy and the passage of time. Note as well that these transfigured beings embody a timeless social theme: the fate suffered by those who are cast out by society.

Transformations of the human form can have a particularly intense emotional impact on us because our identification with the subject is so immediate and profound. And yet one of the reasons artists are a vital cultural resource is that their transformative powers often shift and refresh our perceptions of the most commonplace things in our environment. Look, for example, at the drawing by Max Ernst (Fig. 12–30). By the seemingly simple strategy of applying the texture of wood grain to a leaf, Ernst short-circuits what is often an important clue in recognizing an object—its distinctive surface quality—and makes us consciously reconsider what we normally take for granted.

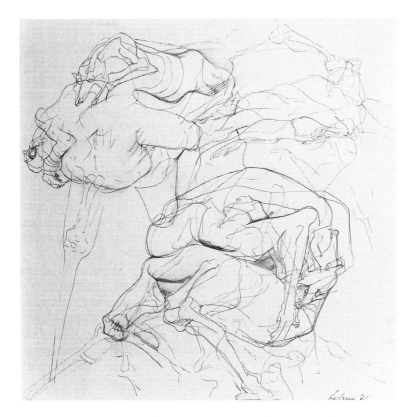

FIGURE 12–29
RICO LEBRUN
Three-Penny Novel—Beggars
into Dogs
Ink on paper, 37¼ × 29⅞"
Worcester Art Museum, Worcester, MA

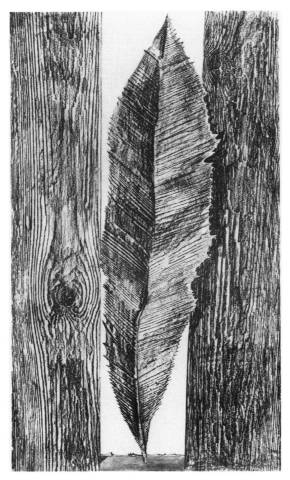

FIGURE 12–30
MAX ERNST
Histoire Naturelle, 1926
Lithograph, 19¹¹⁄₁₆ × 12¾"
© 2003 Artists Rights Society (ARS),
New York/ADAGP, Paris
Solomon R. Guggenheim Museum, New York
48.1172.X547.1-.68. Photograph by Robert
E. Mates

INVENTIONS

The dividing line between visualized-image inventions and transformations is thin and at times impossible to pinpoint. But for our purposes, it seems necessary to differentiate between those images in which a change in the appearance of something known is the critical element and those that are generated by the ambition to graphically portray things that either cannot be seen or that never existed.

Visualized-image inventions are speculative adventures, inspired by a window onto another world. Some illuminate visions of fantastic subject matter such as futuristic landscapes or miraculous plants and animals. André Masson, for instance, populated his *Caribbean Landscape* (Fig. 12–31) with skeletons of as-yet undiscovered vertebrates. The ink drawing by Nancy Fletcher Cassell (Fig. 12–32) reveals a world of phosphorescent primitive life forms bursting with energy and frenzied growth.

Other invented images are of such baffling composites that they defy strict subject-matter classification. For example, *Bio Chemica C* (Fig. 12–33), by Renart, synthesizes plant, animal, and human associations. Its overall form suggests a cushion plant (complete with thorns) or the fleshy pads on the underside of a dog's paws. The mass of bristles is reminiscent of a hedgehog's coat, and the center hints at parts of the human anatomy. Altogether, this organic mongrel both attracts with its erotic overtones and repulses with its unpleasant surface and mysterious origins.

Yet another type of invented image makes visually explicit those natural forces and dimensions that are otherwise invisible. Todd Siler's drawing (Fig. 12–34), for instance, may be understood as a metaphor for the unobservable processes of the human mind. It combines visual and verbal excerpts from a real, neurological text with diagrams of an apparatus apparently designed to initiate a chain reaction within the cerebral cortex and release enormous amounts of energy in the form of human thought.

FIGURE 12–31
ANDRÉ MASSON
Caribbean Landscape, 1941
Pen and ink, 20⅝ × 16⅛"
*© 2003 Artists Rights Society (ARS),
New York/ADAGP, Paris*

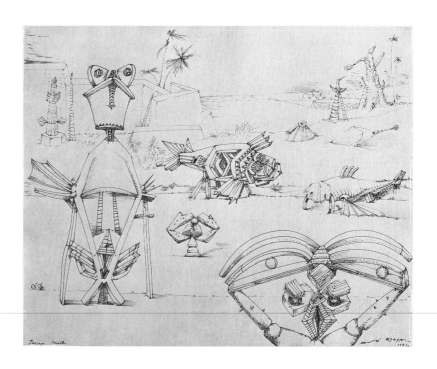

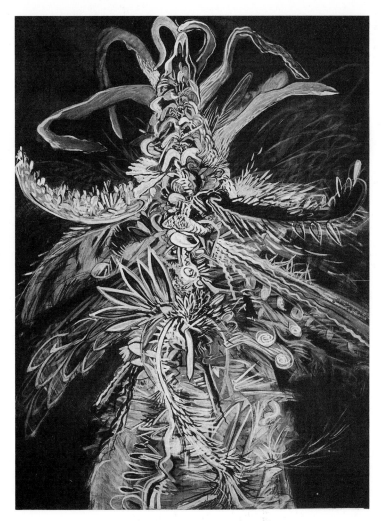

FIGURE 12–32
NANCY FLETCHER CASSELL
naturemind, 2001
Sumi ink and conté, gouache,
40 × 30"
Courtesy, the artist

FIGURE 12–33
EMILIO J. RENART
Bio Chemica C, 1966
Brush, pen and ink, 30 × 44⅛"
Inter-American Fund. (179.1967)
Museum of Modern Art, New York, NY
Digital Image © The Museum of Modern
Art/Licensed by SCALA/Art Resource,
New York

FIGURE 12–34
TODD SILER
Cerebreactor Drawing: Tokamak, 1980
Mixed media and acetate on rice
paper, 24 × 35"
Courtesy, Ronald Feldman Fine Arts.
Photo: eeva inkeri

Exercise 12A *Visualized-image drawing should be practiced frequently as a complement to drawing from observation. Drawing from your imagination sharpens your ability to conceptualize and heightens your powers to express yourself pictorially.*

Drawing 1. *Choose as your subject a couple of kitchen utensils. In your drawing, animate those objects while at the same time providing some kind of spatial environment for them. The example in Figure 12–35 is of particular interest for its dual spatial system. While the graters slide in and out of*

FIGURE 12–35
JEN PAGNINI, Arizona State
University
Student drawing: eggbeaters and
graters in a matrix of marks
Graphite and eraser, 18 × 24"
Courtesy, the artist

FIGURE 12–36
AMY GLOBUS
Student drawing: imaginary
cathedral at night
Courtesy, the artist

*the format in a direction parallel to the picture plane, the eggbeaters plow every which way through
the three-dimensional matrix of marks. Notice how the foreshortening of the eggbeaters activates the
space and makes for an unsettling image.*

Drawing 2. *This time, attempt an illusion of depth by drawing a very large form, such as a huge
animal or piece of fantasy architecture, in some kind of environmental medium. (Imagine a world at
the bottom of the ocean or a mist-filled atmosphere in which things closest to the eye are clear and
things further away are obscured by the medium.) Figure 12–36 shows an imaginary cathedral illu-
minated at the base with the upper spires disappearing into the depths of the night sky.*

*The projects that follow urge you to express subjective responses by transforming subject matter of
your choice.*

Exercise 12B

Drawing 1. *The goal here is to transform the appearance of your subject, stopping short of a meta-
morphic change. To do this, you can choose to improvise on its form and structure (Figs. 12–21 and
12–28). Alternatively, you could transfer onto its surface an inappropriate texture (Fig. 12–30), or
recompose it using an accumulation of other objects (Fig. 12–37).*

Drawing 2. *Choose an ordinary object that, by virtue of some visual characteristic, suggests an-
other unrelated object. In a set of drawings, clearly describe the metamorphosis of the first object into
the second (Fig. 12–38).*

FIGURE 12–37
MARK LICARI
Untitled (Shark), 2001
Ink on paper, 72 × 141"
Courtesy Gagosian Gallery, Beverly Hills

FIGURE 12–38
JIM SHAW
Dream Object (I was looking at
drawings of successful
businessmen which became
increasingly distorted and became
a pornographic hedge . . .),
19 drawings each 14 × 11". Long
drawing 14 × 81". Framed
15.25 × 82".
Ink, prismacolor pencil on paper
Courtesy the artist and Metro Pictures

FIGURE 12–39
CHRISTINE KARKOW,
University of Montana
Student drawing: envisioned
image using collaged material on
sheet rock, 15 × 20"
Courtesy, the artist

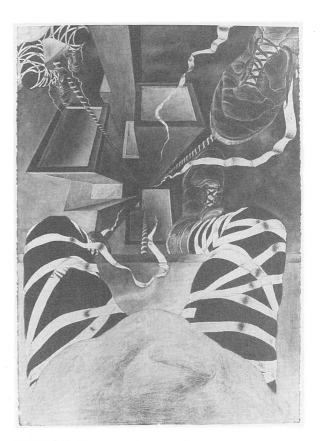

FIGURE 12–40
CHRISTOPHER ARNESON,
University of Wisconsin
at Whitewater
Student drawing: envisioned
image using cross contour
Courtesy, the artist

Drawing 3. *Make an envisioned image by combining collaged material with drawn images to produce a unified work. To free yourself from old habits and expectations, you might wish to incorporate nontraditional materials, as in Figure 12–39, in which sheet rock was used as a drawing surface.*

Drawing 4. *Draw more complex environments, with or without figures. The subjects for these drawings may be images you have seen in your dreams (Fig. 12–38), images that come as a result of reflecting on a passage in a novel or a poem, or even images that pop into your head while listening to music. When drawing more ambitious subject matter from your imagination, it may be helpful to rely on drawing devices with which you are already familiar, such as linear perspective (Fig. 12–8) or cross contour (Fig. 12–40).*

Portfolio of Student Drawings

The chapter is devoted entirely to student drawings. The drawings were selected from sixteen university art departments and art schools around the United States and represent the efforts of students in very large as well as very small programs from each geographic section of the country. Some of the drawings were made in response to specific assignments; others were created in the context of open or "free" projects, when students were left to their own devices. In every case, however, students put their grasp of visual fundamentals to work for expressive ends.

Each drawing represents a sustained effort in which the student artist grappled with challenging issues of form and content. The principal goal of this chapter is to inspire you to synthesize the space, form, and expressive information contained in previous chapters to create ambitious and complete drawings of your own. It is our hope that by looking at the work of some of your peers, you will gain a clearer and refreshed perspective on what you can aspire to, even at an early stage in your artistic career.

To structure our discussion, we have organized the drawings into four categories: self-portrait, visualized images, still life, and abstract and nonobjective imagery.

Self-Portrait

The self-portrait offers a ready subject for artistic exploration. The self-portrait can be used as a vehicle for formal concerns, as in Figure 13–1. Here the image has been split into three competing formal and stylistic parts, thus boldly risking the perils of discontinuity. The daring alternation between representation and abstraction alone could easily disrupt this drawing's form and the legibility of the figurative image. In that regard, note that the heavily patterned center section reads almost as purely nonobjective. This means that subject-matter recognition must depend upon the isolated clues of the head and foot, which are distributed along a diagonal as visual counterweights. To further aid subject recognition, and to forge a total image out of disparate parts, the artist has employed several strategies. First, he has welded the three parts by drawing the forms with trailing edges that continue from one section to the next. Second, the subject is presented in an unforeshortened view, thus enabling the viewer to grasp the figurative gestalt

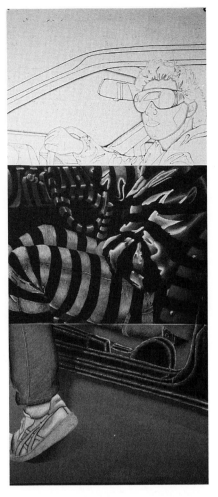

FIGURE 13–1
ROBERT H. PRANGER
*Three Part Self-Portrait Study-
Observed and/or Fantasy*
Colored pencil, marker on
paper/board, 60 × 24"
*Courtesy, the artist.
Instructor: John P. Gee,
Ball State University*

even while being jarred by the abrupt stylistic changes. Third, harmonizing the value key of the middle and lower sections promotes unity in this portion of the drawing. Finally, the varying contours in the top part generate sufficient optical color to balance the visual demands of the tonal zones below.

Despite this drawing's attention to surface effects and style, the design relationships forged from such strong visual opposites make the image conceptually provocative. For example, we might interpret the contrasting divisions of the drawing as an expression of how difficult it is to maintain a sense of integrated identity in a media-driven culture that regularly seeks to redefine who we are. In league with that thought, does the emphasis on surface in this work depersonalize the figure?

In addition to objectively recording outward appearances, self-portraiture can also look inward, as if we are holding up a mirror to an aspect of our personality or to record a chapter out of our private history. Self-portraits with subjective content can be accomplished, for example, by representing a specific facial expression or bodily gesture, or by manipulating the composition to convey the message. The life-sized, half-length self-portrait in Figure 13–2 combines a poignant pose with carefully wrought formal means to divulge feelings that are no less potent because they are subtle. Overall, the posture of the woman portrayed in this drawing exudes an air of reserve. Indeed, the hand raised to the bodice is a gesture of modesty, as if she is bashful, maybe even insecure, about having her shoulders exposed.

From a compositional standpoint, this drawing is a good example of how formal decisions can promote a subject-matter theme in a work of art. Observe

FIGURE 13–2
JAMIE COMBS
Reserved Self-Portrait
Courtesy, the artist.
Instructor: Perin Mahler, Kendall College
of Art and Design

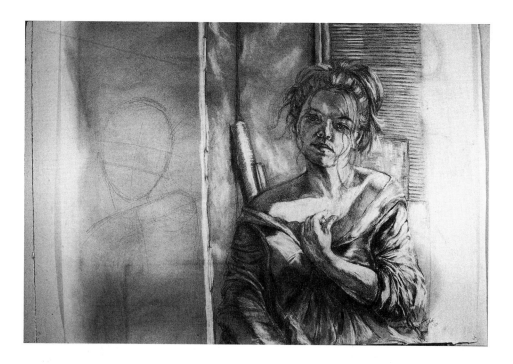

how the silvery tonalities and gently rhythmic line underscore the demure attitude of the self-portrait. Looking more deeply, note how our perception of the subject's preference to be unobtrusive is heightened by the camouflaging of bare flesh within the delicate modulations of light and shade. It is only the bunched-up garment, a source of agitation in the drawing, that has a more assertive presence.

Placing the self-portrait among representations of objects or events that connote a personally symbolic narrative can add to the meaning carried by the subject's pose and the drawing's form. All three content strategies are used to good effect in Figure 13–3. In this touching self-portrait, a homesick art student from Russia lays bare his spiritual yearnings by portraying himself with an abstracted look profiled against a train window that is the ground for projected memories of his homeland. The geometry of the composition maps out the narrative of his recollections and reveals a penchant for order that is echoed in his well-groomed appearance. Spatially, the partial image of a passenger in the foreground acts as a steppingstone, connecting spectator space and pictorial space. Sandwiching the figure between the crunch of fellow travelers and the unresponsive, hard surfaces of the train makes the private moment of this self-portrait that much more moving.

The self-portrait of a young woman in Figure 13–4 is compelling in its intimacy. We cannot escape the presence of this figure, perched on the foremost edge of the spatial illusion, nor can we avoid her melancholy gaze, which implores us to enter her personal narrative. Drawn by a student who is a native of Poland, the image memorializes the recent death of a favorite teacher. The cramped environment, achieved through a succession of clear figure–ground overlaps, integrates the female image among mementos (artworks completed in classes taken with the deceased instructor) and sequesters her in an intimate corner space. The sense of hushed seclusion is advanced by the consolidation of the image into large, simple forms depicted in stark value contrasts. Note the secondary focal points that function as signs to deepen the theme of mourning in this work: the floral offering, recalling the custom in Poland of students bestowing roses on esteemed teachers; and the cameo, which has had a commemorative tradition since Roman times.

The artists in Figures 13–5 and 13–6 have represented themselves acting out symbolic gestures. The expressive intent behind Figure 13–5 is to ask the question,

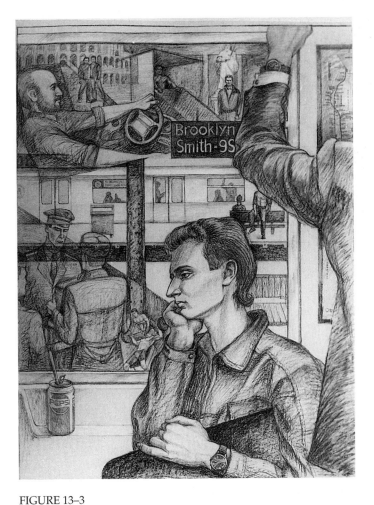

FIGURE 13–3
DENIS NAKHTSEN
Crosstime Train to Brooklyn
4 × 5'
Courtesy, the artist.
Instructor: William Sayler, Pratt Institute

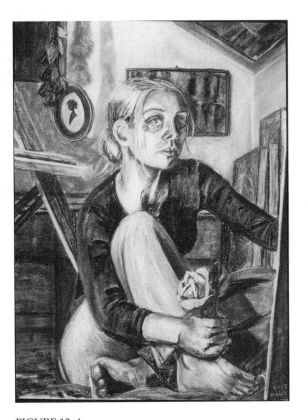

FIGURE 13–4
LUIZA KURZYNA
Untitled Self-Portrait
Courtesy, the artist.
Instructor: Sean Gallagher, Central
Connecticut State University

Where am I going in life? The motivation to ask this question in visual form was grounded in the self-awareness, anxiety, and confusion typically felt by art students as their artistic and psychic lives develop simultaneously. This particular image was inspired by the sight of a blind woman being led by her guide dog through a maze of underground subway cars and tunnels. Impressed that the blind woman could "see" a direction in her life better than he could in his, the artist composed this riveting image of himself as sightless and vulnerable, moving uncertainly away from a ziggurat-like structure that represents his soul and his purpose, as if he were metaphorically blinded by self-doubt, false starts, and misdirected energies.

The contradiction in Figure 13–6 is startling. In a slapstick gesture this young woman has skewered her hair with common utensils, thus undermining to some extent her patrician bearing. That she is aware of the inconsistency (and is not afraid to look ridiculous) is evidenced by the slightly amused, almost dead-pan expression on her face. Our acknowledgment of the spoof helps us to realize the image's higher purpose of using humor to deflate prejudice. This self-portrait is one of a series of drawings the artist made to explore her identity as an Asian American. Recalling, with annoyance, childhood taunts—when her peers would squint their eyes, bow with waxen smiles and clasped hands, and utter "Ah-so!" in a Charlie Chan-like manner—inspired her to create images that subvert such

FIGURE 13–5
CHRISTOPHER RIELY
Sleepwalker
4 × 5'
Courtesy, the artist.
Instructor: William Sayler, Pratt Institute

FIGURE 13–6
SALLY GRIFFITH-OH
Untitled Self-Portrait
Charcoal on paper, 24 × 18"
Courtesy, the artist. Instructor: Susan Messer,
University of Wisconsin at Whitewater

stereotypes. As a mocking gesture, she imitates Japanese woodcut images of women with elaborate ornaments in their hair by bedecking herself with a mixture of chopsticks and western cutlery.

Visualized Images

Visualized imagery is an important outlet for personal content. Like other students, you may be exhilarated by the opportunity to use what you have learned from studying objective reality to chronicle flights of your imagination or to concoct imagery that comments meaningfully on the world as you understand it.

The visualized image takes many forms, from unlocked memories and dreams to altered and invented realities.* Figure 13–7, for example, has captured a scene remembered from a vivid dream, complete with the jumbled reality the subconscious often conjures. The tonal values in this drawing have been organized to contrast angular, warm shadows that envelop the figure against cool accents of ghostly illumination. Modeling is limited primarily to the central female character (a self-portrait), making her more particularized and human in the midst of the generalized apparitions that surround her. The angle from which she is drawn, with her neck exposed and back to the picture plane, renders her frighteningly

*For a detailed discussion of visualized imagery, sources, and processes, see Chapter 12, "Visualizations: Drawing Upon Your Imagination."

FIGURE 13–7
MELISSA EPERT
Untitled Visualized Narrative
Charcoal, 22 × 30"
*Instructor: Janice M. Pittsley, Arizona
State University*

defenseless against the apparent specter behind her, which casts the sinister
shadow on the ground plane. Her desperation is signaled by indications of flail-
ing motions that get her nowhere (a frustration shared by many with similar
nightmares), as perspectival sight lines point toward a vehicle that presumably
symbolizes safe flight from a threatening situation.

Figures 13–8 and 13–9 evoke childhood reminiscences. A playful attitude
abounds in Figure 13–8, which is an affectionate souvenir of childhood imagery
spliced into an overall visual field. The innocent stick figure and cartoon-drawing

FIGURE 13–8
JENNIFER LANGSTON
Dreams and Memories
36 × 48"
Courtesy, the artist.
*Instructor: Bill Lundberg, University
of Texas at Austin*

FIGURE 13–9
Callie Meyer
Untitled Visualized Image
Graphite on wax paper, 16 × 13"
Courtesy, the artist.
Instructor: David James, University
of Montana

styles, along with depictions of common juvenile paraphernalia from kids' toys (jacks, Tinker Toys, Mr. Potato Head) to a soda bottle, tricycle, and dresser drawers, suggest a slice of the collective memory of modern youth. The variety of gestural and scribbled marks energizes this complex drawing and is in keeping with the merriment of its implied theme. Also, you cannot miss the large jack in the lower right, due to its monumental scale and three-dimensional believability (in contrast to the otherwise flat space of the image). Gesturally magnetizing the four corners of the support, this game piece is the single most powerful unifying element in the drawing.

Figure 13–9 is more bittersweet in its connotations. The scale of the child's dress first captures our attention. Its delicate nuances of tone and focus give the garment a haunting, ethereal presence (the neck and right sleeve of the dress nearly melt into the gray field behind them). The ambiguity of the ground intensifies the mystery. On the one hand, the thick application of graphite overlaid by incisive mark making furnishes the ground with the illusion of solid material weight. Yet we might simultaneously read a pictorial space lying within the ground's concrete surface, where small boats float in a murky atmosphere.

These restless figure–ground identities provide a clue to the dichotomy of content in this drawing. The dress is at once a symbol of simple childhood pleasures and the pain of innocence lost. The white hulled skiffs and the pulley imagery recall happy childhood memories of innumerable lakeside launches. Yet layered on top of these sweet memories is the more recent and painful recollection of a close friend's murder. This bitter experience emptied the dress of its purity.

FIGURE 13–10
BEE (BOSTROM) SNOW
*Stranger in a Land between Heaven
and Hell*
Mixed media, 60 × 96"
Courtesy, the artist.
*Instructor: Mary Frisbee Johnson,
Indiana State University*

In covering it with wax, the artist transformed it from a living sign of her youth to a relic preserved as if in amber.

The visual commotion of Figure 13–10 is indicative of its contradictory themes of self-doubt and confidence. Drawn from dreams and self-analysis, the dense story line includes an implied narrative about social conflict. In the three illuminated windows we see a figure that appears to be escaping from an uncomfortable group situation. Personal uncertainty is symbolized on the upper right where the artist portrays herself taking a precarious helicopter ride in the midst of strong winds that threaten to blow her off course. In addition to narrative and symbolism, numerous visual effects contribute to a sense of emotional discord and instability in this work. The diagonals of the whirring helicopter blade and the comet-like projectile that hurtles toward spectator space, the abrupt spatial shifts, the unruly patterns of the ominous storm clouds, and the intense bursts of light all combine to disorient the viewer. Elsewhere, on the other hand, self-assurance is expressed through design stability, particularly by the rectangular motif that repeats the structural harmony of the drawing's format. In this regard, note the alternative self-portrait in the lower left, where the artist depicts herself serenely working while assuming a pose that echoes the corner space she occupies.

Figure 13–11 is an envisioned allegory. The main figure exhibits a ceremonial air due to its formal gestures that are suggestive of Buddhist statuary. This is in keeping with the drawing's ritualistic attitudes and its moral content. The theme of the work is self-destruction through substance abuse. The three X's and three spacemen on the protagonist's head allude to a narcotic "high". Alcoholism is signified by bottles on the table, and a series of clocks tick off this figure's remaining time on earth. The nonchalant display of the amputated hand refers to the obliviousness of this stupefied character to his lethal circumstance. Formally, note how the varied surface embellishments carrying the allegorical narrative have been economically organized into invented, abstract passages that consolidate contrasts of value, shape, scale, and density of incident. As in Figure 13–10, oppositions of form strengthen the subject narrative. Most dramatic is the clash between the large circular movement in the center of the picture (constructed of a series of arcs, including the arms and the half-moon shape of the clock) and the diagonal used as a bold counterforce in the back space of the drawing.

FIGURE 13–11
MICHAEL LUDWIG
Ham Bone
Pen and ink, 10 × 8"
Courtesy, the artist.
Instructor: Chuck Richards, Iowa State
University

Figure 13–12, a transformative family portrait, explores the private domain of interpersonal politics. Here the imagery expresses the hostility the artist felt toward unsavory relatives who overran the home of his adoptive parents. The grotesque, invented characters come off as either buffoons or mean-spirited humanoids; the clumsy manner in which these sinewy bodies are huddled precariously atop an absurdly small vehicle makes them objects of ridicule. The beautifully drawn surfaces and well-defined abstract composition (note the way in which the steering wheel is echoed in the conglomerate of limbs just behind it) may seem to advance content that is contradictory to the harsh emotional tone of the figures. Paradoxically, though, this quality of cool, visual elegance serves to accentuate the sense of dread that permeates the drawing.

Still Life

The still-life artist is perhaps the prime alchemist in the visual arts. Still life traditionally makes use of inanimate objects as its subject matter, and turning lifeless props into impressive imagery poses a distinct challenge. This is especially true in Figure 13–13 where what is drawn is so trifling that it stretches the convention of what is typically referred to as still life. In this project studio debris was swept into the center of the floor and students were asked to draw the "exploded" still life from vantage points along its edge. The relative anonymity of the subject matter freed the artist to explore the drawing process itself as a basis for personal expression. A close stitching of hatched lines establishes the flickering middle-gray tone that extends across the floor plane. (This gauzy film of marks serves as a

FIGURE 13–12
JAMES CONNORS
Family Tree
Charcoal and pencil
Courtesy, the artist.
Instructor: Constance McClure, Art Academy of Cincinnati

FIGURE 13–13
SUZANNE BENNETT
Untitled Still Life
Charcoal and pencil, 18 × 24"
Courtesy, the artist.
Instructor: Joseph Santore, The New York Studio School of Drawing, Painting, and Sculpture

material metaphor for the accumulated dust.) The slight shifts in line weight, focus, and value are responses to subtle changes in mass and atmospheric perspective. They may be equated with almost imperceptibly different gestural energies interpreted from the subject. The most freewheeling marks are the accents of erased dashes that break free of the otherwise tight tonal mesh. The perspectival grid that crisscrosses the tonal shape reinforces spatial illusion in this drawing. Key to this spatial system is the right angle in the foreground.

The objects in Figure 13–13 exhibit a marked uniformity due to our distance from them and their distribution across a large area. It is as if we were viewing a landfill from afar. In Figure 13–14 we find ourselves *in* the landfill, face-to-face with objects that have a magical presence. The drawing is based on different views of a still life created from objects found in a dumpster. Organized as a diptych, the image has a rupture at its center that threatens to pull the two halves apart. The conspicuous seam that divides the image horizontally reflects the

FIGURE 13–14
JUSTIN WHITE
Diptych
Charcoal on paper, 60 × 22"
Instructor: Susan Messer, University of Wisconsin at Whitewater

FIGURE 13–15
KEVIN WIMMER
Still Life with Fan
Instructors: Anthony Batchelor, Art Academy
of Cincinnati; and Ying Kit Chan, University
of Louisville

dislocation of time and space that defined the process of making the drawing. Looking more closely at this dividing line, note that we may infer a transition that has been frozen at a moment when the visibility of both images has been equally maintained. (This effect recalls a video *wipe* when, as one image replaces another, parts of each are revealed.) Observe further how some of the lines and shapes at the middle of the drawing stagger spatially to accommodate the break between image areas. This tenuous connection recalls the effect achieved in Exquisite Cadaver drawings.* An overall brooding mood, that suggests electricity in the air before a storm, serves to unite the drawing. From an expressive standpoint, the structural conflict in this drawing and its allusion to impending change are compatible with the artist's intent to communicate a wavering split in his own mind between a passion for art and the economic realities of a career.

Figure 13–15 is a good example of how form narrative can be used to charge the most conventional still life with new meaning. Created during a beginning

*A Surrealist collaborative drawing technique for conceiving unique form combinations. A sheet of paper is divided into sections, one for each artist. After the first artist has privately completed an image, the sheet is folded over to cover all but the trailing lines and tones of the drawing. The next artist sees only that trace information, which is used as connective tissue for his or her image, and so on. When the surface is covered, the sheet is unfolded to reveal the accumulated result.

drawing workshop, the image embodies key criteria of the assignment, including representation versus expressiveness, light and mood, and line versus shape (reflecting the Chinese concept of bone versus flesh to signify underlying structure). All of these considerations were to be interpreted according to the Eastern concept of *chi*, referring to the unity of energy in a work of art. With regard to levels of energy, the initial impact of the drawing is generated by the shock of its severe two-tone value system. (Note that the two-dimensional design of the drawing is anchored by the repetition of two ovoid shapes that essentially define the light areas of the image.)

The similar shapes of the elliptical table top and the circular fan blade, arranged on a diagonal, represent two major spatial planes in this drawing. Movement from the foreground back into illusory space is slowed, however, by a path that meanders through the series of figure–ground stackings, from the small sugar bowl in front to the farthermost vase of flowers, and back to the fan seen against the wall. Note the graphic economy and expressive variety of these overlapping sets of objects. The sugar bowl and teapot are built as large, slow, contrasty forms, linking them to the similarly conceived forward plane of the table. (Consider the rhyme between the teapot handle and the shadow of the sugar bowl; the right angle they make effectively carries the geometry of the backdrop into the curvilinear foreground.) The crisp lines rendering the flower vases establish a middle ground that possesses increased kinetic content; the tremulous energy of the rapid strokes in this area is curbed, however, by the bulk of optical gray their massed marks produce. Gestural energy unleashed is most keenly expressed in the blurred force lines of the spinning fan blade.

The still lifes in Figures 13–16, 13–17, and 13–18 mix keen observation with a conceptual twist. Jack-in-the-box surprise characterizes Figure 13–16. Excerpted from a series of open-drawer still lifes, this witty drawing is a prime demonstration that the content of a work of art is in the impressionable mind of

FIGURE 13–16
Tom Huang
Untitled Still Life
Pastel, 22 × 30"
Instructor: Janice M. Pittsley, Arizona State University

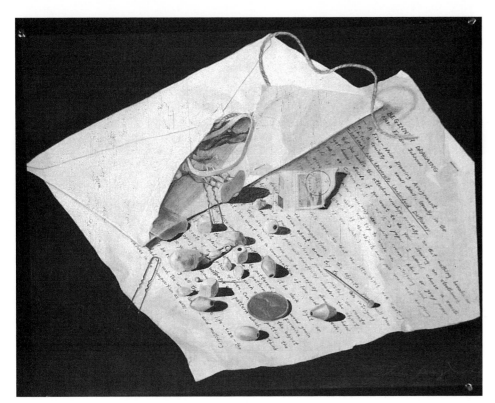

FIGURE 13–17
CHI-HSING LAI
Minutiae Project
Courtesy, the artist.
Instructor: Mary Frisbee Johnson,
Indiana State University

FIGURE 13–18
CHERYL LONG
Machine part
Charcoal, 40 × 40"
Courtesy, the artist.
Instructor: Stephen Fleming,
Kansas City Art Institute

the viewer. With a meticulous realism, the artist has constructed a brightly illuminated stage upon which our powers of imagination can transform the very ordinary into something irrational. Much of the success of this ploy is due to the formal cunning of the drawing. By cropping the image so tightly, the artist fills the format with architectural geometry, leaving little room for escape. Notice as well the bird's-eye vantage point and the tilt of the desk toward the picture plane. All of these compositional choices cause the viewer to feel like a passerby who is instantaneously startled by this undistinguished piece of furniture spilling its evocative contents.

For the "minutiae" project reproduced in Figure 13–17, the student was given an envelope that contained a heterogeneous group of small objects and a page of guidelines, which included the directive to "make a still life by spreading out the items in the envelope on any surface that you please." In an inspired move, the student chose to incorporate the torn envelope and sheet of instructions into the still life, using them as the ground for the miscellany of tiny objects. By constructing an image that explicitly refers back to the set of ideas that generated it, the artist closed the conceptual loop of the drawing and in so doing poised himself as a strategist playing a mind game with the viewer.

In Figure 13–18, multiple realities have been melded together to create an enchanting image while at the same time exposing the artificiality of its visual representation. Put another way, this drawing can be enjoyed as a careful rendering of a piece of hardware set majestically against an essentially empty ground in the manner of salon portraiture. It can also be interpreted as a pointed expression of a current philosophical premise that states that a drawing, like any visually encoded sign, is an imitation that is distanced from the substance of reality.

The conceptual backbone of the drawing is its set of layered spatial ambiguities. Observe, for example, that the dark ground stops short of filling the format along the lower edge and upper corners. This creates the impression that the entire charcoal field could be peeled from the surface like a skin, thereby underscoring that despite the convincing illusion of space, the drawing is flat. Furthermore, the two-toned ground suggests a mirrored surface, like a calm body of water reflecting a landscape image (the blurred and feathered common contour between the two value shapes hints at foliage and atmospheric perspective). Consistent with that impression, the fugitive appearance of this piece of hardware could be read as if it were underwater. The alienation of the constituent parts of this image recalls the effect of a photographic double exposure: things from different places having been brought into one visual moment, frustrating attempts to unify the experience. In that regard, the content of this still-life drawing is similar to that of Figure 13–14; both may be said to parallel the so-called postmodern condition that prevails in Western society today, which is characterized more by feelings of disjunction than of continuity.

Abstract and Nonobjective Imagery

Working from subject matter, artists may choose to veer from a highly descriptive representation to take advantage of latent abstract qualities of forms and spaces in their drawings. In Figure 13–19, for example, the forms of the figure and its environment have been simplified in favor of gestural patterns of spatial movement. Keep in mind that an *abstract* style of art still contains recognizable subject matter, regardless of how many steps the image may be removed from a naturalistic portrayal. A few of the ways in which artists achieve abstraction include:

1. juxtaposing repeated views of a subject, eventually combining aspects of them into new forms;

2. distorting, fragmenting, or reconfiguring familiar things;

FIGURE 13–19
RYAN EARL
Untitled Drawing
Charcoal and pastel, 23½ × 18"
Courtesy, the artist.
Instructor: Ophrah Shemesh, The New York Studio School of Drawing, Painting, and Sculpture

3. improvising on the visual properties of a subject to create variations on a theme;

4. simplifying and/or flattening imagery, sometimes also using graphically rich passages of pattern and texture;

5. displacing objects from their normal contexts;

6. cropping an image so severely that the identity of one or more of the objects is concealed;

7. uninhibitedly exploring media to recast the visual character of a subject.

For artists who wish to work *purely* with the visual elements, however, the manipulation of subject-matter resemblances, regardless of how far removed from objective appearances, is still too restrictive. These artists elect to work

nonobjectively so that they can freely create a pictorial reality that bears no likeness to the visible world. (This is true, of course, only in terms of physical appearances. The forms and spaces constructed by nonobjective artists always invite metaphorical interpretation because no artist can truly get outside of nature.)

Artists work abstractly or nonobjectively not only because they desire the liberty to invent a new vocabulary of forms; they are also attracted by the content potential of these styles. Although both genres are misunderstood and thought by the general public to be devoid of content, abstract and nonobjective styles actually furnish artists with important alternative means to powerfully express ideas and emotions. Abstract and nonobjective imagery offer a valid approach to representing, for example, systems distilled from observable phenomena, or psychic states and metaphysical concepts, or any immaterial subject that could not be communicated as effectively (if at all) in more traditional terms.

The process behind creating an abstraction from the physical world is evident in Figure 13–20, where the repetition of circular and linear motifs has produced a visual riot of bicycle forms. A metaphorical self-portrait, this drawing was the result of an assignment to draw an object with which the student-artist felt a close association. The image in this work may at first appear to be a confusion of fractured shapes and spaces. This is due in part to the sheer proliferation of bicycle components in the image. It is also due to the particular drawing attack, however, which, like jazzy rhythms, places accents where you least expect them. The kinetic momentum of the drawing is a consequence of this "plastic" approach, where observable data is treated as pliable material for the purpose of creating new form combinations.

Despite its noisy surface, after viewing this drawing for a short time you may see larger organizational motives emerge. Most fundamental among this work's design properties are the series of implied vertical and horizontal divisions of the image. These demarcations impose a classical, grid-like framework that unifies the surface of this complex drawing. The most prominent division occurs at about the vertical midpoint, where a husky, dark smudge indicates an extremely foreshortened tire suspended by the pincer-like shape of the bicycle's front fork.

FIGURE 13–20
HEATHER CONVEY
Bicycle Abstraction
Charcoal and pastel, 60 × 83½"
Courtesy, the artist.
Instructor: Billy Lee, University of North Carolina at Greensboro

FIGURE 13–21
MELANIE FOREMAN
Deconstructed box drawing
Charcoal, chalk/oil pastels, conté,
collage on cardboard box, 30 × 66"
Courtesy, the artist.
*Instructor: Allyson Comstock, Auburn
University*

Intersecting this main vertical is a large X, the most dynamic compositional agent in the drawing. Deployed spatially in big, diagonal sweeps, the ends of both axes of this gestural X configuration are capped by a tire, which in turn establishes four clear constellation points in the illusion. This slightly comic assemblage (compare it to the fanciful machines of Jean Tinguely, as in Figure 12–6) seems to possess powers of articulation; as such, it functions in this drawing as a stand-in for the human figure.

Figure 13–21 is an effective synthesis of abstract and literal content. Drawn on a flattened cardboard box, the image of an immense cubic volume in the center of the drawing recaptures the original three-dimensional shape of the format. Note in this regard the cutout section of the actual box, which performs several functions. First, it is a reminder of the physicality of the drawing's support and its former existence as a three-dimensional box. Second, it serves as an intermediate step between the drawing and the wall, integrating the field of imagery with its immediate, real environment. From the standpoint of illusion, observe the way in which the flat ground of the wall merges into the shape of the top plane of the large, depicted box, which is drawn convincingly in two-point perspective. The effectiveness of this transition may prompt a viewer to ask; Which is more real, the blank backdrop of the wall or the visually tactile surface of the box?

Yet another indication of the drawing's material existence is the blunt physicality of the mark marking. Taken together, the crude, somewhat ungainly literal features of the work undergird its thematic aims. Using abstracted figurative imagery, boiled down to graphic essentials, in conjunction with collaged photographs posted as actual artifacts, the drawing undertakes the horrors of war as its subject. Even the anonymous bunker-like cube, composed of a thick application of media, summons the crushing brutality and muteness of war camp atrocities.

Figures 13–22 and 13–23 are instructive in the way they bridge abstract and nonobjective modes. On one level, Figure 13–22 is about contrasts of space, from intimate layers to infinite perspective. On another level, the spotlit setting, populated by an inventory of mechanical characters, lends the drawing an unmistakably theatrical stamp. The objects, which do not readily refer to external subject matter, are derived from fragments of paraphernalia encountered by the artist in his daily routines (such as an espresso machine, vintage fan, cage, urinal). Having undergone various degrees of manipulation in the drawing process, these forms carry visual personalities that are split between abstraction and nonobjective fabrications of the mind.

In theatrical terms we, as viewers, seem to be positioned backstage. Suspended above is a teeming assortment of nondescript industrial-type parts,

FIGURE 13–22
MICHAEL EVERETT
Experimental Space 2
Acrylic, pastel, colored pencil,
and marker, 12 × 4½'
Courtesy, the artist.
Instructor: Denise Burge, University of Cincinnati

compacted into a claustrophobic canopy. Note that the bottom contour of this canopy is curved like the frame of a proscenium arch. In the lower half of the drawing the space opens up to a limitless vista. With more expanse to maneuver than their counterparts above, the mechanized constructions in the bottom portion of the drawing take on robotic, even figurative connotations. Maintaining the theatre metaphor, this section of the image recalls those story lines where inanimate objects come to life in the wee hours after humans have long vacated the premises. In this case the result is boisterous; the assembled forms cavort as if they were a troupe performing antic routines. In particular, notice the comedic flourish of the fanciful headliner in the lower left, a stick figure made of pipe fittings strutting like a vaudevillian trooper!

The amorphous environment in this drawing, and the mysterious forms that populate it, are more appropriate to the expression of an inner, psychological space than to content based on objective observation. And, indeed, the supernatural character of the image as a whole is congruent with the artist's imaginative flight from the immediate world of his everyday existence, in which he has been denied the privileges of a room of his own. Lacking a private space that he can personalize

FIGURE 13–23
CEDRIC MICHAEL COX
Anatomical Rhythms #2
30 × 34"
Courtesy, the artist.
Instructor: Wayne Enstice, University of Cincinnati

and retreat into from the hubbub of the world, the artist has created a new plastic reality that counteracts confinement with immeasurable spatial freedom.

More decisively nonobjective, Figure 13–23 is a portrait, but not the typical kind. Since the goal was portraiture from the inside out, the artist studied medical illustrations of internal organs as a preparatory step. Equipped with impressions from this source material, he improvised the biomorphic segment that dominates the right half of the drawing. This transformation of the original medical data resulted in a personal form vocabulary that eludes specific references. Instead, these forms act as analogs to an array of natural phenomena, such as an inexplicable assembly of soft tissue, cocoons and pupae in the midst of metamorphosis, and botanical hints, including vines and leafy parts.

The lone abstract symbol in the work is a guitar, signifying that the subject is a musician. The guitar's existence can be detected by the horizontal fingerboard that crosses the middle of the left half of the drawing to stabilize the turbulent forms on the right. Note the highlighted fret at the junction of the fingerboard and guitar body, which is but one accent along a vertical axis that separates the congested and open areas of the image. The round guitar hollow is the most conspicuous geometric figure in the work; it plays a transitional role between the nameable object of the musical instrument and the unidentifiable forms with which it is integrated. The curvilinear patterns on the left side of the drawing may be read as aural vibrations from the discharge of energy on the right. In fact, the linear design of the drawing as a whole can be interpreted as a meeting ground for the internal rhythms of the subject's character intermingled with the equally intangible qualities of the music he makes.

Figure 13–24, like Figure 13–21, is an outgrowth of the student's interaction with media. A nonobjective drawing with variations based on a motif, the recurrent geometric forms of this work are carefully arranged to control its visual narrative. The border on the left, stenciled repeatedly with the word art, appears to be pressed against the picture plane. By restating the vertical framing edge, this border anchors the surface depiction to the format and leads our eye, like a stairway step, into the drawing. Three brick-like shapes, also placed on a strict vertical, continue the path across the surface. The regulated movement, from left to right, is violently disrupted by the two overlapped rectangles that, tilted on different diagonal axes, torque the drawing's grid-based geometry and set its design energies in motion.

FIGURE 13–24
KIM HOLLAND
Motif variations
Graphite, charcoal and conté,
18 × 24"

Courtesy, the artist.
Instructor: Janice M. Pittsley, Arizona
State University

Spatially, the overlapped rectangles create the three-dimensional illusion of lifting up and out toward spectator space, as if they have spun free of the gravitational force of the drawing's ground. In that regard, notice how the darkened, haloed emphasis inside each brick enables these forms to act as visually stabilizing counterweights to the unpredictable tensions unleashed by the rotating squares.

The imagery of this drawing connotes a range of potential meanings even though it has no reference point in nature. For example, the transferred textures and geometric modules may be seen to carry allusions to architecture (dank, underground structures, like basements), to the hard, unyielding surfaces of sidewalks (with graffiti and grating), or to cartography (as if the stamped-out shapes represent a road map of landmarks and destinations).

14

Portfolio of Contemporary Drawings

At the opening of the twenty-first century, we may find contemporary art so bewildering in its variety that we are at a loss as to how to characterize it. In approaching contemporary art we may do well to first look at the relationship between Modernism and Postmodernism.

Modern art of the late nineteenth and first half of the twentieth century is generally considered to encompass numerous styles, ranging chronologically from Impressionism through Abstract Expressionism. Theories of modern art are based on a belief in the primacy of artistic form. For the modernist, form is the enduring reality in art, its material "truth" serves as a springboard for artistic innovation. Formal exploration in modernist terms is a highly specialized and "pure" practice, independent of the flux and flow of the mundane world. Thus, it should come as no surprise that subject matter and the use of narrative, both of which carry connotations of "impure" daily existence, were rejected by the modernists as literary rather than visual in their impact. The evolution of modernism bears this out, from abstract Cubism in the early twentieth century to nonobjective high formalism five decades later. Modernist art is frequently viewed as a celebration of technological progress and the transcendent faculties of the modern mind.

Modernist artists, desirous of taking part in an avant-garde movement, sought to produce work that was original, experimental, and formally innovative. Modernist artists put their faith in the authenticity of the art object, a quality derived from pursuing abstract principles that lie beneath superficial appearances and tapped underlying realities (such as myths that bind the collective consciousness). The modernist art object does not refer to a history outside itself; it is autonomous and frozen in the present tense of perceptual experience. Its very completeness encourages contemplation and admiration.

In the latter part of the twentieth century a new group of artists, the Postmodernists, repudiated Modernist avant-garde assumptions with regard to art's autonomy and originality. Postmodern artists sought to restore meaning in art by drawing from a large range of issues pertaining to contemporary experience, and their work often addressed topical subject matter and employed narrative themes. A return to the figure earmarks much Postmodern art, but not as a subject for naturalistic description. In Postmodern art the figurative image is often revealed as a social construct created and promoted by our media-driven society and as

such serves as a ground for a variety of social discourses that include issues of race, gender, and sexual orientation.

In contrast to the purity and self-referential definition of Modernist art, the Postmodern object is more eclectic and open-ended. The Postmodern object is generally presented as a text to be "read" and analyzed. It does not encourage detached contemplation from its viewers, but rather enlists them in a dialog to interrogate critical issues in contemporary society, including anti-imperialism, feminism, multiculturalism, and environmentalism. Many Postmodern artists work in time-based media, such as performance and video. Other Postmodernist forms, such as installation, land-art, public art, and forms based on the appropriation of pop culture seek to integrate art directly with the world at large.

While Postmodernism has significantly challenged Modernism, it has never entirely supplanted it. Important artists have continued to make recognizably Modernist works to the present day. In fact, by the mid-1990s, many artists, feeling frustrated by Postmodernism's conceptual approach, returned to more visceral and aesthetic ways of working, suggesting a renewed interest in Modernist values. But if what we are seeing in the art world today is a return to Modernism, it is a Modernism chastened by the content imperatives that define Postmodernism.

In this chapter we look at drawings produced in the aftermath of the clash between Modernism and Postmodernism. We have grouped the works according to subject matter or formal concerns. Since artworks are frequently complex and multilayered in meaning, you may find that many of the works could easily fit into more than one category.

Realism and Reality

Realism in various guises has been an important working method since art was first made (Fig. 0–1) and its potency as a major stylistic force continues today. In Renaissance art, fidelity to appearances was often used to underscore the idea that the perfection seen in nature is a reflection of divine truths not accessible to sensory experience (Fig. 8–5). In the mid-nineteenth century, realism took on distinctly political overtones. In place of the ideals and exoticism that enthralled artists of a more classical or romantic stripe, realists were engaged in depicting the gritty side of contemporary life, often with the intent of fomenting social change, as may be seen in the Daumier, Figure 8–27.

Contemporary realism is largely regarded as functioning outside the sphere of Modernism. In its primary concern with an investigation of the properties of the media of painting or sculpture per se, Modernist art generally eschews representation or narrative. Realist artists, however, do not necessarily practice a wholesale rejection of Modernist concerns, as may be demonstrated by looking at the drawing by Sidney Goodman in Figure 14–1. We see in this work an adherence to the Modernist injunction to respect the "integrity of the picture plane." (This is generally achieved by curtailing or contradicting spatial illusion so as to maintain consciousness of the flat nature of the drawing or painting support.) Note in this work the inventive relationship between figure and ground. The model, who is lying on her back, is depicted as if seen directly from above so that the surface on which she lies becomes identified with the surface of the drawing itself. The strongly illuminated upper portion of the figure appears to be modeled forward from this plane as if in high relief, while the lower part is indicated with broad strokes that float free of the ground. Both strategies make us particularly aware of the flattened space in which the artist is working and sensitizes us to the artist's literal activity of creating illusion through the application of charcoal to paper, thus paying homage to the Modernist demand for "truth to materials."

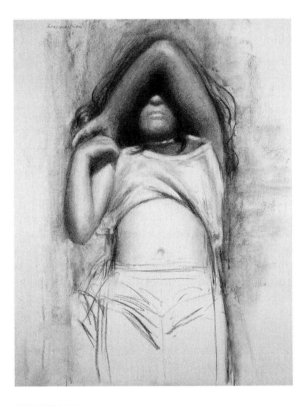

FIGURE 14–1
SIDNEY GOODMAN
Maia with Raised Arm, 2000
Charcoal on paper, 29 × 23"
Courtesy of ACA Galleries, New York

FIGURE 14–2
BILL VUKSANOVICH
Prizefighter II, 2000
Pencil on paper, 29¾ × 44"
Used by permission of the artist.
Courtesy of Forum Gallery, New York,
Los Angeles. All rights reserved

Note furthermore the degree to which Goodman unites realism with formal considerations. While the subject, the artist's young daughter, is one that could easily lend itself to sentimental or idealized depictions, Goodman has instead chosen to focus on the structural properties of his image. The formal climax of the work is the partially revealed face of the young girl, sheltered by the tower-like canopy of the bent left arm. Note how the two arms are visually welded together into an unusual mass that serves as a gravitational pull to move the eye through the drawing. Note also the hypnotic effect of the concentric triangles that frame and shade the face. These formal considerations, along with the animated strokes defining the left arm's outer contour, imbue this recumbent figure with a subtly insistent air of mystery and architectonic stability.

While the Goodman is a realist work with Modernist overtones, the Vuksanovich (Fig. 14–2) is a realist work with a Postmodern twist. Our first reaction to the work may be to marvel at the extraordinary control that the artist has over his medium as he shifts subtly among a very limited range of values. Unlike the Goodman, which is obviously a drawing, this work looks like a photograph, and once we have gotten over the fact that it is rendered in pencil, we tend to regard it as we would a fashionable salon portrait photograph of a model or celebrity. We try to *read* the face and body language for clues to the artist's attitude toward his subject. The stance of this professional pugilist is macho,

but not aggressive. Rather than confronting the viewer, he is turned sideways and looks out with an expression that seems at first glance to indicate grave personal suffering. But can we be sure that the facial expression does not also register distrust, or even veiled hatred? The somewhat unusual close-up viewing angle and use of cropping can cause viewers to be uncomfortably aware that they are looking so intently at the image. This awareness touches upon the Postmodern issue of the "privileged gaze," a concept that lends power to the viewer, who, by virtue of the gaze, exerts supremacy, even implied ownership, over another being. Our initial feeling of being in control as consumers of a glamorous image may ebb as we begin to doubt the propriety of our gaze. As we continue looking at the work, we find that instead of enjoying it purely on aesthetic grounds, we may start to ask questions relating to race and class exploitation in the sports and entertainment industry.

Mark Tansey is another artist whose work casts doubts on the trustworthiness of the visual image. Best known for his complex, multifigured compositions painted in monochrome, he often co-opts the look and authoritative presence of academic history paintings or ceremonial photographs. This appropriation of a style considered stuffy or sentimental by the Modernists identifies Tansey's work as Postmodern. The scene depicted in Figure 14–3 is presented as a vignette, a pictorial form developed in the nineteenth century for book illustrations and popularized later in periodicals. Vignetted illustrations typically offered visual fragments interpreted from a written text, furnishing intimate glimpses to entice the reader. In the Tansey work, however, we are provided a glimpse into a presumably complex reality without an accompanying explanatory text. The man in the scene appears to be lifting some great shards of material, but we don't know the nature of the material he is handling. We wonder whether the "finding" mentioned in the work's title refers to the discovery of what lies beneath these slabs or to the slabs themselves. (The ellipse as format may also bring to mind the word *elliptical*, which is a description of speech that omits words under the assumption that meaning can be derived from contextual clues; ironically, contextual clues are precisely what this drawing withholds.) What we can see is that our protagonist is too caught up in the act of puzzling out his own bit of reality to know that he himself is caught in a great bubble of representation. And where does that leave us,

FIGURE 14–3
MARK TANSEY
Finding, 2000
Graphite and oil gessoed paper,
9½ × 15"
Courtesy of Gagosian Gallery, New York

FIGURE 14–4
LUCIAN FREUD
Pluto Aged Twelve, 2000
Etching, 17⅛ × 23⅝" (plate)
Courtesy, Matthew Marks Gallery, New York

the viewers looking at this drawing? Are we too living our lives in a great bubble of which we are unaware? Who and what might be watching us as we search for our own answers?

The work by Freud (Fig. 14–4) might at first glance strike us as an example of a premodern sensibility because of its fidelity to natural appearances, especially in its exquisite rendering of tactile surfaces. The delicate hatching used to describe anatomical topography, as well as the slightly contorted gesture of the human hand, recall the emotive naturalism of Northern old masters like Grunewald (Fig. 7–25). Note the artist's empathy for the aged pet, evident in the palpable stiffness of legs and vertebrae, the sunken areas of the muzzle, and the dulled gaze. The nervous, brittle style of mark-making seems especially well suited to capturing the image of a thin dog trembling from old age, cold, or innate disposition. It is an image of genuine sentiment, one that engages fully in the physical reality of the animal. One aspect of the drawing that seems out of place in a work exhibiting such a degree of premodern sensibility is the hand edging into the picture space. This anti-classical innovation functions on a formal level to break up the shape of the ground. Furthermore, the hand's elongated shadow, in conjunction with the shadow that courses around much of the dog, emphasizes the flat shape of the image and its association with the format edge. These formal conceptions suggest the artist's awareness, if not full embrace, of Modernist concerns. At the same time, the hand intimates a contextual relationship between the pet and its largely unseen owner; contextual relationships of a social nature are typical of Postmodernist subject matter. So, we have in this dominantly premodern image hints of modern and postmodern attitudes, indicating perhaps a loosening of ideological strictures in recent art.

In the 1980s and early 1990s Rosemarie Trockel was celebrated both in her native Germany and in the United States for her installations of machine knitwear bearing logos of political movements and well-known corporations. Those works along with her videos dealt with typically Postmodern issues related to gender, mass production, and political and corporate power. The drawing pictured in Figure 14–5 is from an installation of drawings and videos titled *Manu's Spleen*. The fictitious protagonist of the videos, Manu, is a somewhat spoiled Teutonic beauty who is at times a lively prankster and at other times given to macabre symbolic acts. The drawing we show here may be interpreted as a contemporary character much given to mood swings. Note the tense quality in the stretched

FIGURE 14–5
ROSEMARIE TROCKEL
Opinion, 2001
Acrylic on paper, 12 × 9"
(30.5 × 22.8 cm)
Courtesy Barbara Gladstone

neck, the turn of the head, the slightly flared nostrils, and the all-too-level gaze. These taut features are provocative, suggesting states of mind that may range from a resolute determination to momentary ill temper or even chronic arrogance. Whatever emotional significance we attribute to this image, we are nonetheless compelled to acknowledge on some level the nuances of the subject's mental state. Imbuing this female portrait with the shadings of a real human encounter is reminiscent of a postmilitant feminism that posits without fanfare rich dimensions of character regardless of gender.

Expressionism

The realist artists we have just considered use fairly objective modes to explore the world around them. Other artists use more subjective means. In Expressionist art representation is strongly skewed by the artist's prevailing worldview. Today's Expressionist art seems to be of a subtler variety than that produced during the Neo-Expressionist wave of the 1980s. Neo-Expressionist imagery tended to feature large-scale heroes struggling against mythic forces. Application of media was wildly gestural in those works, and depicted forms were boldly generalized. The Expressionist work we see today, produced by artists not associated with a particular movement, is less monumental and more individualistic. Nevertheless, one major similarity between Neo-Expressionist work and current Expressionist trends is the use of narrative. Indeed, the three images discussed in this category employ implied moral narratives on themes such as war, gender, and environmentalism.

The etching by the British painter John Walker (Fig. 14–6) is from a long series of paintings and prints using the theme of World War I and his father's experience of it. The paintings from this series often include verses by two World War I poets, David Jones and Wilfred Owens. It is, in fact, a line from the latter poet,

FIGURE 14–6
JOHN WALKER
Passing Bells, 1998
18½ × 14¼"
Courtesy of the artist

noting the lack of bells to toll for those who die on the field of battle, that provides the title for the series of etchings and aquatints from which our illustration comes. A recurring image in the series is a figure with an oversized sheep's skull dressed in a military uniform, symbolizing the artist's father. The sheep skull imagery is rather complex; among its origins is the metaphor of soldiers being led to their deaths like sheep to the slaughter. This metaphor not only appeared in poetry of the era, but also was in the minds of the soldiers themselves who, at Verdun, demonstratively bleated like sheep as they were led to battle. Although this drawing is spare, it embodies a sense of pathos due largely to the off-kilter stance of the figure. This touching gesture suggests that the figure, as he walks, is compensating for severe injuries sustained in battle. Indeed, the soldier's empty right sleeve suggests an arm either lost or held in a sling, while his right leg is lifted in such a way as to suggest a crippling limp. In this context, the sheep's skull mask brings to mind the phrase "the walking dead" used to describe returning soldiers who were physically and psychologically maimed beyond recognition.

The ambiguous portrait by Judy Glanzman (Fig. 14–7) is more gently Expressionistic. The spatial dislocations in this large drawing may result from the artist's practice of working on the floor, often sitting on the paper and drawing separate parts at close range. Tracer-like lines appear to occasionally contact their target in this drawing; at other times they veer off on unrelated tangents. The touch is light, but there is agony too in the lines that mar the picture plane like scratches on a windshield and partially veil the figure. The woman's lopsided half-smile nearly qualifies as a grimace, but it is her eyes that elicit the strongest emotion. They are of uneven size, one squinting uncomfortably as if it has been stitched up and the other bulging and swollen. What misery and what wisdom lie behind these eyes? We may further question whether the mysterious woman is young or old and wonder why her body seems to be dematerializing. A few lines map out thin shoulders, wizened chest, and an impossibly small foot, seemingly dislocated from the rest of the body. How surprising in relation to this

FIGURE 14–7
JUDY GLANZMAN
Untitled, 2001
Graphite on paper, 120 × 55"
*Courtesy, Gracie Mansion Gallery,
New York*

disappearing act are the hands that gain in materiality by the accumulation of marks. Although the hands (apparently switched right-to-left) dangle rather passively, they are nonetheless menacing. Note their blade-like fingers and pincer-like gesture as well as the way in which they advance toward viewer space. Looking back and forth between the figure's remote face and her outstretched sharp clawed hands, we may conclude that we have fallen under the inscrutable gaze of some modern-day sphinx.

Dark gestural marks, rugged shapes, and a handwritten slogan in German deliver an immediate visual impact in Figure 14–8. Depictions of owls and mirrors bring with them a long history of associations. For over four thousand years, pictures of owls have been associated with female deities and witches, and have symbolized both death and preternatural wisdom. Mirrors traditionally are associated with vanity, both in the sense of personal pride and in reference to the fragility of all earthly beauty and riches. Nonetheless, the depiction of an owl that we see here apparently denies all the symbolic associations that we wish to bring to it. Instead, taking the slogan at face value, we grasp that the owl is simply hungry. The preconceptions we were more than willing to bring to our reading of the image are suddenly swept away in the realization that the owl doesn't care at all about its special place in human symbolic systems. Its only reality is to hunt or starve, and our only legitimate response is to empathize with the owl's plight.

The visual structure of the work reinforces this interpretation. Employing a layout that pushes the bird and its gnarled perch to the far right is tantamount to a comment on the marginality of this animal (dare we say the marginality of nature?) in western consciousness. Note the graphic strength of the negative area carved out by the contours of the positive image. As we read left to right across this powerful but empty ground, the vulnerability of the owl is intensified.

FIGURE 14–8
KIKI SMITH
I Have Hunger
Silkscreen and hand-painting on
antiqued mirror glass, 23 × 18¼"
*Courtesy Edition Schellmann, Munich,
New York*

Interestingly, as we process the political implications of this image, we may be reminded that we too are animals. And in turn, our realization that our bodies, which we primp and fetishize, are in fact flesh and blood returns us to the interwoven themes of vanity and mortality.

Expanded Format and Mixed Media

Traditionally, two-dimensional art invites the viewer to contemplate imagery in a fictive pictorial space. A conventional format, one that is small and rectangular, is admirably suited to this end. Its intimate scale invites the viewer to relinquish everyday reality and enter an invented world in miniature. The clear boundary of the picture frame separates the experience of pictorial contemplation from everyday life: The viewer looks through the rectangular shape as through a window or door into another realm of experience.

This tradition of framing continues in much of today's pictorial art, as can be seen by scanning the numerous contemporary drawings included in this and previous chapters of this book. But many other artists have deviated from this tradition. Employing unusual media and expanded formats, their goal has been to maximize the material existence of the art object and to minimize the viewer's escape from real time and actual space. Mural-sized drawings, such as Alison Norlen's (Fig. 14–9a), may draw us in by offering a wealth of detail, but in the end they do not strike us as framed experiences. This is because the scale of the work radically affects our perception of it. Instead of providing us a window (in a wall)

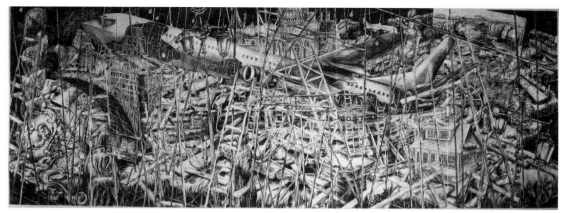

(a)

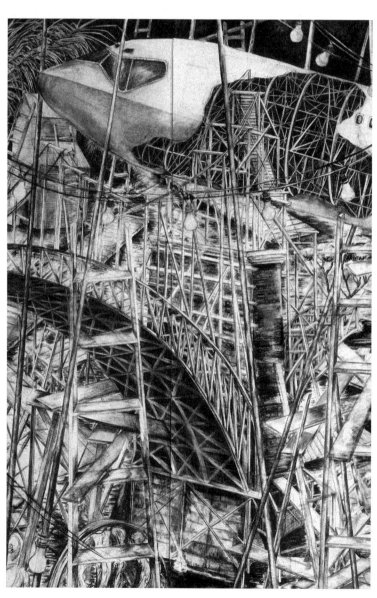

FIGURE 14–9
ALISON NORLEN
Parade II, 2001
Charcoal, 7 × 22'
Courtesy of the artist

(b)

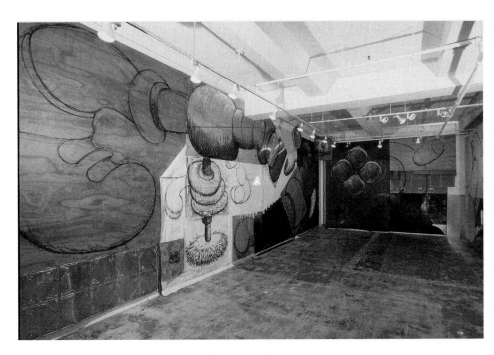

FIGURE 14–10
SANDY WINTERS
Fresh Cuts, 1998
Mixed media and found objects
11 × 55' (variable installation)
Courtesy of George Adams Gallery, New York

through which to observe a scene, the drawing reaffirms the wall on which it is placed, making us associate the drawing with its literal architectural context. Standing at a distance, we take in the whole image, which is one of epic complexity and layered congestion. (Note the simple but effective contrasts between line and mass, and the clear statement of foreground, middleground, and background planes, all of which prevent the drawing's teeming surface from collapsing into disorder.) The overall magnitude of the image hearkens back to the Modernists' use of large scale to inspire awe in spectators, thereby sensitizing them to the power of form. Approaching the work to poke around in its details (Fig. 14–9b), however, shifts our grasp of the work toward a Postmodern theatricality. The time it takes to investigate the drawing's surface implicates us as performers, contradicting the instantaneous "present tense" demanded by a Modernist object.

The installation drawing by Sandy Winters (Fig. 14–10) carries a similar Modern/Postmodern charge. In Winter's drawing, the relationship of the image to its architectural site is more pointed than in the Norlen. One reason for this stems from the extension of the work across two contiguous walls so that the pictorial image partially wraps around the viewer. Rather than sitting passively in a frame, the pictorial elements threaten to swallow the viewer, reversing the traditional role of viewer as consumer and artwork as the consumed. Moreover, because its imagery (including things that look like oversized power tools) and materials (aluminum and plywood) summon associations with the construction trade, the references to the physical space in which the work has been drawn are especially emphatic. The effect that all of these active images have on the viewer is not unlike that produced by theater in the round, in which the action of a play is assertively introduced into the space of the audience.

In an installation addressing the theme of a shipwreck (Fig. 14–11), Nicole Eisenman has assembled scraps of wood and other flotsam-like small objects to create a waveform. This baroque three-dimensional construction echoes the wavelike shape in the wall drawing immediately behind it and serves as a transition between actual viewer space and the illusory space of the drawing. The drawing is melodramatic in its presentation of masts snapping in multiple places, sails whipping about, and the rising ocean swell. Amidst all this tempest is a smaller rectangular composition, tilted off vertical, showing a scene presumably

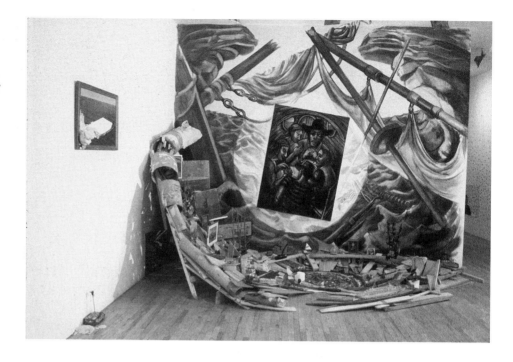

in the hold of the buffeted ship. The cast of characters depicted, including pirates and a tonsured monk, is engaged in some intimate activity, which we might assume to be of a clandestine, sinister, or perhaps simply hedonist nature. The narrative relation of this little scene within the context is ambiguous. Has their revelry distracted them from doing what is necessary to save the ship, or is the storm a manifestation of divine wrath meted out in recompense for sin committed? Whatever the relation of the brigands in the hold to the scene of the ship breaking up around them, we can recognize that the artist's intent is hilariously satirical, as she offers us an entertaining version of poetic justice and the thrill of a great carnival ride.

Narrative

As indicated in the introduction, narrative art has made a comeback in recent years. Throughout the period of early twentieth-century Modernism, when formalist artists were regarding narrative as extraneous to their work, radio, movies, and eventually television were delivering greater and greater doses of it to an eager mass audience. Today, narrative in the visual arts abounds in forms so various that we might, for convenience, organize them into two categories. Grand narratives deal with important contemporary issues that may include morality, politics, ecological and social viability, and various types of cosmology. Lesser narratives include more intimate biographical information, private fantasies, and issues of personal identity.

Sandow Birk recasts the old genre of history painting into puzzling little drawings, framed like book illustrations. Despite their modest size, the works all refer to cataclysmic events located, presumably, some time in the very near future. The scale of the events, mostly war-related, is huge and the results deeply tragic. The manner in which these stories are told is pointedly anachronistic. In Figure 14–12, for example, a group of very contemporary young men gather around their fallen comrade, while the slain figures in the foreground have clearly been fighting with weapons of a bygone era. The image is generally classical in composition, recalling grand narra-

FIGURE 14–12
SANDOW BIRK
The Collapse of the Master Gardner,
1998
Ink and white pencil on paper,
17 × 14"
Courtesy Koplin Gallery, Los Angeles

FIGURE 14–13
HEIDE FASNACHT
Hotel Demolition, 2000
Colored pencil on paper,
60 × 40"
*Private collection, New Jersey. Courtesy Bill
Maynes Gallery, New York*

tive painting of the Baroque and Romantic periods; its mood and subject is reminiscent of Goya's troubling satires pertaining to the horrors of war.

Heide Fasnacht is an artist who has been exploring, through the media of sculpture and drawing, narratives attached to various types of explosive events that occur too quickly to be taken in by unaided vision. The events she depicts range in scale from the sneeze to the dynamiting of buildings, as depicted in Figure 14–13. In this image of a structure's instantaneous demolition, we are impressed by the journal-like personal involvement the drawing elicits versus the depersonalized attitude that would characterize a photograph of the same event. Note the contrast of violence and calm in this drawing. While the building tumbles from the blast, an orderly lineup of stolid sewer pipes appears in the lower region of the drawing, and streetlights nod like delicate flowers by the full light of day.

The drawings and paintings of Rita Ackermann depict a private fantasy realm, rife with problems from the contemporary pop music scene in which the artist also participates as a singer. In this small notebook-sized drawing (Fig. 14–14) we see one of Ackermann's depictions of a landscape inhabited by a sisterhood of waifs. According to the artist, these nymphets support each other through tribulations, which include habitual abuse by men and their own recreational drug use. In this dreamlike scene, one child-woman riding a huge doglike creature assists another to emerge from a trapdoor in the slime. Others recline half conscious in some drug-induced haze, while a lascivious satyr escapes from the feminine domain by climbing an impossibly steep hill. The themes of dream

FIGURE 14–14
RITA ACKERMANN
Purple Lady, 2000
Pencil on paper, 9½ × 7¾"
*Courtesy Andrea Rosen Gallery, New York
and Sadie Coles HQ, Ltd., London*

states and the femme fatale are strongly reminiscent of Art Nouveau, as is the decorative use of line and motif. Perhaps the artist, a native of Czechoslovakia but living now in the fast-paced New York world of clubs and art galleries, finds moorings in this late nineteenth-century style, which flourished in her native land one hundred years ago.

The mixed media drawing by James Barsness (Fig. 14–15) ingeniously blends pop imagery with lore and philosophy about the elephant-headed Hindu god Ganesha. Among the most popular of all Hindu deities, Ganesha is regarded as the remover of obstacles. He is known also as Ganapati, which translates literally as "Lord of Categories." According to Hindu thought, all that can be conceived of by human thought is a category, and Ganesha is the embodiment of the principle by which the connection between all things (all categories) can be comprehended. Ganesha is often depicted riding a mouse (note the saddled mouse in the lower right-hand corner), symbolizing the unity of the great and the small, the microcosm and the macrocosm. In the Barsness drawing we see that Ganesha, the god who chooses to walk the earth in service of humankind, has joined forces with Superman, the Incredible Hulk, and some dubious-looking mustachioed Edwardian type dressed in tails, striped tights, and high-heeled shoes. This unlikely group of heroes appears to be rushing to the rescue as faces from the popular press gaze out at us. While comic book superheroes generally rescue the innocent from physical dangers, Ganesha saves his devotees by helping them to sort out their real spiritual needs from their illusory secular desires.

FIGURE 14–15
JAMES BARSNESS
King of Categories, 2001
Acrylic, ink, collage and paper on
canvas, 75 × 96¾"
Courtesy of George Adams Gallery, New York

FIGURE 14–16
MARCEL DZAMA
Untitled, 2000
Ink and watercolor on paper,
14 × 11"
Courtesy David Zwirner Gallery, New York

 Marcel Dzama specializes in perplexing, small narrative drawings that de-
pict a world in which crime and innocence inexplicably coexist. It is a world in
which stuffed animals and old-fashioned storybook characters come to life and
try out new adventures. Dzama's drawings deliver narrative fragments that tease
us to provide our own explanation. In Figure 14–16 we witness two modish fe-
males, dressed in 1920s costume, studying a hanged male with a large brutish
head. As with most of Dzama's images, there seems to be a clash between the
forces of good and evil, but with so much of the narrative missing it is impossible
to sort out the good guys from the bad guys. Are the women the fragile victims of
the monster who has been justly executed? Or are these ladylike creatures the true

monsters who, having framed an innocent man, now ponder their handiwork in cold blood? Notice that although the subject is one that is gruesome in the extreme, the innocent storybook style of the drawing prevents us from experiencing feelings of horror or disgust. The perplexing amorality proposed here, combined with an incomplete story line, creates for us a sense of unreality and paranoia, even as the light style and winsome cast of characters delight us.

Pop Culture and Glamour

The genre of Pop art catered particularly well to the Postmodern goal of bringing serious or critical art to a broader audience. Using imagery to which millions of people could relate, Pop art drew an entirely new audience into art museums and galleries. The fact that Pop imagery persists in contemporary art is a testament not only to its accessibility but also to its longstanding relevance to contemporary culture. Pop art, which acknowledges and comments upon consumer habits, taste, and popular opinion, may be legitimately regarded as a branch of contemporary realism.

Raymond Pettibon's art frequently employs irony in juxtaposing popular sentiment with popular imagery. In Figure 14–17 we see the doubly captioned image of a great ocean swell about to engulf a little figure in swim-trunks. Given the context, we may assume that he is a surfer, but closer inspection reveals that this unathletic person is not actually on a surfboard, nor does he bend his body in anticipation of the oncoming wall of water. Reading the captions, which we presume to be the thoughts of our would-be surfer, we wonder about the relation between the beautiful ocean wave, the ivory tower to which the little man aspires, and the sea of excrement he complains of. There is something boastful and outrageously egotistical in the surfer's complaint; he lays claim to high ideals but attributes his failure in attaining them to unfair treatment by life rather than to his own weakness. He speaks in cliches about purity and defilement, oblivious to the

FIGURE 14–17
RAYMOND PETTIBON
No Title (I Have Always), 1999
Pen and ink on paper, 8½ × 10¾"
Courtesy Regen Projects, Los Angeles and David Zwirner Gallery, New York

FIGURE 14–18
PETER SAUL
Why is Cubism a Good Style?, 1997
Pastel, acrylic on paper, 23 × 29"
*Courtesy of George Adams Gallery, New York.
Collection of Nancy and Joel Portnoy,
New York*

revitalizing power of the ocean around him. His jaded voice of ironic self-pity and his trite expression of mock chagrin mask his real pain.

The painter Peter Saul has worked for years in a bold, cartoon-like fashion, often with content that addresses important political issues. In this more light-hearted drawing (Fig. 14–18) we see a couple of caricatured heads talking in a self-congratulatory way about Cubism and the politics of style. The spoof is taken to hilarious lengths, for not only are their heads made up of cubic volumes, their speech comes in cubist bubbles, and even their dandruff falls off in little cubes. The heads are also voracious, as the one on the left seems to be moronically devouring part of his own body, spewing forth cubist crumbs in the process. Although the Pop character of this image is playful, the underlying content is serious. Through visual satire, we are urged to confront the arrogance of letting style substitute for substance and are made to see the limitations of certain types of conviction.

Also using cartoon-like imagery, Nancy Chun depicts a frighteningly ordered and smug little world that appears to be routinely serviced by space aliens (Fig. 14–19). On the left (the side traditionally associated with Hell in Last Judgment depictions) we see a spaceship beaming searchlights down on an urban entertainment district. Space aliens, presumably in the employ of Nike (note the swoosh logo emblazoned on the spaceship), bear covered stretchers to their interplanetary craft. They seem to be transporting mass-media stars across the Milky Way to an entertainers' Heaven. In the picture's upper region, a jury of twelve, including stone-faced humans and fantastic space aliens, sits in judgment. The gates of Heaven, surmounted by more Nike logos, open onto a rather grim-looking place that won't admit communists. In fact, Heaven does not seem to be accepting souls, because another large space alien is sending people attached to umbilical cords back to a suburban California-type Eden. Meanwhile, the purgatory of the great American desert is hopping with space launches by both humans and aliens. All this activity is spurred on by the Nike slogan "Just do it!" shining from

FIGURE 14–19
NANCY CHUN
Heaven's Gate, 1998
Ink and pastel on newsprint
(3 pages of *The New York Times:*
March 28, 1997), 64½ × 41¼"
*Courtesy Ronald Feldman Fine Arts,
New York*

the stars. There is something arrestingly normal about this scene; although the narrative is humorous, we can almost accept the absurdity of it. Mergers and conspiracies happen all the time unbeknownst to us, and such a relationship between space aliens and the manufacturer of shoes for superstars, though hyperbolic, does have a certain poetic logic.

John Currin uses style to comment on issues of desire. The stylized work we see in Figure 14–20 is ambiguous in its presentation of glamour and sexual allure. We may recognize first a contemporary beachwear style, accessorized to the max with turban, Blueblocker sunglasses, gauzy imported blouse, and nifty little

FIGURE 14–20
JOHN CURRIN
Blueblockers, 2000
Gouache on paper, 14 × 11"
*Photo: Andy Keate. Courtesy Andrea Rosen
Gallery, New York and Sadie Coles HQ, Ltd.,
London*

bikini bottom. A second unifying style has its roots in the mannerism of several art historical periods. The vapid facial expression and extreme proportions of this aging "beach babe" (note the tiny head and neck and general attenuation of limbs) are common to both contemporary popular cartoons and the art of the Mannerist period. The figure's hesitant *contrapposto* and demure but flirtatious handling of the veil, along with the light on dark sketching technique, all refer to the art of the Northern Renaissance. Combining both styles seamlessly is a tour de force, but Currin goes one step further. Clearly possessing the ability to make an alluring and stylish image, he undermines its glamorous nature with quirky details, including the too-small head, the scrawny neck, weak limbs, and best of all, the slovenly socks.

Social and Political Themes

Dissatisfaction with social or political conditions, a recurrent theme in Western art since the late eighteenth century, is still a motivating force in art today. Much of this work is intended to protest specific injustices, and a growing number of political artists urge viewers to get involved. Still other artists are able to use the production of the art itself as an agent of actual social, political, or environmental change.

The art of Sue Coe, which has addressed issues including apartheid, rape, racism, and animal cruelty, is particularly effective in its consciousness-raising capacity because it has both popular and critical appeal. In Figure 14–21 we are made witness to a horrendous scene of canine annihilation. Notice the irony in the drawing's title; we can be sure that these death row dogs have done nothing to merit the capital punishment meted out to them. Particularly bitter is the sign on the death chamber's wall cautioning employees to wear ear protection so that the dogs' shrieks and yelps of fear and pain will not damage their hearing. The clinical scene in the background is strongly contrasted by the huge mound of disposed

FIGURE 14–21
SUE COE
Death Row Dogs, 1998
Graphite, gouache, and watercolor on white Strathmore Bristol board, 29 × 23"

Copyright © 1998 Sue Coe. Courtesy Galerie St. Etienne, New York

FIGURE 14–22
WILLIAM KENTRIDGE
Landscape
Charcoal and pastel on paper,
47¼ × 59"
From the 1994 animated film Felix in Exile.
Courtesy, Marion Goodman Gallery,
New York

dog bodies in the foreground. Some of the cadavers are skin and bones, suggesting a life of abuse and neglect. Other corpses are of plump-looking pups who may have been stolen from loving homes to be sold to medical laboratories for live experimentation. Although the work is small in scale, it is technically ambitious in the sheer number of figures it portrays. And in its grandiloquent expression of misery, the work is baroque. A measure of this popular artist's sincere dedication to her cause is borne out by the fact that she donates a large percentage of her profit to animal rights groups, retaining only enough money to support a modest lifestyle.

The brooding landscape seen in Figure 14–22, is actually a still from an animated film, *Felix in Exile,* by South African artist William Kentridge. The artist creates his films by photographing the incremental changes that occur during the process of making a group of as many as two dozen drawings. The ghosting of previous stages of a drawing imbue each successive image with the memory of previous action. The physical traces left by erasure are significant to Kentridge, whose stated intent is to preserve the memory of the South African apartheid system and its slow unraveling.

For this artist, landscape is an important and complex narrative element, for under apartheid both the land and its people were colonized and exploited. In his films the land plays the roles of victim, participant, and witness to the apartheid system. The landscape outside Johannesburg, as shown in the still we have reproduced, is portrayed as deeply scarred by tire tracks, remnants of ugly civil engineering and mine tailings. Throughout this film the landscape absorbs history as the corpses of apartheid's victims melt into it while in the distance, a great shape, half cloud, half rock, continues to loom on the horizon. This spectral image of "the immovable rock of apartheid," though oppressive, invites conquest, transforming this symbol of longstanding collective shame into a symbol of hope.

Whereas Coe and Kentridge employ a rugged Expressionist style as a vehicle for their subjective responses to social or political conditions, Lordy Rodriguez uses a cool and more conceptual working method in realizing his long-range project of reconfiguring the map of the United States. When completed, his map will feature five new states, including those of Disney, Hollywood, Internet, Monopoly, and Territory (representing a union of The Philippines, Puerto Rico, and Samoa). The total of fifty-five states corresponds to the national speed limit at the

FIGURE 14–23
LORDY RODRIGUEZ
New York, 2000
Ink on paper, 31 × 24"
*Courtesy Clementine Gallery, New York, and
Finesilver Gallery, Texas*

time the project started. This is a correspondence that may at first blush seem
arbitrary, but in fact points to the artist's recollection of numerous cross-country
trips to visit relatives. Superficially resembling official cartography, these maps
show surprising and often hilarious emendations. In Figure 14–23, for example,
New York State has become a vertically oriented landmass situated between Lake
Huron and Puget Sound. On the east coast, Chicago appears to have replaced
New York City as the state's capital, and Jersey City ranks among its West Coast
settlements. Looking at this map we may be highly amused that the Big Apple,
the heart of our nation's culture and commerce, is missing (though Pear City can
be found on the state's upper east coast). On a more serious level, however, the
prospect of waking up one morning to an America reconfigured according to
Rodriguez would be confounding. Imagine, for instance, the cultural, political,
and economic implications of such a reordering, and the effect it would have on
personal identity, trade, tourism, and the electoral system.

 Art as political or social comment is one route for an artist to pursue. Art as
actual political action is another, and this form of activist art frequently demands
the collaboration of the artist with the artwork's intended audience. Tim Rollins, a
New York-based artist, for years has collaborated with Puerto Rican youth in a
collective called Kids of Survival (K.O.S.). Although Rollins and K.O.S. are profes-
sional artists fully engaged in a for-profit business, Rollins uses art to lure stu-
dents into pursuing a well-rounded education. He has discovered that getting the
young artists to draw directly on book pages is one way of encouraging them to
examine not only the content of the text, but also its historical context.

FIGURE 14–24
TIM ROLLINS + K.O.S.
*Adventures of Huckleberry Finn
(after Mark Twain)*, 2000
Black gesso, bookpages on muslin,
108 × 156"
Courtesy Baumgartner Gallery LLC

The K.O.S.'s handsome work we see in Figure 14–24, at a size of 9 by 13 feet, is a greatly scaled-up version of an E. W. Kemble illustration from the first edition of *Adventures of Huckleberry Finn*. Take note of the wonderful control of value in this work. Massed and hatched line is used to describe the recession of the water's surface, the dimly perceived stand of background trees, the texture of the rough wooden oar, and the chiaroscuro and local value in the figure of Jim, Huck's runaway slave companion. Such use of line recalls the rapid flurry of marks made by the illustrator's pen. Translated onto a large scale and executed in the more cumbersome medium of pigmented gesso, the work becomes monumental, thereby magnifying the darker and more serious dimensions of Mark Twain's satire. The teenage artists have read past the lighthearted manner in which Huck recounts discovering Jim who had fallen asleep believing that Huck had drowned the previous night. This large drawing downplays the comedic aspect of the story, focusing instead on Jim's profound exhaustion and his despair as he contemplates his probable capture as a fugitive and all the tragic consequences to follow.

Ethnic Identities

At the beginning of the twenty-first century, formerly colonized peoples world-wide are struggling for national or cultural identity. In the Western world, that trend also pertains to a search for identity by those who have relocated, either as willing immigrants or by forced dislocation, from their native lands. Artists from former colonies as well as artists living as long-time ethnic minorities often find themselves having to choose between different traditions. They must decide whether their work will be more authentic if they work within the dominant European-based tradition in which they have been schooled or within an indigenous artistic tradition of which they may have little direct knowledge.

Since the early 1990s, Whitfield Lovell has used drawing within the context of installations to address aspects of African-American history. The image in Figure 14–25 depicts a young couple drawn in charcoal directly on the rough plank wall of a one-room cabin. This work memorializes an African-American

FIGURE 14–25
WHITFIELD LOVELL
Whispers From the Walls, 1999
Interior installation view
Photo: Steve Dennie/University of North Texas, Denton. Courtesy DC Moore Gallery, NYC

community that was forcibly removed because local white residents believed it to be inappropriately close to a college for white women. In reconstructing a cabin typical of that dislocated community, Lovell is staking a claim on literal place as well as a place in history. Note that the couple in our illustration is drawn as if their feet were located underneath the floorboards, imparting an archaeological quality to the image. We perceive this dignified young couple as resolutely rooted to their historic home; houses may come and go, but memory and historic fact can be kept alive.

The Sikander work we see in Figure 14–26, made five years after the artist arrived in the United States, introduces multicultural layers to the venerable art of miniature painting. Observe how a painterly, abstract attack is combined freely with passages that are rendered more traditionally. Although the traditional style is used to depict narrative elements in clear and crisp fashion, there is much in this image that is suggested or hidden. Note the female protagonist, who is partially obscured by a symbolically shredded veil; the head of the horse, which is unexpectedly turned away from the picture plane; and also how the rider's male consort is so lightly drawn that he may initially escape your notice. The shredded veil, a common motif in Sikander's work, references the Western cliche of the veiled Moslem woman. In this image the veil, considered by the West as an instrument of subjugation, has extended over and beyond the back of the horse like a ceremonial train that amplifies the woman's status. Other, almost inexplicable images include the ornamented figuration in the upper left corner, like an abstraction of a divine manifestation; the more recognizable male angel and hybrid devil in the lower right; and the two other veiled figures, perhaps referring to lesser wives, slung like saddlebags over the horse's rump. These images seem to flirt with the aesthetic concept of Orientalism, a Romantic trend that portrayed the Oriental woman as mysterious, titillating, submissive, and yet possibly dangerous. Sikander revises this constructed view and suggests that the Oriental woman has power and status that cannot be understood by Western cultures.

Themes in the work of Enrique Chagoya often relate to the ideas of conquest and immigration. In the piece illustrated (Fig. 14–27), drawn in the naive style of a sixteenth or seventeenth century Spanish chronicler, we see a tropical island under attack by modern battleships. The references to cannibalism in this work recall the massive and brutal subjugation of indigenous peoples by the

FIGURE 14–26
SHAHZIA SIKANDER
Whose Veiled Anyway?, 1997
Vegetable pigment, dry pigment,
watercolor and tea water on paper,
11¼ × 8⅛"

Whitney Museum of American Art,
New York: Purchase, with funds from the
Drawing Committee 97.83.1

FIGURE 14–27
ENRIQUE CHAGOYA
Crossing II, 1994
Acrylic and oil on paper,
48 × 72"

Courtesy of George Adams Gallery, New York.
Collection of Jack Kubiliun

Spanish under the pretext of civilizing them and saving their souls. Chagoya's interest in the fact that it is those who win wars who end up writing the history of the conquest helps explain his appropriation of the Spanish chronicler's style of illustration. On the right side of the drawing, the seemingly anachronistic image of an invasion by comic-book gun ships updates the story. Note that both ships bears the letters U.N. This suggests that the well-intentioned intervention

of international peacekeeping forces may result in another rewriting of history as a more global-type culture is brought to this exotic island. Like many immigrant artists, Chagoya draws energy from the opposing cultural values he lives with, and glories in producing wildly hybrid images that even he cannot fully explain.

Art and Technology

The art world, like our culture as a whole, has for a long time had a love/hate relationship with technology. The general sentiment is that technology separates us from direct contact with nature and the verifiable truths of physical reality. Since traditionally the visual arts recreate the physical world by accentuating tactile experience, most artists have been reluctant to give up the sheer sensuality of conventional art media (e.g., drawing, painting, sculpture) for the more disembodied forms of electronic media. A growing number of artists, however, now regard technology as an exciting tool by which to accomplish their artistic ends.

The lack of fixed physical form makes electronic media ideal for Postmodern explorations. Postmodern theorists have questioned the aura of uniqueness we sense in a fine work of art, that very quality which confers status and value on an exceptional art object. They speculate that specialized cultural conventions govern not only the way we respond to art, but also our tendency to assign power to the static art masterpiece (the power is not actually inherent in the object, but a figment of our imaginations). Digital art, by contrast, is especially open-ended or provisional in its form; it can always be easily edited or transformed altogether. Digital technology, aided by the Internet, has also made collaborative and interactive art possible on an unprecedented scale, thus answering the Postmodernist call for a more democratic approach to art making. This inevitably challenges traditional notions regarding authorship and ownership of an image.

Nam June Paik has long been hailed as a pioneer of technologically produced art. In his video work, Paik transformed a medium associated with mass entertainment and marketing into an interactive art experience. His video works are alternately critical, meditative, and delightfully entertaining. It is also worth noting that Paik took a medium formerly regarded as the domain of television networks and delivered it into the hands of thousands of video artists. He proclaimed that the dissemination of video art would promote the coming of a "global village." A recent Paik work, *Three Elements* (Fig. 14–28), is a laser installation conceived for the Guggenheim Museum. It is comprised of three self-contained laser and mirror constructions based on the simple geometric shapes of circle, triangle, and square. The triangular piece we show here recalls the religious architecture of various cultures. Its shape, minimalism, and razor-sharp lines are reminiscent of Egyptian temples, while the tall, central, light-filled space flanked by two smaller side aisles bring to mind a Christian basilica.

Within the work's triangular mirrored chamber, we perceive a space of seemingly infinite depth. Mesmerizing as the illusion is, however, we cannot hold onto it for long. This is because the image changes as motors redirect the lasers and also because we are aware of the apparatus used to create the illusion, since no attempt has been made to conceal it. Thus, our tendency to be hypnotized by the pleasing illusion is thwarted by our awareness that this artful deception is created literally of smoke and mirrors. In theatrically revealing the nature of his artifice, Paik makes us self-conscious collaborators who have to participate with the piece in real time. The nature of audience involvement compromises aesthetic distance and thus dispels the autonomy of the art object so prized in Modernism.

The computer drawings from Jon Haddock's *Isometric Screenshots* series are based on well-known media photographs of events such as Vietnamese children fleeing a napalm attack, the self-immolation of a Buddhist monk, and in the case

FIGURE 14–28
NAM JUNE PAIK
Three Elements, 1997–2000
Lasers, mirrored chambers,
prisms, motors, and smoke;
Triangle, 128 × 148 × 48"

*Collection of the artist. Photograph by David
Heald. © The Solomon R. Guggenheim
Foundation, New York*

FIGURE 14–29
JON HADDOCK
The Lorraine Motel, 2000
*Courtesy Howard House, Seattle &
www.whitelead.com*

of Figure 14–29, the assassination of Dr. Martin Luther King. Using Adobe Photo-
shop to manipulate the image, the artist removes all nonessential figures, details,
and textures, leaving us with an image that, although still recognizable, is much
pared down from the original. By removing the crowd present in the original
photograph, the artist makes the viewer a private witness to what was historically
a tragic event that profoundly affected an entire nation. Nevertheless, what is

FIGURE 14–30
SALLY ELESBY
Page Eleven, from artist's book
Hand to Mouse Line Drawings, 2000
Computer drawing, ¾ × ¾"
Courtesy the artist and Suzanne Vielmetter
Los Angeles Projects

more shocking is that the elimination of details and textures yields an image that bears a striking resemblance to the style of animation seen on video games. Haddock's photo manipulation recasts an event with monumental public ramifications into a private and self-indulgent form of entertainment. By purposefully trivializing a momentous episode in American history, the artist in effect criticizes video-game culture, which typically gratifies its audience's craving for gratuitous violence.

The tiny work we see in Figure 14–30 is one of sixteen drawings comprising an artist's book. In producing these works on a computer, artist Sally Elesby started with the word *line* in various fonts and then used the computer mouse to hand draw on top of the letters. In her introduction to the book the artist describes her fascination with the contradictions inherent to the process used to make the images. Initially, they are drawn freehand, but after interpretation by the computer, they fail to exhibit many characteristics that render a traditional drawing subjective. Missing from these drawings, for example, is the variation in line weight that results from the change of pressure of the artist's hand. Likewise, the sense of a drawing as a layering of marks does not pertain here, for each new mark added to the image simply replaces previous ones, resulting in a drawing that exhibits no physical evidence of its history. The artist does not regard the lack of her drawings' tactility as a loss but rather as an outcome of a curious process in which the mediating forces of mouse and computer objectify her subjective doodling. And, indeed, the jittery little images she produces in her book have a whimsical but alien quality, as if they are endowed with life but inhabit another, less physical plane.

Drawing from sources as diverse as Durer woodcuts and Japanese animation, Carl Fudge uses the computer to radically transform appropriated material for his silk-screened enamel works. The seemingly abstract pattern of marks in Figure 14–31 is actually the result of a thorough reworking of an image of Chibi Moon, a Japanese animation character capable of changing form. If you look carefully, you can barely make out among the latticework of pattern a round face

FIGURE 14–31
CARL FUDGE
Rhapsody Spray 1
52½ × 62½"

*Courtesy Ronald Feldman Fine Arts,
New York. Photo: John Lamka*

with large eyes and small nose and mouth. The endless shifts and variation in pattern appear to be the result of mathematical functions such as multiplication, division, repetition, stretching, and compressing. In fact, the work challenges our aesthetic expectations by offering us a huge vocabulary of marks unlike any that we normally associate with drawing. Fascinating in their hectic evocation of mathematical permutations, these patterned marks do not embody a visceral response to a world of space and form, nor have they the refined character we associate with decorative art; they are, in fact, neither expressive nor decorative. Despite the neutralization of the mark as a carrier of content, aesthetic decisions abound in this work. Especially noteworthy in this regard are the extraordinary risks the artist takes with the concept of balance, the jostling movement across the picture plane, and the delightful syncopation within various clusters of pattern.

Although handmade, the drawing by Ewan Gibbs (Fig. 14–32) seemingly aspires to the look of technology. His photographically derived works at first glance appear to be little more than low-resolution computer images. A closer look reveals that each "pixel" is actually a hand-drawn X or O, and that the value of each mark is achieved through carefully controlled line weight. Looking at the work, we become aware of the tedium and concentration involved in making such a drawing. If we associate this time-consuming task with a protracted meditation, such as a prayer over rosary beads, the painstaking technique seems at odds with the artist's banal subject matter of hotel rooms. Yet a meditative calm does somehow infuse his images. The spaces depicted are quiet and unpeopled, but often feature signs of human habitation, as in this image in which the glow of the television offers some of the comfort we associate with a lit fireplace.

For Keith Tyson, the laws of chance and order revealed by science and technology fulfill yearnings to be in touch with an omnipotent and ineffable presence.

FIGURE 14–32
EWAN GIBBS
Doorway, 1999
Ink on paper, 11½ × 16¼"
Courtesy Paul Morris Gallery, New York

As an example of the awe with which we regard science, the artist points out his own wonder at the theory of the Big Bang, declaring the idea that hydrogen atoms bashing together to create the universe is actually more wondrous than any theological explanation. For his own art output, Tyson depends greatly upon chance, taking his instructions from what he calls his "Artmachine," a semicomputerized device that directs him to fabricate things that seem absurd. (It has instructed him, for example, to compose a painting from 366 painted breadboards.) The gratuitous nature of this art-making process should be considered in light of Tyson's conviction that a seemingly inconsequential act might set off a chain of events that could have beneficial consequences for some people and drastic ones for others.

Figure 14–33 shows one of Tyson's large studio-wall drawings. The work seems to record the fervid thinking of an amateur physicist desperately trying to discover the interconnection between events in the world. Among all the scrawled notations we see references to physics in the simple machines using weights, pulleys, and levers. There is also what appears to be a magnet suspended from the "d" in the word "doing," accompanied by nine cubes it has attracted into a grid formation. Superimposed over the cubes is the armature of a polyhedron which, along with numerous calculations across the drawing's surface, imply that mathematics is being brought to bear on the situation. Dominating the work are two menacing dark forms (the larger of the two resembling a crude molecular diagram) that give the drawing a graphic vibrancy and establish a basic but effective illusion of space.

Globalization

The worldwide dissemination of consumer goods and information has prompted the emergence of the relatively new theme of globalization. The drawbacks and benefits of globalization have been hotly disputed. On the one hand, the global

FIGURE 14–33
KEITH TYSON
Studio Wall Drawing, 2000
"Objects Doing Things."
Mixed media on paper,
157 × 126 cm
© *The artist, courtesy Anthony Reynolds
Gallery, London*

marketplace has been used for the continued export of Western goods and culture, a situation decried by many as detrimental to previously colonized cultures struggling for redefinition and indigenous identity. On the other hand, it could be argued that a global approach to the critical worldwide issues of human rights, world health, population growth, national sovereignty, terrorism, and the environment offers the only hope for the long-term survival of the human species.

Globalization may be inevitable given the exponential growth of world population. One artist attempting to come to grips with the rapid rate of urban transformation is Berlin-based Franz Ackermann. A worldwide traveler, he documents the many foreign places he has visited in small gouache drawings he describes as "mental maps." These works do not aim to please with distinctive exotic scenes or picturesque views. Instead, they are records of urban locales

that combine some of the aspects of street maps with more subjective recollections of specific architectural spaces. Although the artist never depicts people in his scenes, viewing a collection of his urbanscapes will give you the impression of an overpopulated world layered with activities relating to commerce, travel, and the endless building of skyscrapers. In the mental map in Figure 14–34, note how the absence of nature or local scenery frustrates our ability to identify the place, yet we still recognize the all-too-familiar phenomenon of artificial environments that have replaced natural geography and cultural differentiation. Far-reaching jetties and cantilevered platforms have extended the natural shorelines of the three foreground landmasses, and modern buildings disrupt the natural skyline, while their foundations violate the earth below sea level. The ocean itself is crisscrossed with wavy lines reaching like tentacles or nerve cell ganglia from the urban centers. These lines of differing intensities relate to international trade and may be interpreted as shipping lanes, real or intended, or perhaps lines of telecommunication. The impression we are left with is a biosphere already choked with human production and consumption, with no relief in sight.

Contemporary Asian artists have no choice but to recognize the hybrid nature of a world in which the borders between East and West are fast dissolving. Wei Dong, a Beijing-based artist, uses quotations from Eastern and Western art to comment on the changing landscape and mores of his country. In classical Chinese landscape painting, signs of human habitation, small and incidental to the depiction of towering mountains, winding streams, and scraggy pines, might be limited to the inclusion of a lone traveler or the rustic dwelling of a hermit monk or poet. But in Dong's work landscape becomes a secondary player that functions as a stage upon which bizarre, human physical interaction occurs. The spatial dislocations in his work are reminiscent of European art of the Mannerist period. Other Mannerist features include the lurid light, the contorted positions and sinewy bodies of the figures, and also their facial expressions, which are at once wistful and decadent. Wei's work, in spite of its salacious imagery, is best

FIGURE 14–35
WEI DONG
Two Lonely Women #2
Traditional Chinese and Japanese inks and pigments on rice paper, 33¼ × 26⅜"
Courtesy Jack Tilton/ Anna Kustera Gallery

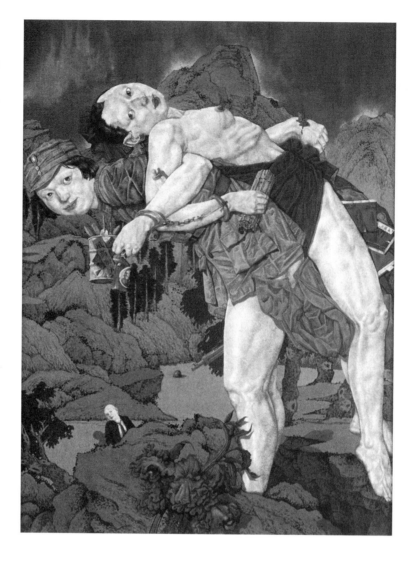

seen as an allegory about the effects that the commodification of desire has had upon contemporary mores. For years the mass media in the West has used sexual imagery to sell everything from entertainment and news to toothpaste and automobiles. As markets for Western goods and mass media open in Asia, such imagery, formerly condemned by the Chinese government, has become more prominent. Wei's figures, as in Figure 14–35, are poised between a historic past, symbolized by the philosophical landscape, and the materialistic present, symbolized by the scantily clad figures.

The collaborative team of Helen Mayer-Harrison and Newton Harrison has for years been concerned with the issue of global warming. Some of their past projects, aimed primarily at raising consciousness about this vital issue, have dealt with futurist visions of how humans can adapt to the new warmer climate and raised sea level. The Future Garden project, illustrated in Figure 14–36, proposes to reverse some of the effects of global warming by installing fully functioning meadows on the rooftops of large buildings in various European city centers. The Harrisons see the meadow as an excellent paradigm for humans working in harmony with nature. A healthy meadow, one that has not been overgrazed, is a sustainable ecosystem supporting a rich diversity

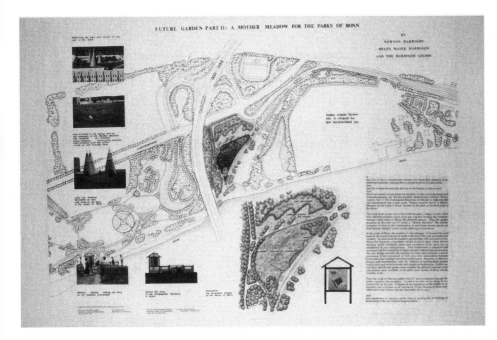

FIGURE 14–36
HELEN MAYER-HARRISON and
NEWTON HARRISON
Future Garden 2: Parks of Bonn, 1997
Ink, pastel, pencil, photographs on
paper, 24 × 36"
*Courtesy Ronald Feldman Fine Arts.
New York*

of wild species in addition to the livestock they were created for. The introduction of meadows into European city centers will provide city-dwellers with a much needed place to commune with nature and to reflect on future initiatives that could be mutually beneficial to both humans and the natural world we inhabit.

Glossary of Media

Papers

The following are definitions of terms commonly used to distinguish the qualities of one paper from another; see also the accompanying table, which indexes popular drawing papers according to relative cost and physical properties.

Acid Free Papers without acid content. Either 100 percent rag papers or papers that have been chemically treated to obtain a neutral pH. Acid free papers are permanent; that is, they will not yellow or become brittle.

Block Solid pack of papers, prestretched and glued on all four sides. Suitable for direct application of wet media.

Cold Press Refers to the texture of certain 100 percent rag papers. Cold press papers have a medium rough texture as a result of being pressed with cold weights during processing. (See also *Hot Press* and *Rough*.)

Hot Press Refers to the texture of certain 100 percent rag papers. Hot press papers have a smooth texture as a result of being pressed with hot weights during processing. (See also *Cold Press* and *Rough*.)

Ply Refers to the number of layers that constitute a sheet of paper or paper board. For example, two-ply papers are made of two layers bonded together.

Rag Papers made from cotton rag or a combination of cotton rag and linen. Rag papers are acid free and permanent. (See also *Wood Pulp*.)

Rough A designation indicating the paper has a good "tooth." In reference to 100 percent rag papers, rough means that the paper has not been pressed and as a result has a naturally bumpy surface. (See also *Cold Press* and *Hot Press*.)

Sizing A dilute glue that is either mixed with the wood or rag pulp during the paper-making process or applied externally to a finished sheet of paper. Sizing inhibits the "bleeding" or spreading of wet media on paper.

Tooth Textural character of a paper due to its fibrous surface. A "good tooth" is desirable for drawings made with abrasive media, such as charcoal or conté crayon.

Weight Refers to the thickness and density of a paper. Typically, the weight of a paper in a ream (500 sheets) determines its price per sheet.

TABLE OF PAPERS

Paper	Price	Fiber/Color	Weight	Surface Qualities	Recommended Media	Other Characteristics
Bond	moderate	usually wood pulp, although better quality has mixture of rag and wood pulp, or even 100% rag; generally white	light to medium weight—in neighborhood of 50 pounds	lighter weights usually have smooth finish; heavy weights generally have more tooth; erases well	all-purpose; recommended especially for dry media and pen and ink	semipermanent, available in separate sheets and a wide range of pads and bound sketchbooks
Bristol Board	moderate	wood pulp, partial rag, or 100% rag; usually very white	heavy—sometimes several ply	available in plate (smooth) finish or kid (vellum) finish; semiabsorbent hard surface, erases very well	pencil, crayon, pastel, watercolor; especially recommended for ink	can stand some wetting without buckling; better qualities are especially permanent; sold loose or in pads
Charcoal Paper	moderate	some rag content, better qualities 100% rag; wide range of color	medium	good tooth on both surfaces; one surface usually has imprinted "woven" texture; the other surface is like vellum; erases well	charcoal, pastel, or conté crayon	sold in single sheets or in pads
Etching Papers	expensive	usually 100% rag, white or off-white; unsized	heavy	very absorbent; soft surface; does not erase well	dry, soft media—pastel, charcoal, crayon, soft pencil, or powdered graphite	sold in single sheets, generally in large to very large sizes
Illustration Board	moderate to expensive	two ply; consists of watercolor or drawing paper bonded to cardboard; better qualities use 100% rag paper mounted with acid free binder	heavy	varies according to paper used	all-purpose; especially good for watercolor and ink	can stand some wetting without buckling; better qualities have great permanency
Newsprint	inexpensive	wood pulp; high acid content; grayish white or yellow white	light	available in smooth or rough—even the rough grade does not have much tooth; soft media erases fairly easily	vine charcoal, compressed charcoal, soft pencil, conté crayon	very impermanent, yellows quickly; fragile, usually available in large pads
Oatmeal	inexpensive	rough wood pulp; oatmeal color	medium	very rough; soft, fragile surface	soft media—pastel, charcoal, crayon	not permanent
Rice Paper	expensive	rice fiber; usually white	very light	very soft and absorbent surface; will not erase easily	sumi ink and watercolor; also collage	
Sketch Paper	moderate	neutral pH wood pulp; off-white	medium-light	medium tooth, surface sized; withstands repeated erasure	pencil, charcoal, pen and ink	
Tag Board	inexpensive	wood pulp; yellowish tan	medium-heavy	slick; erases well	ink, soft pencil, oil pastel	available in single sheets, large size
Watercolor Paper	moderate to very expensive	usually partial rag to 100% rag; usually very white	medium-heavy to very heavy	hot pressed, cold pressed, and rough; absorbent	designed for watercolor; but hot pressed may be used for pen and ink and hard pencil, and cold pressed is good for all pencils	the heaviest papers will not buckle when wet; lighter weights must be "stretched" before use with wet media; this is done by soaking papers for a few minutes and then using gummed paper tape to fasten edges to a wooden board

Wood Pulp The chief ingredient of inexpensive papers. Papers made entirely of wood pulp are highly impermanent unless they have been treated to neutralize their acid content. (See also *Rag*.)

Dry Media

CHARCOAL (FIG. G–1)

Among the most popular of drawing media, charcoal is made by baking wooden sticks until essentially only pure carbon is left. Capable of producing countless effects, from thin lines to husky tones, charcoal comes in two forms, vine and compressed.

Vine Charcoal is easily erased, so it is excellent for the early stages of a drawing when a succession of rapid changes are necessary. But its fragility may also frustrate unwary students who accidentally smear and lighten their drawings. It comes in different diameters, from jumbo (⅜") to fine (⅜"), and in varying hardnesses.

Compressed Charcoal is manufactured from powdered charcoal mixed with a binder. Capable of a broader range of tones and more intense blacks than vine charcoal, it is also more permanent and harder to erase. It may be purchased in soft blocks and also in round sticks or pencils of varying hardnesses.

Charcoal Accessories include a chamois, which is a thin piece of leather used to lighten, blend, or erase deposits of charcoal; a tortillon, or rolled paper stump, which is also used for blending; a sandpaper pad for sharpening charcoal to a fine point; and fixative. (See also *Fixatives* in the Glossary of Media, pp. 360–61.)

CHALKS (FIG. G–2)

Chalks are manufactured from precipitated chalk, pigments, and generally non-fatty binders (such as gum tragacanth or methyl cellulose). The most popular forms of chalk used by the artist are conté crayon, soft pastels, hard pastels, and lecturer's chalk.

FIGURE G–1
Counter clockwise: (1) Vine charcoal, (2) Vine charcoal, (3) Vine charcoal, (4) Compressed charcoal, (5) Stump, (6) Stump, (7) Stump, (8) Charcoal pencil, (9) Charcoal pencil, (10) Carbon pencil, (11) Sandpaper pad, (12) Large rubberband, (13) Art bin, (14) Chamois, (15) Clips, and (16) Workable fixative

FIGURE G–2
Left to right: (1) Conté crayon (white), (2) Conté crayon (black), (3) Litho crayon, (4) Soft pastel, (5) Hard pastel, (6) Carbon pencil, (7) Conté pencil, and (8) Lecturer's chalk

Conté Crayon contains, in addition to the usual chalk, pigments and binders, small amounts of ball clay, soap, and beeswax. It is semihard with a slightly waxy texture, making it difficult to erase. It comes in both pencils and square sticks (which can be sharpened by using fine sandpaper), and it may be purchased in three hardnesses. Pressed with its edge flush against the paper, stick conté achieves thick marks; when sharpened or rotated to a corner or edge, it produces thin and incisive marks. Traditionally available only in black, white, assorted grays, brown (or bistre), and earth reds (sanguine, light medium, and dark), conté crayon has recently been introduced in a wide range of blendable colors.

Soft Pastels are made with a high grade of precipitated chalk, nonfatty binder, and pigment or dyes. The buttery texture of this medium is due to the very slight amount of binder used in its manufacture. Soft pastels come in a full spectrum of colors with a range of tones under each hue. The better qualities possess a good degree of lightfastness because they are made with true pigments, and their hue is generally designated by the name of the pigment (such as raw umber, viridian, etc.). It should be noted that some pigments, such as the cadmium reds and yellows, are toxic, so breathing in their dust should be avoided. The less expensive pastels utilize dyes instead of pigments and are not guaranteed lightfast. Pastel drawings must be handled and stored with care, as their surfaces will always be fragile. The surface of a pastel drawing may be somewhat stabilized by a light application of fixative, but a heavy application of fixative will dull its color. (See also *Fixatives* in the Glossary of Media, pp. 360–61.)

Hard Pastels, in contrast to soft pastels, contain a greater percentage of binder, including some fatty agents. They are not as prone to scatter pastel dust as the softer variety, but they are also more difficult to erase. (See also "Pastel Pencils" under *Colored Pencils* in the Glossary of Media, p. 359.)

Lecturer's Chalk is very soft and nonfatty. It comes in large blocks and in a broad range of colors. Lecturer's chalk is excellent for gesture drawing and for rapidly applying broad areas of tone.

FIGURE G–3
Left to right: (1) Carpenter's pencil, (2) Drawing pencil, grade B, (3) Ebony pencil, (4) Drafting pencil, (5) Woodless pencil, (6) Leadholder, (7) Blackie drawing pencil, and (8) Graphite stick

GRAPHITE MEDIA (FIG. G–3)

Graphite is soft, crystallized carbon, which is available in an assortment of hardnesses, from 9H (the hardest) through the intermediate degrees of H, F, and HB, to the soft pencils from 1B to 8B (the softest). Graphite is easily manipulated by smearing, smudging, and erasing. But, particularly in the softer range, overworked areas can take on an unappealing shine and mottled appearance.

Graphite Pencils, sometimes referred to as *lead* pencils, actually contain a mixture of clay and ground graphite. An *ebony* pencil is somewhat greasier than regular drawing pencils and is capable of deep blacks and lustrous tones. A *carpenter's* pencil, or *broad sketching* pencil, is excellent for layout and blocking in the large masses of a subject.

Graphite Sticks have the same ingredients as graphite pencils, but without the wooden casings. Graphite sticks apply broader single-stroke marks but are usually available only in HB, 2B, 4B, and 6B. Several years ago, a lacquer-coated "woodless pencil" was introduced, which may be sharpened to a point and which keeps the hands from getting dirty.

Graphite Leads come in a wider range of hardnesses than do graphite sticks and are used in mechanical lead holders.

Powdered Graphite may be made by crushing leads or sticks, or may be purchased in tubes from a hardware store (it is used as a lubricant). Rubbed onto a smooth-surfaced board or paper with a cloth, tissue, or soft brush, powdered graphite can produce evenly blended, atmospheric values.

CRAYONS (FIG. G–4)

Crayons are either wax or oil based. Wax crayons are the kind manufactured for children; they are made with paraffin and stearic acid, and are not color permanent. Colored pencils, which contain a wax binder, are, technically speaking, crayons. Oil crayons include lithographic crayons, China markers, and oil pastels.

FIGURE G–4
Left to right: (1) Colored pencil,
(2) Pastel pencil, (3) China marker,
(4) Litho crayon, (5) Colored
pencil, water soluble, and
(6) Oil pastel

Colored Pencils are available in a wide variety of brilliant and blendable colors. Made with a wax binder, they provide little resistance when drawing, but they are also not easy to erase. And due to the hardness of the binder, the value range of many brands is much more limited than graphite drawing pencils. Two alternatives are *pastel pencils,* which produce a wider range of values than conventional colored pencils, and *watercolor pencils,* which can be dipped in water or moistened with a brush to produce washes.

Lithographic Crayons are made for the lithographic printing process, but they have become popular with artists as a drawing medium. Made only in black, they come in pencil and stick forms, and in six degrees of hardness, from #00, which is the softest and contains the most fatty acid (grease), to #5, which is the hardest and most similar to graphite in its grease content. Litho crayons are soft and pliable and make rich velvety blacks, but they are virtually impossible to erase. However, they may be scraped and flecked on heavier papers, and they can be made into a wash when brushed with turpentine or mineral spirits. *Note:* Never use solvents without proper ventilation.

China Markers have an oily texture and an ease of manipulation similar to litho crayons, and they may be obtained in a broad range of colors.

Oil Pastels are soft crayons with an oil and wax binder. (Because of this binder, oil pastel deposits are not fragile like those of soft pastels, but they are also virtually impossible to erase.) Oil pastels are easily blended with the finger or with a brush dipped in turpentine or paint thinner. (Since most, but not all oil pastel brands are non-toxic, it is prudent to wear plastic gloves when using them; if solvents are used, gloves are most certainly recommended and be sure to work in a properly ventilated area.) Oil pastels come in a variety of colors and have excellent covering power. Better quality oil pastels are often lightfast.

COLORED MARKERS

By colored markers we refer to the wide variety of so-called "felt-tip" pens now on the market. Manufactured in fine, bullet-shaped, and chisel tips, they come in a broad assortment of colors, which are bright, flat, and sometimes impermanent. Colored markers may be hazardous if they contain a solvent such as xylene or toulene as a vehicle for the colorant. More recently introduced, however, are acrylic and opaque paint markers, which manufacturers claim to be nontoxic and colorfast.

Ballpoint Pens may be considered a form of colored markers. Although long favored by artists because they are inexpensive, fluid, uniform of line, and possess

FIGURE G–5
Top to bottom: (1) RubKleen pencil
eraser, (2) Pink Pearl pencil eraser,
(3) Combination plastic eraser,
(4) Fiberglass ink eraser,
(5) Kneaded eraser, and
(6) Artgum eraser

an aura of Pop culture, many ballpoint pen inks are unfortunately also highly impermanent.

Gel Pens give a free-flowing, uniform line. Available in a variety of colors including opaque pastels and metallics, they are pigmented pH neutral ink, and may be considered permanent.

ERASERS (FIG. G–5)

As corrective devices, erasers should be used in moderation, lest they become a kind of "crutch." More appropriately, erasers should be viewed as drawing tools by virtue of their ability to initiate and alter surface textures as well as to blend, lighten, smear, and even create hatched or tracery-like white lines through deposits of charcoal, conté, and graphite.

Kneaded Erasers are soft and therefore less likely to tear thin papers such as newsprint. They are easily formed into a point to pick out accents from dry media; and when this eraser becomes dirty, kneading it will produce a clean surface. When using media that does not erase easily, such as colored pencil or conté crayon, you may use the kneaded eraser to lift off the top layer of the deposit prior to using a harder eraser to finish the job.

Artgum Erasers are good all-purpose erasers. Crumbly and nonabrasive, they are particularly effective for manipulating charcoal and graphite.

Pink Erasers in a block form are serviceable for all dry media. More abrasive than kneaded, artgum, or vinyl erasers, they are also more effective on heavy deposits of charcoal, conté, and graphite. Not recommended for soft papers.

Vinyl or Plastic Erasers occupy an intermediate position between artgum and pink erasers, both in their ability to deal with dense deposits of dry media and in their abrasive qualities.

Fiberglass Ink Erasers are very abrasive and should be used on hard papers only.

FIXATIVES

Fixatives traditionally consist of a very dilute solution of shellac or cellulose lacquer; they are now being replaced by the more chemically stable acrylic lacquers.

Fixative is used to protect the delicate surface of charcoal or pastel drawings by minimizing the accidental dusting-off of the media. Fixative is applied by spraying in one or more *light* even coats, and it should be allowed to dry between applications.

Workable Fixative will help to stabilize the deposits on your paper, minimizing unintentional obliteration of your image and allowing you to build up deeper tones.

Nonworkable Fixative is formulated for use on a finished work. Some artists use fixative to cut down on the sheen of graphite drawings.

Caution: Solvents in fixatives are harmful to your health, as are the airborne particles of the fixative itself. Always use fixative in a well-ventilated area and in accordance with the manufacturer's directions.

Wet Media

INK

Ink is a drawing medium with a venerable tradition both in our culture and in oriental cultures. It may be used in a variety of pens or diluted with water to produce graded washes that are applied with a brush. The ink most commonly used by artists is a liquid ink called *india ink,* which comes in a variety of colors under two basic categories: waterproof and nonwaterproof. Ink in a solid form, called *sumi ink*, has been steadily gaining in popularity.

Waterproof Inks contain shellac and borax so that the dried film will withstand subsequent wetting without dissolving. This is an advantage when you wish to layer washes in order to build areas of tone or when you wish to add washes to a line drawing.

Nonwaterproof Inks are more suited to fine-line work and wet-on-wet techniques, since the dried film will not stand up to further wetting. This may work to your advantage if you wish to make changes in your drawing. When using line in combination with washes, it is advisable to begin with your washes and add line only after the washes are dry or near dry.

Sumi Ink, an especially high grade of ink manufactured in Japan, comes in a solid block or stick. Traditionally it is rubbed with water on an ink stone until the desired intensity is produced. Both ink and stone are usually available in art supply stores or oriental specialty shops.

Opaque Inks, intended for use by calligraphers and designers, are less frequently used in a drawing context because they cannot be successfully diluted to produce graded washes. For variety's sake you may wish to try using an opaque white ink in combination with a darker ink or tinted paper.

Acid Free Inks come in a variety of colors and offer a more archival and color-fast alternative to traditional color drawing inks. Acrylic based, they are slightly more viscous than conventional inks, and they dry more quickly. These inks may be used in fountain pens, technical pens, dip pens, or airbrushes, and they are waterproof.

PENS (FIG. G–6)

There is a large variety of pens on the market. Some are designed especially for freehand drawing; others, designed for lettering or drafting, may nonetheless be used by the fine artist.

FIGURE G–6
Top row left to right:
(1) Waterproof ink suitable for technical pens, (2) India ink suitable for fountain pens, (3) Sumi ink and ink stone, and (4) Sepia ink for fountain pens
Bottom row left to right:
(1) Technical pen, (2) Fountain pen with drawing nib, (3) Nylon tipped marker, (4) Steel pen, fine nib, (5) Steel pen, hawkquill, (6) Steel pen, calligraphy, (7) Steel pen, crowquill, and (8) Bamboo pen

Reed or Bamboo Pens do not hold much ink and become blunt quickly if they are oversharpened. They are therefore best suited for bold, short marks and do not lend themselves to flowing line.

Steel Pens come in a wide range of shapes and sizes, and are used with a pen holder. The flexible *crowquill* will give a very fine line and is excellent for small-scale cross-hatch drawing. It should, however, be used on a smooth, hard paper because of its tendency to catch on the fibers of a soft or rough paper. To achieve a somewhat heavier smooth line, use a gillot pen nib (not pictured). Its oval-shaped tip flows more easiily on fibrous supports. *Calligraphy* pens produce a line of the most varied width. They come in a variety of styles and sizes, some of which are well suited to drawing. Because calligraphy pens use a greater amount of ink than the genuine drawing pens, they often have a small reservoir built into the nib to minimize the frequency with which you must dip them.

Fountain Drawing Pens are usually designed to accept interchangeable nibs of varying widths. They are very convenient, especially for field use. *Caution:* Only inks formulated for use in these pens should be used, and ink should not be allowed to dry in the pen.

Technical Pens are designed to give a line of uniform width and are used principally for drafting, as their stylus-type nib is compatible with the use of a straight-edge. They will accept interchangeable nibs, which come in a variety of widths. Unlike other pens, the line of a technical pen is free-flowing in any direction, and for nondrafting purposes its use may be extended to stipling and cross-hatching. The nib mechanism is delicate, so care must be used in cleaning it. *Caution:* Only inks formulated for use in technical pens should be used. In order to function properly, these pens need to be disassembled and cleaned often, and ink should never be allowed to dry in them.

PAINTS

The use of painting media in a drawing context will help accustom you to thinking of your drawing surface in terms of broad areas and will discourage you from

limiting your mark-making to linear elements. Although color is increasingly being used in contemporary drawing, you may wish to limit your palette severely at first so that you can concentrate more fully upon the tonal structure of your drawing. A tube each of black and white paint is generally thought sufficient for the student in a beginning or intermediate drawing class. Alternatively, you may try using white in combination with one warm color, such as burnt sienna, and one cool color, such as prussian blue.

Acrylic Paints are made with pigments or permanent dyes bound with an acrylic (a kind of vinyl) polymer emulsion. Acrylics are soluble in water when wet but dry quickly to a tough waterproof film. These properties, which allow you to apply successive layers of paint in a short amount of time, also make the blending of colors upon the working surface very difficult. You may use the paints directly on paper or board, or if you prefer, you may first prime your paper or board with acrylic gesso.

Gouache (or Opaque Watercolor) is an opaque water-based paint with a gum arabic binder. Intended primarily for use by designers, these paints are tinted generally with dyes rather than with true pigments and should not be considered permanent. Colors can be mixed on the palette but will not blend well once they are laid on the support. Gouache is a good medium to use in combination with other media, since its opacity will allow you to cover unwanted marks; and when dry, its matte, slightly chalky surface is very receptive to media such as graphite, charcoal, and pastel. Drawings made with a limited range of light and dark colors on tinted papers are particularly handsome.

Oil Paint is generally a highly permanent medium comprised of pigments bound with linseed oil. Oil paint colors blend superbly both on the palette and upon the support, and the colors dry true without darkening or turning chalky. If these paints are used directly on paper, the oil will spread through the paper fibers, causing an oily halo around the color and weakening the paint film. For this reason, some artists prefer to coat their paper with acrylic gesso prior to painting with oils.

Watercolor is a transparent water-based paint with a gum arabic binder. Watercolor is especially appreciated for its capacity to recreate the effects of outdoor light and the vagaries of weather. It is generally applied in layers of dilute washes and sometimes wet on wet. When left to dry in separate patches, the areas of color tend to form crisp outlines and thus achieve the dappled effect of sunlight and shade. Although a translucent white (called Chinese White) is available, purists frown upon its use, advocating instead leaving untouched the ground of the paper where the highest values are desired.

BRUSHES (FIG. G–7)

In choosing a brush from the seemingly endless variety available, you should consider the bristle in relation to the media you intend to use. In regard to size, a good rule of thumb is to select the largest size possible for any given task. This will cut down on your work time and will impart to each brushstroke a greater immediacy.

Artists' brushes come in three major styles: *flats*, which have broad, straight-edged tips; *brights,* which are a little less flat with more rounded edges; and *rounds*, which come to a fine point when more flexible hairs are used.

Proper care of your brushes will guarantee them a longer life, so clean them thoroughly after use, never leave them standing for more than a moment in water or solvent, and store them so that their bristles are not bent.

Housepainting Brushes, with either natural or synthetic bristles, are commonly available in sizes ranging from ½ inch to 7 inches or larger. Artists use them primarily for applying gesso, but they may be used also for painting in large gestural strokes.

FIGURE G–7
Left to right: (1) Sable, round,
(2) Sumi, (3) Nylon, flat, (4) Nylon,
round, (5) Bristle, flat, (6) Bristle,
round, and (7) Housepainting
brush

Bristle Brushes are made from bleached hog's bristles. The individual bristles are fairly stiff and slightly forked at the tips. These properties prevent the brush from coming to a fine point but allow it to carry a good load of paint. They are traditionally favored for oil painting but may also be used for acrylics. The flat style is generally considered the most versatile. The round style lends itself well to dry-brush technique and to the blending of dry media, such as pastel.

Sable Brushes are made from a mink-like animal. The individual hairs are tapered and in the best quality brushes are carefully arranged so that the wetted brush comes gradually to a fine point. The flexibility, resiliency, and fine pointing properties of this brush make it a favorite for use with watercolor or detailed passages in oil paint. Sable brushes range in price from expensive to extremely expensive, but if properly looked after, they will last for years. Use with acrylics, however, will diminish the life of a sable brush.

Synthetic Brushes generally have nylon bristles and may imitate the properties of either hog's bristle or sable hair. Less expensive than bristle or sable, these brushes clean easily and are therefore often used with acrylics.

Japanese Brushes come in a variety of styles suitable to water-based media. The round goat's hair brush set in a bamboo handle is available in medium to large sizes, and it possesses a moderate pointing capability. It is excellent for ink and ink washes. Far less expensive, though not nearly so versatile as a sable, these brushes may also be used for watercolor. *Hake* brushes, made with soft white sheep's hair, are wide and flat. More sensitive than the housepainting brush, they are best used for laying down watercolor washes.

Other Brushes include camel's hair or squirrel's hair. These range in price from inexpensive to moderately expensive, depending upon the quality of the hair and the care put into their manufacture. Although they lack the spring and fine pointing qualities of a sable brush, they hold a fair amount of water and therefore may be used for aqueous media. They are too soft to be used with oil paints.

Glossary of Terms

Abstraction The process of selecting and organizing the visual elements to make a unified work of art. Also a twentieth-century style of art in which the particulars of subject matter are generalized in the interests of formal (compositional) invention.

Achromatic Denotes the absence of hue and refers to the neutrals of black, white, and gray. (See also *Chromatic* and *Neutrals*.)

Actual Grays Uniform value achieved by the continuous deposit of drawing media, such as blended charcoal or ink wash. (See also *Optical Grays*.)

Ambiguous Space A visual phenomenon occurring when the spatial relationships between positive and negative shapes are perceptually unstable or uncertain. (See also *Figure–Ground Shift*, *Interspace*, and *Positive–Negative Reversal*.)

Analogous Color Scheme A color arrangement based on several hues that are adjacent or near one another on the color wheel. (See also *Analogous Colors* and *Color Scheme*.)

Analogous Colors Colors that are adjacent, or near one another, on the color wheel and therefore have strong hue similarity. One set of analogous colors is yellow, yellow-green, green, and blue-green. (See also *Analogous Color Scheme* and *Color Scheme*.)

Angling The process of transferring perceived angles in the environment to a drawing surface.

Approximate Symmetry A form of visual balance which divides an image into similar halves but which avoids the potentially static quality of mirror-like opposites associated with symmetrical balance. (See also *Asymmetrical Balance* and *Symmetrical Balance*.)

Artistic Block The interruption of an artist's natural creative output. Often accompanied by feelings of severe frustration and loss of confidence.

Asymmetrical Balance Visual equilibrium achieved by adjusting such qualities as the scale and placement of elements in different parts of a composition. (See also *Approximate Symmetry* and *Symmetrical Balance*.)

Atmospheric Perspective A means for achieving the illusion of three-dimensional space in a pictorial work of art. Sometimes called aerial perspective, it is based on

the fact that as objects recede into the distance their clarity of definition and surface contrast diminish appreciably.

Background The most distant zone of space in a three-dimensional illusion. (See also *Foreground* and *Middleground*.)

Basetone The darkest tone on a form, located on that part of the surface that is turned away from the rays of light. (See also *Chiaroscuro*.)

Blind Contour Line drawings produced without looking at the paper. Such drawings are done to heighten the feeling for space and form and to improve eye-hand coordination.

Brilliance The vividness of a color.

Cast Shadow The shadow thrown by a form onto an adjacent or nearby surface in a direction away from the light source. (See also *Chiaroscuro*.)

Chiaroscuro Refers to the gradual transition of values used to create the illusion of light and shadow on a three-dimensional form. The gradations of light may be separated into six separate zones: highlight, quarter-tone, halftone, basetone, reflected light, and cast shadow.

Chroma See *Intensity*.

Chromatic Refers to color or the property of hue. (See also *Achromatic* and *Hue*.)

Chromatic Gray Gray created by adding hue to a neutral or by mixing complements to achieve a neutralized color. (See also *Neutral*.)

Color Climate Sensations of moisture or dryness associated with the color temperature of a hue.

Color Scheme An association of selected colors that establishes a color harmony and acts as a unifying factor in a work of art. (See also *Analogous, Complementary, Discordant, Monochromatic,* and *Triadic* color schemes.)

Complementary Color Scheme A color arrangement based on hues that are directly opposite one another on the color wheel. (See also *Color Scheme* and *Complementary Colors*.)

Complementary Colors Colors that are directly opposite one another on the color wheel and represent the strongest hue contrast, such as red and green, blue and orange, and yellow and purple. (See also *Complementary Color Scheme*.)

Complex Local Color The natural range of hues of some objects that, under normal light, create the overall impression of a dominant local color. (See also *Local Color*.)

Cone of Vision A conical volume that constitutes the three-dimensional field of vision. Its apex is located at eye level; its base lies within the imagined picture plane. (See also *Picture Plane*.)

Constellation The grouping of points in a three-dimensional space to form a flat configuration or image.

Content The meanings inferred from the subject matter and form of a work of art.

Contour Line A line of varying thickness—and often tone and speed—used to suggest the three-dimensional qualities of an object. Contour line may be applied along as well as within the outer edges of a depicted form.

Convergence In the system of linear perspective, parallel lines in nature appear to converge (come together) as they recede.

Cool Colors Psychologically associated, for example, with streams, lakes, and foliage in the shade. Cool colors such as green, blue-green, blue, and blue-purple appear to recede in a relationship with warmer colors. (See also *Warm Colors*.)

Cropping Using a format to mask out parts of an image's subject matter.

Cross-Contour Lines Contour lines that appear to go around a depicted object's surface, thereby indicating the turn of its form.

Cross-Hatching The intersecting of hatched or massed lines to produce optical gray tones. (See also *Hatched Lines* and *Optical Grays*.)

Diagrammatic Marks Those marks and lines artists use to analyze and express the relative position and scale of forms in space.

Diminution In linear perspective, the phenomenon of similarly-scaled objects appearing smaller as they recede.

Discordant Color Scheme A color arrangement based on hues that compete or conflict. (See also *Color Scheme*.)

Envisioned Images Depictions that are based wholly or in part on the artist's imagination or recall.

Eye-Level The height at which your eyes are located in relation to the ground plane. Things seen by looking up are above eye-level (or seen from a "worm's eye" view); things seen by looking down are below eye-level (or seen from a "bird's eye" view).

Figure The representation of a recognizable object or nonrepresentational shape (such as a tree, a letter of the alphabet, or a human figure), which may be readily distinguished from its visual context in a drawing.

Figure–Ground Shift A type of ambiguous space that combines aspects of inter-space and positive–negative reversals. It is characterized by "active" or somewhat volumetric negative areas and by the perception that virtually all the shapes are slipping, or shifting, in and out of positive (figure) and negative (ground) identities. (See also *Ambiguous Space, Interspace,* and *Positive–Negative Reversal*.)

Figure–Ground Stacking A sequential overlapping of forms in a drawing, making the terms figure and ground relative designations.

Fixed Viewpoint Refers to the depiction of an observed object in accordance with its appearance from one physical position.

Force Lines Lines used to reveal the structure of a form by indicating the counterbalancing of one mass against another.

Foreground The closest zone of space in a three-dimensional illusion. (See also *Background* and *Middleground*.)

Foreshortening In foreshortening, the longest dimension of an object is positioned at an angle to the picture plane.

Form The shape, structure, and volume of actual objects in our environment, or the depiction of three-dimensional objects in a work of art. Form also refers to a drawing's total visual structure or composition.

Formal Refers to an emphasis on the organizational form, or composition, of a work of art.

Format The overall shape and size of the drawing surface.

Form-Meaning That aspect of content that is derived from an artwork's form, that is, the character of its lines, shapes, colors, and other elements, and the nature of their organizational relationships overall.

Form Summary A simplified form description of a complex or articulated object, usually for purposes of analysis or to render a subject's three-dimensional character more boldly.

Gestalt A total mental picture, or conception, of a form.

Gesture Drawing A spontaneous representation of the dominant physical and expressive attitudes of an object or space.

Grisaille The arrangement of an image into varied steps of gray values.

Ground The actual flat surface of a drawing, synonymous with a drawing's opaque picture plane. In a three-dimensional illusion, ground also refers to the area behind an object (or figure).

Ground Plane A horizontal plane parallel to the eye-level's plane. In nature this plane may correspond, for instance, to flat terrain, a floor, or a tabletop.

Halftone After the highlight and quarter-tone, the next brightest area of illumination on a form. The halftone is located on that part of the surface that is parallel to the rays of light. (See also *Chiaroscuro.*)

Hatched Lines Massed strokes that are parallel or roughly parallel to each other. Used to produce optical gray tones. (See also *Cross-Hatching* and *Optical Grays.*)

Highlight The brightest area of illumination on a form, which appears on that part of the surface most perpendicular to the light source. (See also *Chiaroscuro.*)

History Painting A picture that is usually painted in a grand or academic manner and represents themes from history, literature, or even the Bible.

Horizon Line The line formed by the *apparent* intersection of the plane established by the eye-level with the ground plane. Often described as synonymous with eye-level.

Hue The name of a color, such as red, orange, and blue-green. The term *chromatic* is sometimes used to refer to the property of hue. (See also *Chromatic.*)

Installation Art A form of mixed media, multidisciplinary art that interfaces with the architectural space or environment in which it is shown.

Intensity The saturation, or purity, of a color.

Interspace Sometimes considered synonymous with negative space. In many works of modern art, however, it is more accurately described as a type of ambiguous space in which negative shapes have been given, to a certain degree, the illusion of mass and volume. (See also *Ambiguous Space.*)

Intuition Direct mental insight gained without a process of rational thought.

Layout The placement of an image within a two-dimensional format.

Linear Perspective The representation of things on a flat surface as they are arranged in space and as they are seen from a single point of view.

Local Color The actual color of an object, free of variable or unnatural lighting conditions. (See also *Complex Local Color.*)

Local Value The inherent tonality of an object's surface, regardless of incidental lighting effects or surface texture.

Luminosity Certain visual effects achieved through color or tonal interaction, for example, the effect of an illusion of light that appears to emanate from "inside" a color area.

Mass The weight or density of an object.

Mass Gesture A complex of gestural marks used to express the density and weight of a form.

Measuring A proportioning technique using a pencil to gauge the relative sizes of the longest and shortest dimensions of an object.

Middleground The intermediate zone of space in a three-dimensional illusion. (See also *Background* and *Foreground*.)

Modernism An historical movement initiated in the mid-19th century and continuing to the present day. Modernist art is largely characterized by the conviction that content resides chiefly in artistic form. Modernist art, often abstract or nonobjective, recognizes the autonomy of the art object. (See *Postmodernism, Abstraction,* and *Nonobjective.*)

Moire A pattern like that of watered silk, which results from laying one pattern on top of another (such as the stripes of a zebra seen through the bars of a cage).

Monochromatic Consisting of one color. (See also *Polychromatic.*)

Monochromatic Color Scheme A color arrangement consisting of value and intensity variations of one hue. (See also *Color Scheme.*)

Monocular Vision Vision that uses only one eye, and therefore only one cone of vision, to perceive an object.

Motif The repetition of a visual element, such as a line, shape, or unit of texture, to help unify a work of art.

Negative Shape The pictorial, flat counterpart of negative space in the real world.

Neutrals Refers to black, white, and gray. (See also *Achromatic* and *Chromatic Gray.*)

Nonobjective A style of art in which the imagery is solely the product of the artist's imagination and therefore without reference to things in the real world.

One-Point Perspective In one-point perspective, a rectangular volume is centered on the line of vision, thus causing all receding (horizontal) parallel lines to appear to converge, or meet, at one point on the horizon line.

Optical Color Refers to the eye's tendency to mix small strokes of color that are placed side by side or overlapped.

Optical Grays The eye's involuntary blending of hatched or cross-hatched lines to produce the sensation of a tone. (See also *Actual Grays* and *Cross-Hatching.*)

Outline Usually a mechanical-looking line of uniform thickness, tone, and speed, which serves as a boundary between a form and its environment.

Overall Image The sum total of all the shapes, positive and negative, in a drawing.

Overlapping An effective way to represent and organize space in a pictorial work of art. Overlapping occurs when one object obscures from view part of a second object.

Perceived Color The observed modification in the local color of an object, which is caused by changes in lighting or by the influence of reflected colors from surrounding objects.

Pictorial Refers to a picture, not only its actual two-dimensional space but also its potential for three-dimensional illusion.

Picture Plane The actual flat surface, or opaque plane, on which a drawing is produced. It also refers to the imaginary, transparent "window on nature" that represents the format of a drawing mentally superimposed over real-world subject matter.

Planar Analysis A structural description of a form in which its complex curves are generalized into major planar zones.

Polychromatic Consisting of many colors. (See also *Monochromatic.*)

Positive–Negative Reversal A visual phenomenon occurring when shapes in a drawing alternate between positive and negative identities. (See also *Ambiguous Space.*)

Positive Shape The pictorial, flat counterparts of forms in the real world.

Postmodernism A movement initiated in the mid-20th century in reaction to Modernism in which emphasis on subject-matter meaning displaced the modernist artist's preoccupation with form. (See *Modernism.*)

Primary Colors The three fundamental colors—red, yellow, and blue—that cannot be produced by mixing other hues or colors. When mixed in pairs or combined in admixtures containing all three, the primaries are the source for all the other hues on the color wheel. (See also *Secondary Colors.*)

Principles of Design The means by which artists organize and integrate the visual elements into a unified arrangement, including unity and variety, contrast, emphasis, balance, movement, repetition, rhythm, and economy.

Proportion The relative size of part to part and part to whole within an object or composition.

Push-Pull Spatial tension created by color interaction.

Quarter-Tone After the highlight, the next brightest area of illumination on a form. (See also *Chiaroscuro.*)

Reflected Light The relatively weak light that bounces off a nearby surface onto the shadowed side of a form. (See also *Chiaroscuro.*)

Relative Position A means by which to represent and judge the spatial position of an object in a three-dimensional illusion. Generally, the higher something has been depicted on a surface, the farther away it will appear.

Relative Scale A means by which to represent and judge the spatial position of an object in a three-dimensional illusion. Generally, things that are larger in scale seem closer; when there is a relative decrease in the scale of forms (especially if we know them to be of similar size) we judge them to be receding into the distance.

Secondary Colors The three hues—orange, purple, and green—that are each the result of mixing two primaries.

Shade A color darkened by adding black.

Shape A flat area with a particular outer edge, or boundary. In drawing, shape may refer to the overall area of the format or to the subdivided areas within the format.

Shape Aspect The shape of something seen from any one vantage point.

Shape Summary Recording the major areas of a three-dimensional form in terms of flat shape, usually for purposes of analysis.

Simultaneous Color Contrast The enhancement of contrast between two different colors that are placed together.

Space In the environment, space may be defined as area, volume, or distance. In drawing, space may be experienced as either a three-dimensional illusion or as the actual two-dimensional area upon which a drawing is produced. (See also *Picture Plane.*)

Spatial Configuration The flat shape or image produced by connecting various points in a spatial field.

Spatial Gesture The gestural movement implied by a perceived linkage of objects distributed in space.

Station Point In the system of linear perspective, the fixed position you occupy in relation to your subject (often abbreviated SP).

Stereoscopic Vision Normal perception using two eyes. In stereoscopic vision two slightly different views of an object—two separate cones of vision—are combined to produce a single image.

Subject Matter Those things represented in a work of art, such as a landscape, portrait, or imaginary event.

Subject-Meaning That aspect of content derived from subject matter in a work of art.

Subjective Color Refers to arbitrary color choices. Such arbitrary color choices can be used to convey emotional or imaginative responses to a subject and to compose more intuitively or expressively.

Symmetrical Balance Symmetrical balance is achieved by dividing an image into virtually mirrorlike halves. (See also *Approximate Symmetry* and *Asymmetrical Balance*.)

Synesthesia In synesthesia, a subjective sensation accompanies an actual sensory experience—for example, you hear a sound in response to seeing a color.

Tactile Perceptions gained directly from or through memories of the sense of touch.

Tertiary Colors Colors made by mixing a primary and an analogous secondary color. Mixing red with orange, for example, produces the tertiary red-orange.

Three-Dimensional Space The actual space of our environment, or the representation of it, through a pictorial illusion.

Three-Point Perspective The kind of linear perspective used to draw a very large or very close object. In three-point perspective, the object is positioned at an angle to the picture plane and is seen from an extreme eye-level, with the result that both the horizontal *and* the vertical parallel lines appear to converge, or meet, respectively at three separate vanishing points.

Tint A color lightened by the addition of white.

Tonal Key The coordination of a group of values in a drawing for purposes of organization and to establish a pervasive mood. Tonal keys may be high, middle, or low.

Topographical Marks Any marks or lines used to analyze and indicate the surface terrain of a depicted object. Cross-contour lines and hatched lines used to describe the inflections of planes are both topographical marks.

Triadic Color Scheme A color arrangement based on three hues that are equidistant from one another on the color wheel. (See also *Color Scheme*.)

Triangulation Angling between a set of three points on the picture plane to accurately proportion the overall image of your drawing.

Two-Dimensional Space The flat, actual surface area of a drawing, which is the product of the length times the width of your paper or drawing support. Synonymous with the opaque picture plane and flat ground of a drawing.

Two-Point Perspective In two-point perspective, a rectangular volume is positioned off-center—that is, it is not centered on the line of vision—thus causing the receding (horizontal) parallel lines of each face to appear to meet at two separate points on the horizon line.

Value Black, white, and the gradations of gray tones between them, or the lightness or darkness of a color when compared with a gray scale.

Value Shapes The major areas of light and shade on a subject organized into shapes, each of which is assigned a particular tone that is coordinated with the values of other shapes in the drawing.

Vanishing Point In linear perspective, the point on the horizon line at which receding parallel lines appear to converge, or meet.

Viewfinder A homemade device that functions as a rectangular "window" on your subject. It is a useful aid for proportioning and layout.

Visual Elements The means by which artists make visible their ideas and responses to the world, including line, value (or tone), shape, texture, and color.

Visual Weight The potential of any element or area of a drawing to attract the eye.

Volume The overall size of an object and, by extension, the quantity of three-dimensional space it occupies.

Warm Colors Psychologically associated, for example, with sunlight or fire. Warm colors such as red, red-orange, yellow, and yellow-orange appear to advance in a relationship with cooler colors. (See also *Cool Colors*.)

Working Drawings The studies artists make in preparation for a final work of art.

Index

Sketches

Sketches

Sketches

Sketches

Sketches

Sketches